LEGENDARY LOCALS

OF

COVENTRY

RHODE ISLAND

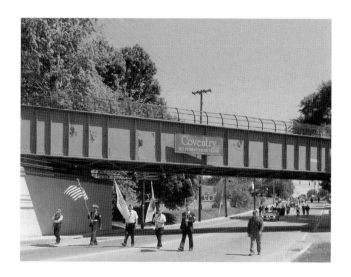

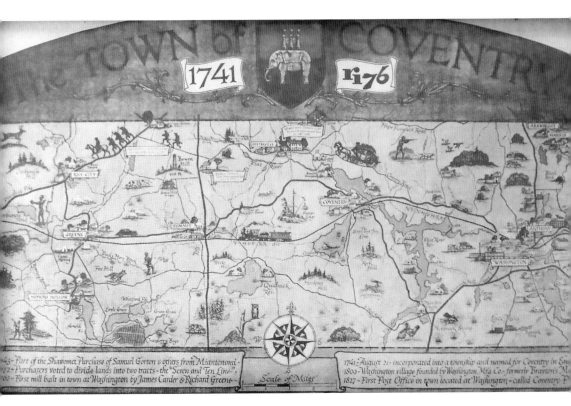

Map of Coventry

This map of Coventry was drawn in honor of the bicentennial celebration of the United States and highlights points of historical interest. A few of the images on this map are featured in this book. (Courtesy of Western Rhode Island Civic Historical Society.)

Page 1: Coventry Pride Sign

This sign is one of two that adorn an old train bridge that is now part of the Coventry Greenway, a bike path and walking trail that connects Coventry to other towns in Rhode Island. This sign represents the spirit of the residents of Coventry. (Author's collection.)

LEGENDARY LOCALS

OF

COVENTRY
RHODE ISLAND

ANDREW D. BOISVERT

Legendary Locals is an imprint of Arcadia Publishing
Charleston, South Carolina

Printed in the United States of America

Library of Congress Control Number: 2013937725

For all general information, please contact Arcadia Publishing:
Telephone 843-853-2070
Fax 843-853-0044
E-mail sales@arcadiapublishing.com
For customer service and orders:
Toll-Free 1-888-313-2665

Visit us on the Internet at www.arcadiapublishing.com

Dedication
This book is dedicated to the residents who have allowed me to write their stories and the stories of their ancestors; may your tales inspire future generations.

On the Front Cover: Clockwise from top left:
Alphee Bleir, Showboat owner (courtesy of Pawtucket Valley Preservation and Historical Society; see page 18); Diane Simmons, youth-services librarian (author's collection; see page 103); William Marcotte, dry-cleaner (author's collection; see page 48); Gail Tatangelo, community gardener (courtesy of Robert Robillard; see page 75); Searles Capwell, mill owner and politician (courtesy of Coventry Historical Society; see page 40); Joseph and James Maguire, lace-and-warping mill operators (author's collection; see page 46); Deana Borges, All Booked Up (author's collection; see page 24); William C. Rathbun, Civil War soldier (courtesy of Rachel Pierce; see page 29); Peter Stetson, Coventry High School science teacher (author's collection; see page 94).

On the Back Cover: From left to right:
Stamatis Karapatakis, Gelina's Ice Cream proprietor (author's collection; see page 24), Lauren Costa, *Coventry Patch* editor (author's collection; see page 109).

CONTENTS

ACKNOWLEDGMENTS

The following people deserve special note for opening doors and making the introductions to the many individuals who provided me with the stories and the pictures that have made this book possible: Norma Smith, Rachael Pierce, Thomas Pierce, Erma Pierce, Brenda Jacobs, Lauren Costa, Raymond Wolf, Richard Siembab, and Lois Sorenson. The organizations that allowed me access to their amazing collections were the Western Civic Rhode Island Historical Society, the Coventry Historical Society, and the Pawtuxet Valley Preservation and Historical Society.

I would also like to thank the following people for taking the time to sit down and tell me their stories and memories: Gail Holland, Gail Tantentaglo, Robert N. Robillard, William F. Marcotte, Guy Lefebvre, Everett "Junior" Hudson Jr., Fr. Paul R. Grennon, Donald Card, Donna Cole, the Hawkins family, Rosemarie and Bruce Guertin, the Skaling family, Diane Simmons, Gail Slezak, Joel Johnson, Patrick Malone, Chief Bryan J. Volpe, Joseph and James Maguire, Robert Maguire, Philip and Coreen St. Jean, Linnea Feraro, Freda Fisher, Robert and Tillie Phillips, Dave Jervis, Tom Jervis, Bob Amaral, Jeffery Hakanson, Louis and Nico Zarakostas, Deana Borges, Cheryl Ring, Jessilyn Ring, Kelly Bryant, Stamatis Karapatakis, Charlie Patel, George Proffitt, Ray Gandy, Fred Curtis, Christopher Moore, Sandy Farnum, Charles Vacca, Linda Crotta Brennan, Peter Stetson, Nichole Hitchner, Robert Grandchamp, Mary Colvin Thompson, and Richard Seelenbrandt.

Special thanks go to my parents, Paul and Sandra Boisvert, who have acted as a sounding board, research team, and overall support staff during the writing of this book.

Unless otherwise noted, all images appear courtesy of the author. Some images noted in this volume appear courtesy of Pawtuxet Valley Preservation and Historical Society (PVPHS), Coventry Historical Society (CHS), and the Western Rhode Island Civic Historical Society (WRICHS).

INTRODUCTION

In 1642, the Shawomet tribe sold the area between the salt water and the Connecticut border, which would become known as the Shawomet Purchase, to Samuel Gorton and his 11 associates for 144 fathoms of wampumpeag. Samuel Gorton and his associates began settling the portion of the Shawomet Purchase now known as Apponaug and its surrounding area, now known as Warwick, because of its proximity to water and because the Indians had already cleared it, making it an ideal site for settlement. In 1644, Samuel Gorton sailed for England to defend the colony. While in England, he received help in acquiring a proper deed from Robert Rich, Earl of Warwick, and that is when they changed the name from Shawomet to Warwick.

In 1675, there was a Native American uprising in New England led by Metacomet, also known as King Philip, to drive the English people off the land. Originally, the war consisted of just Wamponoag Indians, but eventually the Narragansett Indians got involved, and together they burned settlements, including Warwick. Finally, King Philip was killed by the English settlers, and the war ended in 1676. Samuel Gorton, surviving associates, and the next generation of descendants began rebuilding Apponaug and its surrounding area.

Sometime between 1677 and 1682, the town council of Warwick gave land in what is known today as the Washington/Anthony area of Coventry to John Warner, Henry Wood, John Smith, and John Greene for the construction of a sawmill. In 1682, Henry Wood sold his portion of the sawmill to John Greene and Richard Carder. Greene, Smith, Carder, and Warner ran the sawmill from 1687 until 1691, when Warner sold his share to Mark Roberts, and Roberts sold his share to Nathanael Cahoon, who ended up selling his share to Samuel Bennett. Bennett later sold his share to Francis Brayton.

In the 1690s, settlers finally began building homes in this area. The early settlers voted to divide the land into farms and marshlands. The first survey of the area was taken in 1692, and beginning in 1701, the town was divided into four tracts of land over the course of the next 34 years. In 1739, the colony line was resurveyed and more land was added, which was divided into 14 lots.

By the 1730s, the population of this area had doubled. Many families had already been living here for a while and were tired of having to travel to the village of Apponaug, which was the municipal center of Warwick, to conduct their civic business. So in 1741, these citizens petitioned the Rhode Island General Assembly to form a new town. The petition passed, and the town of Coventry was formed, which became the 16th municipality in the state. The name of the town comes from Coventry, England, which had been home to some the founders of Coventry, Rhode Island.

Before 1750, all of the towns located in what is now Kent County were part of Providence County. In the 1800s, local industrialists began cotton and woolen mills along the rivers, and the villages were named for these industrialists or for geographical landmarks. The coming of the railroad helped to unite the villages and move goods between them. With the coming of more jobs came immigration, which changed the ethnic makeup of Coventry but not the sense of community spirit. The late 19th century and the early 20th century saw little change to the life in Coventry, and farms and mills coexisted.

In 1941, in honor of the 200th anniversary of the founding, a town seal was created by Howard M. Chapin. The seal is based on the coat of arms given to the town of Coventry, England, in 1345 by King Henry III. After World War II and during the baby boom, Coventry experienced some growing pains, and the need for new housing developments and schools became very apparent. Farmland was no longer used for farming but became available for these developments and schools. Another aspect of the growing pains was the need for a permanent police force not based on political appointment, so in 1948 the town voted to establish one.

In the 1950s, Coventry became home to many lace mills that provided lace to the garment district of New York and employed many local residents. During the 1960s, the town council established guidelines for redevelopment and began zoning certain areas for residential use and others for commercial. The town expanded again in the 1970s with the arrival of strip malls, new roads, and a new high school to again meet the growing demand of its residents. At the end of the 20th century, a new industrial park was constructed, bringing in new residents and new homes, but the fact remains that many residents of Coventry today still identify with the village they live in.

Everyday life in Coventry is much the same as it was 25, 50, or in some cases, 100 years ago. There are still small family farms, mom-and-pop businesses, restaurants, and clubs that have been in business for a generation or two, and families still worshiping in the churches established by their ancestors. In this book, readers will learn about Samuel Gorton, a friend of the Native Americans who fought for religious freedom; George Potter, a Medal of Honor recipient for his service in the Civil War; Byron Read, who opened the town's first furniture emporium; Ray Gandy, who swam the English Channel; Linda Crotta Brennan, who has provided the children with many stories; Lauren Costa, who presents the news of the day; and Philip Johnson, who was a Boston Post Cane recipient. Joseph Maguire, who learned the lace trade as a young man, continues to operate a small shop producing lace the old-fashioned way. These and many others have interesting stories that tell of the hardships, friendships, heartaches, and memories that make up the people of Coventry.

CHAPTER ONE

Native American Folklore

For approximately 33 years, English settlers in the area that would become known as Coventry were interacting with Native American tribes. They were trading with them and learning the Native American customs and probably the folklore. As a result of being replaced by English customs, very little physical evidence remains today of a culture that had existed for a millennium, but what does remain are the legends. The legends that came from these interactions are loosely based in fact, and this chapter shows how the natives and early settlers used folklore to explain certain characteristics of the landscape. As the Native Americans did not put their legends down in written form, these retellings are reliant upon the written accounts of English settlers such as Samuel Gorton and Roger Williams.

It is written that Miantonomo, chief sachem of the Narragansetts, signed a land deed conveying the area known as Shawomet to Samuel Gorton and his associates. Black Rock and Carbuncle Pond in Coventry were included in this purchase; according to folklore, these spots were sacred to the Native Americans. The rock and the pond were part of the natural landscape and are still in existence today. The Native Americans had a different view of land usage and incorporated nature into all their beliefs. Rocks—like Black Rock in this chapter—and animals were known to be included in their mythology. Snakes rarely had any positive qualities and were often associated with violence and revenge in many Native American cultures. Carbuncle Pond and the legend of the snake included in this chapter might have come about as a way to stop the Indians or the settlers from drinking the water because it might not be safe, or it might have been to explain the color of the water. Some thought it might be that this was a sacred area, maybe a burial place, and the Indians were trying to protect it. However the legend developed, it was significant enough to have survived all these years.

Samuel Gorton

Samuel Gorton, who was born in England and had immigrated first to Massachusetts and then to Rhode Island, was the founder of the town of Warwick. As an early settler, he would have been given tracts of land, and some of this land was in the section that is now Coventry. Though Gorton never lived in the area that became Coventry, many of his descendants did. The Gorton family settled along Harkney Hill near the Maple Root Baptist Church where they worshipped. Many of Gorton's descendants became businessmen, soldiers, and sailors. (Courtesy of Gorton Junior High School.)

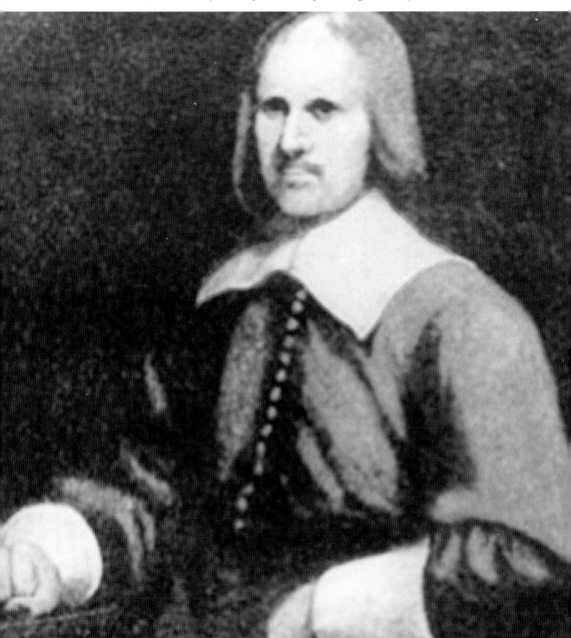

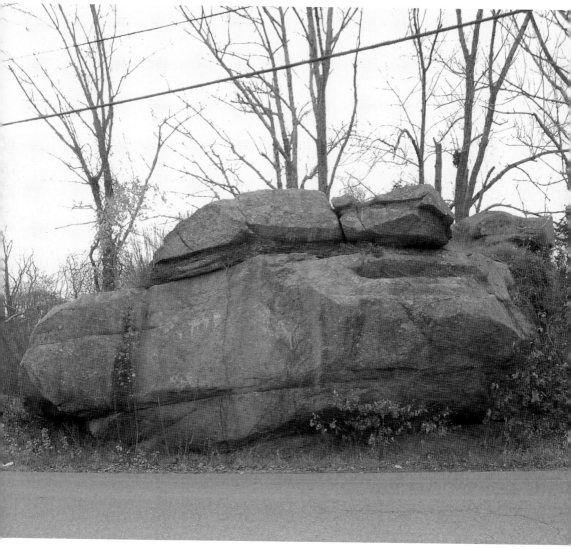

Black Rock

Long before the arrival of English settlers to Coventry, the area was home to the mighty Narragansetts and smaller tribes such as the Nipmuc, Scatacoke, Aqueednuck, Quidneck, Mishnick, and the Tipecanset. These tribes settled along the marshlands, rivers, and ponds and used their resources to hunt, fish, farm, and hold ceremonies. Through archeological excavation, it was determined that a Native American village once stood along the bank of the Pawtuxet River not far from Black Rock. According to legend, this large, dark piece of granite was the site of Native American marriage ceremonies. Besides being an important part of Native American culture, it has provided the name for this section of Coventry as well as the name for an elementary school and a pond. In a 1949 news article, the rock was referred to as a landmark, and though it was not an official designation, it has become a landmark used by the local people of Coventry.

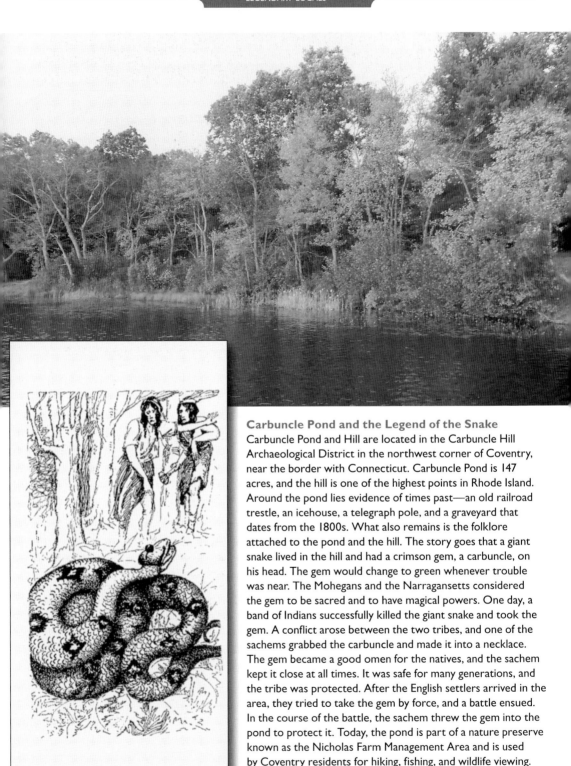

Carbuncle Pond and the Legend of the Snake
Carbuncle Pond and Hill are located in the Carbuncle Hill Archaeological District in the northwest corner of Coventry, near the border with Connecticut. Carbuncle Pond is 147 acres, and the hill is one of the highest points in Rhode Island. Around the pond lies evidence of times past—an old railroad trestle, an icehouse, a telegraph pole, and a graveyard that dates from the 1800s. What also remains is the folklore attached to the pond and the hill. The story goes that a giant snake lived in the hill and had a crimson gem, a carbuncle, on his head. The gem would change to green whenever trouble was near. The Mohegans and the Narragansetts considered the gem to be sacred and to have magical powers. One day, a band of Indians successfully killed the giant snake and took the gem. A conflict arose between the two tribes, and one of the sachems grabbed the carbuncle and made it into a necklace. The gem became a good omen for the natives, and the sachem kept it close at all times. It was safe for many generations, and the tribe was protected. After the English settlers arrived in the area, they tried to take the gem by force, and a battle ensued. In the course of the battle, the sachem threw the gem into the pond to protect it. Today, the pond is part of a nature preserve known as the Nicholas Farm Management Area and is used by Coventry residents for hiking, fishing, and wildlife viewing. Meanwhile, the hill has been developed into a neighborhood. (Left, courtesy of Old Colony Historical Society.)

CHAPTER TWO

Founding Families

Permanent settlement in the region that is modern Coventry did not begin until the end of the Native American conflict known as King Philip's War. The land that had been purchased in 1642 by Gorton and his associates was now ready to be settled by the original purchasers or their descendants. In 1672, the proprietors of the area known as Warwick divided the area that would become Coventry into two large tracts of land. The line down the middle became known as the dividing line, or the seven and ten line. The land north of the dividing line was known as Seven Men's Farms, and the land south of the line was known as the "land above the great river."

When English settlers—such as Randal Holden Jr., John Carder, James Carder, Moses Lippitt, John Knowles, and John Wickes—first arrived here in the late 17th and early 18th centuries, Coventry was still wilderness. Families began clearing land and building homes along existing Indian paths or rivers. Two of the Indian paths would become known as the Great North Road and the Eight Rod Highway. Today the Great North Road is still in existence, but is paved and called Route 14 or Plainfield Pike. The Eight Rod Road today is a portion of Route 3 turning onto Harkney Hill Road and heading toward Voluntown, Connecticut. The farthest point west settlers went was in what is now Greene. They settled along the Moosup River on tracts of land called head lots.

Homes constructed during this time followed a traditional architectural style: one story with a central or end chimney made of fieldstone. The material for the homes came from the land being cleared. After the land had been cleared, the settlers turned to setting up water-powered grist- and sawmills and erecting their houses. Some families, such as the Braytons mentioned in this chapter, opened taverns in their homes where travelers could spend the night and dine on good food. Meetings, such as the first town meeting of Coventry, were held at the Braytons' home, now known as the Paine House. Men and women like Susanna and Joseph Bucklin, mentioned in this chapter, are representative of the great pioneer spirit that shaped America. Founding families of this area came from the colonies of Massachusetts, Connecticut, and other parts of Rhode Island.

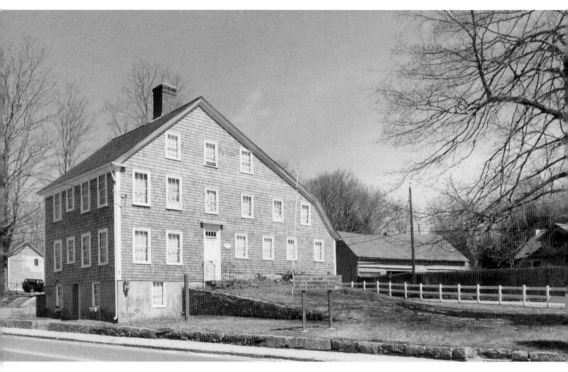

Families of the Paine House

The Paine House in Coventry is believed to have been constructed around 1689. Its history suggests that the house was owned by numerous families over the years but it derived its name from the last family that owned the home. Samuel Bennett, who also built a gristmill, is believed to have built the house. While he resided there, this section of Coventry became known as Bennettville. As there were very few structures in Coventry when it separated from Warwick, the first town meeting was held in this house. When Francis Brayton moved his family from Portsmouth to Coventry around 1749, he purchased Bennett's house and gristmill. Brayton eventually established a blacksmith shop and operated a tavern out of the home. As this building served as the center of the village, the village became known as Braytonville. Brayton's son Francis Brayton Jr. was granted a license to run the tavern. Charles Holden was the next owner and operator of the tavern, and the Holden family owned the structure until 1847, when it was sold to Thomas Whipple. His widow Sally Whipple sold the house to Mary Mathewson and Phebe Wood Paine, who were sisters. Phebe had two children, Herbert F. and Orvilla Paine. Mathewson sold her share of the house to Phebe Wood Paine Johnson, who, along with husband Philip Johnson, was the next owner. They had a daughter, Zilpha, who, along with her half brother Herbert and half sister Orvilla, became the owners of the house. Herbert Paine was the last resident of this house.

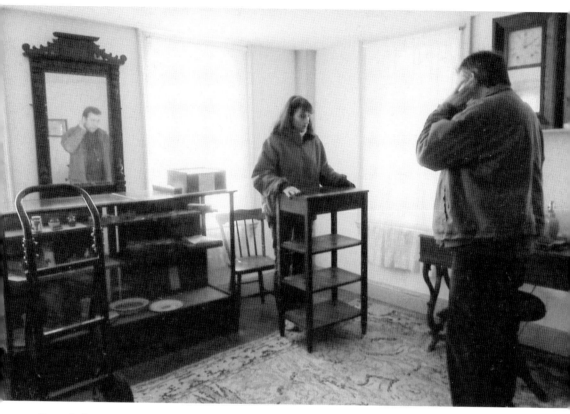

Brenda Jacob, President of the Western Rhode Island Civic Historical Society
Jacob, the president of the Western Rhode Island Civic Historical Society, is pictured here with volunteer Marc Gardner as they set up a research area for library patrons in one of the rooms. The Western Rhode Island Civic Historical Society was started in July 1945 and had been meeting in various locations prior to moving to the Paine House in 1953. This organization offers tours to school groups and the public. The museum, which houses collections of furniture and clothes, a fire engine, and photographs of buildings and residents, believes in educating the public on the history of Coventry through its newsletter, the *Hinterlander*.

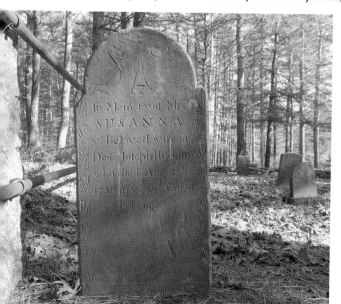

Susanna and Joseph Bucklin
The Bucklins, who moved from Rehoboth, Massachusetts, to the frontier, represent the families that saw an opportunity to farm and raise a family on their own land. Joseph established a gristmill while Susanna took care of the family. Susanna died at the age of 36. Her slate gravestone was made by a local carver named Jonathan Roberts and is one of the earliest in Coventry. Her husband was one of the signers of the petition to form the town of Coventry.

15

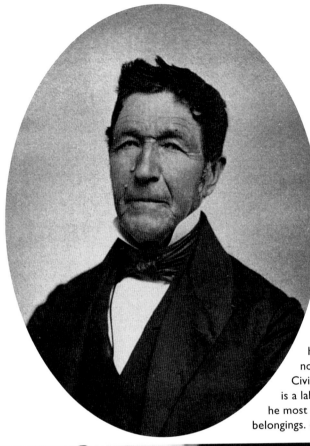

John Jenckes Kilton Jr., Industrialist

Kilton was the son of John J. Kilton Sr. and Sarah Brayton. In 1831, he erected his own mill for weaving cotton cloth. He was a successful manufacturer and one of the most prominent landowners. He was an abolitionist. He supported the Free Public School Act of 1828, and in 1846 established a school library in the village of Washington. He also was a member of the Coventry Temperance Union. The box pictured here was once owned by Kilton and is now part of the collection of the Western Civic Rhode Island Historical Society. There is a label with his name inside the box, which he most likely used as a student to transport his belongings. (Left, courtesy of PVPHS.)

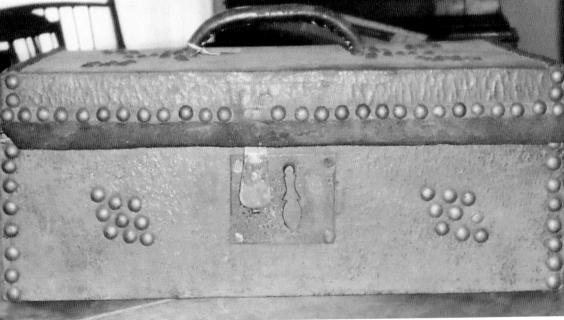

CHAPTER THREE

Let Me Entertain You

Taverns, like the Brayton Tavern owned by Francis Brayton Jr., were used as social meeting places in the early days of Coventry; today, there are 49 different restaurants in which to socialize in town. During the time that the Showboat was in business, Coventry had many restaurants, bars, and clubs, but not another one looked liked an ocean liner and was run by a former wrestler. Families would have birthday parties, weddings, and wedding receptions in this establishment, and organizations such as the Order of the Elks, the Republican Party, and the Democratic Party would hold meetings in the restaurant. The Showboat and Alphee Bleir were a big part of the life of all Coventry residents, particularly in supporting local sports teams. This establishment was so well remembered—not only by Coventry residents but also by outsiders—that the image of the Showboat was made into a Christmas ornament for the Pawtuxet Valley Preservation and Historical Society to sell. The Maple Root Inn, owned by Albert Pastille, Harry Carlson, and James DeMarco, was another dining establishment that was frequented by locals as well as outsiders from the 1920s to the 1970s.

In the past, families in Coventry went to the two movie establishments in town; one was the indoor Jerry Lewis Theatre, and the other a drive-in movie theater. The 1970s Jerry Lewis Theatre is now used as a restaurant called the Olde Theater Diner, currently owned and operated by Louie and Nico Zarakostas. For a quieter form of entertainment, Coventry has a new/used bookstore—All Booked Up, owned by Deana Borges—where one can find local authors signing books and holding discussions.

Coventry families have had a variety of special events to attend, like the Randall Card Circus that was held in the 1930s, Coventry Old Home Days in the 1940s, and Coventry Pride Days in the 2000s. Nearly every day a sports league for children and adults can be found at the Coventry Recreation Center, and many activities for the town's senior citizens are held at the Coventry Senior Center. Many of these and others are the focus of stories gathered from the people of Coventry and included in this chapter.

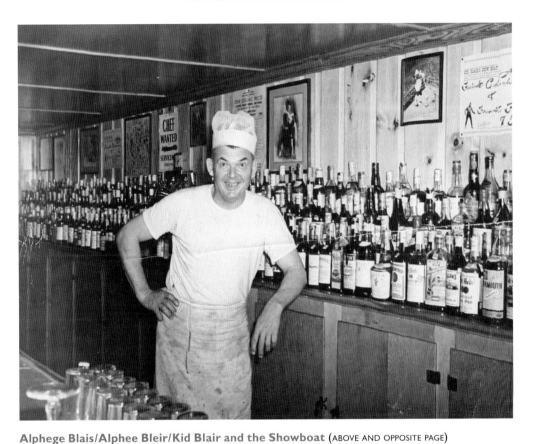

Alphege Blais/Alphee Bleir/Kid Blair and the Showboat (ABOVE AND OPPOSITE PAGE)
The Showboat Restaurant was a boat-shaped building constructed in the 1920s along Arnold Road in a section known as Little Tiogue. Opalma Blais bought it, and Alphege Blais—her husband, who was born in Saint-Alexandre, Quebec, Canada—became the new owner. Blais was orphaned at the age of 14 and joined a lumber camp until the age of 21. He then joined the service, serving as a cook at Camp Devens during World War I. This is where he became interested in wrestling. During his wrestling career, he became known as "Kid Blair" and joined the traveling Jim & Benson Carnival, which brought him to New England and Rhode Island. In Rhode Island, he wrestled in a match in Coventry and met his future wife, Opalma Jacques, who caught his robe when he threw it off. After the match when he retrieved his robe, he talked with her, and he later married her on January 25, 1924. When the carnival moved on, Blais remained behind, operating the Log Cabin restaurant in Arctic, managing the Kent Brewing Company, and eventually purchasing the structure that would later be called Kid Blair's Showboat.

The story goes that Kid Blair had Tiogue Lake drained, and according to Coventry resident Norma Smith, her grandfather Hector Poulin was hired to drive his truck to tow the boat across the lake bottom to the eastern shore of Lake Tiogue. According to an April 1933 newspaper article titled "Here Comes the Showboat, Here Comes the Showboat," a boat had been near the levee on Little Lake Tiogue, and they had planned on moving it across the lake on ice, but the lake never froze. The newspaper stated, "It will be moved over land about 1000 feet with the help of rollers." No matter how it actually happened, it was moved and set up and functioned as a dancing and eating establishment from the late 1930s until it was destroyed by fire in 1976. This restaurant was so well known that more than three decades later, the mere mention of the name Kid Blair or the Showboat to people of a certain age causes their eyes to light up and the stories to come out. (Both, courtesy of PVPHS.)

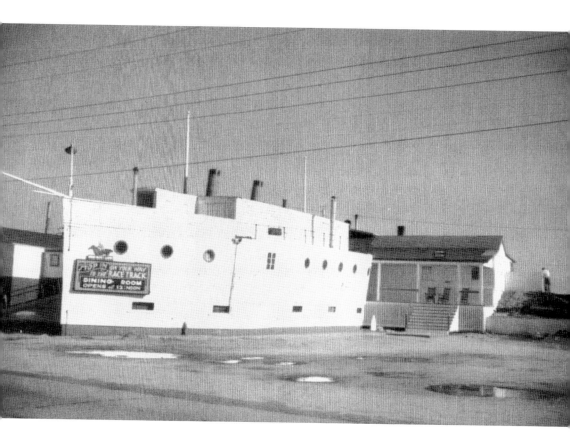

Warners of Coventry (OPPOSITE PAGE)
George Warner opened Warner's Rustic Inn on October 26, 1926, along Route 117 near Alvero Road in Coventry. The foundation of the building and the establishment's rustic tables were made of the logs cleared from the land. The people of Coventry went there to enjoy the live bands and dances. After Warner's death, the restaurant passed to his sons Harold and Earl Warner. Harold, the only graduate of the 1926 class of Read School House, and Earl operated the restaurant until 1974. For many years, the Warner family sponsored Coventry sports teams, such as bowling, golf, and softball. The inn was known for its clambake shed, games, and prizes. (Courtesy of PVPHS.)

The Married and Single Men's Baseball Team
The Married and Single Men's Baseball Team, sponsored by Lavigne Construction, is pictured at its first annual outing at Warner's Rustic Inn on August 21, 1927. Omer Lavigne, a senior partner at O&S Lavigne Co., is among the players. (Courtesy of PVPHS.)

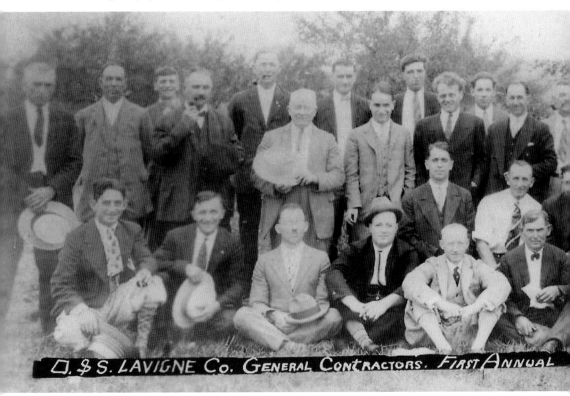

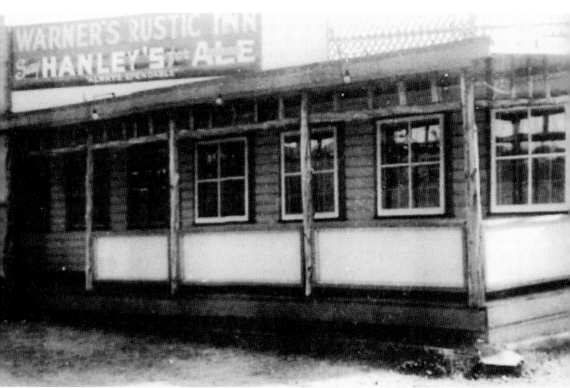

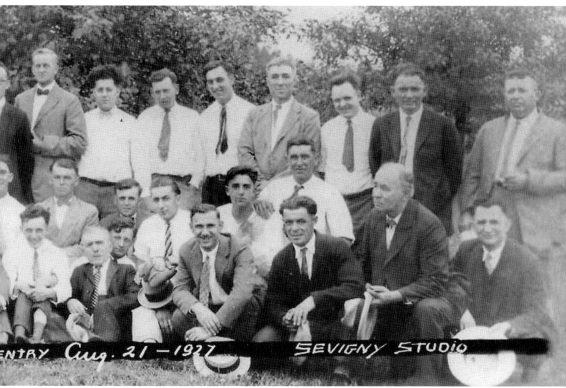

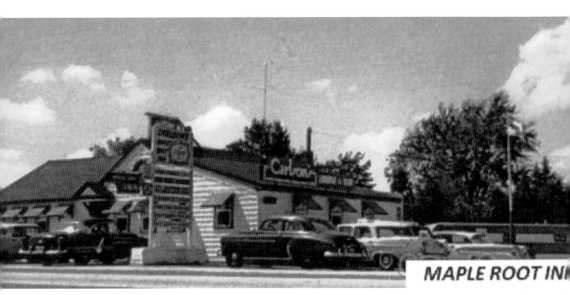

MAPLE ROOT IN[

The Maple Root Inn
The Maple Root Inn was a family-owned restaurant that was open seven days a week at the intersection of Harkney Hill Road and Tiogue Avenue (Route 3). It was first owned and operated by Albert Pastille and his wife, Mary, who was a waitress in the restaurant. In 1945, Pastille sold the Maple Root Inn to Harry and Hazel Carlson, who then named it Carlson's Maple Root Inn. The Carlsons sponsored trips to Fenway Park for the children of Coventry to see the Boston Red Sox. Carlson sold the restaurant in 1969 to James DeMarco. To this day, Coventry residents and others often reminisce about the dinners they had there, such as boiled or broiled stuffed lobsters, steaks, chops, and seafood. (Courtesy of PVPHS.)

Louie and Nico Zarakostas, the Olde Theater Diner
Louie (left) and Nico Zarakostas, father and son, are the owners of the Olde Theater Diner. When Louie was asked what kind of restaurant he wanted, his reply was, "a successful one," and it appears he has been very successful. He has been in the restaurant business for 30 years and has opened 20 restaurants that are all still operating today. In 2010, he opened the Old Theater Diner in Coventry in the building that had been the Jerry Lewis Theatre in the early 1970s. The family-style restaurant is based on the design of the old movie theater, which is a treat to his customers as many of them remember going there on dates when it was a cinema.

Henry Viens
Viens (third from left) was born Henrio A. Viens in Rhode Island to French Canadian parents. He is representative of the American dream. His family came to the United States in hopes of a better life, and a good life he had. He worked as a chauffeur and an insurance agent and opened United Solicitians, which was a burial company. Viens participated in Old Home Days and was a member of the Coventry Chamber of Commerce. He petitioned the town council to open a dining car in 1946 but instead acquired the Tiogue Vista, which he ran with a business partner. The Tiogue Vista had live music and a function hall that residents used for weddings, baby showers, and other gatherings. Viens generously offered the use of this hall to numerous organizations for free. He also held Mystery Rides, which were very popular at that time, in which one person would drive others to a surprise destination. Today, this restaurant is known as Nino's on Lake Tiogue. (Courtesy of CHS.)

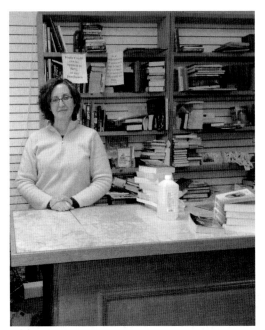

Deana Borges, All Booked Up

The new/used bookstore All Booked Up has been in Coventry only three years, and is the only bookstore in Coventry. Deana Borges is the owner and sales clerk. The farthest away she has ever had to send a book was Antarctica. The business has participated in Operation Paperback, a program that collects books to send to troops overseas. Borges was surprised when she received a letter back from a soldier saying, "thank you." Borges hosts a book reading group as well as book signings for local authors, and has developed friendships with many local residents.

Stamatis Karapatakis, Gelina's Ice Cream

Karapatakis emigrated from Greece to the United States over 20 years ago and began working in the restaurant business in Rhode Island. Steve, as he is known, currently owns and operates Gelina's Ice Cream, where many Coventry families can be found sitting at outdoor tables on hot summer evenings enjoying a wide selection of ice cream. Since 1982, Coventry residents have been enjoying ice cream at Gelina's.

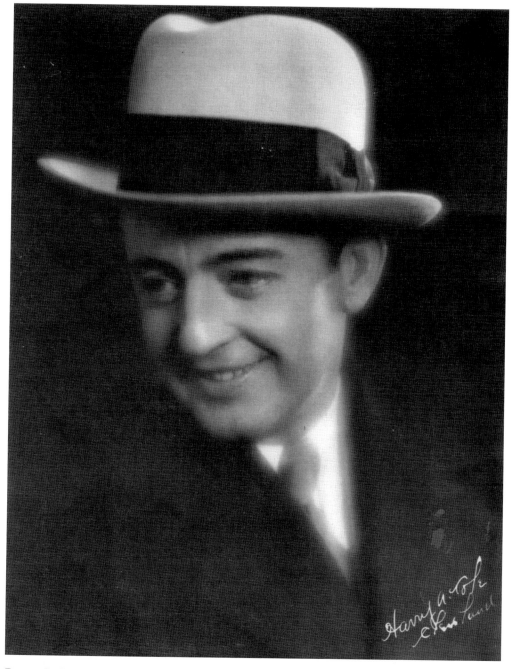

Danny P. Cavanaugh, Entertainer

Cavanaugh of Coventry was born in August 1893 to Daniel P. Cavanaugh and Catherine McKenna and was married to Florence Clean. Before he moved to New York, he worked in various manufacturing companies and sang at local theaters. He was a veteran of World War I, where he sang and entertained the troops. In 1940, he lived in Manhattan and worked as a radio star and actor. He was known as the Ave Maria Tenor. In honor of the 200th anniversary of the founding of Coventry, the town had him perform. He died November 22, 1960, in Hollywood. (Courtesy of PVPHS.)

Randall T. Card, Showman

Card (fifth from right below) was 74 years old when he began his own circus in the style of P.T. Barnum and Buffalo Bill Cody. Card's working life began when he was just seven years old at the John Jenckes Kilton Mill in the village of Washington. His interest in show business came from his stepfather, Professor Potter, a sleight-of-hand performer who performed with local legend Prof. Benjamin Sweet. Card would have seen Sweet perform feats such as walking a tightrope across the Pawtuxet River. Card had his own marionette show, and around 1880 he opened a Barney Chambers museum, which was a traveling museum attached to a wild west show. In his lifetime, he was a stage performer in many shows, including *Around the World in 80 Days*. During the downtime when the show was not out performing, Card clammed and fished along Oakland Beach and provided clams to Charlie Maxwell, who owned Rocky Point. He began his own circus with a dog-and-pony show during the Great Depression and eventually had a big top that could seat 800 people. He worked all aspects of the circus, including cutting tent poles from trees on his own property. His circus traveled around Rhode Island, Massachusetts, and Connecticut in a caravan of vehicles with the name of the show painted on the side. When not on the road, he kept the circus on the old Salisbury Farm. His son George worked as the equestrian director, while his daughter and son-in-law operated the candy concession. His featured performer was Jennie, a rhesus monkey. (Both, courtesy of Donald Card.)

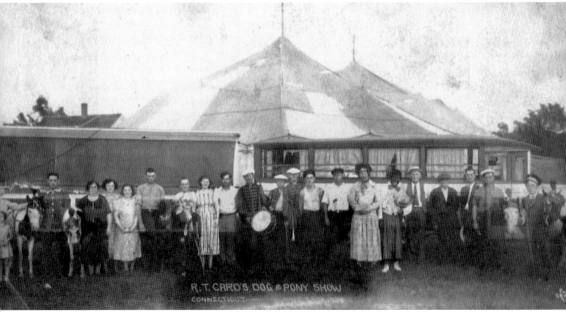

CHAPTER FOUR

Bravery on the Battlefield

Coventry residents have answered the call of duty since the 1600s, and many have made the ultimate sacrifice for their neighbors and country. Two men mentioned in this chapter are representative of the 500 men of Coventry who served during the Civil War. One man received the Medal of Honor for his actions during the Civil War siege of Petersburg, Virginia, on April 2, 1865. The residents of Coventry also formed a local militia company during the Civil War and leased space in Pardon S. Peckham's building to train men and store arms. Four men are known to have enlisted in the Army during the Spanish-American War. Men from the area also served in World War I, and in this chapter their lives will be highlighted. During World War II, the people of Coventry raised money to support their sister city in England, which had been bombed during the Germans' attack on England. On August 14, 1950, the town of Coventry dedicated the World War II memorial located in front of the Coventry Police Department in honor of the men and women from the town who served in the war. Following the examples of their brothers and fathers, many men—including Robert Phillips, Everett Hudson Jr., and Philip St. Jean—enlisted in the armed services and served overseas as well as stateside in Korea and Vietnam. Coventry High School has an ROTC program, and many young people, like Corey O'Connor, have benefited from this program and gone on to pursue careers in the armed forces.

Post September 11, 2001, Coventry residents have continued to follow the example of these brave soldiers by serving in the Rhode Island National Guard and the US armed forces. Just as during World War II they would put up an honor roll listing the men and women who were serving overseas, Coreen St. Jean, Corey O'Connor's mother, created a monument to the men and women who were serving during Operation Iraqi Freedom.

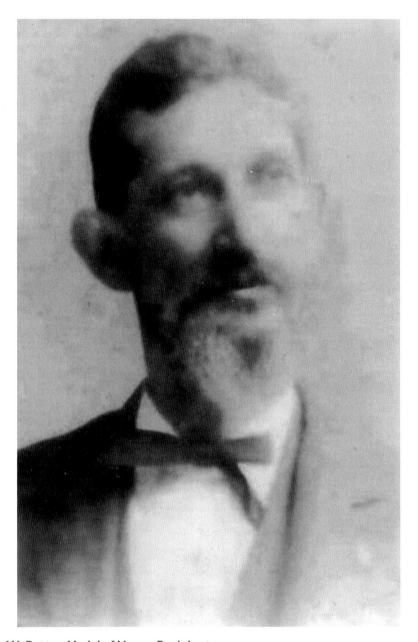

George W. Potter, Medal of Honor Recipient
Potter received the Congressional Medal of Honor on March 4, 1866, for his bravery in the Civil War. Potter, born in Coventry on December 11, 1843, was a single, 18-year-old farmer before enlisting in Providence in the Union army. During the siege of Petersburg, Virginia, he was shot in the left temple and lost sight in his left eye. After discharge, he worked for the railroad as a section hand and was married to a woman named Susan, with whom he had a son named William F. Potter. Potter died at the Soldiers Home in Bristol on November 30, 1918, and is buried in the North Burial Ground in Providence. His citation reads that he "was one of a detachment of 20 picked artillerymen who voluntarily accompanied an infantry assaulting party and who turned upon the enemy the guns captured in the assault." (Courtesy of Robert Grandchamp.)

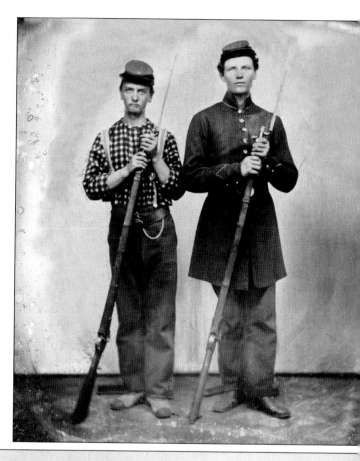

William Carr Rathbun and Oliver Brown
Another brave soldier, Rathbun (right) was one of three brothers from Coventry who enlisted in Company H 7th Rhode Island Infantry at the start of the Civil War. During the Battle of Fredericksburg, he lost his right foot saving his friend Oliver Brown. He returned from the war to West Greenwich and became a farmer. He moved his family to Coventry in the 1880s to a farm located along South Main Street, and the house he lived in still stands today. He was the father of five daughters who all became schoolteachers. (Both, courtesy of Rachael Pierce.)

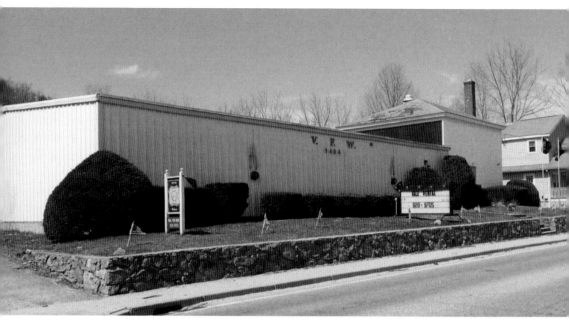

Veterans of Foreign Wars Coventry Memorial Post No. 9404
Veterans of Foreign Wars Coventry Memorial Post No. 9404 was built in 1950 and has served as a meeting place for veterans of the Coventry community. The mission of the organization is to promote patriotism and community service. This post hosts events each Memorial Day and Veterans Day in addition to other holiday events for military and community families.

George B. Sprague, Charles A. Patterson, James T. Hill, and Edward Essex
This Spanish-American War gravestone marker is representative of the markers on the graves of the four Coventry men who served during the conflict. George B. Sprague and Edward E. Essex were both members of the 1st Rhode Island Volunteer Infantry; Sprague was a member of Company B, and Essex was a member of Company C. Both died October 17, 1898. Charles A. Patterson and James T. Hill survived the war.

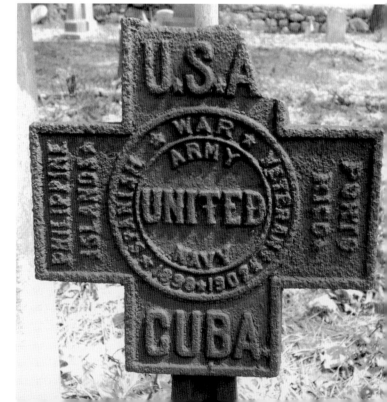

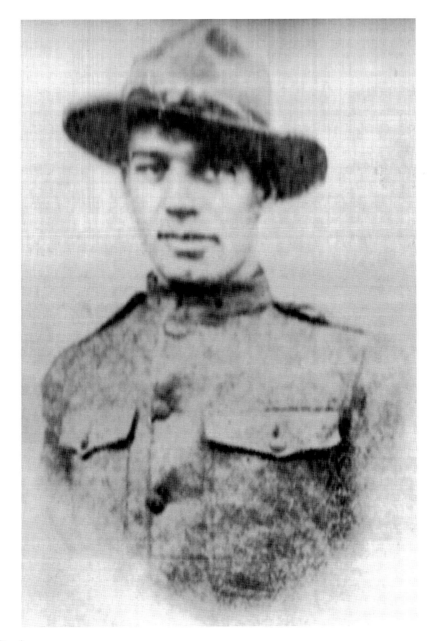

David Papineau

Papineau was a French Canadian American who was born July 9, 1888, in the section of Coventry known as Anthony. His parents were Antoine and Victorine (Loiselle) Papineau. He enlisted in the Rhode Island National Guard on June 11, 1917, and was a member of Battery C 1st Battalion, 103rd Field Artillery. When his unit was shipped overseas in November 1917, they became attached to the American Expeditionary Force. He was mortally wounded July 19, 1918, at Château-Thierry—just 10 days after his 30th birthday—and is quoted as saying "Take care of Johnnie first. His wound is far worse than mine." He was originally buried overseas, but his body was returned to the Pawtuxet Valley for burial in 1921. As a result of his sacrifice, the town of Coventry named an American Legion post after him. (Courtesy of PVPHS.)

George Washington Andrews

Andrews was born June 1, 1893, and worked at the Interlaken Mill. He served in the American Expeditionary Force during World War I and was shot in the head during the battle of St. Mihiel in the Argonne Forest in France in September 1918. After the war, he returned to Coventry and was employed as a security guard at the Centerville Bank for 33 years, and was credited with foiling a robbery. In April 1946, he helped the Coventry police apprehend two youths who had stolen a car. The youths had stopped along Nooseneck Hill Road near Andrews's house to change a flat tire. When they could not open the lock on the car, they went to Andrews to borrow a hammer and screwdriver. Something about them aroused Andrews's suspicion, so he called the police, who quickly came and arrested the youths. Andrews had a nephew named Daniel George Wood who died in World War II. Andrews died in 1964. (Courtesy of Rachael Pierce.)

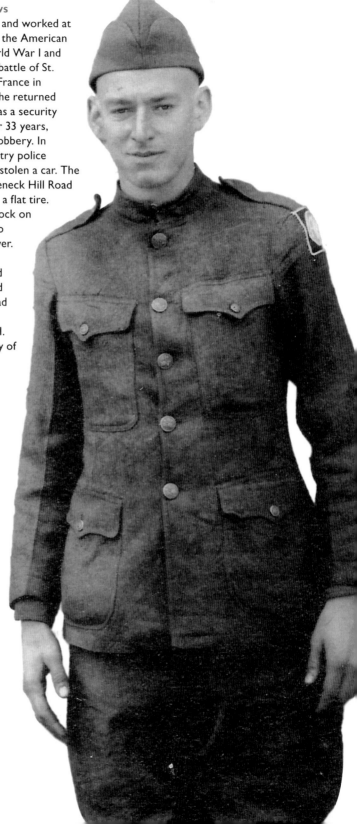

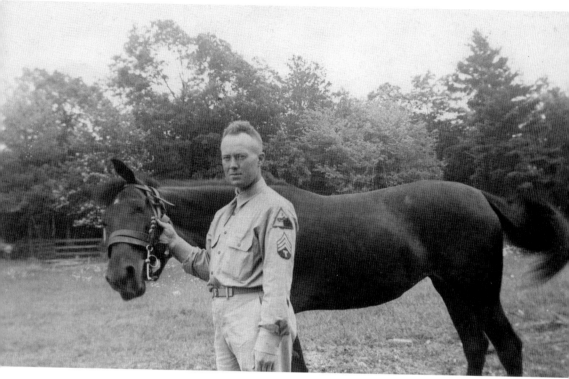

Daniel George Wood and Trixie
Wood was born in Coventry and served in the 3rd Armored Division during World War II. His sister recalled how he loved his horse Trixie and hated to sell her before he left for the service. He was one of 35 causalities from Coventry. He was killed in action during the Battle of the Bulge. He was buried overseas, and his body was later brought back home to be interred in the family cemetery in Coventry. In honor of his service, the town of Coventry named Wood Street after him. (Courtesy of Rachael Pierce.)

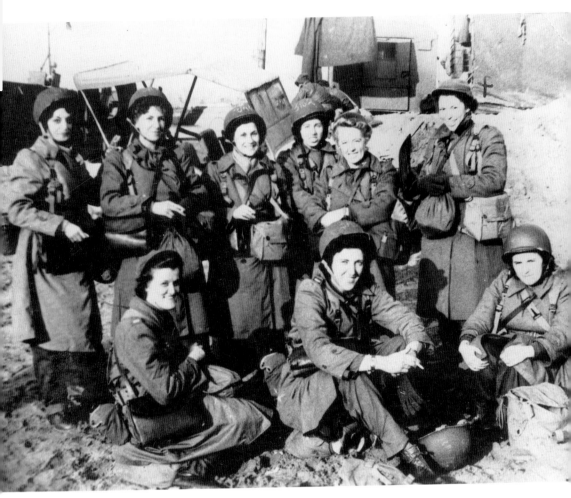

Mary Agnes Delehantey, Army Nurse
Delehantey (first row, left) was a first lieutenant US Army nurse. She was born February 3, 1921, in Vermont but moved to Coventry when she was nine years old. She graduated from Coventry High School and attended nursing school. She was one of 20 women from Coventry who served in World War II, and her name was added to the Honor Roll dedicated on August 14, 1950. After the war, Delehantey worked at South County Hospital and lived in Wakefield until her death on May 13, 2009. She is buried in the Rhode Island Veterans Memorial Cemetery in Exeter. (Courtesy of Rachael Pierce.)

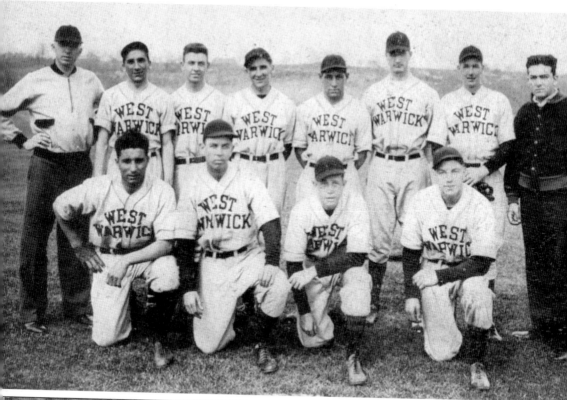

Richard Hudson, Professional Baseball Player

Hudson (second row, second from right), a Coventry native who graduated from West Warwick High School in 1934, was drafted to play professional baseball for the Cleveland Indians in 1937. He played for various farm teams before enlisting in the US Army and serving in World War II, where he saved a fellow soldier's life after the soldier fell in a hole. (Courtesy of Rachael Pierce.)

Arthur Dubuc, World War II Civilian Contractor

Dubuc was a civilian contractor during the Aleutian Islands Campaign of World War II. He was born in Bristol on May 16, 1913, and died August 5, 1990. During his lifetime, he worked for Aetna Insurance, Electric Boat, and US Rubber. After his marriage to Grace Smith, they moved to Coventry. He was a secretary for the Coventry West Greenwich Elks. (Courtesy of Norma Smith.)

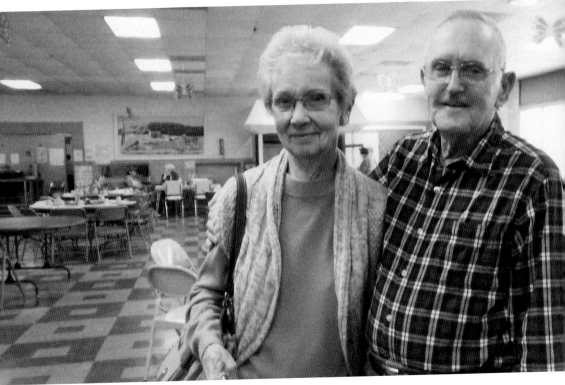

Robert and Tillie Phillips, Volunteers
The Phillipses are both volunteers at the Coventry Senior Center. Robert, who had 10 siblings, moved to Abbotts Crossing in Coventry at the age of seven. He entered the 145th Infantry Division in the US Army around 1951 and served in Korea. He earned a Purple Heart, a Bronze Star, and a Combat Infantryman Badge. Upon returning from the war, he worked for his father at Phillips Garage in Coventry.

Bob Amaral
Amaral worked for Acme Laundry (now known as Falvey Linen) in West Warwick and for many years provided laundry service to his father's nursing homes in Coventry. Amaral played in the dance band at the Showboat, served in Korea, played the drums, and was a member of the Portuguese Marching Band. Today, he is a volunteer at the Coventry Senior Center.

Everett Hudson Jr.
Hudson served as a driver for a lieutenant colonel when he was stationed at Pusan, Korea, in the 863rd Transportation Company in the US Army. When he returned home, he worked as driver for Suburban/Phillips Propane Company. Like his father and mother, he was active in the Republican Party in Coventry and served on the town council. (Courtesy of Everett Hudson Jr.)

ELECT EVERETT E. "JUNIOR" HUDSON

"A NATIVE SON"

FOR TOWN COUNCIL DISTRICT 2

Special Election

TUESDAY OCTOBER 18

REPUBLICAN

Philip St. Jean
St. Jean served during the Vietnam War in the US Army. He worked as a battalion mail clerk at headquarters, and one of his jobs was to sort the mail containing the notifications of causalities for his unit. After his service, he returned to Coventry and today operates a transmission repair shop—the Transmission Shop—with his sons.

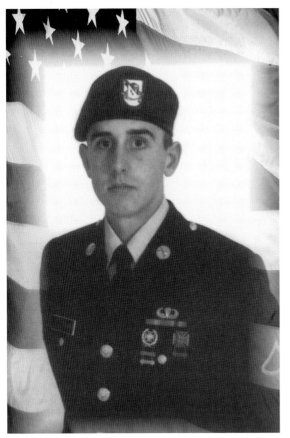

Corey O'Connor

O'Connor was a member of the Reserve Officers Training Corps when he was a student at Coventry High School. After graduation in 2001, he enlisted in the US Army and served in the 82nd Airborne Division. He was one of a group of friends who all enlisted in different branches of the service around the same time. Upon completing basic training, he was deployed to Iraq. O'Connor served two tours of duty in Iraq. During his service, his mother, Coreen, and his stepfather, Philip St. Jean, approached the Coventry Town Council and proposed the idea of a board located outside the Coventry Recreation Center to highlight the service of men and women from the area. The town approved, and, through volunteers and donations, the board was completed and named Coventry's Bravest. Pictured below is O'Connor's home decorated for his return. (Both, courtesy of Coreen St. Jean.)

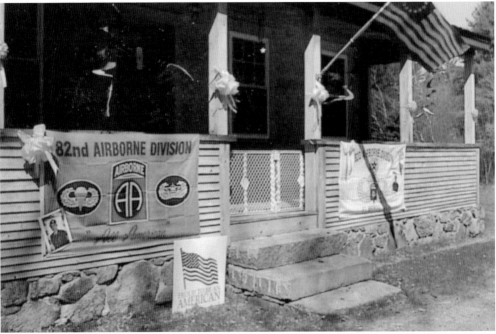

CHAPTER FIVE

Lumber, Lace, Stores, and More

The founders of Coventry began gristmills and sawmills. As the Industrial Revolution began and progressed, textile mills and machine shops took their places. Then, the arrival of the railroad in the 1850s changed the economic structure of Coventry. The ability to transport goods to larger cities improved the economy of the area. Coventry became home to two quarries, which provided jobs for many. By the turn of the 20th century, the cotton- and wool-manufacturing companies moved south, leaving a void that would be filled by local residents who started lace mills and employed many of the skilled textile workers. These include Joseph Maguire of Maguire Lace & Warping and Jack Beattie of Beattie Lace. Lace produced in one of these textile mills appeared on dresses worn by Miss America and Dale Evans as well as on the clothing of local residents.

The men and women in this chapter saw opportunities to establish small shops and family businesses as their ancestors had. They played such important roles in the history of the town that streets were named for them. Today, the core of Coventry's economy is based on family-run businesses, just as it always has been. In this section, readers will discover Searles Capwell, who is known for his lumber mill, and Hector Poulin, who not only ran a mill but also moved the Showboat. Coventry has cleaners, printers, hairdressers, grocers, and web designers, as well as small shops—such as the Krafty Sisters, providing residents with handmade crafts, or George Proffitt's and Gregory Iannotti's floral businesses, providing flowers for proms, weddings, and funerals (such as those held at the Gorton Menard Funeral Home, now located in the former Byron Read homestead). For local news in the early days, one would head down to Everett Hudson's well-known Hudson Store. Today, residents can go to Skaling's Summit General Store or to Veterans Market. And, for that occasional Cinderella-like experience, there is no place like Bruce and Rosemarie Guertin's Magical Affairs.

Searles Capwell, Mill Owner and Politician

Capwell (above right, with daughter Nettie Northop and granddaughter Lois Alice Northop) was born in West Greenwich, Rhode Island, on April 8, 1838, and died October 2, 1916. He married twice—the first time to Susan D. Greene and the second time to Florence E. Briggs. He owned a lumber mill and served as a politician from Coventry. Capwell set up his Sash, Doors and Blinds mill in the mill complex that had been the Perez Pecks Machine Shop, which had provided machinery for the textile mills. The Capwell house was constructed on Main Street in Anthony, not far from Capwell's mill. Capwell lived in this Queen Anne–style house with his wife, Florence, and the architectural details of the structure show the wealth of the owner. Currently, it has been divided into apartment units. (Above, courtesy of CHS.)

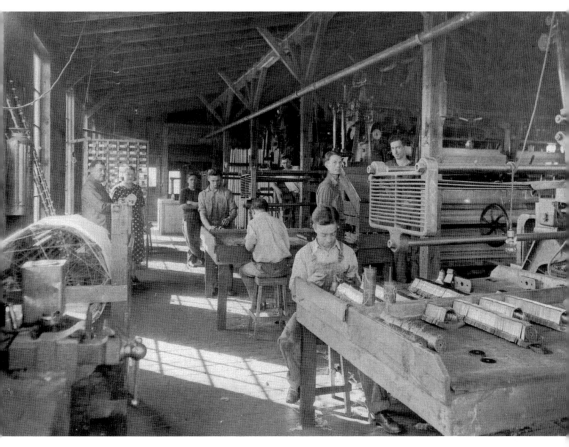

John William "Jack" Beattie, Lace Mill Owner
Coventry was once known as the lace capital of the United States. Jack Beattie was born in Long Eaton, England, on January 10, 1892, and was the owner of Beattie Lace Works, located along Hopkins Hill Road in Coventry. This image shows Beattie (far left), his daughter Irene Beattie (beside him), and several unidentified workers inside the mill. These mills produced a product called "leavers lace," which is a fine, delicate pattern that resembles handmade lace. The first laceworks in Coventry was Washington Lace Works, which was formed in 1929 by Charles Thompson and George Clarke. In 1951, Coventry was home to 24 lace companies, and the Linwood Lace Mill, the Washington Lace Works, the Mruk Lace Mill, and Beattie Lace Works were all active there at one time. There were 428 lace machines in operation in 1963. (Courtesy of CHS.)

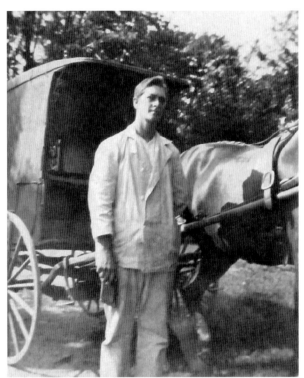

Charles William Whitford, Salesman

Whitford was known as "Wil" in this small, tight-knit community. He worked in Benoit's Market (pictured below), where people went to vote, went to Knotty Oak Baptist Church, and walked to work. His father-in-law was Philip Johnson, a Boston Post Cane Recipient, and Whitford was the grandfather of J. Francis Remington, a well-known police officer. As a grocery clerk, Whitford delivered goods to people's homes by horse-drawn wagon. (Left, courtesy of Lois Sorenson; below, courtesy of PVPHS.)

Everett E. Hudson Sr., Businessman
Hudson owned and operated the Hudson Store along Main Street in the village of Washington from the 1930s through the 1960s, when the building was bought and moved into the new shopping plaza. The store would open early in the morning so the men and women on their way to the factories could buy a newspaper. Children also stopped by on their way to and from school to buy penny candy. Hudson served as a senator from Coventry and was active in the Coventry Republican Party. He was known as "Boots" among his friends.

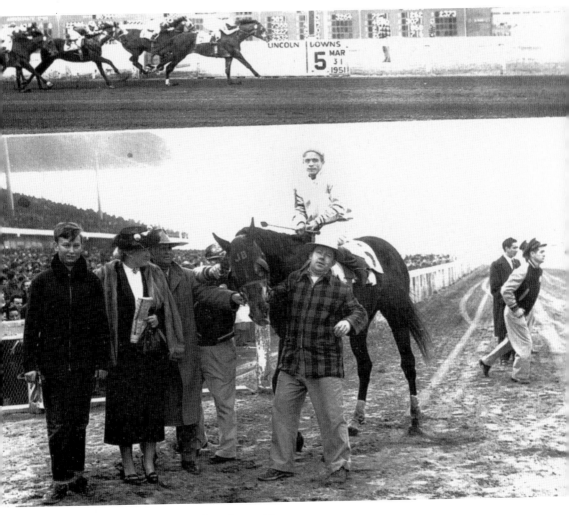

William James "Jim" Beattie, Racehorse Owner
Beattie was born February 23, 1890, in Derbyshire, England. He was the treasurer of Linwood Lace Mill and also owned a stable of racehorses. In October 1959, one of the barns located on his horse farm burned to the ground, killing 17 of the 21 racehorses that he owned. The only reason four horses survived was that Pat Patterson and Beattie ran into the burning barn to save them. This was not the first time tragedy struck Beattie: his first wife had died, and his son-in-law and business partner, who had flown missions as a fighter pilot during World War II, had succumbed to a fatal disease the previous year. But Beattie vowed to rebuild the barn and to continue racing horses, which he did. Beattie died on July 11, 1969, on the *Queen Elizabeth* cruise ship traveling to visit the old sod of England. In this image, Beattie is third from the left, Augustus Hutchins is the horse handler in the plaid shirt, and the boy at left is his son George Hutchins. The horse was Linwood Harry. (Courtesy of the Hawkins family.)

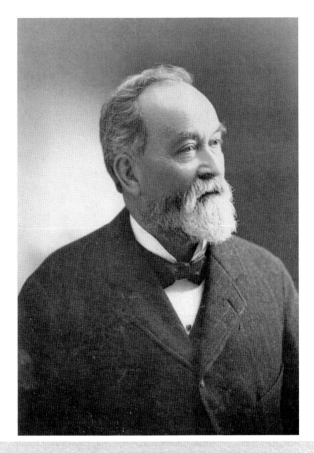

Horace N. Foster, Violinist, Engineer, and Surveyor
Foster was a violinist as well as an engineer and surveyor in the Anthony section of Coventry. He constructed many buildings and homes in the town. He was born September 15, 1836, and died December 23, 1928. He was married to Sybil W. Read. A talented violin player, Foster could play and entertain guests as well at the age of 90 as he could when he was 40 years old. He was active in the Anthony Grange, which was named after the village of Anthony, which in turn was named after Daniel Anthony, the founder of the village. The Grange had a hall that was used by residents for political get-togethers and social events, and Foster provided this organization with music. Guests were quoted as saying, "Horace plays a wicked bow." (Both, courtesy of CHS.)

H. N. FOSTER,

ENGINEER & SURVEYOR.

Anthony R. I.

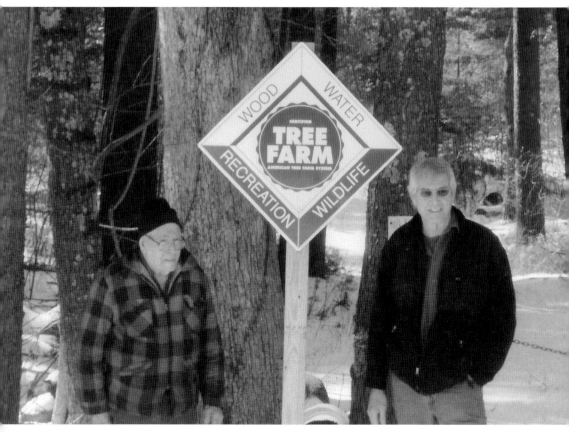

Joseph Maguire, Mill Operator and Tree Farmer (ABOVE AND OPPOSITE PAGE)
Maguire Lace & Warping Mill, located at 65 Stone Street, is owned and operated by the Maguire family. The company was started in 1951 by Joseph Maguire, and he remains at the helm today with his son James alongside him. Maguire, who is a spry 90-something, is still operating the looms and fixing the broken threads, just as he has done since he began the trade as a younger man. This laceworks, one of three operating in Coventry, represents a dying industry. It provides lace to the stores of New York, and its product has appeared on dresses worn by Miss America and Dale Evans. Joseph Maguire owns many acres of wooded property in Coventry and was awarded the Rhode Island Tree Farmer of the Year award in 2009. (Above, courtesy of Rhode Island Foresters Conservators Organization.)

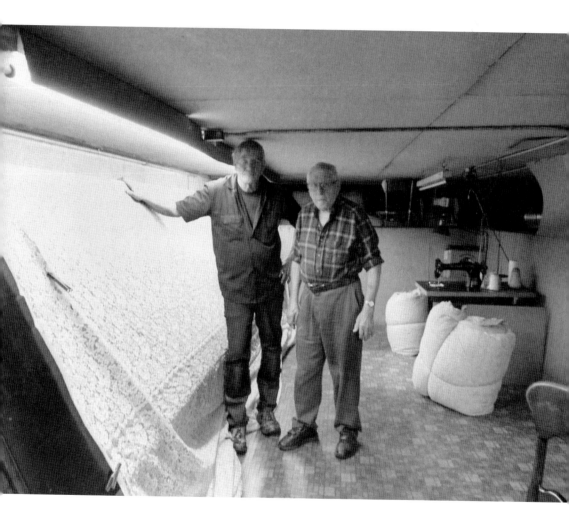

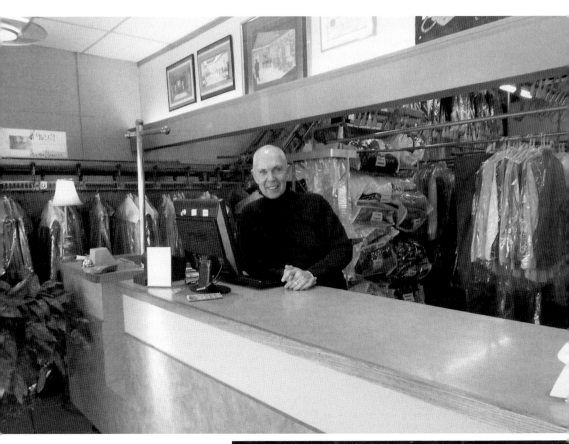

William and Leslie Marcotte, Businessmen

Crystal Cleansers was started by Leslie Marcotte (right) in 1946 at 157 Main Street. Marcotte also helped to establish the Coventry Credit Union, which stood across the street from the dry cleaners and now has two locations in town. Crystal Cleansers represents one of the many family-owned businesses that make up the backbone of the town's economy. The Coventry Shoppers Park, where Crystal Cleansers is located today, opened in 1965 on the site of the first dry cleaner. On display in the shop is an original advertising sign that was placed in Leslie Marcotte's Volkswagen when he made deliveries. Leslie's son William Marcotte (above) is the current owner. (Right, courtesy of CHS.)

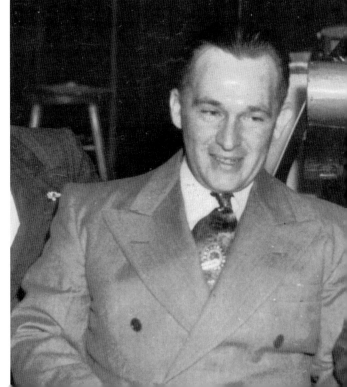

George Proffitt, Sailor and Businessman

The Anthony School House and an icehouse were originally located on the property that now houses Ice House Flowers. Ice House Flowers, at 655 Washington Street, was founded in 1974 by George Proffitt. Before he started the business, Proffitt had served in both the Army and the Navy. During his stint in the Army, he was part of a unit sent to help rebuild Japan and was called up to serve in Korea when the war broke out. He transferred to the Navy, became a member of the Naval Criminal Investigative Services, and was stationed in Rhode Island. His introduction to the flower business happened when he was doing a background check on a US Marine. He visited a local florist shop looking for the Marine's brother-in-law and struck up a conversation with the owner. After his retirement from the Navy, he started selling flowers from the side of the road. As time passed, he was able to rent a building that had once housed the Anthony Sporting Shop. When he moved into the building, there was no running water, and he had to haul water from the pond to water the plants. The name of the company was derived from the fact that the structure had been the old icehouse. Proffitt has provided the Coventry community with flowers for weddings, funerals, and special events, and the flowers used in these arrangements come from places like Thailand, Ecuador, Colombia, and California. The business suffered a devastating fire in August 1981, but Proffitt stayed open, rebuilt, and still serves the community today. Over the course of his career, one of the major changes he has noticed in the floral business is the decline in elaborate arrangements because of changing funeral practices.

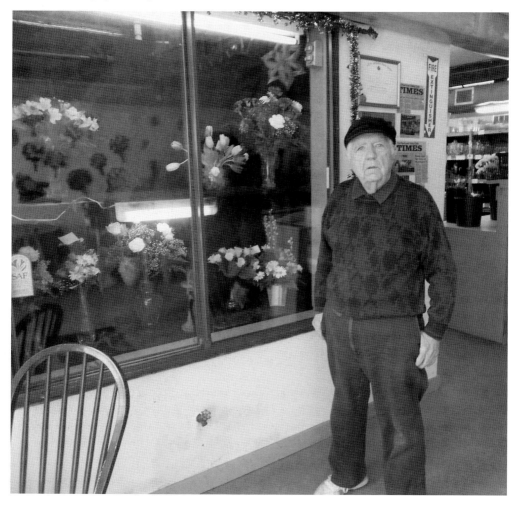

Kim Skaling and the Summit General Store

Skaling is shown here in the Summit General Store where she has been working since the age of 14. The Summit General Store was established in 1969 by her great-grandfather William Skaling and has been a family owned and operated store for three generations, selling everything from food to clothing to farm supplies. The store, which is located along the trestle trail near the site of the old railroad storehouse, serves as the center of the community. In the summer, residents can be seen stopping by to pick up their orders of smoked ribs, newspapers, or last-minute items. Skaling's father is one of the current owners of the store.

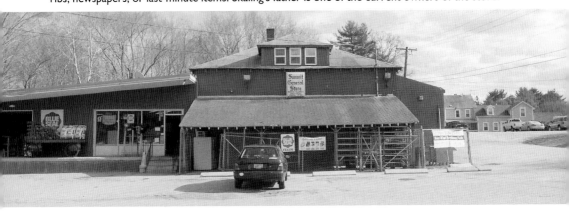

Gail Holland, Realtor

Being a Coventry native has prepared Holland to help people find not just a home in Coventry, but a place to establish their roots. As a real estate agent for Keller Williams, she provides her clientele with historical background, insight into the community, and her sense of Coventry pride. Holland especially enjoys working with first-time home buyers, some of whom were raised in Coventry. Holland's father worked for the L&M Lace Mill in Coventry, and her brother worked at the Showboat restaurant. When she was young, her father brought home pink lace from the mill, and her mother made her a dress that she wore for the Little Miss Natick Pageant. Over the years, Holland has witnessed the economic impact on Coventry housing in good times and in bad, but, being a true Rhode Islander, continues to maintain the hope for better times ahead since the downturn of the 2000s.

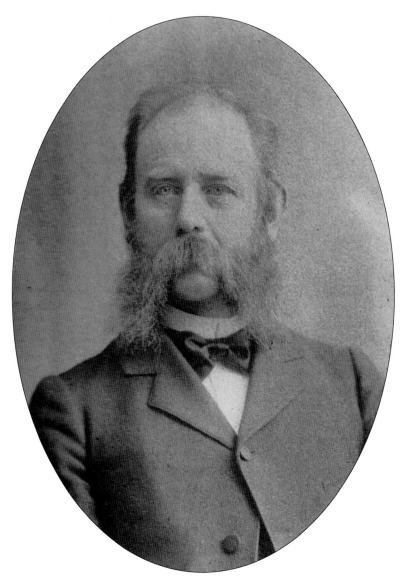

Dr. Franklin Bailey Smith
Smith was born in Georgia in 1848. He studied medicine under Drs. William A. Lewis and F.S. Abbott before entering the University of Vermont and the medical department of the University of New York. Smith graduated from the University of New York in 1873 and helped to establish the Kent County Medical Society, which still oversees physicians today, in 1912. He began practicing medicine in Coventry in 1880, working with his father-in-law, who was also a physician. His medical practice was located at 2 Park Street in Washington Village. Smith served the community through the influenza epidemic of 1918 and the early part of the 20th century. As a part of his practice, he went to local roadhouses to care for the women who worked there. On one such visit, he counseled a young woman to leave that life before it became her undoing. Many years later, the door to his office opened, and in walked a woman with a child. She asked if he remembered her. Smith did not, so she proceeded to tell him that she was the young woman he had counseled and that she had taken his advice and left the roadhouse. As a result, she had married a good man, had his son, and had a house in Providence. She thanked him for saving her life. Smith died in 1930. (Courtesy of CHS.)

Benjamin Franklin Tefft Jr., Doctor
Tefft was the oldest practicing doctor in Rhode Island when he retired in 1972. He had been practicing for 67 years, and the oldest patient he had ever treated was 104. He was a leading ear, nose, and throat doctor, and he attributed his own longevity to not drinking, not swearing, and only smoking when he was four years old. He was the president of the Nathanael Greene Family Association, formed in 1924. This association currently operates a museum telling about the life of Nathanael Greene, a Revolutionary War general. (Courtesy of WRICHS.)

Angeretta Remington, Midwife
Remington was a widowed mother at 29 with two sons. As her female ancestors had done when Coventry was a new town, she served the local women as a midwife. When the pregnant woman felt the time was near, Remington would go and live with the family until the birth. As all children were born at home and the town did not record those who assisted, the exact number of babies she helped into the world is not known. (Courtesy of Lois Sorenson.)

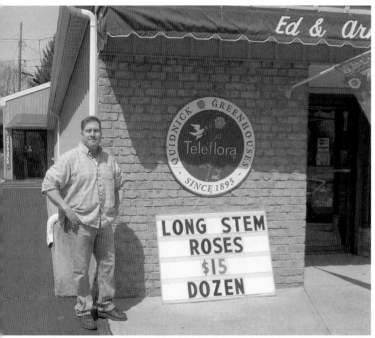

Gregory Iannotti, Florist
The Cushing family built greenhouses and opened Quidnick Florist in 1895. In 1926, the Iannotti family, which already operated a florist shop in Providence, purchased the business. Gregory Iannotti is the fourth generation of the family to run the shop at its current site. He recalls that during the 1960s he and the other Iannotti children used to play Christmas carols on a variety of musical instruments while the shoppers shopped.

Frank R. Gorton, Funeral Home Director
Gorton was the founder of the Gorton Funeral Home and was also a descendant of Samuel Gorton. Frank learned the trade of the funeral business from Herman Read, Byron Read's son. At one time, the town of Coventry received an ambulance from this funeral home. The Gorton Funeral Home has served the community since 1937, so upon its purchase by Alfred Menard and his wife, Laura Wistow-Menard, in 2001, its name was changed to Gorton-Menard Funeral Home. (Courtesy of PVPHS.)

Byron Read, Businessman
Read owned a furniture and undertaking business in the late 19th century and the early 20th century. He was appointed by the town to provide coffins and perform burial services for Coventry's indigent and Civil War veterans. His funeral home and business were located along Main Street, and the mansion that he built is now used by the Gorton-Menard Funeral Home. Read opened the first emporium in Coventry in 1882. It was 40 feet by 100 feet and had two stories and a basement. The Read family owned a horse named Old Tom, who worked for the family until his death in 1886. At the time of his death, Old Tom had worked over 1,100 funerals. This noble animal was known for his exemplary character and the dignity with which he conducted himself during funerals. (Left, courtesy of PVPHS; below, courtesy of CHS.)

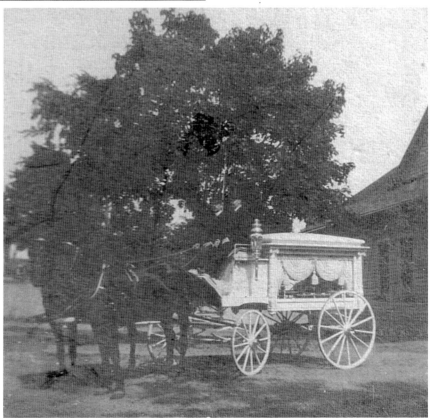

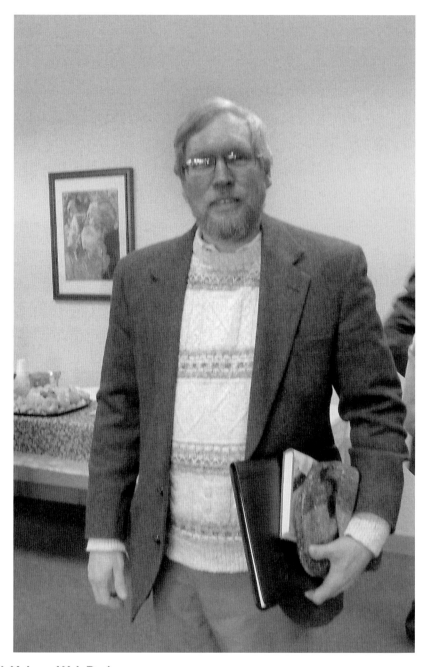

Patrick Malone, Web Designer
Malone is the founder and operator of Marshmallow Fox Web Design. When the company where he worked as a printer left Rhode Island, he went back to school, learned new technologies, and turned his hobby of web design into a career. Choosing his logo became a daunting task as everything he chose was already taken. Malone resides in the country, in a section of Coventry known as Greene. Animal enthusiasts, Malone and his wife began leaving a trail of marshmallows in the yard to entice a fox onto their property. One night, his wife yelled "Marshmallow Fox," and that became his logo. It stuck, and Marshmallow Fox now lures in clients like Nino's on Lake Tiogue and the Coventry Historical Society to create their websites.

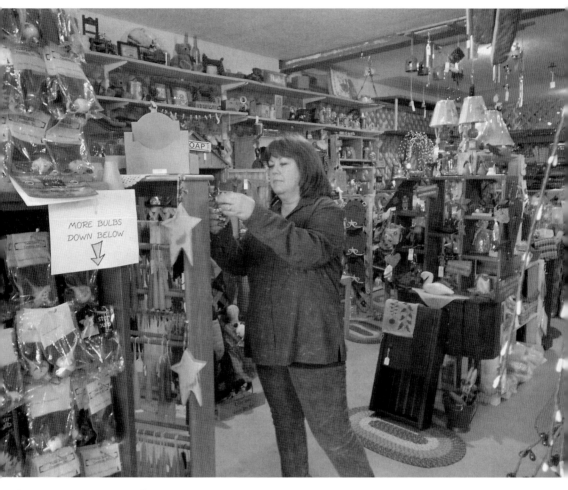

MORE BULBS
DOWN BELOW

Patricia Florio, Krafty Sisters

Krafty Sisters, run by Florio, Gayle Doyle, Ann McMahon, and Chris Jarbeau, has been in business for 18 years. This group has been friends since childhood and has enjoyed doing crafts together, so it was only natural for them to form a business. The store carries only handcrafted items, many of which are made by Florio and her fellow crafters. Florio takes pride in helping customers get special orders just the way they want them. She says that "during the latest economic downturn many crafters who had made crafts for fun have now turned it into a small business."

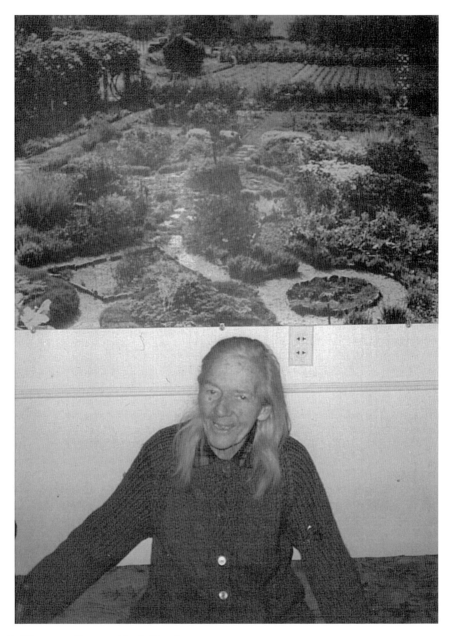

Maggie Thomas, Greene Herb Gardens

In 1942, on a farm in Greene, Maggie Thomas and Mittie Arnold began the Greene Herb Gardens, one of the first wholesale organic gardens in America. Thomas and Arnold would employ local help to work on the farm and would educate the workers about the various herbs. They were not interested in using them for medicinal purposes, but for culinary uses. The Wantaknohow Garden Club would visit the gardens, and Thomas and Arnold would give tours and lectures to the members. They were approached by the Perkins Institute for the Blind to create an herb garden for the visually impaired, and they came up with a design concept using three of the six senses: taste, touch, and smell. The garden was displayed at the Boston Flower Show and was such a success that many garden clubs across America began planting herb gardens for the blind.

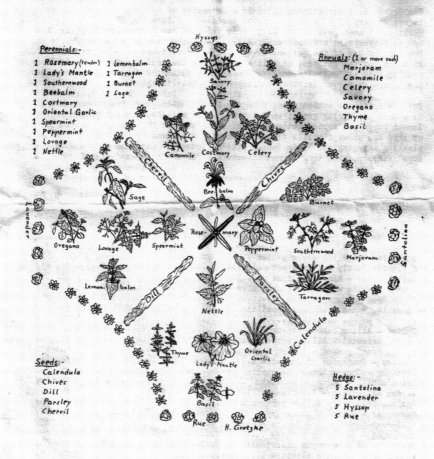

Greene Herb Garden

Perennials:-

1 Rosemary (tender)	1 Lemonbalm
1 Lady's Mantle	1 Tarragon
1 Southernwood	1 Burnet
1 Beebalm	1 Sage
1 Costmary	
1 Oriental Garlic	
1 Spearmint	
1 Peppermint	
1 Lovage	
1 Nettle	

Annuals:- (1 or more each)
- Marjoram
- Camomile
- Celery
- Savory
- Oregano
- Thyme
- Basil

Seeds:-
- Calendula
- Chives
- Dill
- Parsley
- Chervil

Hedge:-
- 5 Santolina
- 5 Lavender
- 5 Hyssop
- 5 Rue

GREENE HERB GARDENS

Growers of Fine Seasonings
GREENE, RHODE ISLAND

Allen Menton Hopkins
Hopkins was born September 20, 1875, in Coventry and was married to Olive Louise Whitford. As a young man, he began working as a grocery clerk in and around Coventry, assisting people with their purchases and delivering items to their homes. His job as a clerk provided him with a comfortable living to raise his family, which included his son, Elliot Allen Hopkins. After he retired from the grocery business, he went to work as a janitor for the Union Trust Bank until his retirement in 1946 at the age of 71. He died in February 1959. (Courtesy of Lois Sorenson.)

Eugene Fremont Chase, Printer
Chase (standing center) was married to Hattie L. Whitford and owned IF Chase Print Shop in Coventry. The print shop was opened in 1867 by his father, Isaac F. Chase. After Isaac's death, Eugene became the owner, and after his death the ownership passed to his widow. This shop, which was still in business in the mid-20th century, claimed to be the best print-and-stationery shop in the valley and at times was hired to print tax books for the town of Coventry. (Courtesy of Lois Sorenson.)

Elliott Allen Hopkins, Banker
As a young man, Hopkins worked as a bank teller and then as a partner in the Clarke, Kendall & Bradley insurance company. He was elected to the Coventry Town Council in 1936 as a member of the Republican Party. While Hopkins served as president of the town council, it was approached by a concerned citizen to come up with a plan to help veterans find housing. Like a lot of American cities at the end of World War II, the town of Coventry faced a housing shortage. Hopkins was one of five men—two of them returning veterans from World War II—who made up a committee to study the housing problem, specifically focusing on the needs of veterans and their families. Hopkins was also a member of the Rhode Island Draft Board and the rationing board. He died in 1998. (Courtesy of Lois Sorenson.)

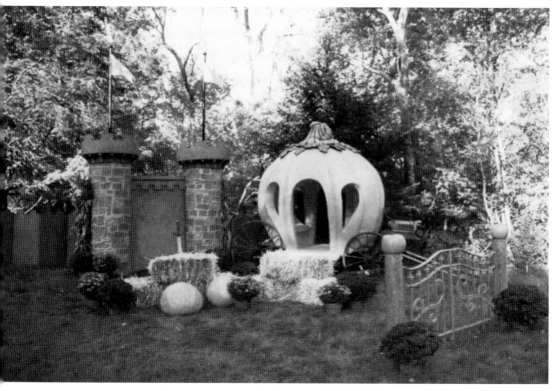

Bruce and Rosemarie Guertin, Magical Affairs

Magical Affairs began when Rosemarie came home and found Bruce, who is a contractor, creating an object that resembled a pumpkin on their lawn. After Bruce painted the pumpkin orange, Rosemarie said, "you know you need a white pumpkin too," and the next thing she knew she came home to a whole carriage. Since then, the Guertins have been creating the whole Cinderella experience for brides and prom goers as the owners of Magical Affairs, which was incorporated in October 2003. The Guertins' daughter dresses up as Cinderella, and each bride or prom attendee receives a handmade photograph album shaped as a pumpkin carriage to keep. In all their many events, the Guertins recall two stories with particular fondness.

Two cousins from Harrisburg, Pennsylvania, discovered Magical Affairs online and began saving their money to hire them for the prom. The mothers of these young women found out about their dream and helped them with the funds. The Guertins recalled loading the pumpkin on the wagon and driving it to Harrisburg for a prom and how everyone looked at the young ladies when they pulled up in the Cinderella coach while the others arrived in limousines.

The white pumpkin carriage is kept in the Guertins' yard and can be seen from the road, and people sometimes stop to have their picture taken with it. On one occasion, a mother and young daughter stopped by so the little girl could pretend to be a princess. When Rosemarie Guertin went out to talk to the mother, she discovered that the little girl had a rare form of cancer and that the mother thought that having her pretend to be a princess might lift her spirits. The little girl had such a wonderful experience that she kept coming back until a few days before she passed. The orange pumpkin is now kept at Roger Williams Park and is part of the Halloween Jack-O'-Lantern Spectacular. To the Guertins, another magical part of this experience is the number of people who have used the carriage and still send them cards. (All, courtesy of Bruce and Rosemarie Guertin.)

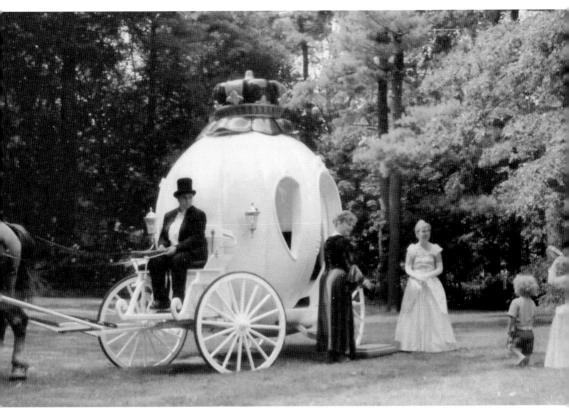

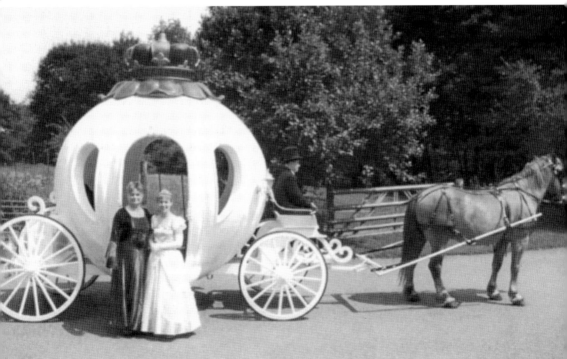

Charlie Patel, Veterans Market

Patel, who has owned the Veterans Market since 2012, was born in India and immigrated to the United States five years ago. After purchasing the store, he made a few changes, but the business has retained its status as a place where neighborhood residents can go pick up a few things and see their neighbors. Patel is continuing to run a business that has been serving the same families for 60 years. In snowstorms, he stays open for people to buy their milk, bread, and eggs. Alyssa Rose, pictured here with Charlie, works with Patel as a clerk.

Hector Poulin, Mill Owner

Poulin moved to Coventry from Woonsocket to rent the mill that had been owned by Searles Capwell. According to his granddaughter Norma Smith, Poulin was hired to drive his truck to tow the boat that would become the famous Showboat restaurant across the lake bottom to the eastern shore of Lake Tiogue. (Courtesy of Norma Smith.)

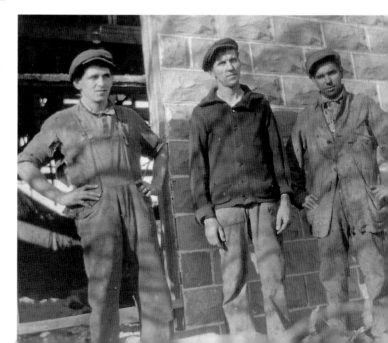

Terrence E. Duffy

Duffy (at microphone) owned a grocery store and served on the town council as the president. He first served as the town clerk beginning in 1954 and was still clerk in 1966. Duffy was also a state senator and served as the acting postmaster in Coventry. It was during his time as town clerk that the memorial to the Coventry men and women who served in World War II was dedicated, and this photograph was taken at that event. Under Duffy's tenure, the town of Coventry expanded, and many new schools and homes were built. In 1969, the town dedicated the community center at the Knotty Oak Village and named it in honor of Duffy. (Courtesy of CHS.)

Grace Smith, Hairdresser and Business Owner

After the death of her husband, Grace Smith, who had small children to support, opened a small beauty shop in her Coventry home. As a widowed woman in an era when women stayed at home, she had a hard time obtaining a loan and acquiring a space to operate her shop. With the assistance of a customer/friend, Smith was finally able to obtain a loan from Coventry Credit Union and open her shop, which she owned and operated until her death. Her daughter Norma Smith continues the business today under the name Beyond Grace. (Courtesy of Norma Smith.)

CHAPTER SIX

Community Contributors

Besides the businesses, another part of Coventry culture is the men and women who give or have given of their time and money to help their fellow neighbors. The town of Coventry established a poor farm in 1851 to help the less fortunate, and Horatio Nelson Waterman set up a fund to help the poor of the community. Following in his footsteps, Gail Tatangelo has established a community garden to provide food to those in need while giving students the opportunity to meet community-service requirements and providing senior citizens with meaningful tasks such as planting seedlings and watering the gardens. Civil servants in this chapter include William Longridge, J. Francis Remington, Anthony Ottaviano, William Heaton, and Bryan Volpe, as well as senior center volunteers like Marco Marotto and Freda Fisher, who have all contributed to the well-being of the community.

Fundraising and supporting one's neighbor are important to the residents of Coventry, as evidenced by Ray Gandy, who swims to raise money for the Leukemia & Lymphoma Society, and Christopher Moore, who participates in the annual Penguin Plunge to raise money for organizations like the American Cancer Society. Other organizations, such as 4-H and the Wantaknohow Garden Club, create friendships while providing various services to the community. Additionally, Norma Smith and the Friendship Link establish long-lasting friendships worldwide. Others, like George Parker of Parker Woodland, have established permanent preserved areas for the survival of natural habitat and for the people of Coventry to explore and remain connected to nature. Just as Cora Jordan, a local artist, provided the residents of Coventry with paintings of the town's history, Joel Johnson is the current-day driving force behind the committee that is providing Coventry with a lasting tribute in the form of a statue of Nathanael Greene, a famous war hero who resided in Coventry and whose family still maintains his home under the Nathanael Greene Homestead Association.

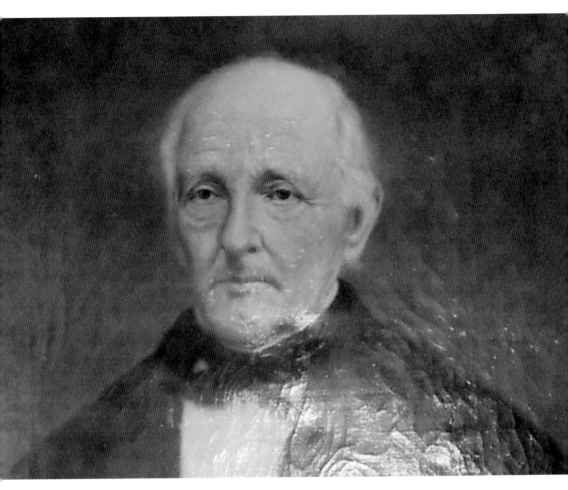

Horatio Nelson Waterman, Farmer and Laborer
Waterman was born February 26, 1806, in a house once visited by Washington, Rochambeau, and Lafayette during the American Revolution. The son of Capt. William Waterman and Hannah Gardner, he was a direct descendant of Roger Williams, the founder of Providence. He worked as a farmer and laborer and lived frugally, saving his money. After his death on June 16, 1891, he left about $50,000 to the town of Coventry in support of the poor. One of the first acts performed with this money was the update of the heating system in the town's poorhouse. The poorhouse, also known as the poor farm, closed by the mid-1940s. This fund was invested and is still used today to help the poor. Waterman is buried in the family cemetery on Bowen Hill, and his portrait hangs in the Coventry Town Hall (where, according to his will, it has to be displayed).

George Burrill Parker, Town Clerk
Parker was born in 1862, when the Civil War was in its second year, and died in 1946. He served as a town clerk and donated 250 acres of land to the town of Coventry in 1941. This property is now known as the George B. Parker Woodland Wildlife Refuge and is part of the Audubon Society. The refuge includes an archaeological dig site that shows the remains of mills and charcoal mounds. The charcoal was used in cold blast furnaces, which were used in mills such as the Hope Furnace Mill, located nearby, and the Greene Forge, owned by Gen. Nathanael Greene's ancestors. The Isaac Bowen House is also on this site and is listed in the National Register of Historic Places. (Right, courtesy of CHS.)

Thomas R. Hoover, Town Manager

Hoover, who has served for 43 years in municipal government, was hired in July 2009 from Royal Oaks, Michigan, to serve as the town manager of Coventry. As the town manager, Hoover is responsible to the town council for the administration of all town affairs on a daily basis. During his administration, Hoover has been guiding the town through difficult economic times.

Bryan Volpe, Chief of Police

Volpe has served as the chief of police in Coventry since January 2011. Before becoming the chief, he served for about 20 years as a Coventry police officer. Over his years of service, he visited the local schools to teach the students about safety. Volpe just recently hired a new officer for the force who had grown up with his children.

William Heaton, Dog Officer

Heaton was an auxiliary police officer until 1968, when he became the one-man Animal Rescue Division. His position required him to take care of all dog ordinances and save animals in distress. Heaton said, "Dealing with the people may be the most important part of the job, but it's the animals that make it all worthwhile." He once saved a dog from drowning in a swimming pool, herded cattle, and caught horses on the run. One of his more embarrassing moments came when he chased a sparrow up and down rows of women's dresses at a dress shop in the Coventry Shoppers Park. Heaton received a humanitarian award from the statewide Volunteers for Animals organization. He served as a US Navy corpsman in the Philippines during World War II and also sang Christmas carols at the Quidnick Baptist Church. In the photograph above, Heaton's family is dressed up for the reenactment of the founding of Coventry held during the 225th-anniversary celebration. (Both, courtesy of Hawkins family.)

William Longridge, Police Chief (ABOVE AND OPPOSITE PAGE)

Longridge was the chief of police in Coventry from 1924 to 1930, during the age of Prohibition and prior to the transition to a permanent full-time department. He was 25 years old when he was appointed chief of police, and at the time he was the youngest chief to serve in the state of Rhode Island. He was born to Alexander Longridge, who had worked as a mason in the quarry near Hill Farm Road, and Elizabeth Bruce. He was married to Sally Mallie and lived on Whaley Hollow Road on a farm his family called "the Ponderosa." Longridge owned and operated an automobile repair shop and a sporting goods store on Main Street from 1927 until his death in 1967. The shop was listed in the *Pawtuxet Valley Daily Times* as western Rhode Island's largest sporting goods store and was located at 655 Washington Street in the section of Coventry known as Anthony. This is the site where Ice House Flowers stands today. The repair shop and sporting goods store also gave the guys a place to hang out, play cards, and talk politics. Longridge owned a pet monkey named Nippy, which he kept at the garage and his house. He was a veteran of the world wars and was also part of the group that was organized to build a monument to the veterans of World War II. He was a member of the David Papineau American Legion post and marched in parades. He died January 17, 1967, and was buried in the Rathbun Cemetery. He was known for taking young boys fishing and hunting and teaching them about the outdoors, and he was also noted for getting Christmas presents for families in need. Longridge was remembered as "a gruff powerful man who breathed color." Despite his tough, gruff exterior, he gave of himself in many ways. In one instance, when a man broke into his store and robbed the register for money to buy groceries and cigarettes, Longridge sent groceries to the man's family. (Both, courtesy of Robert Maguire.)

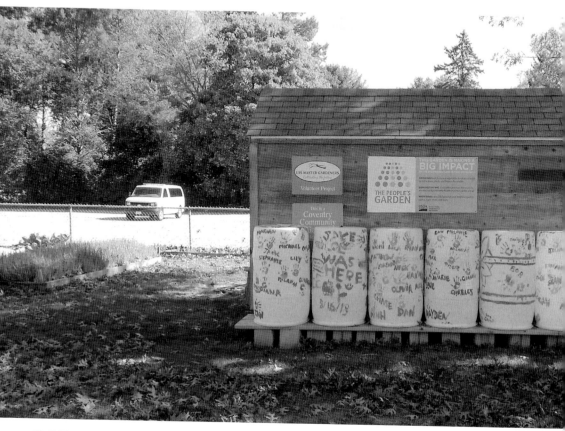

Gail Tatangelo and the Community Garden

Tatangelo, who is a University of Rhode Island master gardener, approached the town of Coventry about starting a garden based on the Victory Gardens of World War II. Tatangelo had noticed that people, especially children, were unaware of healthy eating and the origins of their food. After the town approved the garden location in front of the Coventry Town Hall Annex, she obtained donations of wood and garden supplies. Because of the garden's placement in front of the annex, Coventry residents became aware of it and some began volunteering. Students and seniors help to plant seeds and nurture the plants, making the garden a classroom for the young and old, whose handprints are pictured here. With the help of the Coventry Human Services Department, Tatangelo is able to distribute the food to the needy of the community. In 2012, she accepted a $4,000 grant for this garden from DeLoach Vineyards through a contest hosted by *Organic Gardening* magazine. (Opposite, courtesy of Robert Robillard.)

Marco Marotto

Marotto lives on Breezy Lake in Coventry. There, he has befriended a swan that has a deformity and named her Hilary, and he waits for her annual return to the lake. During his lifetime, he has been a food-safety inspector and a food distributor, so it was only natural for him to volunteer in the kitchen at the Coventry Senior Center two days a week. He also volunteers at the USS Saratoga Museum Foundation in North Kingstown and works as a fundraiser for children with disabilities at the Fogarty Center. He enlisted in the Navy at the end of the Korean War and brought the *Saratoga* into commission in 1956.

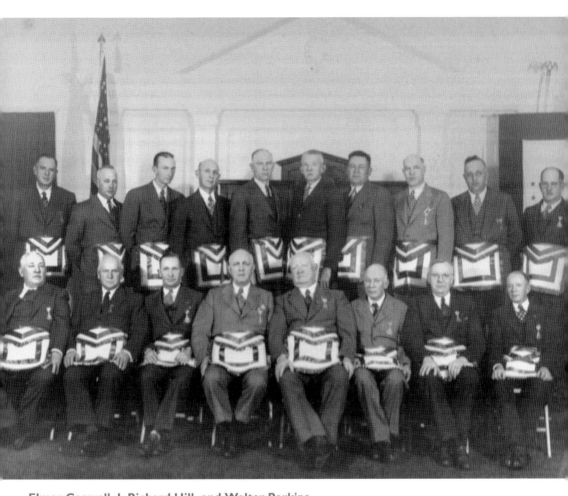

Elmer Capwell, J. Richard Hill, and Walter Perkins
Elmer Capwell (first row, second from right) was a fire chief; J. Richard Hill (second row, second from left) operated a shoelace-tip factory in Coventry and helped to form the Hill Farm Fire Department, and Walter Perkins (second row, fourth from left) owned a fruit store in Coventry. They were all Masons. Coventry is home to two Masonic lodges that have been playing a role in the community since they were formed in the 19th century. The Masons give scholarships for college, host blood drives, and hold family events around the holidays. (Courtesy of CHS.)

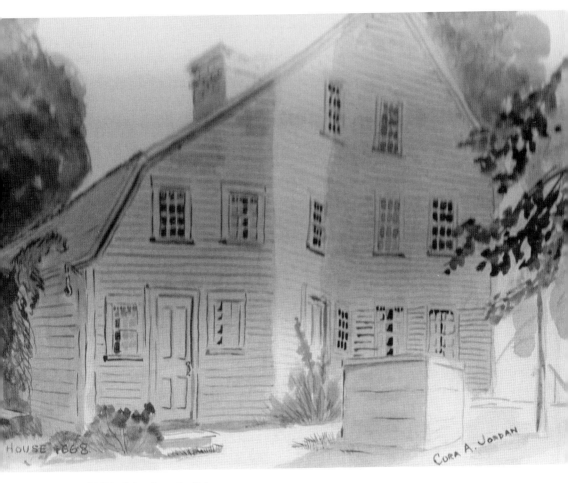

HOUSE 1868

CORA A. JORDAN

Cora A. (White) Jordan, Artist

Jordan was a local artist who painted images of Coventry's past. She was born October 17, 1920, in Cranston, Rhode Island, to Edwin W. White and Clara B. Myres, and she died February 13, 1974, while attending a funeral. She was married to Earl Leslie Jordan Jr. who had served in World War II. While her husband was stationed in Germany, she attended art classes. She was a member of the Providence Art Club, the Providence Art Water Club, and the Wickford Art Association, and was president of the Pawtuxet Valley Art Association. She graduated from the Rhode Island School of Design and hosted art shows in the Coventry Shoppers Park for the Coventry Chamber of Commerce. Her art is on display at the Coventry Credit Union and the Paine House. This image of the Paine House is a sample of Jordan's artwork. (Courtesy of WRICHS.)

Fred Curtis, Merchant Marine and Sea Captain

Curtis is a Coventry native who served in the Merchant Marines, during which time he visited 39 countries and served as captain. As a young man, he worked as a gardener for Maggie Thomas and Mittie Arnold at the Greene Herb Garden. While in college, he worked on various boats, including the research vessel the *Endeavor*. Whenever he was on leave, he went back to the Greene Herb Gardens or worked as a schoolteacher in the Plainfield Connecticut School District. Today, Curtis is a gentleman farmer in Coventry and president of the Coventry Historical Society, which is now located in the Old Summit Baptist Church, has a museum in the Summit Free Library, and operates the old one-room Read School House. The Coventry Historical Society held its first meeting April 22, 1971.

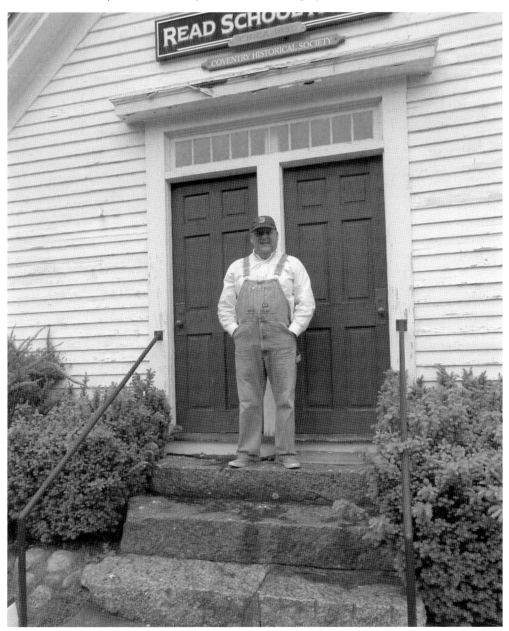

Gary P. Cote, Town Council President
Cote is a Democrat who represents District No. 4 and currently serves as the town council president. A lifelong resident of Coventry, Cote is a truck driver by occupation and drives for J. Tartaglia Trucking. He has advocated for improvements in education and the schools of Coventry.

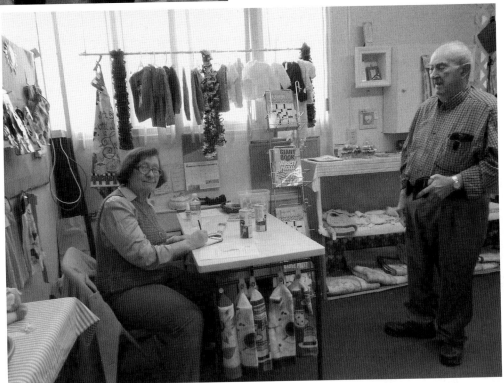

Freda Fisher, Volunteer
Fisher has spent the past 10 years volunteering in the Coventry Senior Center gift shop and kitchen, where she provides a warm and smiling face to all. Everyone at the Coventry Senior Center says, "You have to meet Freda." Fisher introduces visitors to everyone. Fisher came from Boston, where she met her husband, and together they moved to Coventry. She formerly worked for Verizon in the accounting department.

Christopher Moore, Firefighter
Moore is a lieutenant in the Hopkins Hill Fire Department in Coventry. He lives in town with his wife and two children and has been an active member of the department for 10 years. During the day, he works for the state fire marshal, and at night he is a call man for the fire department. He and his fellow firefighters participate in the annual Penguin Plunge to raise money for charity.

Gareld A. Shippee, Police Chief
Shippee was the first police chief of the Coventry Police Department after it became a full-time department in 1948. Shippee served in that position until 1968, and during that time he saw the town's evolution from a farming community to a bedroom community of Providence. Shippee was a veteran of World War II and is seen here in the Coming Home Parade of 1946. (Courtesy of Rachael Pierce.)

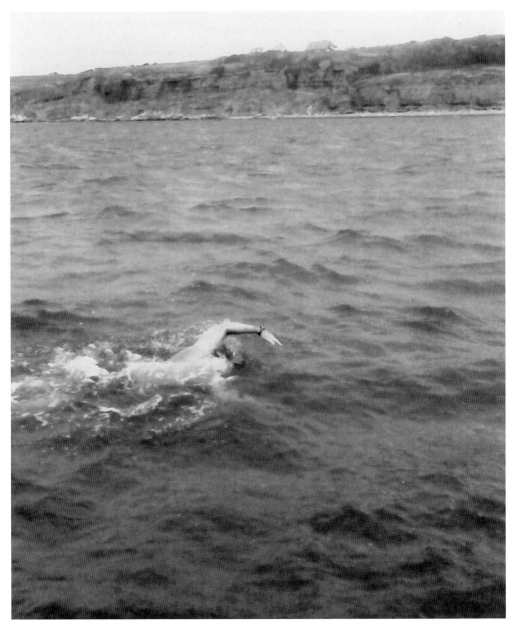

Ray Gandy, Swimmer

Gandy began swimming at the age of nine. When he was in college at Clarion University in Pennsylvania, he was a repeat NCAA Division II All-American swimmer. After the birth of his daughter in 1990, his life changed. His wife was diagnosed with chronic myelogenous leukemia. Gandy stopped swimming until 2000, by which time his wife had virtually recovered. Today, Gandy is an open-water marathon swimmer. In 2009, he became the first and only Rhode Islander to successfully cross the English Channel. In 2010, he was the first person to swim around Conanicut Island, which he circled twice in one swim. He swam the 57th-longest swim in history in July 2011 when he swam for 27 hours and 42 minutes in Narragansett Bay. One of Gandy's goals is to raise money for the Leukemia & Lymphoma Society of Rhode Island. (Courtesy of Ray Gandy.)

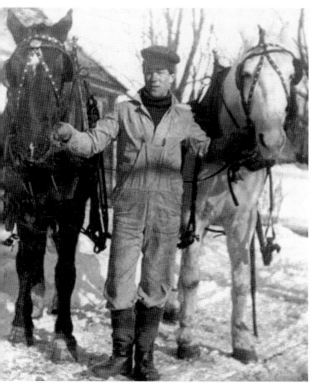

John Francis Remington, Town Constable

Remington was born in 1892 and grew up on a farm in Coventry. He was the grandson of Philip Johnson Jr., a Boston Post Cane recipient. His family, pictured below on the couch, includes, from left to right, Russell Franklin Tourgee (grandson) holding the infant Jo-Ann Tourgee (great-granddaughter), Helen Mae (Remington) Tourgee (daughter), John Francis Remington, and Angeretta (Whitford) Remington (mother). The image at left shows Remington working the horses on the farm. Having grown up on the family farm working with animals, it was only natural that he was appointed to be the pound keeper. In addition, Remington was a town constable in the early 20th century, and according to his cousin William Marcotte of Crystal Cleansers, he used to direct traffic at the intersection of Main Street and South Main Street. He died in 1968. (Both, courtesy of Lois Sorenson.)

Joel Johnson, Nathanael Greene Statue Advocate

Johnson, a lifelong Coventry resident, had an inspiration for a statue of Nathanael Greene when he first visited the Nathanael Greene Homestead in Coventry as a young boy. Greene had owned and operated a forge in Coventry before becoming a general in the Continental army and second in command to Gen. George Washington. The homestead still stands today, now known as Spell Hall, and is a museum dedicated to telling the story of Greene and his family during their time in Coventry. Generations of schoolchildren have visited this museum. With the dedication of a monument to Greene in Greensboro, South Carolina, the idea for the statue in Coventry resurfaced in 2008. In August 2012, Johnson and others formed a nonprofit organization known as the Nathanael Greene Monument Foundation. Johnson wants to put the statue in Coventry because there is currently no statue of Greene in town despite his vital role in the area's economy and his pivotal role in the American Revolution. The foundation began investigating locations for the statue and is now leaning toward a piece of land near a bridge that was just dedicated to Greene. The statue is based on the existing statue in Greensboro. Edward Walker and James Barnhill are the artist and the sculptor for this project. When completed, the statue will be 22 feet tall. Johnson hopes to have the public schools participate in fundraising. The organization's board of directors consists of all Coventry residents.

Anthony C. Ottaviano, Police Officer
Ottaviano was a member of the US Navy in World War II. After serving, he became a Coventry police officer on the first permanent police force under Gareld Shippee. Ottaviano served as the director of the Coventry Junior Police Corps in 1953. In the photograph at left, Officer Ottaviano took a group of Junior Police Corps members to Washington, DC. Serving as the Coventry school safety patrol director, Ottaviano had the privilege of congratulating Stanley S. Stasiowski Jr., a seventh grader at St. Mary's Parochial School, for pushing several children to safety when a car careened toward a line of students crossing the street. (Both, courtesy of Coventry Police Department.)

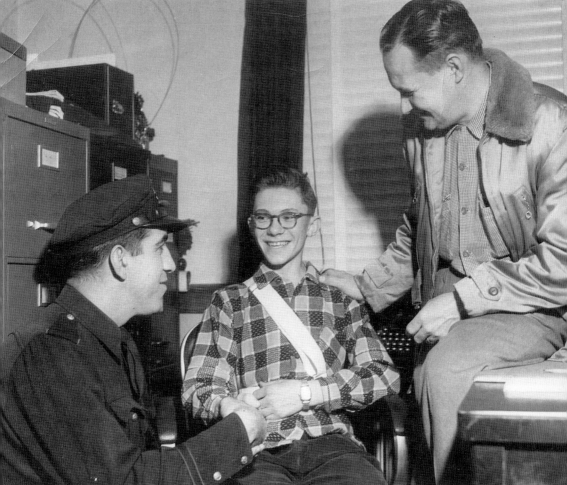

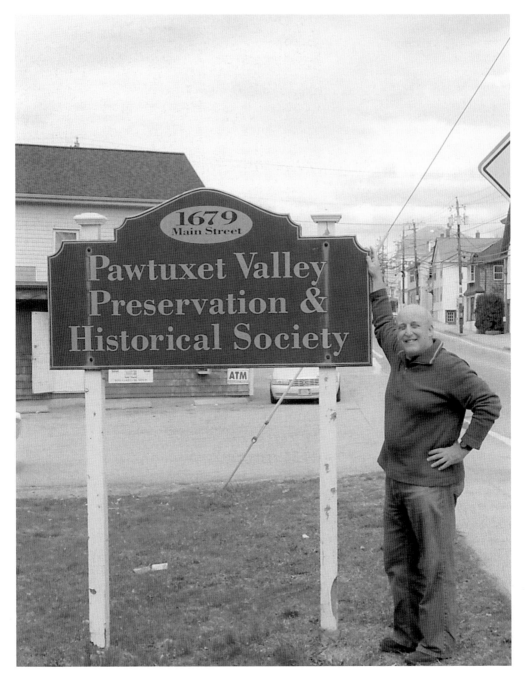

Charles M. Vacca Jr., Journalist and Lawyer

Vacca grew up in Centredale, Rhode Island, and majored in history and economics at the University of Wisconsin. He worked as a journalist for the *Coventry Townsmen* and is currently a lawyer. He is a past president of the Pawtuxet Valley Preservation and Historical Society, has served as the chairperson for the Coventry Republican Party, and is a member of the Pawtuxet Valley Preservation and Historical Society Cemetery Group. Vacca is a strong supporter of history and civic pride and credits the *Golden Book of America* for his interest in history.

Cheryl Ring, Leader of Wag'N Tails

4-H is a national organization whose mission is to offer youth the opportunity to address the four Hs—Head, Heart, Health, and Hands. Cheryl Ring (right) has been involved in 4-H for six years and is the current leader of Wag'N Tails, a Coventry chapter whose focus is dogs. In addition to dog training, members learn leadership and public-speaking skills and participate in community-service projects and fundraisers for local animal shelters as well as for at-risk families. Shown below are Kelly Bryant (left) and Jessilyn Ring with their artwork that was recently entered in the Photo Fine Arts Fair (where Bryant received the People's Choice award and Ring received Best in Show for the photograph of her dog). Both girls feel 4-H has provided them a variety of experiences and agree that dog training has made them very competitive.

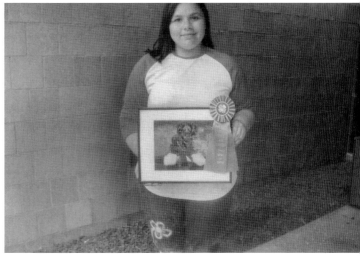

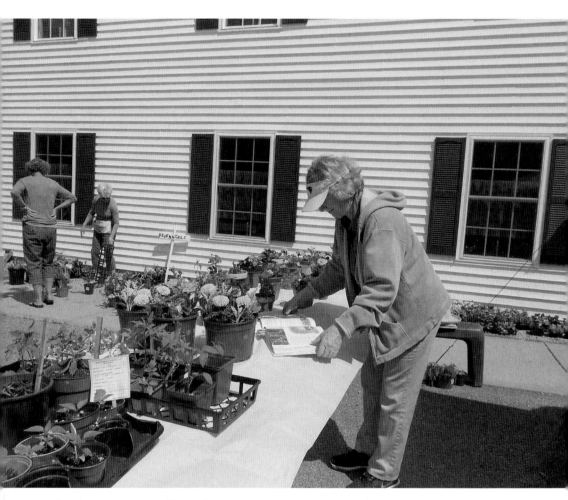

Sandy Farnum, President of the Wantaknohow Garden Club (ABOVE AND OPPOSITE PAGE)
In the group image opposite are, from left to right, Debbie Fisher, Candy Haas, Sandy Farnum, Sharon St. Martin, Sandi Fisher, Etta Izzi, and (in front) Mary Sunderlin, officers and members of the Wantaknohow Garden Club, which was started in 1938 by a group of women in western Coventry. In 1983, the club joined the Rhode Island Federation of Garden Clubs. The organization holds an annual plant sale to benefit the Wantaknohow Garden Club Scholarship (given to students who are studying environmental science) and other local civic projects. The club's current civic project, known as Adopt-A-Spot, involves planting and maintaining the flowers around the Greene Library. Gail Slezak from the Greene Library is an associate member. President Sandy Farnum believes the club is a way of sharing gardens with the community and says, "Gardeners are perennial."

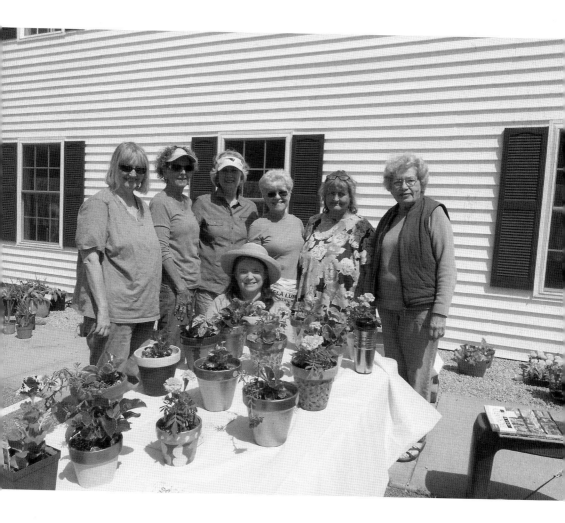

Norma Smith, Coventry Friendship Link

The Coventry Friendship Link was formed in 1975 when the lord mayor of Coventry, England, visited Coventry, Rhode Island, to establish a cultural relationship between the two cities. The first group of visitors arrived in 1975 from England to stay for two weeks. The image above shows Norma Smith, a past secretary of the organization, in England as part of the exchange. The sister cities are now Coventry, England; Vannes, France; and Meschede, Germany. In 1992, visitors from Germany came to Coventry, and much to the surprise of one of the women in their group, a friend originally from Germany who was now living in Arizona and whom she had lost contact with in the early stages of World War II had made arrangements to be at the home of the host here in Coventry. An offshoot from Coventry's Boy Scout Troop 11 became Troop 76 as an exchange-scout link. (Both, courtesy of Norma Smith.)

CHAPTER SEVEN

Authors and Educators

Coventry has been home to many authors since the 19th century, when Annie Kilton began composing poetry and stories about life in the village of Anthony. In this chapter, readers will meet Robert Grandchamp, who has written numerous Civil War books and articles focusing on Rhode Islanders who served in the war, and Linda Crotta Brennan, who has authored children's books and numerous stories for children's magazines.

Librarians and educators have been inspiring and shaping the minds of Coventry's youth for generations, and in this chapter readers will be introduced to just a few, such as Carrie Ina Jordan Shippee, Mary Harvey, Nichole Hitchner, Peter Stetson, Diane Simmons, and Gail Slezak.

Education in colonial Coventry was sparse and usually took place at home. The town did not have a public schoolhouse until 1765, and it was not until 1800 that the town began to use taxes to support education. Coventry was divided into 18 school districts, and each district had to provide the wood, school supplies, and teachers for the summer and winter sessions. Most schools were one-room structures with separate entrances for boys and girls. Teachers boarded with local families during their terms. As the town developed and new immigrants of different faiths arrived, parochial schools were established. Education was also supported by the establishment of free libraries in Anthony and Summit in the 19th century. There remain two libraries today—one in Greene and the main branch attached to the town hall—and children's programs, computer classes, and employment resources are available there. In 1926, Coventry ran evening classes. In the 1940s, the town decided to consolidate the individual school districts into five new districts. The town constructed new schools of brick and concrete to replace the one- and two-room clapboard structures.

Anne Kilton, Poet

Kilton was a Coventry poet who wrote a poem in 1910 titled, "The Village of Eighty Years Ago." She was a descendant of the Brayton family, one of the founding families of Coventry. This poem describes life in the village of Anthony in 1830, and the Pawtuxet Valley Preservation and Historical Society used it to create a walking tour of Anthony. Anne's grandfather was a Revolutionary War soldier and a member of the party that burned the HMS *Gaspee*, a British Ship that got stuck on a sandbar in Narragansett Bay off the coast of Warwick. This image is of her house at 38 South Main Street in the village of Washington.

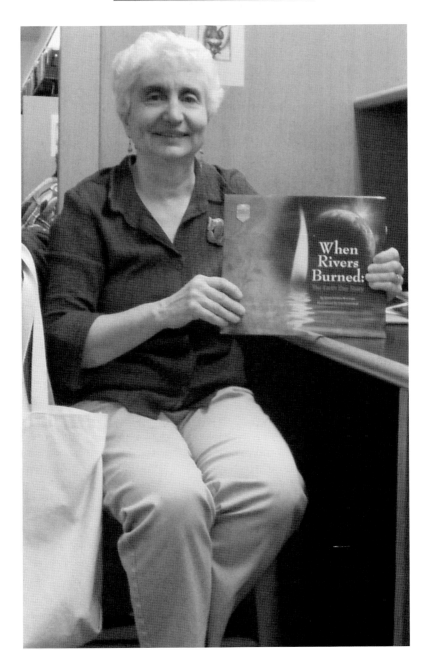

Linda Crotta Brennan, Children's Author
Brennan has authored over a dozen children's books and numerous stories for children's magazines such as *Highlights for Children*, *Ranger Rick*, and *Cricket*. Her latest book is *Where Rivers Burned: The Earth Story*. She also authored *Women of the Ocean State*, which is part of the *American Notable Women* series. Her book *Flannel Kisses* was designated one of Kathleen Odean's Great Books for Babies and Toddlers, and *Marshmallow Kisses* was nominated as one of the Best Children's Books of the Year by Bank Street College. This book also won the Oppenheim Toy Portfolio Gold Seal Award. Brennan worked at the Coventry Public Library and served on the Rhode Island Teen Book Award committee. She is a member of the Society of Children's Book Writers and Illustrators and the Author's Guild.

Peter Stetson, Science Teacher (OPPOSITE PAGE)

Stetson, an environmental earth science teacher at Coventry High School, has been teaching for 36 years. He is also a cochair for the Envirothon Club. Students who attend his classes learn about aquaculture and also work on projects such as raising rainbow trout. Stetson's easy-going personality and his hands-on techniques help him interact with the students. He started a garden at the high school, and when they put the addition on the school he worked with the architect to design the greenhouse. Stetson has received numerous awards and grants for his work teaching students about the environment. He is also involved with the Wantaknohow Garden Club.

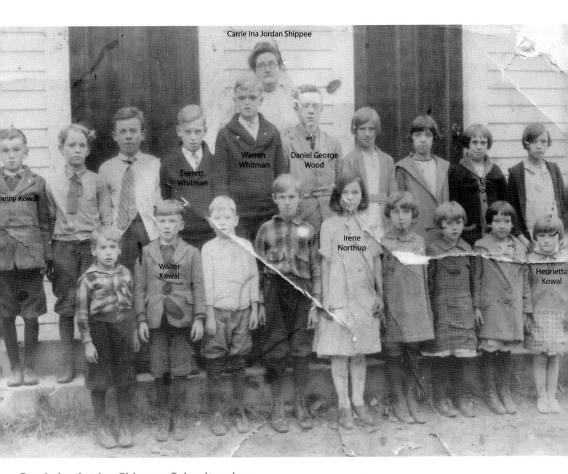

Carrie Ina Jordan Shippee, Schoolteacher

Shippee worked as a schoolteacher at Spring Lake School in Coventry during the early 20th century. She had come to Providence in 1910 from Connecticut, where she was born, to attend the Rhode Island Normal School. After graduation, she returned to Connecticut and began teaching. She returned to Coventry and was married in 1913, and started a teaching career that would impact the lives of many students. In 1940, at the age of 60, she was still teaching. A former student recalled seeing her working late in the night on lessons. Here, Shippee stands in the center background with her students. (Courtesy of Rachael Pierce.)

Nichole Hitchner

Hitchner has worked for the Coventry School System for the last 17 years. She received both an undergraduate and master's degree in education from Rhode Island College. Her introduction to teaching started in 1989 when she volunteered in a program that helped students with special needs. Her love of teaching is immediately felt when she begins talking and explaining how she interacts with students who have learning issues. She travels around the school districts, working with teachers on assessing the progress that the students are making and strategizing on how to reach students who are having difficulty excelling. As with Carrie Ina Jordan Shippee, it is not uncommon for parents to drive past a school and see Hitchner working after hours.

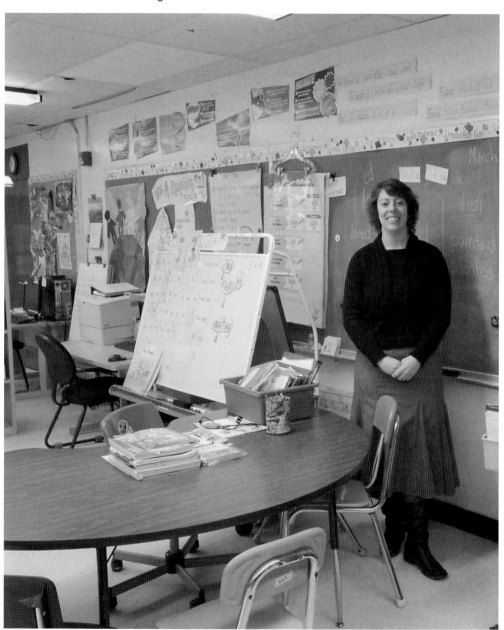

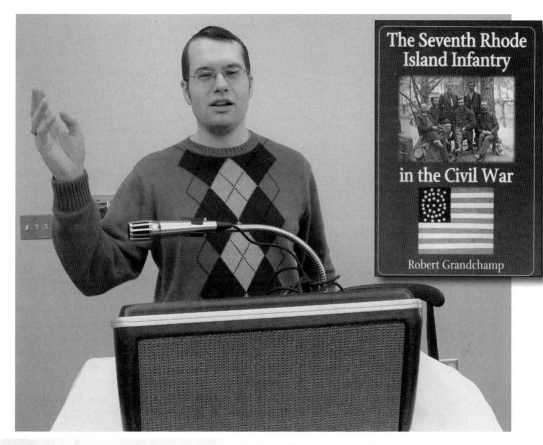

Robert Grandchamp, Author
Grandchamp is the author of numerous Civil War books and articles focusing on Rhode Islanders who served in the war. His book *The Seventh Rhode Island Infantry in the Civil War* includes William Rathbun, whose story is also included in this book. Grandchamp is a graduate of Coventry High School and Rhode Island College. He is currently employed by the Department of Homeland Security, working in Vermont.

Julie Lima Boyle, High School Teacher
Boyle is a graduate of Coventry High School. She received her bachelor of arts and master of arts degrees from Rhode Island College and her teacher's certificate from Providence College. She has been a teacher in Coventry schools for 13 years and is the department chair for the English department at Coventry High School. In 2011, she was named the Coventry Teacher of the Year and the Rhode Island Teacher of the Year. (Courtesy of Coventry Patch.)

97

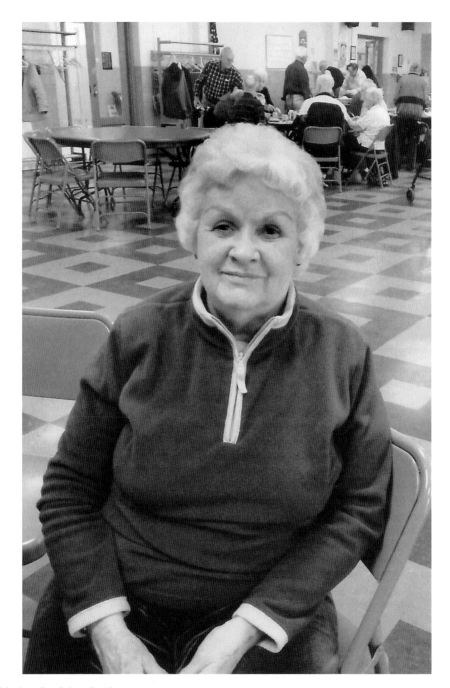

Gail Lake, Aspiring Author
Lake began writing her life story in 1978 as a means of coping with the death of her mother when she was eight years old and the death of her husband at the young age of 42. She started by writing about the house she had lived in. She began her story as memoirs but, having since taken writing courses, is in the process of changing her memoirs into books. In addition to being an author, Lake has been running the Sociable Group at the Coventry Senior Center for 13 years. Members have to be single, and Lake makes all the arrangements for their outings to plays, museums, and more.

Mary M. Harvey, Teacher and Principal
Harvey was a teacher at the Washington Village School who later became principal. Child Incorporated, which operates a federally funded Head Start daycare program, is housed in the former Washington Village School today. In this 1925 image with the children of the school, Harvey is the woman on the left in the black hat. (Courtesy of CHS.)

Tara D'Aleno, Elementary School Teacher
Editor Lauren Costa announced in the online Coventry Patch newspaper that Tara D'Aleno had been selected as Teacher of the Year for Coventry for the 2012–2013 school year. D'Aleno, who is a teacher at Tiogue Elementary School, stated that she was inspired by her father, who is also a teacher. (Courtesy of Coventry Patch.)

Graduates of Combine.

Coventry Elementary Schools 1926 Graduation
The Coventry Elementary Schools graduation of 1926 was held in June, with 119 graduates from 11 grammar schools. One ceremony was held at the Odd Fellows Hall in Anthony, while a separate graduation took place for the new Quidnick School in its assembly hall. Rev. Henry Parson gave the invocation and presented the diplomas at the Odd Fellows Hall. Parsons was the pastor of the Quidnick Baptist Church and was also the clerk for the Coventry School Committee. The address was given by Col. Merton

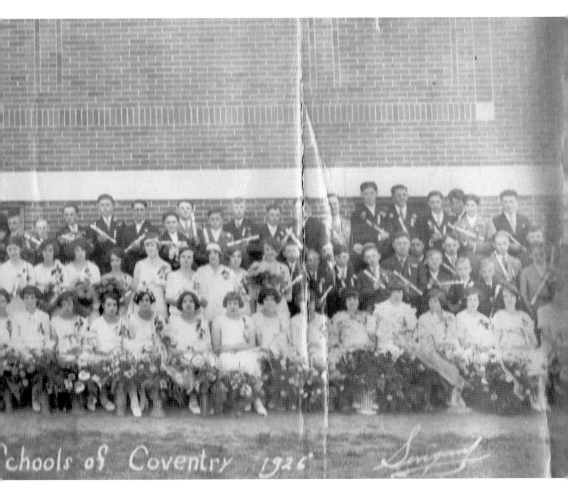

chools of Coventry 1926

Cheesman. Officers of the class were president Harold Young of Quidnick, vice president Lloyd A. Moon of Washington, secretary Mary C. Murningham of Harris, and treasurer Elizabeth MacClintock of Quidnick. The executive committee consisted of Philip H. Matteson of Maple Valley, Mary E. Kowal of Spring Lake, Harry O. Capwell of Summit, Harry L. Warner (future owner of Warner Rustic) of Read, and Susan A. Tew of Rice City. (Courtesy of Coventry Public School System.)

Guy Lefebvre, Director

Lefebvre has been the director of Coventry Parks & Recreation since October 1978 and has worked in the town for over 34 years. He began working as a referee for youth sporting events at the age of 14. He went on to college and, after graduation, went to work for the town of North Smithfield. Under his directorship, he helped to create the bike path system utilizing the old trestle trail. He served on the committee to celebrate the 250th anniversary of Coventry in 1991 and is active in preserving and promoting the history of Coventry. The Coventry Teen Center offers programs for children, teens, and young adults as part of the Parks & Recreation Department.

Diane Simmons, Youth Services Librarian
Simmons is the Youth Services Librarian at the Coventry Public Library located at 1672 Flat River Road.
She provides story time for children of various ages and assists in the preparation of special events held
during school vacations. She works outside the library at various day care centers, encouraging children
to read and visit the library. Simmons, who usually wears the same perfume when working at the library
or visiting schools and day cares, recalls, "One day I had cut through a preschool to get into the toddler
room. When the preschoolers came in from recess, the teacher later told me, one little girl said, 'I can
smell Mrs. Simmons!' " The Coventry Public Library is a member of the Ocean State Libraries system,
and Simmons has worked there for 20 years.

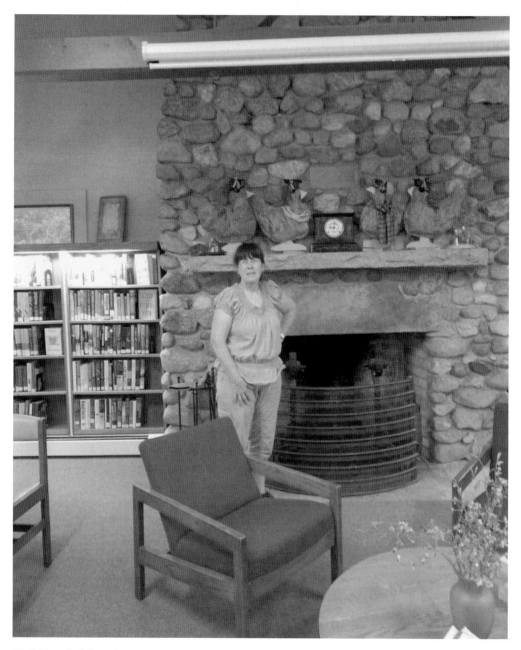

Gail Slezak, Librarian

Slezak began working 30 years ago as the cleaning lady at the Greene Public Library and worked her way up to a position at the desk. She then spent 10 years working at the Scituate Public Library and has spent the last five years as the head of circulation at the Greene Public Library. She has lived in Greene for 32 years and has noticed how the Greene Public Library is just a living room where one can see all their neighbors. She is now coming to know the children of the adults that she knew as children. As a child, she wanted to be a farmer. She learned how to farm from Maggie Thomas of the Greene Herb Garden, and she and her husband rented Nicholas Farm when they first got married. Slezak rides her bicycle to work when weather permits and has become known as the "bicycling librarian."

CHAPTER EIGHT

News of the Day

In the early days, messages were sent by rider or by stagecoach along the Old North Road and the Country Road. The telegraph poles would have also brought news to families in the area. With the coming of the trains, newspapers that were being printed in Providence could be shipped to rural areas of Coventry and distributed to the small local stores.

Before 1876, the newspapers that served the Coventry area were based in Providence and were the *Providence Evening Bulletin* and the *Daily Journal*, which had been started by Henry B. Anthony. This newspaper would have brought information about the election of Henry B. Anthony as governor of Rhode Island, the wounding of William Rathbun during the Civil War, and local job announcements. These announcements played an important role in attracting immigrants to Coventry.

In 1876 the *Pawtuxet Valley Gleaner* was established, and as time went on, other newspapers were started, including the *Pawtuxet Valley Daily Times*, the *Coventry Townsman*, the *Kent County Daily Times*, and the *Coventry Courier*. All of these newspapers served the Coventry area at various times, and the *Kent County Daily Times* and the *Coventry Courier* are still in existence today. The Stevens family started a weekly circular known as the *Coventry Reminder* in 1954 that is still published today. This circular reminds residents of upcoming events at the local libraries, the Wantaknohow Garden Club, and the Coventry and Western Rhode Island Civic Historical Societies. It also publishes advertisements for local businesses.

With the coming of the Internet age and the decline in published newspapers, the need for an online news source was apparent. Thus, Lauren Costa brought the Coventry Patch to the community. This online newspaper provides residents with the opportunity to blog and to obtain news around the clock, which helped many residents during the blizzard of 2013.

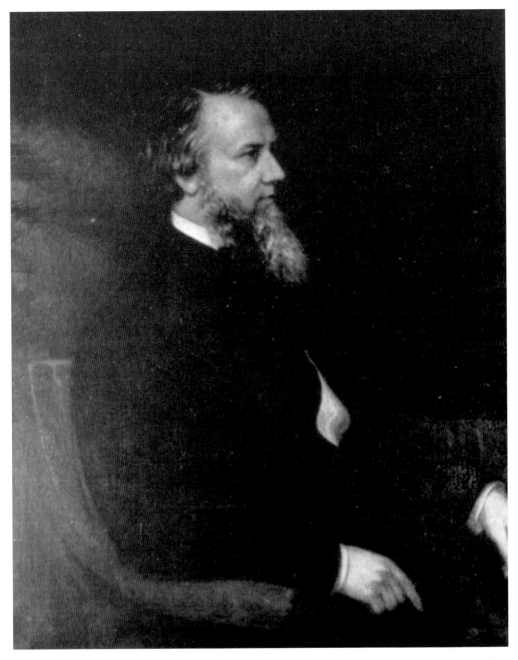

Henry Bowen Anthony, Editor, Governor, and Senator
Anthony, editor of the *Providence Journal*, was born in the Anthony section of Coventry on April 1, 1815, into a prominent family that was involved in the Society of Friends (also known as the Quakers). He attended the local public school, which at that time was located where Ice House Flowers stands today. Anthony graduated from Brown University and was married to Sarah Aborn Rhodes until her death. He was a member of the Whig Party and the Law and Order Party, and served as governor of Rhode Island from 1849 to 1851. He also served as a US senator from 1859 until 1884. His lieutenant governor, Thomas Whipple, was also from Coventry. (Courtesy of PVPHS.)

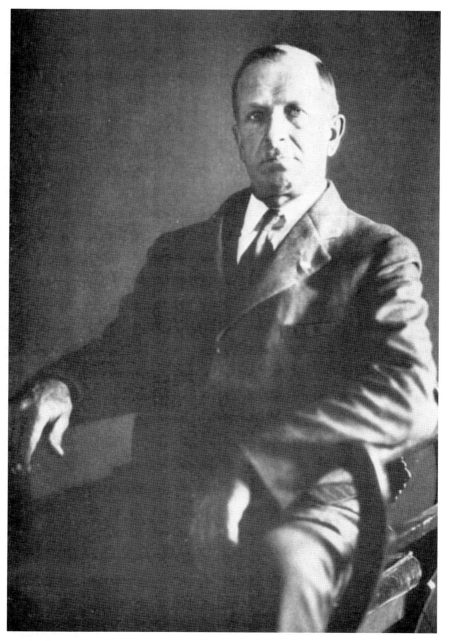

Irving Pearce Hudson, Editor, Auditor, Representative, and Senator
Hudson was born August 5, 1873, to J. Ellery Hudson and Eliza J. Pearce. He worked at the *Pawtuxet Valley Daily Times* before he became the editor in 1906. He became the auditor for the town of Coventry and was a member of the Coventry Republican Town Committee. From 1910 until 1914, he served as a representative, and in 1915 he was elected senator, serving at the state house. After his death in 1949, his widow, Thirza, continued to operate the *Pawtuxet Valley Daily Times* until her own death in 1961. Their four daughters, Dorothy I. Havens, Lucy M.H. Potter, Marion T. Goddard, and Thirza H. Chettle, served as the board of directors. This newspaper is now known as the *Kent County Daily Times*. (Courtesy of PVPHS.)

Lauren Costa, Editor (OPPOSITE PAGE)
Hurricane Irene of 2011 not only had an impact on the state of Rhode Island but on the Coventry Patch as well. Editor Lauren Costa reported that having a good rapport with people in the community allowed her the opportunity to set up in the command center and report directly to people's cell phones the power-outage restoration schedule, free-water locations, availability of showers, and other necessities as the damage from this powerful hurricane left many Coventry residents without power for days. After power had been restored and life started to return to normal, Costa remembers receiving emails and phone calls saying that the Patch had helped them find the news they needed; thus the Coventry Patch became a means for people to connect with the outside world, increasing its readership and popularity. Today, Costa invites members of the community to blog on this site, submit articles of interest, and report daily happenings. An annual happening in Coventry is the Tree Lighting Ceremony held every December in front of the Coventry Parks and Recreation Center to herald the start of the holiday season. Pictured opposite is Costa previewing a photograph she had just taken for use in the Patch.

Lauren Costa is a graduate of Coventry High School and has remained a Coventry resident utilizing her education in communication from the University of Rhode Island and her love of journalism to serve the people of her hometown. She began her journalistic career in middle school working on the school newspaper. After graduating from high school, she attended the University of Rhode Island and interned at the *Warwick Beacon*, learning the trade of journalism. She believes in the printed word but understands that the future of the newspaper is going to be online. While a student at URI, Costa heard of the Patch, an online news source for local communities started by AOL. In 2010, Costa decided to launch the online newspaper Coventry Patch. Her first journalism teacher was Julia Lima Boyle, 2011 Teacher of the Year.

The Coventry REMINDER
Your weekly shopping guide ★

627 Washington St. Coventry, R. I.

Est. 1954

Mail Advertising *Mimeographing*

Wedding Invitations

Business and Social Stationery

Howard and Luella Stevens

Howard Stevens, Founder and Publisher
The *Reminder*, a circular published by Stevens Publishing Inc., was founded in 1954 by Stevens in his home. He worked as the publisher until his retirement in 1991, and his children Peter Stevens and Amey Stevens Tilley now operate the *Reminder* at 1049 Main Street. This circular offers the Coventry community a place to advertise their employment services, yard sales, businesses, real estate, and restaurant coupons. The population relies on this publication to find out the goings-on in the community. (Above, courtesy of Coventry Police Department.)

CHAPTER NINE

Boston Post Cane Recipients and Honorees

The Coventry residents mentioned in this chapter have contributed to the fabric of the community not by giving money or time, but by providing their neighbors something to celebrate. Unlike today, extreme longevity was not as common in the early days of the community, so members found ways to honor those who lived a long life. The Boston Post Cane award was established in 1907 by the *Boston Post* to recognize the oldest resident of each town in New England. Both the cane and the plaque are on display in the Coventry Town Hall. The individuals represented in this chapter have been honored because they provide a link into Coventry's past. One such person, Mary Thompson, was born on Decoration Day 1914 and has witnessed the evolution of Coventry from an industrial center to a bedroom community, from a place of streetcars to one of automobiles. German-born Herman Rusauck, who represents the American dream, was the last recipient of the Boston Post Cane in Coventry in 1994. He died December 31, 1997, and is buried in Coventry.

Also mentioned in this chapter are two individuals who did not set out to receive awards. Linnea LaPointe was going on vacation and ended up having the honor of being an ambassador from the littlest state welcoming the biggest state into the union, and Jeffrey Hakansack was simply living by his motto—Preserve, Protect, and Improve—by cleaning up Lake Tiogue for future generations when he was recognized as the Hero of Conservation by *Field and Stream* magazine in 2009.

Philip R. Johnson Jr., Boston Post Cane Recipient (ABOVE AND OPPOSITE PAGE)
Johnson was born in 1822 and died in 1914. He was married to Tryphena Hoxsie Greene in 1849, and they had five children. His second wife was Phebe Wood Pine, with whom he had one daughter. He had many grandchildren and great-grandchildren. Margaret Estelle Whitford, on his lap on the opposite page, was one of his great-granddaughters. Johnson was a farmer who lived in the Paine House at one time. He was awarded the Boston Post Cane in Coventry. The Boston Post Cane was established in 1907 by the *Boston Post* to recognize the oldest resident of each town in New England. (Both, courtesy of Lois Sorenson.)

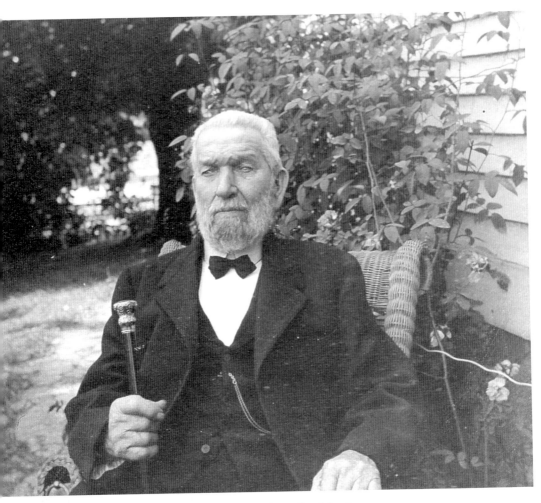

Samuel Augustus Edmunds, Boston Post Cane Recipient
Upon the death of the previous Boston Post Cane recipient, Philip R. Johnson, the cane was passed to Samuel Augustus Edmunds, who was born on March 4, 1821, and died February 28, 1916, at the age of 94 years, 11 months, and 24 days. Edmunds worked in the coal industry in Providence and made a considerable fortune, which he used to build a beautiful home in East Greenwich. During the economic downturn of 1893, he lost some of his fortune and decided to leave the coal business and open a market in East Greenwich. After the death of his wife, he moved to Main Street in Washington Village to live with his daughter Mary Edmunds. Herman Rusauck, who was the last recipient of the Boston Post Cane in Coventry in 1994, was born July 31, 1896, and died December 31, 1997. He is representative of the American dream, having been born in Germany, immigrated to the United States, bought a piece of land, and started a farm here in Coventry. He had two children, Ernest G. Rusauck and Karen A. DiPadua. (Above, courtesy of Richard Siembab.)

Pardon S. Peckham, Leading Industrialist

Peckham was born in 1822 and died in 1921. He was a leading industrialist in the town of Coventry, owning and operating a mill in Spring Lake and one in Coventry Centre. He began the mill at Spring Lake in 1871 and retired in 1895. He was also responsible for building the Christ Episcopalian Church in Coventry Centre. His wife, Hannah Gorton, was a direct descendant of Samuel Gorton. (Courtesy of PVPHS.)

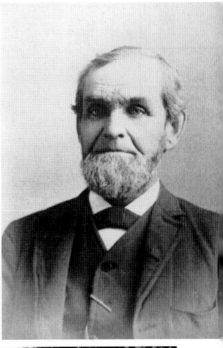

Charlotte Spencer

Spencer (seated second from right) was awarded the Boston Post Cane by Germain Saute, Coventry Town Council president, in August 1968 when she was 94 years old. She had resided in Coventry for 60 years and was the mother of 11 children. She had 22 grandchildren, 57 great-grandchildren, and 4 great-great-grandchildren when she received the Boston Post Cane. (Courtesy of Marie McShane.)

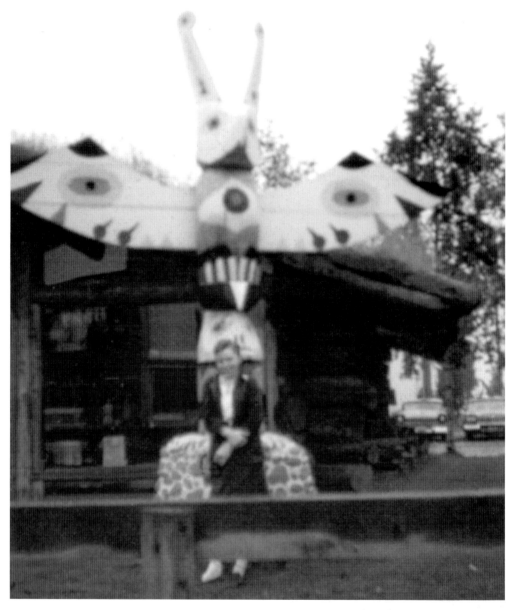

Linnea LaPointe, Goodwill Ambassador (ABOVE AND OPPOSITE PAGE)
LaPointe was a Coventry resident in 1958 when, at the age of 13, she was going on vacation and ended up having the honor of being an ambassador from the littlest state welcoming the biggest state into the union. LaPointe recalled that she had saved enough money to visit her aunt and uncle in Alaska when the press found out about her trip and the politicians decided to make a big deal out of it. Rhode Island governor Dennis Roberts sent a letter and three bags of goods representing the products of Rhode Island with her to Alaska governor Mike Stepovich, welcoming Alaska to statehood. Flying all by herself, LaPointe was met by the acting governor, as Governor Stepovich was in the District of Columbia signing the law making Alaska a state. LaPointe also recalled the beauty of the state and the hospitality of the people. After she returned, she was invited to talk about her trip to the Catherine Littlefield Greene Chapter of the Daughters of the American Revolution. (All, courtesy of Linnea LaPointe.)

Mary Colvin Thompson
At the age of 99, Thompson represents a living link to Coventry's past. She was born at home on Decoration Day in 1914 and recalls going to the Maple Valley one-room schoolhouse and passing only a couple of houses along the way. Thompson worked as a weaver at the Stillwater Worsted Mill. She is still actively attending the Coventry Senior Center a couple of times a week.

Jeffrey Hakanson, Hero of Conservation
Hakanson was named the Hero of Conservation for the month of March 2009 by *Field and Stream* magazine. He received this distinguished honor for his work on restoring the spillway on Lake Tiogue and was presented a proclamation by the Coventry Town Council. He is a past president of the Tiogue Lake Association and is a letter carrier. He lives by the motto, Preserve, Protect, and Improve.

CHAPTER TEN

Faith of the Immigrants

The individuals mentioned in this chapter helped to foster the spiritual growth of the town of Coventry. When the population of western Warwick separated to form a new town, the majority were of the Baptist faith, followed by the Quaker faith, whereas today there are not only Baptists but also Methodists, Catholics, and Jehovah's Witnesses. Families such as the Greenes, Anthonys, and Pecks were strong Quakers, while the Gortons, Bennetts, and others were Baptists. Religion was an important part of the lives of the early settlers because of the precariousness of life and death at that time. Mortality was high because of disease and accidents related to the establishment of the town. As the town grew and developed with the Industrial Revolution, the demand for labor meant more immigration. These new waves of immigrants brought new religions with them. These new churches not only provided the new immigrants a place to worship but also a place to learn to interact with different cultures and a safety net in the new, uncertain land. Early on, the immigrants shared church space with the existing religions, but as the communities and the congregations grew, the need for separate churches and religious leaders representative of their congregations' cultures arose.

A few notable religious leaders were Fr. John Marianski from Poland, who served as the leader for the new Polish church; Rev. Timothy Greene, the first pastor of Maple Root Baptist Church; Perez Peck, who served as an elder in the Quaker Church; and today Fr. Paul Grennon, who preaches at SS John & Paul Catholic Church, and Richard Seelenbrandt and Robert Johnson, who serve as elders for the Jehovah Witnesses. Continuing on in the tradition of Samuel Gorton, who settled Warwick on the basis of religious freedom, residents of Coventry are still enjoying that freedom today.

Timothy Greene, Pastor

On May 17, 1744, Baptists living in Coventry asked permission of the Baptist church in Warwick to form their own church. Maple Root Baptist Church was organized October 14, 1762, when 26 members gathered together and chose Timothy Greene to be their pastor. Greene was ordained as minster of the new church on September 1, 1763. Under his pastorate, the church flourished, and he performed three marriages during this time. Greene served the congregation until he moved to the Midwest in the 1770s. Greene, who came from West Greenwich, was married to Silence Burlingame by Elder James Colvin, and they became the parents of eight children. Many of the founding families of Coventry—including the Rice, Colvin, Greene, Harrington, Whaley, and Gorton families—attended this church, as their descendants do today.

John Marianski, Priest

Rev. Matthew Harkins, the head of the Catholic Diocese of Providence, was approached by the growing Polish community about establishing their own place of worship. Like many other immigrant groups in the region, the Polish people were attracted to Coventry because of the availability of work. Construction began in 1906, and when the new house of worship was completed and dedicated, the Polish community chose the name Our Lady of Czenstochowa Church in honor of a famous church in Poland. The story of one of the church's earliest priests, John Marianski, goes that his name was really John M. Nowicki and that he was on the Russian Czar's blacklist and could not return to his native Poland. So, when the opportunity arose to come to Rhode Island and serve as a priest, he came to Our Lady of Czenstochowa. The current priest is Fr. Stephen Amaral, and the church is still a vital part of the Coventry Polish community, sponsoring festivals throughout the year.

Rev. Daniel L. Bennett and Nathan O. Bennett (ABOVE AND OPPOSITE PAGE)
Daniel L. Bennett, above right and opposite page, was born in Apponaug to Daniel E. and Mary (Bennett) Bennett on March 22, 1847. His brother, Nathan O. Bennett, above left, was born on July 4, 1844. Their father fell under the spell of the gold fever in 1849 and left for California when Daniel was only two years old. The story goes that Bennett's father died along the way, leaving his mother a widow with six young children. Bennett received a basic education but never completed school. As he grew up, he worked for various manufacturing companies until he heard the call from God in 1877. In the course of his ministry, he served 50 years in Coventry and attended to countless baptisms, 483 marriages, and 952 funerals. Besides being a church elder, he owned and operated a farm with his wife, Sarah, and their children Charles and Carrie, and with his second wife Sarah. Rev. Bennett died February 11, 1928, in Coventry. Florence Capwell sang three hymns at his funeral that were chosen by Rev. Bennett himself. Nathan Bennett became a general contractor, constructing buildings throughout the state until the age of 85.

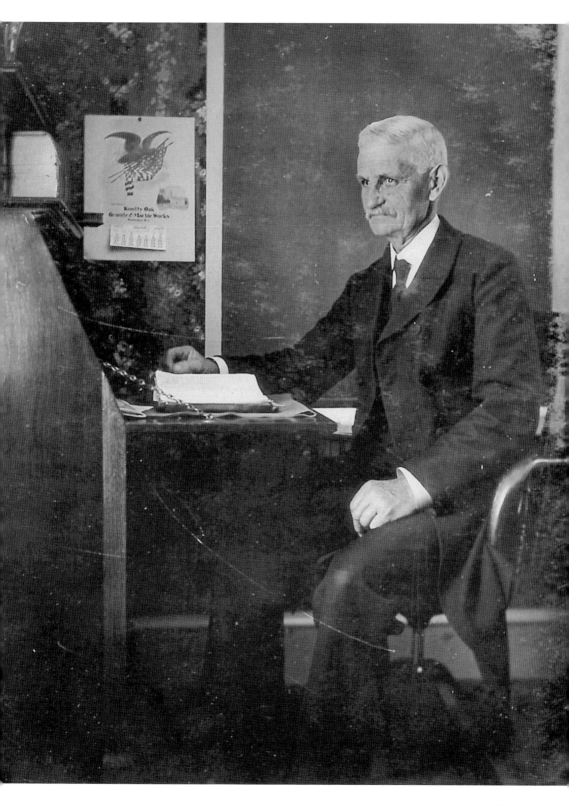

Fr. Paul Grennon, Priest

Grennon, who was raised in Pawtucket and educated in New York, has served at SS. John & Paul parish since 2003. This parish was established in 1955 and was consecrated in September 1957. The church is located along Tiogue Ave and South Main Street and has one of the largest congregations in the Providence Diocese. It has about 5,000 families. (Above, courtesy of Marie McShane; right, courtesy of Father Grennon.)

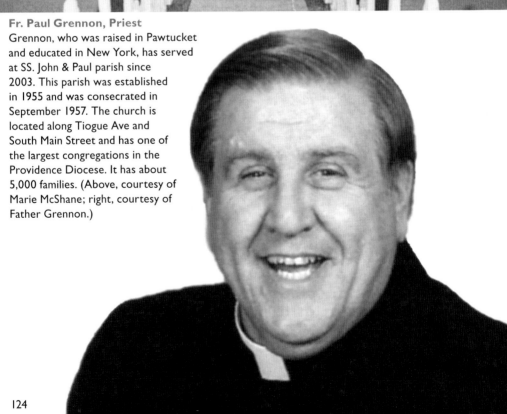

Perez Peck, Quaker

Peck served as an elder and was a member of the Quaker faith. Peck, who was an abolitionist, also owned a machine shop that produced machines for new cotton mills. As an abolitionist, he was a supporter of the practice of only using cotton that had been picked by free men. After Peck's death, Searles Capwell acquired the property and machine shop and converted it into his blinds-and-sash works that was later bought by Hector Poulin. The remains of this shop are still there today. Peck was an active member at the Quaker meetinghouse until he died in 1876. As with many religions, the congregation decreased, and the building was sold. In 1926, this building was converted to the Polish National Alliance Club.

Richard Seelenbrandt, Elder

Seelenbrandt (left) and Robert Johnson (right) are both elders in the Coventry Jehovah's Witness hall. Seelenbrandt is a carpenter by trade, and when there is a disaster, he and other volunteers travel to the area to assist in the rebuilding. Seelenbrandt has been to Costa Rica, Florida, Mississippi, and recently, New Jersey, cleaning up and rebuilding after earthquakes or hurricanes. Each Elder shepherds or looks after the well-being of about 20 families. Seelenbrandt believes in home visitations as a way of staying connected with the families and the community.

Pawtuxet Valley Preservation and Historical Society Cemetery Group
From left to right, Maureen Buffi, Bob Chorney, Julie Nathanson, and Joan Hamlin are members of the Pawtuxet Valley Preservation and Historical Society Cemetery Group. This group began as the Friends of the Coventry Cemeteries in 2005 to help preserve historical cemeteries in the town of Coventry. They mey at various locations in Coventry until the group, which is made up of volunteers, grew and needed to find a bigger place to meet. The Pawtuxet Valley Preservation and Historical Society offered them space on the condition that the group would take on the task of preserving the cemeteries of West Warwick as well. With this merger, the group adopted its current name. They meet once a month to discuss which cemeteries need to be cleaned up, photographed, or, in the case of lost cemeteries, found. Cemetery cleanups are then planned for weekends. Volunteers bring their own tools and provide the labor. The town provides dumpsters. This group resurrects, repairs, and documents gravestones during its cleanup projects. In this image, they are preparing to level the base so they can resurrect a fallen gravestone. Often, property owners or neighbors participate in the cleanups as well. The group has located cemeteries that were reported as lost, as well as a few gravestones that had not been seen for over a century.

INDEX

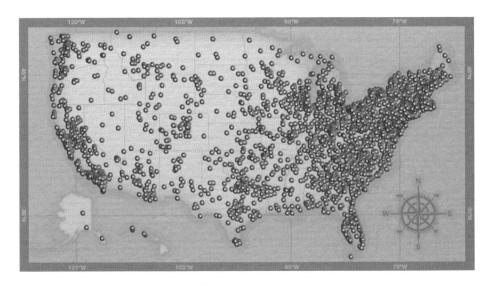

INFINITY REBORN

ALSO BY S. HARRISON

Infinity Lost
Infinity Rises

INFINITY REBORN

BOOK THREE OF THE INFINITY TRILOGY

S. HARRISON

SKYSCAPE

SKYSCAPE

This is a work of fiction. Names, characters, organizations, places, events, and incidents are either products of the author's imagination or are used fictitiously.

Text copyright © 2016 by S. Harrison

All rights reserved.

Published by Skyscape, New York

www.apub.com

Amazon, the Amazon logo, and Skyscape are trademarks of Amazon.com, Inc., or its affiliates.

ISBN-13: 9781503933460
ISBN-10: 1503933466

Cover design by M. S. Corley

Printed in the United States of America

BREAKING NEWS UPDATE
THE SEARCH FOR THE BLACKSTONE
FIFTEEN CONTINUES

International authorities are continuing their efforts to locate thirteen students and two teachers after they failed to return from a high school field trip. The fifteen individuals departed this morning from Bethlem Academy, a prestigious learning institution near London, England, and sources at the school have informed us that they were scheduled to visit a research-and-development facility allegedly owned by Blackstone Technologies. Those same sources have also told us that two of the missing students include Margaux Pilfrey, the seventeen-year-old daughter of Charles and Olivia Pilfrey, heirs to the Pilfrey's department store empire, and Brody Sharp, son of Hannah Sharp, senator of California. All efforts to contact the missing have failed, but the school's jet was tracked to a privately owned airstrip near the border of the eastern European country of Luvania.

Rare pictures of the supposed facility can be found on the net, but the identity of the person who took those photographs and the location where they were taken remain unknown. The fact that the jet was found near the border of the notoriously private nation of Luvania does suggest that the facility may indeed be located somewhere in its untamed wilderness.

High-ranking Luvanian officials are denying any knowledge that such a place exists within their borders, and every government surveillance agency we've approached has refused an interview at this time. The apparent ineffectiveness shown by international governments in resolving this

matter quickly has resulted in many of the world's most powerful parents threatening to violate international law by illegally sending retrieval teams into Luvania to mount private searches for their children. In an attempt to quell the escalating tension, the chairman of the United Alliance, Nicolas Tenzin, is advising caution:

"We must all tread carefully to discover the whereabouts and ensure the safety of the children without making this disagreeable situation even worse than it already is. I'm sure there is a reasonable explanation for what has happened, but even if there isn't, first and foremost we must keep calm. Panic and unsubstantiated rumors help no one."

Chairman Tenzin may be quietly optimistic, but that certainly hasn't stopped the rumor mill from churning. There have already been whispers of a mass kidnapping, and if that turns out to be the case, the kidnappers may very well ask for the world, because the parents of the thirteen missing students certainly have a very sizeable chunk of it to offer. Richard Blackstone, CEO of Blackstone Technologies, is currently unavailable for comment, but we will be sure to keep you informed of any further developments concerning the whereabouts of the Blackstone Fifteen, as they come to hand . . .

CHAPTER ONE

Absolute terror.

So powerful I can taste it.

Jonah steps from the doorway toward the bed, and the small dark box of a room seems to close in around me. I try to move my arms, but my wrists are strapped to the metal frame and jolt against their restraints. He takes another step, and I screech at his lumbering silhouette.

"GET AWAY FROM ME!"

Ignoring my plea, Jonah slowly reaches a hand toward me. I stare wide-eyed at his outstretched fingers and recoil in horror. Jonah's hand inches closer still, and I tug helplessly at my bonds as a familiar and sickening feeling of dread surges through me. Suddenly the room bursts into stark white light as a horrific memory spews forth from the depths of my mind. I'm fifteen years old again, strapped to a chair in sublevel nine. There are machines against the walls and surgical tools scattered on the white-tiled floor, and Jonah's hand is grasping a large metal ring with wires twisting from it. My whole body is paralyzed. Tears are running down my face from eyes that I'm unable to close. Carlo is lying on a table behind Jonah, his hair matted with blood. Nanny Theresa's

body is lying on the floor, her tongue a limp pink slug between her pale dead lips.

"Just like it never happened, Finn," Jonah says as he puts the metal band on my head. "I'll fix your memories. Wipe this whole day clean away. I promise." His voice drips like warm syrup, and his consoling smile sends shivers through every atom of my entire useless body. I unleash a desperate scream, and suddenly the room is small and dark again.

Jonah steps forward once more, reaching out to me with an open pleading palm. This is a man who I looked up to, who I thought of as more of a father than my real father could ever be. Jonah was a loving, caring man who raised me with a gentle hand. But now, all that has been brutally erased, only to be replaced by the searing visions of the atrocities he repeatedly forced upon me. I struggle, but my wrists are bound, jolting and straining at my sides, the brief flash of that horrific memory from two years ago serving as a cruel reminder of who this man *really* is. Jonah used to be my hero, but now my broken heart longs for the Jonah I once knew, not this monster towering over me in the dark.

"Calm down," he says as he gingerly approaches. "You're safe now."

"WHERE AM I? WHAT HAVE YOU DONE TO ME?" I rage at him.

He's getting closer. I try to kick out at him, but my ankles are strapped to the bed frame, too. As my eyes adjust to the light from the doorway, I can see his shadowed face. His forehead is lined with worry, his eyes glistening with concern. His hand is getting closer. The thought of him touching me makes my stomach clench with disgust. My fear rises and curls inside me like a cresting wave, and as his fingers brush my arm, the wave smashes against my stone heart and explodes into burning red shards of scorching hatred.

Fire spears through my limbs, and hot blood rushes up my neck into my face. Adrenaline floods my body, turbocharging my awareness and electrifying my senses, causing time to slow to a crawl. Jonah's futile

cooing reassurance becomes a lagging, vibrating mumble of stretched syllables. In my imagination I can already see my fingers wrapped around his neck, choking the breath from him, but far deeper still, in the part of my mind that lets my lungs fill on their own and makes my heart beat without thinking, I can feel the cells of the bones in my arms hardening as the muscles wrapped around them expand and tighten.

Roaring with anger, I curl my fingers and power surges through my arm as I thrust it forward. There's a metallic ping as my wrist breaks from the restraint and life snaps back to full speed as my hand streaks through the air and grabs Jonah by the throat.

With wild shock flashing through his eyes, he grasps my wrist with both of his big hands and wrenches my hand away. He stumbles and staggers back toward the open door. Like a demon unleashed from hell, I throw my head back and scream at the ceiling as I forcefully pull my left arm across my body. With a loud snapping sound the other restraint breaks away from my wrist. My fingers scrabble at the straps around my ankles. I quickly free one foot and then the other. Jonah grabs the door frame and steadies himself.

I glare right at him and see his big brown eyes. They're the same, but I can never look at them in the same way again. When I was little they used to be so kind, peering over the top of a book as he sat on the rickety green chair beside my bed, reading me a story as the fire flickered in the hearth on a snowy winter night. He always wore the same style, a black suit, white collared shirt, and sky-blue tie, and I remember how he would drape his suit jacket over me when I was cold or sad or when I just needed to feel special. To feel loved. And I did feel special. I was loved. At least . . . I thought I was.

But it was all a lie. He strapped a machine to my head and stole my days from me over and over and over again, but much worse than that, now even the happy memories I had of him have been torn apart, ground into the dirt, and smeared with filthy deception. My childhood and trust have been completely destroyed by a man that I cherished, a

man who I thought I knew better than anyone else in the world. Now that man has become a complete stranger.

A liar.

A thief.

A two-faced betrayer.

Tears of anger and loss stream from my eyes as I coil my body like a spring and pounce across the room like a hunting jaguar. The flimsy paper gown I've been dressed in flurries around me as I slam shoulder first into Jonah. We both burst through the open door into the next room. Jonah falls heavily onto his back, and spittle flecks my face as the wind thumps from his lungs. I pin his arms to the floor with my knees, and my hands blur as they spear toward his neck, gripping his throat with a vise-tight death lock. My limbs feel powerful and beyond my control, like my bones and joints have been replaced with iron rods and hydraulic pistons. Primal rage sears through me, and I wail through gritted teeth as I tighten my stranglehold even more. Jonah's eyes bulge in their sockets, and veins swell on his temples as his face begins turning a deep shade of blood-flushed red.

Die. You. Bastard.

I don't know how he does it, but he manages to lever his arms out from underneath my knees, then quickly raises his hands and grabs my forearms tightly.

"Stop," he hisses breathlessly. "Stop!"

I struggle against his hold and wrench my arms free. I roll off him and glance from side to side, taking in my surroundings as Jonah spasms with coughs and retches. I'm in a medium-size room with a gray concrete floor. The low ceiling is covered with rows of bright lamps positioned over long tables of potted flowers and seedlings.

Jonah slowly hauls himself to his feet, grabbing the edge of a nearby table for support. Strings of saliva drip from the foam at the corners of his lips. He wipes his mouth on the back of his sleeve. He doesn't look concerned or worried anymore. Now his expression is stern and serious,

just like it used to be during our training sessions in sublevel one. I saw that look for the first time on the front steps of the house when I was thirteen years old. I've seen it many times since, and I know it well. It's his military face. His "do what I say or else" veneer.

"Infinity One!" he booms. "Stand down. That's an order."

I snatch a gardening trowel from a table beside me and thrust it threateningly in his direction. "Let me out of here!" I screech.

"Infinity One, stand down, right now!" he bellows.

"Stop calling me that!" I scream. "That's not who I am!"

I can't stop the tears streaming down my cheeks. My hand gripping the handle of the trowel is shaking uncontrollably.

Jonah leans forward and stares at me. He frowns and looks me right in the eyes, studying my face. All of a sudden his expression changes again. His eyes soften, and his shoulders slump. He looks sadder than I've seen anyone ever look before.

"Oh, Finn," he whispers. "It *is* you. The neural scans told us you were back in control, but when you attacked me I thought—"

"SHUT UP!" I shout. "I remember what you did to me the day that Carlo died! I know that you've been messing with my head since I was a little kid! You screwed up my mind and made me a killer! You're a monster, and you made *me* into one, too!"

Jonah's face drops. He looks like he's been kicked in the stomach. "I . . . I can explain, sweetheart."

I jab my makeshift weapon toward him and growl from the depths of my soul. "You don't get to call me that. Ever again!"

I hear the sound of footsteps hurrying this way, and there's a blur of movement as someone dashes into the room behind Jonah. Suddenly I see big brown doe eyes, a freckled button nose, and that oh-so-familiar heart-shaped face appear from behind Jonah's bulky frame. I'm so glad to see her that all my anger instantly melts away, but it's replaced with unexpected surprise.

With her flawlessly pressed white school blouse and tartan skirt, her thick black-rimmed glasses, and a computer slate permanently attached to her hand, she used to make me think she was some kind of robot nerd, designed to study and programmed to do homework. In the three years that we've shared a dorm room, she has always been up and dressed in the morning long before I am, and she hardly ever seems to sleep, so I'm taken aback when it suddenly dawns on me that I've never seen her wearing anything other than her ever-present uniform. But now her glasses are gone, and she's standing there barefoot, in boxer shorts, wearing a t-shirt that's three sizes too big. She looks like she's just leapt out of a shower, her usual frizzy hair slicked wet and dripping on her shoulders. She's the same person, and yet somehow everything about her is so strikingly different. It sounds crazy, but she suddenly seems more human to me, more real. It almost feels like I'm seeing my best friend for who she really is for the very first time . . . and she's so beautiful.

"Bit?" I whimper.

I drop the garden trowel, and it clatters on the floor. Bit quickly pushes past Jonah and runs straight at me, nearly knocking me over as she collides with me and squeezes me in a tight embrace. I wrap my arms around her and sob. I usually hate being touched, but right now, a hug is *exactly* what I need, and I grip my friend even tighter.

"You're awake." Bit sighs, her voice laden with relief. "I was so afraid for you. We almost lost you so many times. I thought you were going to die." Bit pulls away and looks into my eyes, and then she smiles with a huge beaming grin. "Welcome back, Finn."

"Where are we?" I ask shakily, scanning the room.

"We're underneath Blackstone Technologies," she replies. "You were hurt; we brought you down here, and Dr. Pierce tended to you. Do you remember?"

"I . . . I don't know. Everything is hazy. Dr. Pierce . . . does he have a beard . . . and glasses?"

"Yes, that's him," Bit replies. "He told me he used to be the gardener at your house or something like that. I mean, that's what he said, but from what I've seen, he seems a little overqualified."

"Graham. His name is Graham," I murmur.

"Yes. What else do you remember?"

"It's . . . it's all fuzzy and patchy," I mumble. "I vaguely know what happened. I mean . . . I remember snippets of it, but, it's all . . . murky."

Bit smiles and nods. "Dr. Pierce said something like that might happen. It'll come back to you. I'm sure of it."

I look over at Jonah. "What is he even doing at Blackstone Technologies?" I say, snuffling as I wipe the tears from my eyes.

Bit glances over her shoulder at Jonah as he undoes his tie and pulls it away from his neck.

"I was already here, Finn," he croaks. "I was training a new team of young people who—"

"A new team of *killers*?" I seethe at him. "More brainwashed assassins to do your dirty work?"

Jonah actually looks hurt. "No . . . no, I swear. They're a specialized rescue unit that I've—"

"Shut up," I growl. "Everything that comes out of your mouth is a lie." Jonah takes a deep breath and lets out a long, dispirited sigh.

Bit looks awkwardly flustered. "What's going on, Finn?" she asks as she looks back and forth between me and Jonah. "Is everything OK?"

Now is not the right time to explain my sordid history with that traitor, so I decide to lie instead. "Yeah, everything is fine."

"Are you sure?" asks Bit.

I take a deep, cleansing breath, and I can feel my heartbeat normalizing. Part of me still wants to rip Jonah's head from his body, and my skull feels like it's stuffed full of cotton wool, but besides that I'm genuinely surprised that I actually feel . . . kinda great. "Yeah, I'm good," I reply with an amused smile. "How long was I out?"

"Almost four hours," Bit stammers.

"Why was I shut in that room, and tied to that bed?" I ask, looking over at the still-open door.

"About an hour ago you started screaming and thrashing around. It was pretty disturbing. We had to strap you down so you wouldn't hurt yourself. Jonah, I mean, Mr. Brogan and I took turns watching you, but you were scaring the others so Dr. Pierce suggested that we move you in here."

"The others?" I whisper. "Is everyone OK?"

"Yeah, a few of us made it down here," she murmurs, her eyes glazing over with a film of tears. It's not the vague answer I was looking for, but for some reason she forces a smile and leaves it at that. The subject is obviously too painful for her to talk about right now, but whether my memories clear or I see for myself, I'm gonna find out soon anyway, so I decide not to push it.

"Well, I'm glad you're safe," I say, changing the subject for her sake.

Bit grins at me. "Oh, I'm so happy that you're back, Finn. Brody has totally been following me around and bringing me cups of cocoa for no reason. Oh, and he also fabricated these clothes for me. Look, this t-shirt has Einstein printed on it. Because I'm smart, he said. He's so weird." Bit rolls her eyes as if she's annoyed, but I see a hint of a smile flicker on the edge of her lip.

Brody and Bettina? She's right; that *is* weird. Bit is way too good for that dim-witted jock. Never in a million years would I ever have imagined that he would be the one to make her smile like that, but it seems like Brody has been a welcome distraction for her, so I can't help smiling as well.

Bit's gaze drops to my left hand. She grabs it and squeezes the palm, then my fingers. She turns my hand over, rubs the back of it with her thumb, and with a look of complete fascination whispers, "Incredible."

I frown, confused by her strange behavior at first, but then, out of nowhere, images begin to pulse behind my eyes. It's almost like blurry watercolor snippets of Infinity's memories are fluttering out of the dark

into a dim spotlight in my mind. The courtyard and the crumbling buildings, the flames, red eyes glowing in dark smoke, trying to run, falling, the hellish piercing screech of a rail gun, the splintering wood and the crash of a fallen tree . . . then blood dripping from a ragged stump at the end of her arm. *My arm.*

I gasp and stare down at it. "My hand—" I murmur.

"You remember," Bit says, looking into my eyes with amazement.

I hold my hand up in front of my face and glare at it. I clutch it into a fist, then open it again, trying my best to comprehend the impossibility of it.

"That really happened?" I ask.

Bit nods emphatically. "When we brought you down here, you were in a bad way, Finn. I honestly don't know how you survived. Both your legs and five of your ribs were broken, your ankle was twisted backward, and your left hand . . . it was . . . it was *gone.* But within an hour you were completely healed, and your hand—" Bit stares in wide-eyed wonder as I wiggle my fingers, and she chuckles like a little kid. "You *grew* another one."

I shake my head in disbelief. "What . . . what am I?" I whisper.

"I was hoping you'd be able to tell *me*," says Bit. "I tried to get some answers out of Dr. Pierce and Mr. Brogan, but they said they wouldn't discuss it until you were awake."

"I'll tell you what you are!" shouts a voice from across the room. I look over Bit's shoulder to see Brent Fairchild's scowling face. "You're a freak!"

Two of my classmates, Margaux and Brody, step around the corner behind him. Brody smiles and nods at me, but Margaux is looking me up and down with a mixed expression of wariness and suspicion.

Jonah turns toward them. "Maybe you three should leave us alone. I think Finn needs a little time to process this."

"I think all of you should leave," I say, glaring at Jonah.

"I think someone wants to be alone with her girlfriend," Brent says snidely.

"You better watch your mouth, Brent," I seethe.

"Or what?"

"Or you'll be watching my fist pummel all the pretty teeth from that mouth."

Brent looks at Jonah and jabs his finger at me. "Did you hear that? She threatened me. She's dangerous. She's the reason all of us are trapped down here like rats. She is the reason everyone up there is dead."

A shiver runs through me as Brent's words stab me like a knife, and for a reason I can't explain, I feel a growing nausea churning in my gut.

"Go back in the other room please," says Jonah.

"All of you get out of here!" I bark at them. "Especially you!" I grunt at Jonah. "It makes me sick to my stomach just looking at you."

"But, Finn . . . ," coos Jonah.

"GET OUT!"

Everyone flinches at my booming outburst, even Bit, and for the briefest instant I see a glimmer of fear flash through her eyes. I look around at the faces in the room and I see anger, pity, mistrust, and unease in every direction. Suddenly I'm hit with a terrible realization.

Maybe Brent was right.

I just brutally attacked Jonah. Yes, he's done terrible, unspeakable things to me, but I honestly believe that if I had remembered them before today, all I would've done is broken down and cried. After that there would've been screaming and swearing for hours on end, I'm sure, but Jonah raised me, and I'm not a violent person. I can't imagine that I ever would've physically assaulted him.

But now, I'm different. And I can *feel* it. The instant I saw him . . . I wanted to kill him. And that's exactly what I tried to do. I don't know whether the enormity of everything that's happened is pushing me toward the edge or whether I just need time to get it all straight in my

head, but right now I feel like a coiled spring is wound around my guts and my temper is a quivering trip wire that could snap at any second.

What is *wrong* with me?

I take a deep breath and try to calm down. "I'm sorry," I murmur. "It's all just so . . . confusing."

Bit smiles and takes my hand. "Are you hungry?" she asks.

I nod sheepishly.

"You can have a hot shower; I'll bring you something else to wear, and the food printer down here makes a half-decent roast beef sandwich."

"That's a very good idea. But I'd like to check her over first," says another voice. I look toward the thin, white-bearded old man in the lab coat who has walked into the room behind Margaux, Brent, and Brody. He sidles around them and, with a black leather medical bag clutched in one hand, walks over to me and Bit. "Chairs. Bring us some chairs," he orders.

Brody immediately snaps into action and wheels a worn office-style chair toward Dr. Pierce, as Bit jogs into the room that I woke up in and quickly returns with a wooden stool for me.

Dr. Pierce and I both take a seat. "Leave us," he grunts.

Brody gives me a coy smile as he disappears around the corner, and Brent and Margaux are still eyeing me with disdain as they slowly turn to follow him.

"I'd like to stay, if that's OK with you, Finn?" says Jonah.

Dr. Pierce raises his eyebrows at me, and I shake my head.

"Sorry, Major, out you go," says Dr. Pierce.

Jonah's sad eyes look toward the floor, and he nods, defeated. "We can talk later, Finn," he says before slowly turning away and walking out of sight around the corner.

Bit smiles reassuringly and turns to leave, but I grab her wrist.

"No, please. I'd like you to stay."

Bit gives me a gentle smile. She upturns a nearby plastic crate and sits down beside me.

The man I knew from my childhood at Blackstone Manor as Graham the groundskeeper puts the black bag at his feet, opens it up, and rifles through it. "I told you to fetch me as soon as she woke up, girly," he says to Bit as he retrieves a penlight and a stethoscope from the bag.

"I only left her for five minutes," she protests.

"Hmmm," grumbles Dr. Pierce as he glares at her through the wire-frame spectacles perched on the end of his scarlet-pointed nose. "It's just as well sound carries through this concrete cave like a megaphone," he says as he clicks the light on and shines it in my eyes.

"How are you feeling?" he asks.

"Like the world is against me," I reply, squinting in the light.

"No pain anywhere? Full movement restored?" he asks, ignoring my snide remark.

"I'm fine," I reply dryly as he clicks the penlight off.

He hooks the stethoscope into his ears and presses the other end to the gown over my chest. "What do you remember?" he asks.

I take a second to think. Rapid flashes of memory scroll through my mind, but it's like I'm seeing them through frosted glass. "I know what happened," I reply. "I saw it all, but . . . it comes and goes."

"I suspected that might be a possible scenario," he says. "You and Infinity have two very different sets of brain wave patterns. While you were unconscious your brain was constantly alternating between the two. I'm afraid the overlap might make remembering specific details a little difficult for a while."

"When will it clear?" I ask.

Dr. Pierce shakes his head. "I'm not sure, my dear. Your situation is unique; my predictions of the behavior of your complex neural landscape are still largely based on theory and conjecture. Until thirty

minutes ago, I wasn't even sure which personality would be dominant when you woke up."

"Well here I am," I murmur.

"Yes, and I'm glad that you are, but I have to be honest, Finn. I was very much hoping to be talking to Infinity right now."

"Dr. Pierce!" Bit blurts out, clearly offended by his blunt comment.

"Why?" I ask, more than a little offended, too.

"I didn't mean to sound so callous," says Dr. Pierce. "But I don't think I have to remind you that there are three giant war robots waiting for us out there, and Infinity has skills and abilities that would greatly increase our chances of getting out of here alive."

"We don't need Infinity," growls Bit. "We'll survive if we all work together."

"For all our sakes I hope you're right, girly," Dr. Pierce says as he packs the penlight and stethoscope away. "In any case, we'll just have to work with what we've got, so after you've freshened yourself up and had something to eat, come to the main laboratory. I'd like to bring you up to speed concerning our escape plan, among other things."

"Other things?" I ask.

Dr. Pierce stands, and his expression darkens. "Yes, Finn. I think it's time that you learned the truth . . . about everything."

CHAPTER TWO

Dr. Pierce disappears around the corner, leaving Bit and me alone. I take a moment for his words to sink in. When we first arrived at Blackstone Technologies, all I wanted was answers. Dr. Pierce may be willing to tell me the truth, but if the truth is even half as screwed up as I expect it to be, then I'm not sure I'm ready to hear it. Everything that I've discovered so far has been like fuel thrown on a fire that's burning me alive. I'm still trying to accept the fact that I'm a ruthless killer with a split personality who can grow new limbs like a freakin' salamander. Correct me if I'm wrong, but that seems like quite a lot for a girl to wrap her head around in just one day.

"The showers are just down the hall. C'mon, I'll take you." Bit gets to her feet and makes her way across the room. I push off my seat and follow her around the corner to an open door. It's like the kind you might see in a submarine, thick and made of metal, with one of those big wheels in the center instead of a door handle. I step through behind Bit into a narrow, low-ceilinged, beige-painted concrete passageway. Bright fluorescent tube lights suspended from rods jut down from a tangle of pipes and wires that run along the entire length.

I shuffle down the passage, staring absentmindedly at the floor, feeling numb and shell-shocked. I try to concentrate on clearing the fuzz from my memory of the past few hours. It's all in there; I can feel it, but right now it's nothing more than a scattered mishmash of flickering images and grainy fragments of emotion. It's like a blurry moving jigsaw puzzle, and it's incredibly frustrating. Bit obviously feels the annoyance emanating from me because she glances over her shoulder, gives me an encouraging smile, and tries to fill the uncomfortable silence with small talk.

"Dr. Pierce said this place is part of an underground base built during the Eurasian War," she says. "Some of it was modernized and converted for use when the facility was built over it, but some sections, like this one, are pretty much untouched except for some plumbing and electrical that's been routed through it to the buildings above. Apparently Richard Blackstone is some kind of history nut, so a lot of the rooms are exactly like they were during the war, with all the old equipment and stuff still in them."

Bit is trying to sound like her normal self, but she's not very convincing. I can hear the underlying tremor of worry in her voice. I certainly know how she feels, and if giving me a little history lesson helps her deal with this messed-up situation in any way, then I'm certainly not going to stop her. In fact I welcome it.

She disappears through an open door on the right, and I duck through behind her into a small tiled room. There are three shower cubicles lining the adjacent wall, beneath a large extractor fan. There's a stainless-steel sink bolted under a mirror to my left, and pushed up against the opposite wall is a small antique table with a stack of white towels folded on it.

"Dr. Pierce works up in the facility during the week," Bit says as she hands me a towel. "But from the meager amount of info I was able to wheedle out of him, I discovered that he's spent nearly two years bringing equipment down and setting up a secret lab in what used to be the

base's infirmary. Now he pretty much lives here, working on, as he calls it, his personal project."

I step into a shower cubicle and draw the curtain behind me. "What do you think he's doing down here?"

"I don't know," says Bit. "He grows seedlings. That seems pretty innocent. But you only have a secret lab if you don't want anyone to find out what you're up to."

I pull my hospital gown off over my head and sling it and the towel over the curtain rail. I twist the taps; hot water sprays onto the top of my head, and I let out a long, breathy sigh. It feels heavenly.

"I'll get you some clothes. I'll be back in a minute," Bit says from the other side of the curtain. I don't bother answering; I just close my eyes, let the water hit my face, and try to block out the world.

That lasts for all of five minutes before my thoughts resume their relentless nagging.

How the hell did all of this happen? Everything has spun out of control. When I think about how much my life has changed since yesterday, it feels like a ton of bricks has been tied to my ankle and it's dragging me to the bottom of a deep, dark lake. And the worst part is, it's taking everyone around me down, too.

I pick up a bar of soap from the recessed dish in the cubicle wall and scrub it against my body. As the bubbly lather runs down my leg, I look at my feet. Bit said one of them was twisted backward. Now they're both fine. And five broken ribs? I press my fingertips into my side. I should hardly be able to breathe, and yet now they're completely healed—they're not even tender. There isn't a scratch on me, and the strangest thing is I'm not really surprised at all. I feel like I've known I can heal like this for a long time. In fact, I saw it in a memory once; I'm sure of it. I fell off my bike and broke my arm when I was younger, and I fixed the bone back together just by willing it.

At least I think I did. That memory is pretty fuzzy, too. I run the soap over my hair, down my neck, and as I scrub my shoulder, an image flickers behind my eyes.

I was shot.

Right through my shoulder and my stomach, too, and my leg. I remember my blood speckling the ground. I was trying to escape from someone, and after I was shot I healed the bullet wounds. Did that happen? I'm not completely sure.

Trying to hold on to these memories is like drinking from a leaking cup. I only barely get a taste before they drain away, back into the dark pool of my subconscious. I don't even remember who shot me or why they did it, but I think I remember the new kid at school being there, watching from a distance. Ryan . . . that was his name. Maybe he saw what happened? I'll have to ask him about it later.

Frowning, I plunk the soap back in the dish, shut the water off, and pull the towel from the rail. I dry myself, wrap the towel around me, and pull back the shower curtain. Lying on the antique table are my bra and underwear, a black hooded long-sleeve top, a pair of gray jeans, balled-up socks, and a pair of green sneakers with white stripes on the sides. Bit must have left them for me. I get dressed and then walk to the mirror. The steamed-over surface not only tells me that I spent more time in the shower than I thought but in the same instance mocks the haze in my mind with the faded colors of my own blurry reflection. I wipe a clear streak across the mirror with the palm of my hand, and the girl I see looking back at me somehow looks different than I remember.

I can't quite place it, but I can't shake the feeling that something is missing.

I touch my face and study my eyes. Maybe it's the dim light in here, but they seem darker than before. I look at the reflection of my left hand against my cheek, the hand that grew back after being severed from my wrist. I inspect it closely, studying it with a morbid curiosity.

Healing cuts and broken bones is one thing, but full appendage regeneration? That *is* surprising. I always felt that I was different, but that is a *whole* new level. It's like I'm a completely different species. Who am I really? For the past month I've been reliving my life inside my dreams every night. But now I know that some of those memories belonged to someone else, someone who's been hiding in a dark corner of my mind. In the past few hours Infinity has made herself known to me and everything has changed, but that new discovery begs the question that scares me to my very core . . . maybe *I've* been the intruder trapped inside *her* mind all along? Finn or Infinity?

Who is the *real* me?

When I was tied to that bed, I broke those restraints easily, so I'm incredibly strong. I can see in the dark just by thinking about it; I remember being able to do that. My favorite food is a big, juicy cheeseburger; I can heal wounds faster than it's humanly possible, and I know a shortcut through the cafeteria to the science wing when I'm late for class. I'm excellent at mathematics; I can speak Russian, Spanish, German, French, Japanese, Arabic, and two dialects of Chinese fluently; and I've killed sixty-eight people, nine of them with my bare hands. I love the feeling of the wind in my hair when I'm horseback riding around the shores of Blackstone Lake, my favorite childhood toy was a stuffed unicorn, and I've only kissed one boy in my entire life. I know all of these things because they are who I am. I'm the girl who can turn pain into bells with my mind. I giggle out loud and touch my hand to my lips, and all of a sudden I can actually hear the bells ringing, softly chiming in the distance of my consciousness. I smile at the girl in the mirror. Her smile curls into a sneer, and blood trickles from the reflection of her mouth as she whispers three chilling words. *"Let . . . meee . . . out."*

"I thought I'd better put some jeans and shoes on, too . . . ," Bit says as she walks into the room behind me. "When I heard your voice from next door, I jumped out of the shower so fast that I only got half

dress—" Bit's sentence stops dead. I look at her face in the mirror, and she's frozen in her tracks, her eyes wide with startled shock. "Finn!" she screeches.

"Hi, Bit," I murmur dopily, wondering what on earth she's yelling for. She snatches a towel from the antique table and rushes to my side.

"What have you done!" she shrieks.

As usual, I have no idea what she's going on about.

Bit grabs my arm and cradles it in the towel. I look down and see that the sink basin is red with splashes and drips of blood. I look up at the blank sapphire-blue eyes staring back at me, and there's more red around my mouth, trailing lines down the pale skin of my face. I glance at my hand, and it's steadily pulsing blood from a ragged gash torn into the meat around the base of my thumb, the flesh split open all the way to the bone. Bit binds the towel around the wound and pulls me by the wrist toward the door. I stumble along with her as she drags me down the narrow painted corridor.

We haven't gone far when it opens up into a large beige concrete-walled room. There are medical-looking machines gathered around a stainless-steel table with a light on a hinged arm hanging over it. There are trolleys with surgical instruments and a collection of computer slates and monitors on a long bench, and on the far side of the room, I see Dr. Pierce and Jonah. They're in a corner, hunched over a round wooden table, studying some large paper documents under the light of a desk lamp.

"Help!" shouts Bit. "I need some help here!"

The startled men flinch and look over at us as Bit pulls me toward the steel table. Jonah and Dr. Pierce lunge away from the documents and rush in our direction, pushing trolleys and wheeling machines out of their path. "What, what, what!" Dr. Pierce squawks, hooting like a wild white-haired mallard. He and Jonah arrive at the metal table and glare down at the blood-soaked towel.

"What the hell happened, girly?" asks Dr. Pierce as he swings the light over us and flicks it on.

Bit opens the towel and reveals the nasty-looking split in my hand. "I found her standing at the mirror, just staring into space. I think she . . . did this to herself!"

Jonah has a look of worry on his face as he leans on the edge of the table and surveys the tattered gash in my hand. "You did this to yourself, Finn?" he asks.

I feel a spark of hate flare inside me, and my first impulse is to scratch out his eyes, but as I look down at the wound and listen to the bells quietly ringing in my mind, I can't help smiling dreamily. The red of the blood, the pink of the flesh, and the white of the bone are all so pure and pretty. Especially the white, it reminds me of fresh winter snow blanketing the ground in a quiet Ukrainian forest. I smile contentedly and look up at Dr. Pierce. He's not smiling at all. I mimic his frown and mock it with a gruff chortle. "Cheer up, Graham," I gibe. "She's the best hacker in the world, and I'm a highly trained assassin."

"What's happening?" asks Jonah.

"I'm not sure," Dr. Pierce replies. "Concentrate, Finn," he says, staring into my eyes. "Picture the cut sealing closed. You can heal this."

I smirk and snort at his weird request. "That's ridiculous, not to mention impossible," I say with an amused giggle.

"Finn?" Bit says softly, her forehead creased with concern. "What's wrong with you?"

I glare at her. "There's nothing wrong. You're the best hacker in the world," I say, jabbing a finger at her. "And I'm a highly trained assassin!"

Bit looks at me, studying my eyes carefully. "There is something *very* wrong," she says, her voice trembling with worry. "Dr. Pierce?"

He leans across the table and quickly runs the back of his knuckles down my breastbone. "Oh no," he says as his eyes go wide behind the lenses of his wire-frame spectacles. "We've got a problem. Keep pressure on that hand, girly."

Bit nods and does as he says. She folds the towel back over the cut and pushes down hard on the bundle of red and white, as Dr. Pierce scrambles through the pockets of his lab coat. He pulls out a screwdriver, tweezers, a magnetic swipe card, a small lollipop, and loose change, among other things, but thrusts all of it back into his pockets as he quickly turns and begins scanning the trays on all the trolleys. He looks highly perturbed as he wheels the closest one to him and begins pulling open drawers and rifling through them.

On the far side of the room, beside the round wooden table with the lamp on it, is an opening that leads to another passageway, and down that corridor I can see the shapes of people approaching under the light of the fluorescent tubes above their heads. That monorail track must've hit me harder than I thought, because as they enter the room, I know who they are, but their names are foggy. The solidly built boy with the closely shorn hair is called . . . Brody. Yes, that's it. And *Margaux* is the sour-looking blondie girl. The wiry boy, with the floppy sandy-brown fringe, limping behind her is called Brian? No, it's Brent, and I think the pretty Asian girl with the long, silky black hair is . . . yes, I remember; that's Jennifer Cheng. She looks particularly miserable today, but then again, all of them look different than I remember. Why exactly? At first I'm not too sure. Jennifer is in my calculus class at school and . . . then it hits me. At school they all wear uniforms! That's it! They look different because they're all wearing civilian clothes. Ha, silly me, how did I miss that?

"What's going on?" asks Brody as they all cross the room toward us.

"Ugh, blood!" blurts Margaux.

"Where on earth is it!" yells a clearly frustrated and still-searching Dr. Pierce.

"Where is what?" mumbles Brody.

"Is she alright?" asks the pretty Asian girl whose name is escaping me again. She's looking this way, so I think she's probably inquiring about me. I could be wrong though. I'm hungry. Didn't Otto say

something about a roast beef sandwich? That sounds really good. I wonder if there's gravy.

"She's hurt," Bit says as she presses down even harder on my hand.

"Is that . . . blood on her chin?" Brent says, leering in my direction. "Did she . . . did she *bite* herself?" He slowly shakes his head and sneers. "Wow, I told you she was crazy. Look at her eyes, there's no one home in there. She's lost it."

"What did you just say to me?" I growl as I glare at Brent. That sniveling excuse for a civilian can't talk to me like that. I ball the fingers of my right hand into a tight fist and try to pull away from Otto.

Brent's eyes go wide. "I didn't say anything." He whimpers as he backs away behind the blondie girl wearing the pink cardigan.

"Finn! Keep still!" Bit says sternly as she tugs on my arm, and I look down at the blood-soaked towel in confusion as Dr. Pierce darts from trolley to trolley, wrenching open drawers.

"Where the hell is it!" he booms. "I never would have removed it? Would I? No, of course not!" he says nonsensically to himself. "But if I did, I would've put it somewhere safe, somewhere close!"

"The bandages are right there!" screeches Bit.

"I don't care about her ruddy hand, girly!" barks Dr. Pierce.

"Then what are you doing?!" Bit bellows.

Dr. Pierce doesn't seem to hear her as he mumbles to himself. "It was only theoretical. I didn't think it could actually happen, but the symptoms fit, and it certainly explains the unusual readings from her neural scans—"

"Symptoms?" Otto blurts. "You know what's wrong with her?"

Dr. Pierce nods emphatically as he rushes toward the bench with the computer slates on it and begins clattering them aside. "The two sides of her mind are colliding," he shouts. "We need to separate them before they mix completely or . . ."

"Or what?" Bit asks, her face fraught with distress.

"Or she could go into full-blown neuropsychotic degradation," replies Dr. Pierce as he tosses slates left and right. "Like I said, it's only a theory of mine, but if that is what's happening here, then there's a very real chance that her two distinct personalities will begin destructively competing for dominance."

"What does that mean?" asks Otto.

"Confusion, hallucinations, maybe even brain damage," Dr. Pierce says ominously. "If we don't stop this now, she may never be able to differentiate between one mind and the other. She'll be lost in a dark maze inside her own head forever."

"Good!" Brent barks as he peeks out from behind Margaux. "Let it happen. She deserves it!"

I smile at Bit, or was her name Otto? Either way, this is hilarious.

"Shut up, Brent!" yells Bit. "How do we stop it?" she asks as tears begin rolling down her cheeks.

"We need to find her command module," says Dr. Pierce.

Jonah's eyes go wide. He lunges across the table and tugs the collar of my t-shirt to one side. "She's not wearing it?" he blurts.

"No! It's gone," the man in the lab coat with the white beard yells from the other side of the room.

"Command module?" asks the husky kid who I think I heard someone refer to as Brody. "One of those silver wristband things?"

"No! Don't be stupid!" barks Dr. Pierce as he runs to the round wooden table and begins flinging and sliding documents and books onto the floor. "It's a black stone set in a silver circle. It has a chain, and she wears it around—"

"It's a pendant on a necklace," says Jonah, then he slowly folds his arms on his chest and looks me in the eyes, frowning curiously as Dr. Pierce begins rifling through nearby drawers.

"Yes!" he shouts. "Like the Major said, it's a pendant on a necklace! Everyone start looking!"

Brody and Jennifer begin looking around their feet as Bit releases my hand and drops to her knees, scanning the floor near the table. Everyone is scurrying about in a manic flurry, all except for pink-cardigan blondie girl, who is obviously trying to avoid looking at me, and Major Brogan, who is doing exactly the opposite. He's standing perfectly still, staring directly at me, watching me intently with a tilted head and narrowed eyes.

"I think she was wearing it when I dressed her in the gown," says Bit.

"How long ago was that?" Jonah asks.

"I don't know," replies Otto. "A couple of hours ago at least."

"So she hasn't been wearing the pendant at all?" asks Jonah. "For two whole hours?"

"I don't know," says Bit as she rechecks the top of a nearby trolley. "Maybe."

Major Brogan turns back to me and stares again, like he's waiting for something to happen. "What's your name?" he asks me.

I leer at him suspiciously. "It depends who's asking," I say snarkily, and he tilts his head and narrows his eyes at me, like he's wondering what to make of my answer.

"Maybe it came away from her neck in the other room," says Otto as she dashes toward the passageway.

"Wait," says Blondie. "It's . . . it's not in there."

Bit stops in her tracks and looks over at her. "Where is it? Did you see it somewhere?"

Blondie's nose crinkles, and her lip curls. "It was pretty," she says as she loops her finger underneath a thin chain around her neck and pulls a beautiful black-and-silver pendant out from the collar of her white blouse. "And she was in a coma for god's sake. I didn't think she'd miss it."

Otto glares at Blondie like there are bullets machine-gunning from her eyes, and she marches straight toward her, sending medical tools

clattering to the floor as she barges into a trolley, knocking it out of her way. She stops right in front of Margaux and thrusts out her hand. "Give it," Bit growls.

"Fine." Margaux sighs as she rolls her eyes and pulls the chain up over her head. "This is your fault anyway," she says, dangling the pendant in the air above Bit's hand. "You said she was going to die."

"I said I hope she *doesn't* die!" Otto screeches as she snatches the necklace from Margaux and rushes back to the table. "I can't believe you'd steal from a person who's in a coma!"

"That is pretty cold," says Brody.

"Shut up," Margaux snaps at him. "I didn't steal it; I repurposed it. And she's not a person. She's some kind of weird human-looking robot or something."

Bit gives Margaux a murderous look.

I feel weird, light-headed, dazed, and jumbled. Whatever is happening right now is as confusing as hell, and I wish I could just get one thought straight in my mixed-up head.

"Quickly!" shouts Dr. Pierce as he strides toward me. "Put it on her, and pray like hell that we caught it in time!" he bellows.

"Wait," says Major Brogan. "Maybe we should leave the necklace off her for a little longer . . . and see what happens."

"Are you mad?" says Dr. Pierce as he snatches the necklace from Otto. "The two sides of her mind could barely coexist when she was an infant. You know as well as I do that her very sanity has become completely dependent on this device. She needs it."

Jonah studies my face. "According to your theory she should have been brain-dead nearly an hour ago. That hasn't happened, so maybe we've been wrong about it all these years?"

"I'm not wrong. I'm the expert here, Major. The necklace stays," barks Dr. Pierce as he slips it over my head.

Suddenly a wave of nausea ripples through me. I thought I felt out of it before, but now I can hardly tell which way is up. My whole brain

feels like it's sinking into cold mud, and all I can do is sit here and watch everyone in the room stare at me.

"What exactly does it do?" asks Bit.

"The pendant is a neural processor," says Dr. Pierce. "One of its functions is to order her thoughts and separate the two different sides of her mind." Dr. Pierce and Jonah stand by the other side of the table and stare at my face, as Bit presses down on my hand and looks up at me, her brow creased with worry.

"Finn? How do you feel?" she asks as her gaze flicks from one of my eyes to the other.

Finn? That kinda sounds like my name, but it somehow feels incomplete. I smile, and I'm about to tell her that I feel absolutely fine and thanks for asking, but for some reason the words aren't traveling properly from my brain to my lips, and the only thing I can think of to say is, "Who are you?"

The girl's face drops, and her eyes widen. "It's me, Bit."

I focus on her face, and the name she just said slides away from my mind like water off a duck's back, forgotten just like that.

"Who are you?" I ask again.

"Dr. Pierce, what's happening?" the girl says as she looks over at an old man in a lab coat.

"Oh no. We may have been too late," the old man says as he shines a light in my eyes. "Keep talking to her, girly," says the old man. "And pray for a miracle."

The girl looks up at me, and tears begin rolling down her cheeks. I smile at her. Her lips start moving, but the sounds coming out of her mouth don't make any sense.

She looks so familiar. I know her from somewhere—I'm sure of it—but I just can't place exactly where from. Are we related? Are we friends? Maybe she's my sister?

I look at her freckled nose and big brown eyes and try to concentrate on the first time we met. I open my mouth to ask but instead of

speech coming out, a huge gasp of air rushes in, filling my chest as the room suddenly begins moving. It sways and undulates, but the girl's face stays steady and in sharp focus right in front of me.

A big bald guy in a suit and a weird old man with wire-frame glasses perched on his nose are watching me intensely. Behind them I see two teenage boys and two girls looking at me as the walls of the room distort and warp around them. Soon the men and four teenagers start to change, along with the walls. Their faces begin to melt, dripping down their bodies, melding into their clothing like molten wax. The ceiling bows and sags in the middle as all the light and color in the room begins running into liquid stripes and sliding into where the floor used to be, because even that has disappeared completely. It's like someone has dumped turpentine on a painted world and everything is dissolving away, revealing an empty void behind it.

All the color gradually ebbs from view, leaving the purest shade of black that I've ever seen. Six of the seven strangers have gone. The walls have gone. The whole room is gone. All that's left is the girl with the heart-shaped face and freckled button nose, staring up at me with her big brown worried eyes.

The first time we met was . . . let me think . . .

I look down at her and try to concentrate. I think it's coming back to me.

Her dark wet hair begins to turn a lighter tone of mousy brown as it gradually dries and frizzes on her head. Her dark-gray t-shirt with a picture of a wise-looking old man on it suddenly turns stark white. It grows sleeves, and buttons pop into existence down the center as a neatly ironed collar folds out around her neck and a tie rolls down her chest. Thick black lines draw themselves over the bridge of her nose and connect at the corners to form the frame of chunky, nerdy glasses. She turns away from me and props her cheek on her hand. Her worried expression transforms into one of studious contemplation as a small wooden desk fades into view and positions itself perfectly beneath her

elbow. A small potted plant, a bendy-necked lamp, and a glowing computer slate all sprout from the desk in front of her. She flicks a finger through the holograms floating above the slate, and when I look around I suddenly notice that we're in a completely different room.

It's an average size, not very big but not too small, either. The forest-green wallpaper is patterned with gold crests surrounded by leafy vine designs. It looks expensive. The adjacent wall has a door with a frosted window, and I can see silhouettes passing by on the other side of it. I'm sitting on the edge of a messy single bed, and there's another against the opposite wall, but unlike this one it's neatly made. This side of the room has clothes strewn all over the place. The other side is tidy and ordered.

Outside, through the tall windows on the adjacent wall, I can see the light of the afternoon sun shining over tiled roofs and brick chimneys and through stone arches into a grassy courtyard lined with buildings that remind me of old English cathedrals. Small groups of teenage girls in school uniforms are walking through the courtyard, chatting and giggling and sharing pictures on their computer slates. I look down and see that I'm dressed in a white button shirt and plaid skirt, too, just like they are, just like the girl sitting at the desk in this room is. I quickly assess the situation. For some reason command has planted me in a school of some kind and dressed me like a student. I've been activated, but I don't have any mission details. I'm not hearing any instructions in my head, and I don't have any weapons or equipment. Something about this doesn't feel right at all.

"Where am I? What's your name?" I ask the frizzy-haired girl with glasses. She looks up at me with a half frown, half smile.

"What?" she asks.

"Are you my contact?" I ask. "What are my mission details?"

She looks at me, clearly confused, so I rephrase the question. "I'm requesting information regarding my mission objectives. Do I need a code word for you to surrender them? I don't recall being given one."

"Very funny, Finn," she says, smiling as she turns back to her computer slate. "Your *mission objective*, as you call it, is to do your physics assignment and turn it in to Professor Francis before five tomorrow afternoon."

Maybe this is a training exercise? If it is, it's an unusual one. I need more information. "What day is it?" I ask, becoming more and more confused the longer this strange conversation continues.

The girl looks back at me, and her eyes narrow behind her glasses. "It's . . . Thursday."

"What's the date?" I ask. "What month?"

"Are you kidding?" she says, swiveling in her seat toward me. "It was your birthday yesterday and you don't know what today's date is?"

"Was it my seventeenth birthday?" I ask, studying her microexpressions for deception.

"Yeah . . . ," she says, nervously leaning away from me in her chair. "This isn't funny, Finn. Stop joking around."

"Why do you keep calling me that?" I ask as I get off the bed and walk to the desk. I slide the girl's computer slate to me and swipe away the holograms.

"Hey! What are you doing? That's my homework!"

I ignore her as I open a connection to the Hypernet. A search engine holograph pops up over the slate, and I speak into it. "Access command, BCT Division, authority nine fourteen."

A holoscreen opens over the surface of the computer. Lines of encryption flicker all over it, then clear away to reveal a black diamond shape revolving inside a silver circle. "Bio scan verified; log-in voice pattern recognized. Access granted," says a calm male computerized voice. "Welcome, Infinity One."

"Hello, Onix," I reply. "What's my current mission status?"

"There are no missions currently underway," says Onix.

"Then why have I been activated?" I ask.

"There is no record of your activation. You have not been activated."

"I'm speaking to you right now, Onix, so, obviously I have."

"You have not been activated," he replies annoyingly.

I feel angry frustration beginning to boil in my gut. No mission parameters, no weapons, no instructions, and no record of my activation. None of this makes any sense. I take a breath and decide to retrace my steps. "Onix, what was my last mission?"

"Your most recent mission was the assassination of Mr. Bernard Munce, former board member of Blackstone Technologies. The mission was successfully completed, resulting in his termination, last night on the rooftop of his private residence in Paris, France, at ten thirty-three p.m. local time. Well done, Infinity One."

"Who's Bernard Munce?" whispers the frizzy-haired girl. "Is that why you were away from school yesterday? Wait a second," she says, sitting to attention and glaring at the slate. "Is that real? That can't be real."

"Thanks, Onix. Log out." At my command the holoscreen vanishes and the slate goes blank.

I look at the girl and suddenly feel pity for her. "You're not my contact, are you?" I ask even though I already know the answer.

She shakes her head, clearly confused. "Was that . . . what I think it was?" she asks, her wide eyes flicking from me to the slate and back again. Her mouth drops open. "That was an encrypted site. A Blackstone encrypted site!"

I was so caught up in getting to the bottom of all of this that I didn't stop to think about what this girl was witnessing, and to make it worse she seems to have a vague idea of what she just saw. I've never killed a civilian who didn't deserve it, but it looks like I don't have any choice but to silence her. I look around the room. There's a bathrobe slung over the back of a chair. I can use the belt around the waist to hang her by her neck from the antique coat hook bolted to the wall; it certainly looks robust enough to take her weight. And sadly for her, the way kids are relentlessly bullied these days will make it look like just another tragic teen suicide.

I stand and apologize as I walk to the chair with the bathrobe on it and pull the toweling belt free from the robe's loops. "I'm sorry. But you shouldn't have seen any of that. I'll try to make this as quick and painless as possible."

She doesn't seem to hear me at all. "That was an encrypted Blackstone site," she gasps again, still staring at the slate. "You didn't tell me you could access the Blackstone mainframe, Finn!"

I can't help feeling a tiny bit bad. I'm about to throttle her dead, and the poor thing has absolutely no idea. I think that's probably for the best, and I really will try to make this fast. I wrap the belt tightly around my fists, making a taut garrote between them, and silently approach her from behind.

"Finn, show me that again," she says excitedly as she pulls the slate closer and taps the "On" button.

With a slightly remorseful sigh, I quickly whip the garrote over her head and loop it around her throat, twisting the two ends together behind her and squeezing as tightly as I can. She doesn't even have time to struggle before I quickly jerk the belt upward and hear the bones pop apart in her neck. Her body goes limp, and it's done. Quick and simple. She's dead.

Well, at least that's exactly what I imagine *would* have happened if my body would actually move right now. I have absolutely no idea why, but instead of strangling this girl to death, I'm frozen to the spot, my arms have dropped to my sides, the belt is unraveling from my hands onto the floor, and I'm staring at the back of her head in confusion as she scrolls through the holograms floating above the computer slate.

She glances over her shoulder at me, and all I can do is look at her in bewilderment as an intensely unpleasant feeling shudders through me. If I didn't know any better, I'd think it was . . . guilt. Do I actually feel guilty just for *thinking* about killing this meaningless stranger?

"Finn, what are you doing?" she asks. "Show me that classified access point again."

"You do realize that I'm trying to kill you, don't you?" I murmur as she leans forward over the slate and begins scanning through the search history. "I mean, I don't really want to terminate you but . . ."

"Stop messing around," she says, prodding at a holoscreen floating over the slate. "Whoa. The memory cache, the hard drives, everything has been wiped clean; even my homework is gone."

"Hey, who's been using my computer?" says a girl's voice on the other side of the door.

"What's going on?" says another girl just outside the room. "My assignment has disappeared!"

Out in the courtyard groups of girls are looking bewilderedly at their slates; some are shaking them, and some are just staring blankly at them as they poke and swipe ineffectively at their surfaces.

"Every computer in a two-hundred-foot radius has been erased." I say the words as if I'm trying to impress this girl, and even though I can't for the life of me figure out why I would want to do that, she does indeed look suitably impressed.

"Holy crap!" she says as she turns and grins up at me. "Technically they're completely possible, but I've never actually seen a localized blanket delete before! That's next-level stuff, Finn; how did you . . ."

Her expression suddenly drops, and the mood in the room darkens. "That *was* real, wasn't it?" she says, her voice quivering. "You actually killed a man in Paris last night, didn't you, and when you said that you were going to kill me a minute ago . . . you . . . you actually meant it."

I nod. "I'm sorry." I take a step toward her, and I can tell by the way she holds up her hands and her eyes crease at the corners that she knows I'm deadly serious.

"I won't say anything. I promise. You're my best friend, Finn. Please don't do this."

I pause and look at her curiously. "Why do you keep calling me that?" I ask.

"Because . . . that's your name?" she stammers.

"And I'm your . . . best friend?" I ask, frowning at her.

She nods emphatically.

I'm suddenly curious. With my eyes glued on her, I walk to the bed and sit down. "How long have you known me?"

"I dunno," she says, shrugging as she slowly lowers her hands. "About three years I guess."

Now I'm completely intrigued. "And . . . what am I like?"

She's frowning and squinting at me again, like I'm a crazy person. "Just indulge me," I say.

"I dunno," she says, eyeing me nervously. "You're intelligent, quiet, and kindhearted . . ."

"You're not saying that just to keep me from killing you, are you?"

"No, I swear," she says, shaking her head.

"What else?"

"Um . . . you like horses, you adore science, and you're really good at maths. I mean *really* good. The way you manage complex processes in your head without thinking is incredible. I'm actually quite jealous of that." Suddenly she sighs and sneers like she has an unpleasant taste in her mouth. "Oh and you're in love with this guy called Carlo who lives in Italy, even though you haven't seen him or spoken to him in years and he *never* texts you back—"

"Stop," I grunt at her, and she flinches in her seat. "I don't remember any of that. That's not me. You're lying." I lunge off the bed and grab her by the collar of her shirt. "Did Captain Delgado put you up to this? Is this a test? Because if it is, I don't like it, and you can tell him that it's really starting to piss me off!"

"No, I don't even know who that is," she whimpers. I study her face. Either she's an expert liar, or she's actually telling the truth.

I let go of her collar and flump back onto the bed. I feel stunned and confused and angry and sick all at the same time. "Are you saying that I have a whole different life, and that for some reason, I have no memory of it . . . whatsoever?"

"I don't know," she says, gingerly smoothing her rumpled shirt. "Is that what I'm saying?"

"Yes, I think it is," I reply, staring into nowhere. I quickly look up at her. "Does this Finn person have . . . parents?"

The girl leans forward and looks into my eyes. "You're really not Finn, are you?"

"No," I say sternly. "My military designation is Infinity One, and I'm a Vermillion-Class weapon created for the Blackstone Covert Tactical Division." I frown and snort, surprised at myself for blurting out highly classified information. "I also don't know why I'm telling you this."

She smiles. "Well, for one, no one would believe me if I told them, and two, you'd easily kill me if I did."

"That's true," I reply, even though, after the guilt I experienced before, I doubt I could raise a finger toward her without feeling like I was about to torture a basketful of puppies.

"Can you feel Finn inside your mind?" the girl asks.

I frown at the ludicrous question. "No."

"Wow, this is wild," she says as her stare flicks and scans over my face. "So are you some kind of sleeper agent or something?" From the way she's looking at me, I feel like a zoo animal or a museum exhibit. I'm finding her bizarre reaction and sudden acceptance of this whole situation more than a little disconcerting.

"I don't know," I respond, and it's my turn to stammer. "I train, and I execute mission objectives and . . . nothing else. I'm a weapon. That's what I was made for; that's all I ever wanted to be. That's what I am."

Her eyes narrow like she's pondering something. "So . . . you've never wondered about all the time you can't account for between missions?"

I shake my head at the ridiculous notion. "Absolutely not. I know exactly what happens between missions. I'm either training or put in neural stasis and stored in a secure location until I'm required again."

"No, you're not," she says. "Between missions you attend classes, and on weekends we go into London together, eat junk food, and go to the movies."

The girl stares at me, and it's plain to see that she's stunned. "Everyone's heard the urban legends about mind control and how people can be murdered by Blackstone exploding their cybernetic organs. But they're only stupid stories. Either you've got some acting skills I've never seen before, and you made that website as part of an elaborate prank, or everything you've told me is real."

"This is no prank," I reply.

She shakes her head and gives me a look that I recognize as pity. It's the first time the expression has ever been directed at *me*. "I've been watching them for a long time and always suspected Blackstone Technologies did some highly immoral things, but this is nuts. Infinity One . . . they've made you into a slave. Worse than a slave, because at least slaves actually know that they're prisoners."

Her words stab me like a knife in my back. I've performed military-sanctioned executions, my hands have been elbow deep in blood, and I've returned to base with brain matter splattered on my uniform more than once. But the thought that I've been duped into mindless servitude for my whole life disgusts me more than every scream from every contorted face of everyone I've ever shot, stabbed, strangled, or decapitated.

"That can't be . . . it's not true," I say as I try to absorb the enormity of this betrayal.

The girl leans back in her chair and taps her finger on her chin. "Y'know, with your access codes and my hacking skills, I bet I could help you find out more."

My eyes narrow suspiciously. "If you're an enemy operative and this is some kind of trick to expose proof of my covert actions, then . . ."

"You'll kill me. Yeah, we've already established that," she says as she nods and smiles with a strangely enthusiastic gleam in her eye. "Look," she says, pulling her chair closer. "Any serious hacker would give their

left arm just to get a glimpse inside the most secure computer system on the planet, and after what I just saw, meeting you is like getting a backstage pass to the best show on earth. I'll help you find out as much about yourself as I can, and all I'm asking is to come along for the ride. We won't get caught. I guarantee it. What do you say?"

I study her face closely for the slightest hint of treachery, and all I can see is an excitable nerd with a mischievous streak. I do need to know how I was activated without authorization, and I definitely want to learn everything I possibly can about this Finn person and why a whole side of my existence has been completely hidden from me. I want answers, and somehow—I don't know why—I feel that I can trust this girl.

"Exactly how good a hacker are you?" I ask.

She smiles. "Well, there was the time my mother scheduled a flight to a business meeting in Switzerland instead of staying home for my tenth birthday."

"So?"

"So . . . I shut down the air-traffic control grid and grounded every plane in Europe for seven and a half hours. I got to have cake and ice cream with my mother . . . and I never got caught."

I can't help but smile. I like this girl already.

"OK then," I say. "Where do we begin?"

She beams at me. "Well, first we're gonna use your access to get into all the classified files we can." She thrusts a hand out and grips my palm tightly. "It's nice to meet you, Infinity. I'm Bettina Otto."

CHAPTER THREE

She's still gripping my hand tightly as I look down into her big brown tear-filled eyes.

"It's me," she says, her voice quivering. "Please say you remember me?"

Her name drips into my mind like water tapping a beat on a tin can.

"Otto. Your name is . . . Bettina Otto. We . . . we share a room at school. That's where we met."

"Yes," she replies, smiling and nodding. "But you've always called me Bit, remember?"

"Of course, Bit," I say, returning her smile.

"She almost didn't remember your name. She's brain damaged," an angry-looking boy says from the other side of the room.

Bit turns and glowers at him. "Shut up, Brent. She's just confused!" she barks. "I'd like to see how you'd be if you had a monorail track collapse on your head!"

"The silver towers," I whisper to myself. "Falling."

"You remember?" asks Bit.

"Yeah . . . I think so. It's hazy, but . . . I remember the sound, and . . . there was so much dust that I could hardly see; everything was falling all around me, but then . . . nothing."

"You were badly hurt," says Bit. "You took a very nasty knock to the head."

"So that's why everything is all foggy," I say as I rub my temple.

A bearded old man leans in, clicks a penlight on, and shines it in my eyes. "Do you know what your name is?"

"Yeah," I reply, smirking at the stupid question.

"Well? What is it then?" he asks.

I snort, amused at the weird old man. "It's . . . Infinity."

Bit's mouth drops half-open, her face frozen into a startled glare as the old man's eyes narrow behind his glasses. "Infinity? Are you sure?" he asks.

"Of course," I say, frowning at their unusual reactions. "But . . . everyone calls me Finn for short."

"Gooood," the old guy says, drawing the word out as he eyes me curiously. "And do you know where you are?" he asks.

I look around the lab and nod. "Yes, we're underneath Blackstone Technologies. Like Bit said, I was hurt and carried down here."

"That's right. We're in an old Eurasian War shelter beneath the facility," says the old man. "Do you recognize me?"

I study his face for a second, and out of nowhere I suddenly remember something from when I was thirteen years old. It was a beautiful summer's day, and I was running across the grounds of Blackstone Manor toward a large garden shed. The wooden walls were painted dark green, and through the open door I could see the old man standing inside. He was dressed in a plaid shirt, khaki overalls, and black rain boots and was completely absorbed in tending to some seedlings in little pots. I remember storming into the shed like a force of nature and shouting his name as loud as I could. He jumped a foot off the ground. His glasses sprung off his nose, flipped once in the air, and disappeared

into an open bag of potting mix. "Your name is Graham," I say, smiling at the memory.

He nods. "Very good. But considering that I'm giving you a medical exam, maybe you should call me Dr. Pierce."

I look down at the blood-soaked towel that Bit is clutching. "What happened to my hand?"

"You blacked out in the bathroom," Bit says as she cradles my arm in the towel. "It's quite badly cut."

"First a monorail track, and now this," I grumble. "I'm a walking disaster zone."

"Do you know who I am?" says the large bald man across the table from me. He's standing side-on to me, holding an open palm up, looking at me warily, almost as if he's afraid that I'm going to attack him or something.

At first I'm at a loss, but as I look closer a sudden surge of mixed emotions pushes his name to the surface of my mind. "Jonah?" I whisper. "What are you doing here?"

He seems to relax a little, and his expression shifts from trepidation to concern. "That's not important right now," he says. "The main thing is that you're OK."

"One last question," Dr. Pierce says as he motions toward my classmates, who are standing in a little group, watching me from across the room. "Do you know who those people are?"

"We all go to Bethlem Academy together," I reply. "We were on a field trip, and . . . and everything started to go wrong."

"That's right," Dr. Pierce says with a look of relief. "Her memories seem to be reordering themselves. But it may be some time before she's a hundred percent."

"I'm fine, really," I say. "Apart from a slightly fuzzy brain, I actually feel pretty good."

Dr. Pierce nods. "OK. Well, let's tend to that hand then, shall we?"

He turns and walks to a nearby trolley and begins sorting through a drawer. I cast my gaze over Bit's shoulder to my other four huddled classmates, and all of a sudden I feel uneasy, like I'm forgetting something important. I turn to Bit and whisper, "Where is everyone else? Where are Dean and Sherrie and Karla? Where's Miss Cole?"

Bit's expression immediately darkens. "They're . . . they're gone, Finn."

"Gone where?"

A distant look glazes over her eyes. "They're all . . . dead," she murmurs.

I frown at first, then let out a quiet snort and a soft chuckle. It's a little cruel of Bit to play such a grim prank, especially just after I've woken up from fainting. "They're all dead," I gibe sarcastically. "No really, where is everyone?" I ask, still smiling as I scan the room. But as I take in the expressions on the faces all around me, my grin slowly begins to fade. Brody is looking at the floor. Brent has a faraway stare. Margaux's eyes are pooling with tears, and Jennifer has begun sobbing quietly.

I turn and stare at Bit. "They're dead?"

With a trembling lip, and fighting back tears, she solemnly nods.

"What about Millie and . . . and Amy?" I ask, spitting out the first names that emerge from the ominous knot that's beginning to twist and tighten in my gut. Bit avoids my gaze as she slowly shakes her head.

"Ryan?" My lips whisper his name, and an image of his eyes rekindles in my mind. They're an amber-hazel color, with little flecks of gold. I see his thick, wavy brown hair and his crooked smile, and I remember the warmth of his skin setting butterflies free in my stomach as we walked hand in hand through the jungle all those hours ago. I see him again, a rifle against his shoulder, firing bursts of rounds into Combat Drones as they fell onto the grass outside Dome One when we were trying to make it to the bus, but most of all I remember catching him studying my face with a slow-moving gaze, as if he were trying to soak

me into his thoughts, whenever he looked at me. I look at Bit hopefully, but she's looking at the floor. A cloud in my heart begins casting a bitter shadow over the sweet promise of the fleeting memory. "Please . . . not Ryan," I murmur, every anxious syllable tightly wrapped in fragile scraps of hope.

Bit looks up at me, and even if she didn't speak, the sorrow in her eyes would've said it all. "I'm sorry, Finn," she says, her voice aquiver. "Ryan died trying to save your life. He's . . . he's gone, too."

I just sit there, staring into nowhere. I can't believe it. I only knew him for a few hours, so why does it feel like I've lost one of my dearest friends? He can't be dead . . . he just can't be.

All of a sudden my whole body flinches as tattered pictures flicker and strobe through my head. I see blood. Ashen faces. I hear screaming, gunfire, and the ringing echo of distant explosions.

Bit is telling the truth. I can feel it. And it hits me like a kick to the stomach.

They *are* dead, and a gnawing, churning ache deep in the core of my soul is telling me that it's all my fault. It feels like a plug has been pulled from my heart. All the blood drains from my face, and I suddenly feel light-headed. My knees buckle, and I stumble backward; my hand tugs away from the towel as I stagger against a trolley behind me. It topples, and I reach out and clutch at it, pulling it down with me as I crumple to the floor. The trolley clangs beside me as surgical instruments clatter across the concrete. My mind is reeling, and I suddenly feel so incredibly weak and powerless. I screw my eyes closed, and I can see their faces. Millie; Dean; Amy; Miss Cole; Sherrie; Ashley; poor Karla Bassano; Percy, our brave tour guide; Professor Francis; and worst of all . . . Ryan. All of them gone. All because of me.

I look down and see speckles of blood peppering the paving stones beneath me. I look up and see Carlo's father, Javier Delgado. He's wearing a military uniform with a Captain's insignia on the shoulder and standing at the top of an open cargo ramp beneath a large gray transport.

He shouts to someone inside. The turbines throttle up, and the transport suddenly begins to lift off. I see Ryan. He's facing a gathering of angry soldiers, all of them swaying unsteadily on the open cargo door as the transport rises. The aircraft leans sharply; Ryan loses his balance, and the rifle he's holding slips from his grasp and clatters at his feet. Captain Delgado suddenly pulls a pistol from a nearby soldier's hip.

As he raises the gun toward Ryan's chest, the horrific memory slows down to an excruciating crawl. The folds of the Captain's camouflage sleeve tighten as he straightens his arm and takes aim. His top lip curls up over his clenched teeth, his nose wrinkles into a sadistic sneer, and his knuckles turn bloodless white as he grips the gun tightly and pulls the trigger. The jolt from the recoil ripples his hand, and a smoking shell casing spits from the side of the pistol. The tiny brass cylinder tumbles through the air as a bloom of sparks erupts from the barrel of the gun, lighting up Captain Delgado's face like a demonic mask captured in the flash of a camera. Ryan's body jerks with the impact of the bullet. He staggers and trips, then finally, with his hair flurrying from the downdraft of the turbines . . . he topples backward off the edge of the ramp.

I remember Ryan falling.

I saw him hit the ground.

I remember watching him die.

"Finn!" shouts Bit as she lunges toward me.

My heart races; my vision swims. There are footsteps from all directions. I reach out to Bit, but Jonah's face comes into view as he kneels beside me, and all of a sudden hands are grabbing me and hoisting me up. "They're all dead," I murmur. "Everyone is dead."

"Not everyone," a familiar voice says from behind me. I turn and see Percy's face at my shoulder, his hands under my arms helping to lift me to my feet. Behind him I see Professor Francis rushing into the room from a side passageway.

I stare at Percy and Professor Francis. Both of them are wearing coveralls that are draped in cobwebs and smeared with streaks of rust.

I feel a warm current of relief rise from the depths of an ocean of guilt. "You're alive," I stammer.

"Yes, I'm glad to say that we are," says Percy. "And I'm also happy to see that you've finally woken up, albeit a little unsteady on your feet."

"Help me get her onto the table," says Jonah.

Jonah and Percy lift me onto the metal slab, and I sit on the edge, trying to catch my breath and process the horror that's just been pulled from the mire inside my head.

"Are you OK, Finn?" Bit says, fussing over me. "Be careful of your hand! It's—" Bit freezes midsentence.

Dr. Pierce quickly sets a tray of sutures and bandages down on the table, pushes past Percy, and grabs me by the wrist. "It's . . . completely healed."

"Incredible!" exclaims Percy. "If I hadn't seen your severed hand regenerate with my own eyes, I would never have believed it."

"Severed? As in amputated?" I gasp.

Percy nods emphatically.

"That's not what I'm talking about," grunts Dr. Pierce. "Finn had an accident while you were in the tunnels. There was a four-inch-long gash; it was a deep one, too," Dr. Pierce says as he prods at my hand with his thumb. "Did you fix the cut intentionally, Finn?"

I pull my hand away from him and begin rubbing the caked blood from my skin. "What? No, how could I? I . . . I don't even remember it happening."

Dr. Pierce is looking at me in a way that makes me very uncomfortable. It's the kind of look that I imagine scientists have when they're studying a lab rat in a cage. In fact, I don't like the way that everyone is gathered around me, gawking at me as if I'm a thing instead of a person. The way they're all looking at me feels very familiar and deeply unsettling, like I've been subjected to this kind of cold scrutiny all my life. I can feel an infuriated flicker spark in my gut just looking at all their stupid faces.

"So, just to clarify . . . ," says Dr. Pierce. "You had absolutely no conscious knowledge of the wound healing? You didn't focus your thought on it at all? Not even for a moment?"

I frown at him, my anger growing with every second. "What part of the word 'no' did you not understand?" I growl.

He seems to ignore my rising annoyance as he stares at my hand and strokes his beard in thought. "Interesting. Very interesting indeed."

"What does it mean, Doctor?" asks Jonah.

"Well, it could indicate an array of things. I wouldn't like to jump to any conclusions without running some tests, but I think Finn's rapid-healing ability might actually be functioning on a subconscious level."

"Do you mean that . . . she can do it without thinking?" asks Jonah.

"It appears so. We can test that theory right now." Dr. Pierce picks up a scalpel from the top of a trolley, and with a wide-eyed, almost joyful grin, he grabs my wrist tightly.

"Hey!" I shout as I wrench my hand away from him.

"Graham!" bellows Jonah.

"You're not slicing me up just because you want to," I say, holding my fist to my chest.

Dr. Pierce looks at me with an annoyed frown, but then his eyelids flicker and his expression changes to one of shameful realization. "Sorry," he mumbles sheepishly. "I got a little carried away for moment there, but . . . if the rest of your enhanced qualities behave in a similar way, then this is a very, very exciting development."

"It's amazing is what it is," says Percy. "Maybe we should change the plan to include her? We'd stand a much better chance of pulling it off if Finn is involved."

Jonah shakes his head. "Dr. Pierce and I were debating the possibility of Finn's participation in the plan, but after what I've just seen it's apparent that she's in no state to join us. She woke up barely twenty minutes ago. Her head isn't clear; we can do this without her."

"What plan?" I ask. "What are you talking about?"

"Some of us have been discussing the situation," says Jonah. "And we've decided that we're going to try and regain control of the facility. It's the only way to ensure a safe escape."

"Wait a second," blurts Margaux. "No one told me about this! I thought we were waiting for the police to rescue us?"

"No, I'm afraid not, Miss Pilfrey," says Professor Francis. "Mr. Brogan has informed us that it could take weeks, or perhaps even months, for a rescue team to reach us. Even if we ration what is left, the fabrication gel for the food printer will run dry in just a few days."

"No one is coming for weeks?" whimpers Jennifer.

"Months," a twitchy-looking Brent mutters. "I heard him say months."

"So we're on our own?" Margaux whines. "Well that's just awesome, isn't it? I'm going to starve to death in a basement with a bunch of old guys, a nerd, and a freak who never needs a Band-Aid."

"I don't understand. Why will it take so long for a rescue?" asks Jennifer.

"Because great effort has gone into hiding the location of this facility," says Dr. Pierce. "There are a handful of people who know where it is, and the ones who do won't risk revealing it."

"But what about everyone who was killed today?" asks Brent. "Like that technician guy in the Security Station."

"George," says Bit. "His name was George Parsons."

"Yeah, that's him," says Brent. "What happens when he doesn't come home tonight? His family isn't just gonna sit around doing nothing."

"That might be the case if he actually *had* a family to go home to," says Dr. Pierce. "Everyone who works here was handpicked. They're all either ex-military, government intelligence, or highly skilled fugitives with nowhere else to go, few ties to the outside world, and no one who will miss them. In most cases, the families of our employees thought they died a long time ago. For all intents and purposes, they're ghosts."

"It's true," says Percy. "Percy isn't even my real name. It's actually—"

"Now is not the time to confuse the children any more than they already are," interrupts Dr. Pierce. "Let's just stick with Percy, shall we?"

"Holy crap! What kind of place are you running here?" yells Brent.

"I told you," Dr. Pierce says calmly. "A very secretive one."

"No, I don't accept that at all," says Margaux, her already high-pitched voice rising higher with every word. "Someone must have realized that I'm trapped here by now. Daddy is very important; somebody will tell him where I am!"

"I don't think so, missy," replies Dr. Pierce.

"My name is Margaux, and why the hell not?" she says, crossing her arms on her chest.

"Because bad things happen if you go up against Richard Blackstone," I murmur.

Dr. Pierce throws me a narrow-eyed glare. It's the kind of look that's asking "what do you know" mixed with a large dose of "shut your mouth before you say something you'll regret." I look away and clench my jaw closed. My memory may be little more than a patchy blur right now, but I know the truth when I feel it.

"'Bad things,' as Finn so diplomatically put it, have certainly happened," the Professor says grimly. "But now we must all do our part to ensure our survival."

"I couldn't have said it better myself, Professor," says Jonah. "And us *old guys* and that *nerd* have come up with a plan to get all of us out of here." He turns to Bit. "Is your presentation ready, Bettina?"

She nods.

"Are all the sensors in position along the tunnel?" he asks Percy. Percy also answers with a definitive nod.

"Well done," says Jonah.

"Sensors? What's going on?" Margaux asks bewilderedly.

Jonah smiles at her. "All will be explained. Now, I'm going to gather our mission supplies while Bettina sets up." Jonah turns and strides off

toward a big yellow duffel bag and three large gas tanks in the corner as Bit sidles around the metal table and heads for the bench cluttered with computer slates.

"Can someone push a few of those trolleys together in the middle of the room please?" Bit calls over her shoulder. "I need a decent-size flat surface."

"You heard the girl," Dr. Pierce barks at my classmates. "Make yourselves useful." Jennifer and Brody nod and begin pulling trolleys to the center of the room, as an agitated-looking Brent and a sullen Margaux begrudgingly drag their feet to help.

Bit is fumbling with a pile of slates and a tangle of connector cords on the long bench table that's set against the wall. "I need a hand here," she says.

Brody immediately jolts into action and strides across the room toward her, as Brent snidely shakes his head with disapproval. In a strangely affectionate manner, Brody picks up Bit's glasses from the bench and gently slides them onto her nose. She smiles warmly at him and begins stacking computer slates in his arms.

I'm eager to see what everyone's been working on, and I'm about to go and help set up, too, when Professor Francis takes my arm and gives me a strangely grim and curious look. "It really does boggle the mind," he says. "A covert operative with an enhanced physiology, sitting in my very own class."

My brow furrows with confusion and surprise as Professor Francis gives me a sideways glance. "Come now, young lady. I understand that you must be accustomed to maintaining a veil of secrecy, but after what we've witnessed, your handler, Mr. Brogan, had no choice but to answer a few of our more pressing queries."

I glare at him, perplexed. "What exactly did he tell you, Professor?" I stammer.

"Well, he told us the reason you came here today."

All I can do is stare bewilderedly at Professor Francis, and the only word that comes out of my mouth is a highly confused, "What?"

"You were sent to test the security," says Percy. "To see if someone could secretly infiltrate the facility."

Right now my memory has more holes in it than a slice of Swiss cheese, but I remember enough to know that explanation is a complete lie. Jonah did not send me here to test their security, but apparently he is quick off the mark when it comes to making up a fitting cover story on the spot.

The Professor's expression darkens even more than before, and he leans in uncomfortably close. "My father was in military intelligence, and it drove him to drink," he whispers ominously. "Every now and then he would let something slip, tales so horrible that I have no doubt the weight of that knowledge played a part in sending him to an early grave."

From the corner of my eye I can see Dr. Pierce turn away and begin sorting medical supplies on a nearby trolley. He's trying his best to look innocuous, but it's plain to see that he's listening intently.

I awkwardly lean away from the Professor as he glowers at me over the top of his glasses. "I don't understand, sir?" I mumble.

"Thanks to my dear father's stories, I came to accept the fact that there are many powerful and morally devoid people in this world. Training children like you to do their bidding, while shocking, is sadly not surprising. But the fact that they allowed you to hide in a school group of innocent civilians and break into a potentially dangerous place like this goes far beyond the boundaries of ethical responsibility. The tragic loss of life today speaks for itself. You've got a lot to answer for."

I'm completely taken aback by this sudden confrontation. The fog in my brain is unyielding; it's adding to my confusion, and I don't know what the hell he's talking about. Part of me wants to get off this table and just walk away, but strangely, another part deep down inside of me wants to grab the Professor by the scruff of the neck and tell him to

shut the hell up, but I decide it's wiser to take the middle ground, so I just sit still with my mouth shut.

"Those deaths were hardly her fault, Professor," says Percy. "Finn didn't know a cyberterrorist would hack the computer and take control of the robots on the same day."

I stare at the two men with a blank expression on my face.

"Perhaps not," sighs the Professor as he frowns at me. "You do deserve some credit for attempting to save us, young lady . . . but the fact remains that your actions contributed to our dire situation and now our lives are hanging in the balance."

I don't know what to say, so I just sit and look at the floor, avoiding the Professor's accusatory glare as an unpleasant silence festers.

"Everyone, gather around please," Jonah calls.

"Let's go," Percy says as he takes Professor Francis by the arm and guides him away from the table. The Professor's expression is still painted with disdain as he and Percy head to the middle of the room to join the others, who are all gathered in a loose circle. I let out a deep, uncomfortable sigh. That conversation was unexpected, confusing, and very painful to hear. Professor Francis has always been a fair and kindhearted man. He's always been nice to me in the past, but after everything that has happened today, it's clear that he's a different man than he was before. I could see the pain in his eyes, the anger, the disappointment, and the fear. He was looking at me as if he didn't know me. I can't blame him for that. Lately I've been feeling like a stranger to myself.

I slide off the steel table, walk to the center of the lab, and awkwardly take a place between Percy and a sullen-looking Margaux. In the middle of the circle, half a dozen trolleys have been pushed together to form a makeshift desktop. On top of the trolleys Bit has arranged an array of ten or so computer slates. With their scratched-up surfaces and chipped edges, I'm surprised any of them are in any kind of working order. Bit picks up the least decrepit-looking one and begins prodding

at it, as Jonah stands tall, puts his hands behind his back, and clears his throat. "Bettina, if you wouldn't mind displaying the map?"

Bit swipes the screen in her hands, the slates in the array suddenly light up at all once, and a large and surprisingly detailed glowing 3-D model of Blackstone Technologies shimmers into the air. The whole thing is rendered in thin blue lines, Domes One, Two, and Three are represented by overturned holographic baskets of decreasing sizes, and surrounding them is a series of angled blocks representing the landscape and some of the buildings. "I'm sorry it's so crude," says Bit. "It's a far cry from the detailed model Percy showed us when we arrived, but it's the best I could do at short notice."

"You did a very good job, Bettina," Jonah says with a smile. He looks up at the diagram, and his expression becomes more serious. "As you can all see, this is a diagram of Blackstone Technologies. The artificially intelligent computer that controls this facility is malfunctioning and currently sees us as a threat. It will do anything it can to eliminate us, so if we want to stand a decent chance of getting out of here alive, we need to regain control of it. To do that, our first objective is to retrieve Bettina's computer slate from the wreckage of the fallen transport inside Dome Two."

Bit taps the slate. The second wire-frame basket turns red, and inside the red wires a little green spot representing her lost computer lights up and begins blinking.

"Why exactly?" asks Jennifer.

"Well," says Jonah, "Bettina believes that she can use her slate to access the main computer and reset it. Once that is achieved the mechanoids and any remaining Drones up there will shut down, and we can search for survivors, tend to the wounded, and get to the school bus safely."

"What?" Margaux blurts as she glares at Bit. "Why the hell didn't you do that before?"

"I couldn't," Bit snaps back at her. "The main computer was blocking the Hypernet signal, so I couldn't access it wirelessly. My slate contains all the source code I need to repair the mainframe, but the only way to do that now is to plug directly into the neural core."

"And we're going to give her the opportunity to do exactly that," says Jonah.

"How?" asks Jennifer.

"Bettina?" says Jonah. "Would you like to fill them in?"

Bit gives Jonah a serious nod and jabs at the slate in her hand. A small green circle appears on the diagram. "This is the hatch we all entered to get down here," she explains. "I'm going to exit through that hatch and make my way up the hill to a maintenance door that leads beneath Dome Two. From there I'll climb up inside the dome and get my computer slate from the transport wreckage. After that I'll take it to the main computer's neural core and plug in."

"All by yourself?" I ask Bit.

"No, Finn, she won't be alone," says Jonah. "The computer's neural core has a level-twelve-security-access door with a DNA-coded lock. The only one here who can open it is Dr. Pierce, so he's going with her."

"And so am I," Brody says, beaming at Bit. She returns his smile, and her cheeks flush a telling shade of pink.

Brent and Margaux both turn to Brody and glower at him. "You're part of this plan and you didn't tell us?" growls Brent.

"Bit told me about it, and I wasn't going to let her do it without me," he says defiantly. "And how was I supposed to tell you guys anything when you've been shut in the bunk room sleeping the whole time we've been down here?"

"We weren't exactly sleeping," murmurs Brent.

Margaux frowns and backhands him on the arm. "Shut up," she seethes at him.

"Ugh. Gross," whispers Bit.

Jonah ignores them all as he studies the holographic map. "Bettina makes the plan sound simple, and it would be if it weren't for three tall green problems."

"You mean the Remote Articulated Mechanoids, don't you?" Jennifer murmurs with a quiver in her voice.

"The R.A.M.s," Brent whispers ominously.

"Yes," says Jonah. "Dr. Pierce, Brody, and Bettina can't exit the hatch without setting off the facility's motion sensors. As soon as that happens the mechanoids will come running. So, first we need a diversion to draw those robots away from the hatch."

"How?" asks Margaux.

"By giving them another target," Jonah replies. "The Professor, Percy, and I will exit through a second hatch farther along Sector B. It's the hatch that I initially came through to get down here."

Bit taps the slate again, and a second green circle appears much farther along the map. Little red dashes blink on one after another, forming a line connecting the first hatch with the second.

"As soon as we exit that hatch, our mere presence will trip the motion sensors and send the mechanoids toward us and away from Dome Two," says Jonah.

"That's suicide," blurts Brent. "They'll hunt you down and turn you into mincemeat."

Jonah smiles. "Of course it's going to be very dangerous, but believe me, I certainly don't have a death wish. There's an administration building a short distance from the second hatch," he says, pointing at a rectangular block on the hologram. "We're going to position ourselves on the roof. It should hold up against the R.A.M.s' weapons long enough for Bit to get the slate, access the neural core, reset the computer, and shut the R.A.M.s down."

"Why do all three of you have to go?" I ask. "Surely you only need one person to trip the motion sensors to bring the R.A.M.s running?"

"Yeah," agrees Brent. "Just stand by the hatch and wave your arms around. As soon as you see them jump back in!"

"I wish it were that easy," says Jonah. "Even after we distract the R.A.M.s, there's a chance they may decide to turn back toward Brody, Bettina, and Dr. Pierce once they exit *their* hatch. If that happens I need to present a much bigger threat to the facility in order to keep the R.A.M.s heading toward us, away from Dome Two. That's where these come in," Jonah says as he puts a hand on top of one of the three gas tanks he dragged over from the corner.

"I've drilled the valves and rigged them with ignition caps from emergency flares. It's an old trick I learned from my days in the military. Drop one of these from the roof in the right way, and it'll go off like a bomb. The computer will surely prioritize the explosions as a more serious danger and choose to focus the R.A.M.s' attention on us, giving Dr. Pierce, Brody, and Bettina time to complete their part of the plan in safety."

"Ohhh-kaaay," Jennifer replies unsurely. "But, how will Bettina and Brody know when the R.A.M.s are a safe distance away? It must be at least a mile between the hatches. And there's all those buildings in the way," she says, pointing up at the hologram.

"We'll take binoculars, and we have walkie-talkies," Jonah says, kicking a yellow duffel bag at his feet. "Hopefully we should be able to spot the R.A.M.s from the roof as they approach the border between Sectors B and C. Then we can report their locations back to you."

"Hopefully?" Brent gives Jonah an incredulous look. "You're pinning a lot on 'hopefully.'"

"Actually," Jonah says, looking over at Bit, "when it comes to tracking the movement of the R.A.M.s, our resident computer expert came up with an ingenious idea."

"It's not ingenious," Bit replies sheepishly. "It was kinda obvious really."

"Show everyone what you've done, Bettina," prompts Jonah.

Bit smiles and nods. "Four hours ago Dr. Pierce positioned a stack of medical ultrasound-capable computer slates near the surface and sent a message carried on a high-frequency vibration. That's what guided us down here," says Bit. "Percy and Professor Francis were kind enough to spread those slates along the entire tunnel between the two hatches." Bit jabs at the screen in her hands, and up on the diagram of the facility, ten orange circles appear along the red dotted line between the hatches. "Using the slates as sensors, we can monitor the vibrations of the R.A.M.s' footsteps. Even when we can't see them or hear them, we'll know where they are when one of these circles starts flashing."

"That's very clever," says Jennifer.

"Yeah it is," Brody agrees, smiling at Bit.

"It was pretty simple," Bit says shyly. "I just boosted this slate's frequency scanner in a similar manner to my own one and tuned it to—"

"Yeah, yeah, the whole school knows you're some kind of super computer geek," interrupts Brent.

"So, after you get your slate from Dome Two, you're gonna plug into the main computer and make it all friendly again?" asks Jennifer.

"That's the plan," says Jonah.

"How do you know you can even do that?" asks Margaux.

"I'm certain I can do it," replies Bit.

"But surely Dr. Pierce knows more about the Blackstone computer than you do. Why doesn't he reset it?" asks Brent.

"Because," Dr. Pierce murmurs as he absentmindedly stares into space, "I have absolutely no idea how Bettina broke it in the first place."

CHAPTER FOUR

Margaux turns and stares wide-eyed at Bit. Brent is frowning in confusion, and Jennifer's mouth drops open.

"Miss Otto?" says Professor Francis.

"I . . . I didn't know all of this was going to happen," squeaks Bit. I can see her eyes beginning to glisten with a film of tears. "All I did was put our school on the visitors' roster."

"She's being extremely modest," Dr. Pierce says, smiling admiringly at Bit. "What she did was hands down the most brilliant encryption cracking I've ever seen. She accessed classified files that even I didn't know were in there!"

Bit looks toward the floor and shakes her head. "I've never hacked an artificially intelligent system before," Bit sniffles. "I didn't know I would corrupt the whole system."

"Onix," says Dr. Pierce. "The artificial intelligence that controls the mainframe is named Onix. And you didn't just corrupt him, girly, you seem to have damaged him quite severely when you decided to schedule this little field trip of yours."

Professor Francis stares at Bit in disbelief. "You're responsible for bringing us here? For all of this?"

"Ha! I knew it!" blurts Percy. "I knew there was something fishy going on the moment I saw that a bunch of high school kids were scheduled for a tour. But I didn't say a thing, did I, oh no. Didn't raise a fuss. I just did my job and led the tour like I was supposed to. Now everyone is dead, half the complex is destroyed, and I'm crawling through tunnels praying that I'm not the next one who's gonna be turned into meat paste by giant robots!"

"Holy crap," Brent says, glaring at Bit. "I bet that's how the cyber-terrorists got into the computer, too. Right behind you!"

"I'm not even supposed to work on the weekends!" Percy wails.

Bit is quietly sobbing and clutching the slate to her chest as I take a determined step forward.

"I'm just as much to blame," I declare loudly. Jonah's head snaps in my direction, and his eyes narrow as he glares at me with surprised confusion. "She never would have been able to get so deep into the computer's systems without my help. I clearly remember sitting in our dorm room giving classified passwords to Bit so she could gain access to the Blackstone files and systems."

"Wait," says Jonah. "Your mind is still muddled, Finn. There's no way that you could know how to access any information that could lead to a catastrophe like this. Head injuries like the one you sustained can affect people in very unusual ways. I don't think you're remembering anything properly right now."

"Is that what happened, Bit?" I ask.

She sniffles and slowly shakes her head. "Nnnnooo . . . not really."

"Did those passwords come from these lips or not?" I bark, pointing at my own face.

Bit frowns. "Yes . . . but—"

"Then it looks like I'm beginning to remember just fine," I state, glaring at Jonah as a strange urge to punch him in the face ripples through me.

"Well, you've certainly got a lot to answer for as well, Mr. Brogan," declares Professor Francis. "You gave your operative here the order to breach the security, and she clearly manipulated a naïve civilian to do it!"

"Now is not the time to be pointing fingers," says Jonah. "We need to focus on the task at hand."

"Well, considering what has recently come to light," says Professor Francis. "I believe it is incredibly reckless to allow the young lady who caused this tragedy to have access to the computer yet again."

Jonah levels his gaze at Professor Francis. "With all due respect, Professor, Bettina may have played a part in causing this, but she's also the only one who can fix it. Sure, there are risks. What if the mechanoids don't take the bait? What if Bettina's slate has been destroyed? What if we retrieve her slate and she can't reset the mainframe? The truth is, we're pinning our survival on a whole lot of luck. Our chances to get through this are slim at best, but if we don't let Bettina try, the alternative is certain. None of us are getting out of here alive."

"It's very difficult to argue with that little logic bomb," murmurs Dr. Pierce.

The Professor's brow is creased with frustrated anger. But after a moment he eventually sighs and grudgingly nods in agreement.

"I know what I did was unforgivable," says Bit. "But I don't want anyone else to get hurt because of me. I need to do this."

Percy nods solemnly. "She needs to undo whatever she's done."

"And I'm going every step of the way, right beside her," I say determinedly. Bit looks up at me, and her lips twitch into a trembling smile.

"Absolutely not, Finn," says Jonah. "Your head isn't clear."

"She's my best friend," I growl. "And this is my fault, too. I'm going."

"No," he grunts. "It's far too dangerous."

"That's all the more reason why I should go!" I shout at him.

"You're not well!" barks Jonah. "What if you black out again? Not only will you endanger your own life, but you'll jeopardize the plan as well. I won't allow it."

"I'm telling you . . . I'm fine."

"No, you're not!" Jonah yells. "Do you remember what happened in the other room? You don't, do you? Well, I'll tell you what happened. You attacked me!"

The room goes completely silent. Everyone else looks just as dumbfounded by Jonah's outburst as I do. What he just said is so ridiculous I actually laugh out loud. "Why on earth would I do that?"

A highly flustered, red-faced Jonah almost looks embarrassed as he takes a breath and tries to regain his composure.

"Give me one good reason why I would attack you?" I ask, frowning at him. "The man that raised me since I was two years old?"

Jonah opens his mouth and raises one finger, but he's obviously stumped for an answer.

"That's what I thought," I sigh.

"Look, all I'm saying is . . . you're not a hundred percent and . . . you could get hurt out there," Jonah says.

First he tries to keep me down here with a lie about how I attacked him, and now he's being a patronizing dick. I feel a flicker of anger growing in my belly. This argument is starting to piss me off.

"Any one of us could get injured or even killed up there," I growl. "You heard what Dr. Pierce said. I can heal instantly without even thinking. And if that can help keep Bit alive, then *I'm going with her.*"

"The only thing Dr. Pierce has is a theory," argues Jonah. "So stop being so pigheaded, and leave this to us. You're staying down here."

Suddenly a burning fury surges through me. I quickly scan around. I spot a scalpel sitting in a tray on top of a trolley just behind me, and I swear I can hear a voice in my head whisper, *"Do it."* It almost feels as

if my hand is lunging out on its own, and before Jonah has a chance to make up another ludicrous story or bark another order at me, I quickly pull the sleeve of my top all the way to my bicep, snatch the scalpel up from the trolley, and stab the point hard into my flesh. With one deft stroke, I slash the blade all the way from my wrist to my elbow.

Everyone in the room instantly recoils in shock as my skin splits open in one long, clean gaping incision. The pain hits immediately, but I can hear chiming tones ringing in the back of my mind as well, the sounds and the sensation mixing into a stinging thread that sears along my arm.

"Finn!" screeches Bit.

"Oh my god!" shrieks Margaux.

"She's gone insane!" shouts Brent.

Panting short, adrenalized breaths, I place the scalpel back onto the trolley and hold my fist out as blood streams in thick rivulets down the sides of my arm. I stare at Jonah's stunned face, and ribbons of unfettered anger thrash through every inch of my body like tentacles of fire. Suddenly, I don't know why, but I feel like I want to leap across the space between us and choke Jonah to the floor until his eyes bulge out of his big bald head. In fact, I'm picturing it so clearly I can almost see it.

"Her arm," Dr. Pierce gasps gleefully. "Look at her arm!"

"I can see it!" screeches Brent. "She's lost her freaking mind!"

"No!" a grinning Dr. Pierce blurts. "It's working! Just like I said!"

The bleeding has stopped as quickly as it began, and I watch with my own eyes as the ten-inch gash in my flesh seals closed as if the edges were being drawn together like strips of magnetic tape. My rage begins to fade, and I smear the blood away with the palm of my hand. Everyone in the room is staring at my arm, and it's plain to see that the cut is completely healed. Not even a scratch remains.

"This conversation is over. I'm going with Bit," I say, calmly tugging my sleeve back down to my wrist. "And Margaux was right; I won't be needing any Band-Aids."

Jonah eyeballs me with a military glower. "Was that reckless little demonstration of yours really necessary?"

"It got my point across, didn't it?" I reply. "And now we know that Dr. Pierce was right about my healing ability."

"Hell of a way to test it," says Jonah. "The Finn I know would never be so foolish."

Another confusing surge of anger ripples through me. "Yeah, well . . . I guess I'm not the Finn you used to know."

"Clearly," Jonah sighs. "Obviously it's pointless for me to argue with you. I can't force you to stay behind."

"If you did try to stop me, one of us would get hurt," I reply venomously. "And I think you know it sure as hell wouldn't be me."

Jonah glances at me disapprovingly, then looks begrudgingly around the rest of the group. "Is everyone else willing to let her participate?"

Bit and Brody nod enthusiastically.

"Like I said," Percy chips in, "I think we've got a better chance of pulling this off with her help."

Jonah's indignant expression becomes one of resentful resignation. "Fine then. But if you mess anything up," he says, pointing at me. "It's on you." With one last glare at me, he leans down, grabs the handle straps of a bright-yellow canvas duffel bag sitting at his feet, and hoists it onto the trolleys. The holographic map of Blackstone Technologies flickers and vanishes as he sets the bag directly on top of the slates.

"I was preparing a training simulation inside Dome Three when the power failed and the dome collapsed," says Jonah. "I stumbled over this rescue kit when I was digging my way out of the grains." He unzips the bag and begins unpacking the contents on top of the array of slates.

When he's done, I take a quick inventory. There are nylon ropes, carabiners and harnesses, six walkie-talkies, six heavy-duty metal flashlights, and three sets of binoculars, as well as a bunch of road flares, a

first-aid kit, and a loose collection of survival-type objects like water-proof matches, a packet of foil blankets, a snare kit for catching small animals, a compass, glow sticks, and a few other moderately useful knickknacks someone might take on a hiking trip.

"This is some of the equipment my specialized team uses during training exercises," Jonah says as he arranges the gear.

"The ones that pulled us out of the wreck when our transport crashed into Dome Two?" asks Jennifer.

"Yes," says Jonah. "Bettina told me they were a big help."

"We nearly escaped on that transport," Jennifer says sadly. "We were so close to flying far away from this horrible place."

"But we didn't get out, did we," murmurs Brent. "We're still here, and thank you very much for reminding me just how screwed we are."

"The only reason you're alive to be reminded is because of Major Brogan's rescue team," Bit says, eyeballing him disdainfully.

As Bit mentions Jonah's team, a strangely familiar voice suddenly whispers through my head. "We're the Saviors," it says. The words echo in my ears, and a shape begins forming out of the fog in the back of my mind. Wisps of smoke curl and mold into the blurry peaks and curves of human features. The image condenses and solidifies, then flushes with color before it sharpens into the pretty face of a teenage girl. She must be fifteen or sixteen years old, with dark pixie-cut hair and kind light-brown eyes. "I'm Caitlin," she says, smiling down at me. "But everyone calls me—"

"Gazelle!" I gasp.

"Finn? You remember Gazelle?" asks Jonah.

"Yes," I reply. "I . . . I remember she was carrying me, on her back. The wind was rushing through my hair, and I was holding on as tightly as I could, and . . . and then there was an explosion in the distance. The last time I saw her, she was running faster than I've ever seen anyone run before . . . and she was heading straight toward the huge cloud of black smoke and fire."

"That sounds like her," says Jonah. "Running toward danger is second nature to the Saviors."

"The Saviors? Is that what they're called?" asks Margaux.

"That's right," Jonah says, nodding proudly. "They're some of the most capable young people I've ever had the pleasure to work with."

"What are they exactly?" Brent grumbles. "More freaks like her, I bet?" He looks sideways at me.

"Well, Major?" Professor Francis says, eyeing Jonah suspiciously. "Are those children another one of your experiments? Adolescent spies hiding behind a heroic title perhaps?"

"No, Professor," Jonah says with polite annoyance. "All the members of the Saviors were once military operatives, but all of them were injured in some way and retired from service. I repurposed them, and now they're part of a rescue team with very special abilities."

"Like Finn?" asks Brody.

"No," replies Jonah. "Finn is one of a kind. The Saviors' already considerable skills are complemented by their advanced cybernetic implants."

"What can they do, Major?" Bit asks with a fascinated expression on her face.

"Well, I assume some of you saw Gazelle. Her real name is Caitlin Grant, and her replacement limbs enable her to run at extraordinary speeds. Lila Volkov is code-named Bulldog. She has a reinforced skeleton, and her torso and arm implants give her incredible strength. Jackson Pike, code-named Jackdaw, was a brilliant young technical engineer until his accident, and now his right hand is a sophisticated multitool of his own design. William Solarin is known as Kestrel. He's the pilot of the group, and his neural implants provide him with lightning-quick reflexes and dexterity. Saloma Lasonde is the fifth member of the group. Her ocular implants can receive and project almost every wavelength in the electromagnetic spectrum, giving her remarkable vision. Her code name is Mantis."

"Oh, I get it," says Jennifer. "Like a mantis shrimp. They've got the most amazing eyesight in the animal kingdom. We studied them in biology."

"That's right," says Jonah. "She chose her code name for exactly that reason. And the sixth and final member is the leader of the Saviors. A resourceful young man, with a cybernetic arm, whose code name is Zero."

As Jonah mentions the one called Zero, I notice his eyes flick toward me and linger like he's expecting some kind of reaction. I glare back, frowning questioningly, and he quickly looks away. What the hell? Yelling at me, accusing me of ridiculous things, trying to order me around, and now weird little looks? Something strange is going on with Jonah. He's not being the man I know, and it's starting to creep me out.

"Wow. They all sound so cool," Bit says goofily.

"Except for Zero," Brent says snidely. "He's got a lame code name."

"He also has a long and complicated history. But if you're ever in a pinch, trust me, you'd want Zero by your side," Jonah says, eyeballing me weirdly again.

"Have you been able to contact any of them?" Percy asks Jonah. "I know I'm stating the obvious, but a rescue team is exactly what we need right now."

"No, I lost contact with them when the power went out," says Jonah. "The signals to their headsets were relayed through the transport, but of course that went up in flames. There were walkie-talkies on board as well, and I've been trying to reach them on the agreed channels, but so far . . . there's no reply. Hopefully they've found somewhere safe to hide, and once we repair Onix, we can access the facility's loudspeaker system to notify the Saviors and any remaining survivors that help is on the way."

"And the sooner we do that, the better," says Dr. Pierce.

Jonah nods in agreement. "One final run-through, just so everything is clear. Bettina, Brody, and Finn, you'll go with Dr. Pierce to

the reservoir hatch. He'll open it and wait while you three climb to the manhole in the center of Dome Two. With no set program running, the dome will be completely empty, except for the transport wreckage, but it will be dark in there, so you'll need to take flashlights.

"When you retrieve the slate, Dr. Pierce will take you to the computer core in Sector A, and then, Bettina, the rest is up to you. We'll all keep in contact with the walkie-talkies, but should anything go wrong, get back to the hatch. If you can't make it back, find somewhere to hide, and if there's nowhere to hide . . . run." Jonah looks around the group of solemn faces. "Are there any questions?"

No one says a word, but all of a sudden the flash of gunfire that ended Ryan's life bursts into my mind again, lighting up the emotionless stare in the cold eyes of the evil bastard who killed him. "What about Captain Delgado?" I mutter as I try to shake the image from my head. "He's a slippery snake. I wouldn't be surprised if he's still alive up there somewhere."

Jonah's expression darkens into a look of grim contemplation. "I've been told what he did, and while there's no excusing his actions, I know firsthand how a misguided intent to protect others can drive people to do unspeakable things."

Jonah glances at me from the corner of his eye for a split second, and for some reason an uneasy shudder ripples through my entire body.

"If you see Captain Delgado or any of his soldiers, my advice is to run the other way," Jonah says sternly. "When this is over, I will personally see to it that my old friend is brought to justice before a military court of his peers. He'll pay for what he's done. I promise you that."

My hands tighten into fists, and my jaw clenches. If I see the Captain, I sure as hell won't be running the other way. I'll dispense my own justice. And I'll enjoy every sweet second of it.

"Your school satchels will easily hold a flashlight and a walkie-talkie," continues Jonah. "But it might be a good idea to take a can or two of Dr. Pierce's spray-on bandages as well. I'm sure you won't have

to use them, but it's better to have them and not need them than to need them and—"

"Watch as your blood leaks out of your bullet-ridden bodies?" says a twitchy-eyed Brent.

Jonah throws a disapproving sideways glare at Brent. "The Professor clearly made a wise decision to leave you out of this."

"Hey, that's fine with me," Brent says, raising his hands in mock acceptance. "If you guys don't make it, I'll be safe and sound down here."

"Slowly starving to death," says Bit.

Brent's silence and sour expression are supremely satisfying to witness.

"I . . . I'd like to help," squeaks Jennifer. "If there's anything I can do . . . I'd really like to."

Jonah smiles at her. "Are you sure?"

She meekly nods her head.

"Brave girl. OK then." Jonah picks up one of the walkie-talkies and tosses it to Jennifer. With a clumsy finger-dancing fumble, she manages to catch hold of it. "You can come through to the far hatch with us and keep lookout. You'll stay by the opening, and the moment you feel you're in any danger, get back underground right away."

Jennifer nods, and Jonah turns to Percy and Professor Francis. "Gentlemen, are you ready?"

"Absolutely," Percy replies as he and the Professor walk around the trolleys to join Jonah beside the oxygen tanks. In what I can only assume was part of a previous discussion, both men lay the tanks down on their sides, take nylon harnesses from the assortment of gear, and begin fixing them securely to the heavy metal canisters in a clever effort to make them easier to carry.

Jonah turns to Bit. "It should take us about twenty minutes to lug these through the tunnel to the other hatch and another ten minutes to get to the rooftop of the building I have picked out. When we get to

the hatch, I'll radio back and you can make your way up to the other exit point. The R.A.M.s will be on the move toward us as soon as we're out in the open, so be ready to exit your hatch as soon as they're a good distance away from you."

Bit is trying to look brave as she listens to Jonah, but her slightly quickened breathing is giving away her apprehension, and Jonah can see it as clear as day. He puts a hand on her shoulder and looks down into her eyes. "Keep your mind on the task. You've got Finn and Brody and Dr. Pierce to help you," he says with a reassuring smile. "And don't worry about us. The R.A.M.s won't be able to reach us on the rooftop. I'll make sure everyone is as safe as they can possibly be."

"It'll be a piece of cake," Percy says, grinning at her with his perfectly straight, flawlessly white teeth.

"OK," she says nervously, looking down at a small version of the holographic map that's floating above the slate in her hands.

Jonah helps Percy and the Professor sling the harnesses over their shoulders and position their oxygen tanks as comfortably as possible against their hips. Then he packs some of the flares, two flashlights, two pairs of binoculars, carabiners, and a rope into the yellow duffel bag and zips it closed. He clips one of the walkie-talkies to his belt, hoists the harness of the third tank onto his shoulder, grabs the duffel bag, and looks over at Jennifer. "All set?" he asks, and she nods determinedly. "Alright then. Let's go."

Percy gives a serious nod and heads toward the opening to the passageway that leads into the tunnels.

"Good luck, everyone," the Professor says, his voice slightly strained with effort as he grips the tank and follows Percy with a weighted-down waddle. Jennifer gives us all a nervous smile as she crosses the room and disappears into the dimly lit corridor behind the Professor.

Jonah looks over at Bit. "I've switched all the walkie-talkies to channel three. Expect to hear from me in twenty minutes."

Bit lets out a huge tightly wound breath and nods up at Jonah.

"And, Finn," he says, fixing a resolute stare on me. "I've trained you well. If you find a weapon, take it, and don't be afraid to use it if you have to. I'm relying on you to keep Bettina and Dr. Pierce safe. I'm relying on both of you," he says, looking over at Brody.

"I'll protect her with my life, sir," Brody says dramatically.

"Be careful," I whisper earnestly to Jonah. He smiles and nods his head, and as he turns toward the doorway, a sudden wave of affection and concern ebbs through me.

"Twenty minutes, Bettina," he says over his shoulder as he walks toward the corridor on the other side of the room. "And I'm taking your fire axe, Graham." Jonah opens a red cabinet on the wall and unhooks an axe from inside. Then, with a positive smile and a confident nod, he turns and ambles into the passage and out of sight.

"Everything will be fine." Jonah's voice echoes into the room from the shadows.

I want to believe him; I'm sure we all do. But judging by the looks on everyone's faces and the bad feeling writhing in my gut, I'm not alone in thinking that the moment we step out of that hatch onto the surface is the moment we all walk straight back into hell.

CHAPTER FIVE

Dr. Pierce collects a walkie-talkie from the trolleys and strides across the lab. "Make sure you all have the equipment that you need," he calls over his shoulder as he walks off toward the hallway on the far side of the room. "I'm going to make my final preparations. Be ready to go when I'm done. We leave in twenty minutes."

"I'll go get our schoolbags to carry the gear," Brody says to Bit. She nods at him and gives him a little smile as he turns and follows Dr. Pierce.

"So that's that," says a perspiring Brent as he anxiously wrings his hands. "Now we just wait until you all willingly march off to your deaths."

"You can come with us if you like," I joke as I walk to the trolley and begin sorting through the remaining equipment.

"Hmmm," Brent murmurs as he lifts his hands up and down, pretending to weigh the options, with a mock pondering expression. "Stay down here out of harm's way, oooor . . . be turned into cat food by giant robots? That's a tough one," he says, rolling his eyes.

"I'm going with them," says Margaux.

"What?" exclaims Brent.

Bit and I look at Margaux, then at each other. If my look of surprise is anything like hers, then we both must appear just as shocked as Brent does right now.

"Why?" he blurts.

Margaux turns to him. She looks deadly serious and at the same time pensive. "What have you ever done in your life that actually meant something?" she asks solemnly. "When was the last time you did something that really . . . mattered?"

Brent looks dumbstruck. He's so stunned he doesn't have the slightest idea of what to say.

"This is the most important thing any of us will *ever* do," Margaux says solemnly. "Our lives depend on it. If the plan fails and I chose to stay down here and starve to death . . . then I'm a loser. And Margaux Pilfrey is not a loser. If I'm going to die, I want to die trying, so if it's alright with you . . . ," she says as she walks forward to the trolleys and looks stoically at me and Bit. "I'm coming with you."

Bit smiles admiringly at Margaux.

"Well, holy crap," I say with an amazed smirk of my own. I may be having a little trouble remembering the last few hours, but I definitely recall how permanently stuck-up and vapid Margaux was at school. I always knew it was a facade, but she never let it drop, not until now. This is a side of her that I've never seen before.

"I can fire a gun," Margaux says bluntly. "I won't slow you down, and I'll do whatever you tell me to do. I can help . . . I've decided that I want to help."

"Well, it's pretty hard to say no after a speech like that," I say, frowning bewilderedly at her. "What do you think, Bit?"

"I guess we'll need to find you a gun when we get to the surface, but, yeah, I think we can use all the help we can get."

Margaux grins. "Thanks, you guys, and, Finn . . . I'm sorry I took your necklace."

I frown at her, and my hand reflexively goes to my chest. I can feel my pendant beneath my t-shirt, and I have no idea what she's talking about. "You did what?"

Margaux's eyes go wide. "Oh, um . . . nothing," she stammers.

I stand there in silence, eyeballing her suspiciously, as Brody jogs into the room with three satchels clutched in his hand.

Brody must sense the change of mood in the room, because as he arrives at the trolleys, he scans all our faces. "What did I miss?" he asks as he drops the empty satchels on top of the slates.

"Margaux is coming with us," Bit says, still beaming at her. "We're gonna need another bag."

"Two more," says Brent. I can see him struggling with the wheels of doubt that are grinding in his mind as he takes a deep breath, steps up to the trolleys, and gruffly clears his throat. "There's no way that I'm staying here alone. I'm coming, too," he says, his voice quivering slightly.

"What about your leg?" asks Bit. "That gunshot wound will slow you down. It'll slow all of us down."

"Hey, I'm tougher than I look," Brent argues unconvincingly. "And besides, the Doc gave me some of his personal stash of pain meds. I can't feel a thing, and I bet I can move just as fast as any of you."

Brent turns to Margaux. "I'll be there to protect you, princess," he says, lowering his voice an octave and puffing out his chest. It's so pathetic.

"Aww, baybeeee," coos Margaux.

He is terrified and isn't fooling anyone. Well, no one except for Margaux, who grabs him by the collar and pulls him into a deep and awkward-looking tongue kiss.

I grimace and look away from the grappling pair, but the wet, slurping noises they're making cause my skin to crawl. "I'll . . . get the satchels," I say as I stifle an involuntary retch, grateful for any chance to

leave the room for a few minutes. I sidle behind the canoodling couple and head across the lab toward the entrance to the passageway.

"The bunk room is down the hall to the left," Brody says, and I nod him a thanks as I pass by.

I walk across the lab into the passageway and head down the corridor. When I think about it, I actually respect the sentiment behind Margaux's decision, and a couple extra sets of eyes and ears may come in handy up there. But on the other hand, I can't help thinking that having her and Brent tag along might also turn out to be a giant mistake. What if they panic and run off into danger? No doubt Brody and I will end up being the ones who have to save them. Either way, it's their choice and I won't try to stop them from coming. As long as Bit is safe, part of me doesn't give a damn if Margaux and Brent live or die.

I arrive at the first door on the left and duck into the submarine-style doorway, wondering where such a cold and callous thought came from. It's not like me to disregard anyone's lives so flippantly, even if I do think they're a pair of elitist douche bags. I push the thought to the back of my mind and look around the room.

Even though it's quite large, the low ceilings and the rows of metal-frame bunk beds make the space feel cramped. There's a faint musty smell, as if this room hasn't been properly used for years. Dr. Pierce said something about this place being a war shelter. I feel for anyone who was forced to spend any considerable length of time down here. I count four rows of five bunks, twenty in all. Each mattress has a pillow and a thin blanket on it, and most are tidily made, but as I duck down and scan the lower bunks, I see a few blankets have been disturbed. One bed in the center of the middle row is obviously where Brody emptied out the contents of the three satchels. There's a lacrosse ball, crumpled fast-food receipts, a stick of deodorant, a couple of notebooks, some pens, a key ring, gum wrappers, and a few other useless things that always seem to gather in the bottom of every bag. There's even a vaguely familiar-looking tube of lip gloss that I think may be mine.

I walk between the rows of beds toward the one right in the corner, where I see Brent's and Margaux's bags hanging from the post of the top bunk. I take them both down and shake their contents onto the lower mattress. Margaux's ridiculously expensive Jonti Lamoureaux satchel is mostly cluttered with makeup, and Brent's bag is unusually clean and nearly empty, save for a comb, a notepad and pen, and a lacrosse tournament "Most Valuable Player" ribbon. The fact that he carries that around everywhere he goes is exactly why he deserves to become something a giant robot has to scrape off the bottom of its foot like a dog turd.

I reprimand myself for such a dark thought and yet chuckle to myself as I picture it. I take the empty bags and head back toward the door, but as I'm passing the small heap of satchel scatterings on Brody's bunk, something on the floor just beneath the bed catches my eye. It must have fallen under there when the other satchels were emptied. I kneel down and pick it up.

It's a photograph of a young woman. She's dressed in a t-shirt and shorts and hiking boots and kneels by a campfire at the edge of a river. She's pretty, with dark, frizzy hair tied back in a ponytail. Freckles pepper her nose, there's a slight smile on her lips, and her big brown eyes look just like Bettina's. At a guess, she must have been eighteen or nineteen years old when this was taken, and something about her seems so familiar that I almost feel angry that I can't put a name to her face. I stare at the young woman, willing her identity to reveal itself from the persistent fog clogging the back of my mind, but . . . nothing comes. I know her face. I'm sure of it. But for the life of me, I just can't remember where from.

Judging from the physical similarities of the girl in the photo, this most likely belongs to Bit. It could be her sister, or maybe her mother when she was younger, I suppose. I don't recall Bit ever mentioning a sister, but that's hardly surprising considering the state of my memory at the moment. Whoever it is, if Bit carries the photo around with her,

it must be a cherished keepsake. With one last look at it, I slip the picture into the back pocket of my jeans and head toward the door, still pestered by the annoying fact that the name of the mystery girl in the photo is lingering somewhere on the tip of my addled brain. I try to focus on hearing her name as I scroll through random guesses in my mind. Sarah? No. Mary? No, that's not it, either. Frustration is setting in, but as I step through the door into the hallway, I actually hear a name whispered faintly from somewhere down the hall.

"Infinity."

I turn and look down the corridor. They were only fleeting murmured syllables; the voice was barely perceptible, but I heard it. I'm certain it wasn't just in my head. Then again, the fact that my mind has a habit of playing tricks on me lately isn't very reassuring, so, just to be sure, I quiet my breathing and walk down the hallway, listening carefully. In the dim florescent light, I see a closed door in the right-hand wall twenty feet or so farther down the corridor. I focus all my attention on the door, and all of a sudden an unexpected rising hiss begins growing in my ears, like the sound you hear when you max out the volume on a stereo.

"She has been through a lot today, but she's coping well, I think," a muffled male voice says.

I knew I wasn't imagining things. In fact, the voice sounds so much louder than it did before. Curious, I softly creep along the passage, and as I take a step forward, to my surprise, I can hear the amplified rustle of my clothes against my skin. A gentle draft wisps down the corridor, and I can hear the air moving against the walls. I can even hear the tic-tacking footsteps of a small black beetle as it waddles along a seam in the floor near my foot. I smile at my suddenly enhanced hearing as I slink farther along the passage, and when the voice speaks again, I can hear it loud and clear, as if I were standing on the other side of that closed door.

"All things considered she's in perfect health," says the voice. It's Dr. Pierce. From what I've seen, he seems like a quirky old man, but

is he actually holed up in that room, talking to himself? The answer to that question is immediately answered when I hear another man's voice. It's slightly raspy and distorted, as if it's coming out of the speaker of a walkie-talkie.

"Good," the stranger says. "It's important that she remains unharmed until she's required."

Now I'm completely intrigued.

"Yes," replies Dr. Pierce. "We have a problem. Infinity has insisted on joining us on our little errand."

"Is there some way you can detain her?" says the man. "We may need her if the initial conduit fails."

"Of course, that's why I tried so hard to save her. But I can't detain Infinity without raising a lot of questions."

"Infinity should never have been released from Blackstone Manor. At least that way we would have avoided a lot of difficulties," says the man.

"Well, Major Brogan and his military pals in the boardroom are responsible for *that* rash decision," says Dr. Pierce. "But there's no need to worry. She might even increase our chances of success. Right now I'm more concerned about our other little problem."

"Ah, yes," says the other man. "How much does she know?"

"I'm not sure," says Dr. Pierce. "We need her to repair the damage she did to Onix, so allowing her access is necessary . . . but it's also very risky. If Bettina gets her hands on any more files, she may unearth some very sensitive details about a particular member of her family. You know who I mean, and we both know that's who Bettina has been searching for. If she discovers the truth . . . it could jeopardize everything."

"I'm well aware of Miss Otto's motives, but once Onix is repaired we can initiate the final stages of Project Infinity and none of that will matter," replies the man. "Do not fail me, Graham. Today's disastrous circumstances will no doubt have attracted unwanted global attention by now. I don't know when they're coming, but they will. And when they do, they won't understand what we're trying to achieve for

the future of humanity. They could undo everything. The timing is not ideal, but our hand has been forced. We must do this as soon as possible."

"I won't fail," says Dr. Pierce.

"Good. I'm relying on it. Contact me again when Onix is restored to full working order. I will do it if I'm forced into a corner, but the last thing I want is to completely replace him. That could be very . . . complicated."

"Yes, it could," says Dr. Pierce.

I hear a click and some shuffling, then the quiet whine of the metal wheel in the door winding open.

I quickly turn and jog as quietly as I can back down the corridor toward the lab. Who was Dr. Pierce talking to? It certainly wasn't Jonah or Captain Delgado. Why do I need to be kept safe? What was all that about someone from Bit's family? And what the hell is Project Infinity? I clearly don't have enough pieces to make a complete picture of this puzzle, but whatever's going on, I don't have a good feeling about it at all. I think I'm gonna have to keep a very close eye on Dr. Pierce, but first, I really need to speak to Bit.

I scoot into the main room with the satchels in my hand as I hear Dr. Pierce step out into the corridor behind me. I stride over to the trolleys, dump the bags onto the slates, and pull Bit aside.

"We need to talk," I whisper.

Bit frowns at me with a look of concern. She can obviously tell that I'm more than a little flustered. "Um . . . OK," she murmurs. I glance over my shoulder and see Dr. Pierce striding down the hall toward us.

"Not here."

Bit looks sideways at Dr. Pierce and seems to get the message. "This way," she whispers. Bit sets her slate down on the trolleys and heads across the room toward another passage. I fall in step behind her.

Brody looks up from packing some of those useless camping knick-knacks into his satchel. "Is everything OK?" he asks.

"Absolutely," says Bit. "Finn . . . just wants something to eat before we go."

"I could eat," Brody says as he turns to come with us.

"No," Bit replies sharply, and Brody frowns. "I'll . . . I'll bring you something." Brody nods disappointedly and sheepishly turns back to the trolleys as Dr. Pierce walks into the room.

"Ten minutes," he says, looking at his watch.

"OK," chirps Bit. "We're just going to the kitchen."

"Don't be long. It's almost time," he says, and I throw him a painted smile as Bit and I nonchalantly walk across the lab and into the side corridor. A few feet in, Bit ducks into an open doorway, and I follow right behind her.

Inside the room is a bench table with half a dozen wooden stools around it. Up against the wall, there's a stainless-steel kitchen sink with cupboards underneath it, and in the corner is a machine that resembles a large, cumbersome photocopier. The words "Nutra-Print 1000" are written across the front. It's an industrial-size, well-used, and clearly outdated food printer. Maybe antiquated is a better description.

Bit quietly pushes the door closed behind us, winds the wheel, and slides a lever, locking a sturdy bolt into place. Then she walks over to the printer and jabs a few buttons, and it noisily whirs to life. I take a seat at the table, and with a wide-eyed look of expectation, she comes over and sits on the stool beside me.

"What is it?" she asks.

"When I went to get the satchels I heard Dr. Pierce talking to someone, on a walkie-talkie."

"Who?"

"I don't know. It was a man, but I didn't recognize his voice. At first they were talking about me, how they need to protect me until I'm *required*."

"Required for what?" asks Bit.

"I'm not sure, but they did mention something called Project Infinity. Do you know what that is? Was there anything about it in any of the files you accessed?"

Bit shakes her head. "No, I didn't see anything about that. But if it's named after you, I'm not surprised they need you to be a part of it."

"I know, it's super creepy, but there's more. They were talking about you, too."

Bit's eyes narrow. "Me? Why?"

"They need you to fix Onix, not so we can escape, but so they can use him to initiate Project Infinity. The man said that if the outside world found out about it, they'd try to shut it down, so I'm assuming whatever it is, it can't be good."

Bit frowns. "So do I fix the mainframe or not?"

"I guess you have to, if we want to get out of here alive."

"We need to find out more about Project Infinity," says Bit. "After I repair the computer you need to buy me some time to delve deeper into the classified files. Maybe I can find out what we're dealing with."

"OK, when the time comes, I'll make sure Dr. Pierce is suitably . . . distracted."

"How?"

"Oh I don't know," I reply with a sly grin. "I was thinking a swift kick to the head might do the trick."

Bit smiles, and in the corner of the room, the whirring printer stops with a little ping sound. Bit starts to stand up, but I grab her by the arm and pull her back onto the seat. "There's more. Dr. Pierce and that man mentioned someone else."

"Who was it?" asks Bit.

"I'm not sure what it means, and I didn't hear a name, but they said something about how they had information about a certain member of your family?"

Bit goes so still I could swear that time has stopped.

I reach into my back pocket, pull out the photograph of the young woman, and slide it onto the table. "Is this who they were talking about? I found it in the bunk room." Bit's eyes dart in the direction of the picture and her gaze lingers on it as she nods sadly.

"What did they say about her?" Bit whispers gravely.

"That you've been looking for her."

"They must have seen the files I was trying to access. I didn't cover my tracks properly. I'm so stupid," Bit says. Her voice is shaky, fearful.

"It's weird," I say, taking another long look at the girl in the photo. "She looks so familiar. What's this all about?"

Bit looks up at me with tears in her eyes. "Please don't hate me."

"Why would I hate you?" I ask, frowning with confusion.

"Because I've been lying to you," Bit says, and her already tortured expression darkens even more.

"About what?" She shakes her head, and her lip trembles. I gently put my hand on her arm. "Bit, you're my best friend, you can trust me. Tell me what's going on."

Bit avoids my eyes and looks at the picture instead. "The girl in the photograph is my half sister," she whispers sadly. "I only found out about her a year ago when I was snooping through my mother's computer. It took months of searching in a lot of different places, but I finally dug up everything about her that I could find. It's pretty messed up, Finn."

"What is?" I ask, suddenly intrigued.

Bit takes a deep breath and lets out a huge sigh. "My mom got pregnant in high school and put my sister up for adoption. Years later my mother had become a successful businesswoman and respected public figure. A scandal would never do, so she deleted every record of the adoption and paid the father to keep his mouth shut, but she should've known better. Nothing ever gets deleted, not really. Anyway, my sister obviously had talents of her own, because she tracked my mom down. My mother threatened her with lawyers, but my sister didn't want to

hurt my mother; she wanted to make her proud. She got a job working for Blackstone Technologies and . . ." Bit lets out another long sigh. ". . . she stole research from them. The tech my mother's company developed from that research made my mom a billionaire."

Bit looks so ashamed. She drags her arm away from my hand and stares at the photograph. "That's why I didn't tell you about any of this. I'm sorry I kept all this from you, Finn, but I hope you can try to understand the reasons why I did, and I hope you can forgive me."

"Whoa," I say, staring at Bit in disbelief. "So that's why you hacked into this place? That's why we're all here?"

Bit nods. "My sister went missing nine years ago, and that's where the trail went cold. When I confronted my mom about all of this, she denied everything. She even denied that my sister ever existed. But that was just another lie. Someone at Blackstone Technologies must have found out who my sister was and what she was doing and had her . . . killed. I was sure the proof I needed was somewhere inside the main computer, but it was impossible to hack from the outside. But then a month ago, that night in our dorm room, suddenly I had all those passwords, and I finally had the access I needed. I knew this was my only chance to infiltrate the facility and find proof of my sister's death."

I lean back against the table and try to take this all in.

"I'm sorry I kept this from you, but I couldn't take the chance that you might reveal my plans to your father." Bit slides the picture closer to her and studies it wistfully. "Most of all I'm sorry I came here. I didn't mean for so many people to die. But I thought I was doing the right thing. All I wanted was some justice for my sister." Bit holds the photo up and stares at it. "If she was alive, she would've turned thirty-five this year," she says, turning the picture toward me. "I look a lot like her, don't you think?"

Still a little stunned at Bit's revelations, I look over at the picture. It's true; it's easy to tell that they're related. Their features are very similar,

and as I noticed before when I found it in the bunk room, they even have almost exactly the same big brown . . . *eyes*. Her eyes!

All of a sudden a face, her *sister's* face, is revealed in my mind, like the fog has been whisked away. I can see her standing by my bed in her crisp black-and-white maid's uniform, her hair pulled back tightly in a bun, smiling down at me with a gentle sadness in her eyes. She leans down and tucks the covers up under my chin, just like she has done so many nights before. She kisses me on the forehead and whispers, "Goodnight, Miss Blackstone." Bit jumps in her seat beside me as I gasp her name out loud, "Mariele!"

Bit's eyes widen. "That's right . . . ," she murmurs as she stares at me bewilderedly. "My sister's adopted name was Mariele Sanders, but . . . I thought you said they didn't mention it?"

"They didn't," I whisper.

"Then I . . . I don't understand," Bit says, and I grab her arm as my heart pounds in my chest.

"I knew her. She worked as a maid in my house when I was a little girl. I didn't remember until right now, but . . . I knew your sister!"

Bit looks understandably stunned. She grabs my hand and squeezes it tightly. "Really?" she says as her eyes begin glistening with tears.

I nod emphatically. "But that's not all, Bit. The way Dr. Pierce and that man were talking about her was—"

"What?" Bit blurts out.

I look her right in the eyes. "Your sister. I think she might be . . . alive."

CHAPTER SIX

Bit's face goes completely blank.

I don't know what she's feeling right now, but she's turned so pale she looks like she's seen a ghost, which, in a way, is exactly what her long-lost sister must have been to her, right up until this very moment.

"What do you mean . . . she's alive?" Bit mumbles.

"They said that by the time you find her it will be too late. I don't think they'd say something like that if she was already dead, do you?"

"I don't know," Bit says, looking more and more bewildered with every passing second. "Did they say where she might be?"

I shake my head.

"Hello?" says a muted voice from the other side of the door, and both of us freeze.

It's Dr. Pierce.

The wheel in the center revolves, and he pushes against the door, but it jars against the bolt. "Why is this door locked?" he asks.

"Just a minute!" I yell. Bit looks catatonic. "Hey," I whisper, and her eyes twitch toward me. "I care about my father and his company about as much as he cares about me, which is not at all. I get why you lied,

and if your sister is alive and being held captive somewhere, we're gonna find out where she is, and we're gonna go get her . . . together. OK?"

"I . . . I never imagined that Mariele might still be . . . alive," stammers Bit.

"What are you two doing in there?" shouts Dr. Pierce.

"We're just talking . . . about girl stuff!" I shout back, cringing at my lame excuse.

"Well, make it snappy! It's almost time to leave!"

"OK. We'll be right there!" I yell, and I can hear him muttering to himself as he walks off down the corridor. I turn back to Bit. "C'mon," I whisper as I stand and pull her up by her wrist. "If we're gonna save your sister, we have to make sure that we save ourselves first."

I stride across the room, slide the latch, wind the wheel, and swing the heavy door open. Bit crosses the room and follows me into the corridor, but she's looking at the floor and shuffling like a zombie. "My sister is alive," she murmurs.

I swing around and hiss at her to be quiet. "Shhhh." I walk over and grab her by the shoulders. "For her sake, for all our sakes, you need to pull yourself together," I whisper sternly. She looks up at me, takes a deep breath, and nods. I give her an encouraging smile, put my arm around her, and we both head down the passage into the main room together.

Dr. Pierce and the others are gathered around the collection of trolleys. "It's about time," he says over his shoulder. He does a double take at Bit. "What's wrong with you, girly?" he asks. "You didn't open one of those old cans of tuna fish in the bottom cupboard, did you?"

"No, she's fine," I say as I guide her across the room. "She just had a last-minute attack of nerves, that's all."

Dr. Pierce picks up the slate that Bit was using from on top of the trolley and thrusts it into her hands. "We need you, girly," he says gravely. "This may sound harsh, and if it does, I apologize in advance, but we don't have time for anyone to get cold feet right now." He glances

at his watch. "It's almost been twenty minutes since Major Brogan and the others left, so I'm expecting them to make contact any second now."

"I'm good," Bit says unconvincingly.

Brody walks over with our schoolbags in his hands. He passes mine to me and offers the other one to Bit. "We've got four walkie-talkies left. Dr. Pierce and Margaux have one each, and I put the other two in your bags. There's also flashlights and a can of spray bandages in both of them. Finn? Do you want the binoculars? They don't fit in here," he says as he takes them from the top of his bulging bag and holds them out to me.

"Um, sure, thanks, Brody." I stuff them into my satchel, sling it over my head, and adjust the strap across my chest. "What on earth have you got in there?" I ask, pointing to the overstuffed satchel hanging at his side.

"Oh," he says with a goofy smile. "Pretty much one of everything that was left. Rope, matches, foil blankets, a coil of fishing line . . . I've even got a couple of flares in here if you want one?"

"No, it's OK," I say with a bemused smile. Bit, on the other hand, is still obviously very shaken, and it shows.

Brody looks at her with an expression of concern. "Everything is gonna be OK. I won't let anything bad happen to you," he says warmly.

Bit smiles. "I made you a cupcake, but I left it in the printer," she says meekly.

Brody chuckles. "When we get out of here, cupcakes are on me."

"What I wouldn't give for some food that isn't made from printer slime," sighs Margaux.

"You can keep your cupcakes," says Brent. "Cheeseburgers, fries, and double-chocolate thick shakes all around after this. I'd even eat the ones they make in the school cafeteria."

Bit grins. "Don't you think you're risking your life enough already?"

Everyone laughs nervously, but as all of our eyes meet, the smiles slowly fade, and we stand there, looking at each other in silence.

Everyone's face has turned stony serious, and I'm sure I'm not the only one who has a bundle of nervous energy clawing at my stomach. Brent looks especially on edge. Knowing that you have to do something that you're dreading is bad enough, but the waiting before it happens is excruciating.

I'm almost relieved when there's a short burst of muted static and Jonah's muffled voice issues from inside three of our satchels. "Hello, are you reading me?"

I reach into my bag, pull my walkie-talkie out, and jab my thumb into the "Talk" button. "We can hear you, Jonah," I reply.

"Finn, is Dr. Pierce there?"

Dr. Pierce glares down at the unresponsive walkie-talkie in his hand, and I watch him with justified suspicion as he twists the channel knob on top three clicks to the left. "Blasted thing was on the wrong frequency," he mutters as he presses the button on the side. "Graham here, Major."

"We're almost at the exit point," says Jonah. "Make your way to the first hatch, and contact me when you get there."

"Will do," replies Dr. Pierce. "We're on our way."

Dr. Pierce slides his radio into one of his lab coat pockets and strides across the room. Bit and I share one last look of nervous determination and fall in behind him. Brent and Margaux follow suit, and we all walk in silence into the corridor on the other side of the lab. The passageway is short and dim and ends in a landing with a rickety-looking metal cage elevator. Dr. Pierce slides the door open, steps inside, and positions himself beside a control panel that has three large buttons set in a vertical line. None of us says a thing as we all shuffle in around him. Brody rattles the door closed. Dr. Pierce presses the middle button, and a motor whirs into life somewhere above us as the elevator jolts and begins to rise. There is no eye contact and no smiles or words, only the quiet sound of anxious breathing under the mechanized hum

of the motor and the metallic twangs of the cable echoing through the dank and musty air.

It isn't long before the elevator shudders to a halt and Dr. Pierce slides the door open. He steps out, and we follow as he leads the way along a narrow metal lattice gangway and up a flight of stairs. Margaux is ahead of me, and in the dim yellow light I can see her hand trembling at her side. Half hunched over in a low-ceilinged tunnel, we carry on in single-file silence until eventually we arrive at the opening of a large copper-colored metal pipe. It's angled diagonally upward, with hand-holds cut into the sides. Dark-brown streaks of dried blood are smeared down the length of the lower curve, and I remember . . . it's mine. I know that I was badly hurt when everyone carried me down here, but seeing the sheer amount of blood I left behind makes me a little queasy to say the least. Even with my rapid-healing ability, it's no wonder that everyone was so surprised I survived.

Dr. Pierce crouches down beside the mouth of the pipe. He retrieves his walkie-talkie from the deep pocket of his lab coat and squeezes the "Talk" switch. "We're in position, Major."

"Copy that," replies Jonah. "Bettina? Are you there?"

Bit quickly fishes her walkie-talkie from her satchel. "Yes, I'm here."

"Even though you'll be monitoring the R.A.M.s' positions, I'm not willing to leave anything to chance," says Jonah. "Jennifer will stay at the open hatch at our end to alert you when she has direct visual contact with all three of the mechanoids. When she has them in sight, they should be far enough away from your exit point to give you time to reach the entrance to the reservoir."

Even though Jonah obviously can't see her, Bit nods at the radio in her hand. "OK, we'll wait for her signal."

"Good. I'd wish you luck, but you don't need it," says Jonah. "Move fast, keep your wits about you, and you'll all be fine."

"Do your best, everyone!" Percy shouts in the background.

"Alright. Let's get this show on the road. We're exiting the hatch now," says Jonah, and with a short burst of static, our walkie-talkies go quiet.

Bit tucks hers away, pulls the slate from her satchel, and switches it on. A small version of the holographic schematic of the facility glimmers into view, and we all crouch around it to get a better look.

"How long do you think it will take for the R.A.M.s to take the bait?" I ask.

"I don't know," replies Bit. "As soon as Jonah and the others exit that hatch they should trip the motion sensors. I can't imagine it will take any longer than a few minutes before—"

"Look!" blurts Brody. "One of those dots is flashing."

"Already?" exclaims Dr. Pierce.

I study the hologram, and sure enough the first in a line of ten small orange circles on the map is flickering sporadically. One of the slates Percy and the Professor set along the tunnel is registering movement, but as suddenly as the small amber light came on, it goes out again.

"The R.A.M.s must be on the move," says Bit.

"I don't feel any vibrations," Margaux whispers as she looks around the walls. "I don't hear anything, either."

"That is weird. We should be able to hear them," Bit says as she takes a moment to listen. The tunnel is silent.

"Well, something is moving up there," I murmur.

"And it's moving fast," barks Dr. Pierce as the second circle in the line lights up.

"Too fast," Bit whispers ominously. She looks up at me, and she looks confused. "Our sensors are spaced out at specific intervals. The R.A.M.s don't move quickly enough to have tripped the second one, Finn."

"They might be rolling," says Brody. "They rolled down that hill, remember?"

"It's pretty hard to forget," Brent mutters shakily.

"But that was a hill," Margaux points out, staring at the diagram. "The ground on the way to the other hatch looks flat to me."

The second circle dims, and less than ten seconds later, the third lights up.

"Major Brogan said that the R.A.M.s can self-propel in rolling mode," says Bit. "But we took their top speed into consideration when we were planning this. Whatever is setting off the sensors is hitting the ground just hard enough to register but moving way too fast to be a mechanoid."

The third light goes out; there's a moderate delay, and then the fourth in line flickers on.

"What could it be?" Margaux says as the light blinks off.

I pull my walkie-talkie from my satchel and thumb the "Talk" button. "Jennifer? Are you there?"

There's a short hiss of static, and Jennifer responds. "Yes, I'm here."

The fifth orange circle illuminates.

"The seismic beacons are being tripped. Something is heading toward you, and it's moving fast. Can you see anything?"

Jennifer must be squeezing her radio tightly, because the sound doesn't cut off as she shuffles to her feet. "The whole place is lit up now, even Sector C," she says quietly. "I have a clear line of sight for quite a distance into Sector B, but I don't see or hear the R.A.M.s at all."

Light number five goes out.

"I don't think it's a mechanoid," I say into my radio. "I think it's something else . . . *someone* else."

"What do you mean?" Jennifer asks nervously as light number six starts glowing.

"I think it might be Gazelle."

"One of the Saviors?" asks Jennifer.

"I think so," I reply. "Her legs are cybernetic prosthetics. And she's the only one I can think of who can move that fast."

"Gazelle is alive?" Jonah's voice pipes in as orange circle number six cuts off.

"You really think it might be her?" asks Bit.

"I do," I reply with a nod. "Who else could it be?"

"OK," Bit says with a puzzled look on her face. "But if it is Gazelle, how did she know to head toward Jennifer? There's no way she could've seen her from that distance."

"Yeah, you're right," I reply as orange light number seven lights up and then just as quickly flickers out. "It doesn't make any sense. Be careful, Jen," I say into my radio. "Gazelle or not, whatever it is, it's getting real close."

"I still don't see anything," Jennifer replies as dot number eight blinks on.

"The only way that Savior girl could see Miss Cheng," Dr. Pierce mumbles to himself, "is if she had access to the mainframe's video feed . . . or motion sensors . . . or, oh no . . ."

Circle nine begins flickering on the map, and Dr. Pierce quickly puts his walkie-talkie to his lips. "Wait! Miss Cheng, did you say that the lights are on in Sector C?"

"Yes," replies Jennifer. "I can even just make out the top of Dome Three from here."

"Major Brogan!" Dr. Pierce blurts into his radio. "What's your position?"

"We're in the fire escape stairwell of the admin building at the southern end of Sector B," says Jonah. "My magnetic key card worked on the lock and saved us having to bust in, so we're making good time."

"Look out the window, Major!" shouts Dr. Pierce. "Can you see warehouse eighteen from where you are?"

There's a pregnant pause.

"We're nearing the fifth-floor access door, and yes, I . . . I can see it," replies Jonah.

"The warehouse door, is it open or closed?"

"What?" says Jonah.

"The large retractable door! Is the door to warehouse eighteen open?" Dr. Pierce's eyes dart anxiously from side to side behind his glasses as he waits for an answer.

On the slate the tenth and final orange circle lights up, and Bit grabs my walkie-talkie hand. "Jenny, the last sensor has been tripped," she says into my radio. "Whoever or whatever is out there should be in sight in a few seconds."

Suddenly Jonah's voice issues from our radios. "Oh no, Graham . . . warehouse eighteen is open."

Dr. Pierce's face drops.

"It is her, I can see her!" yells Jennifer. "Gazelle! Over here!"

"Miss Cheng!" Dr. Pierce shouts into his radio. "Get back inside the hatch and lock it behind you, right now!"

"She's seen me, too! She's coming this way!" yells Jennifer. "Wow! She's so fast!

"No!" bellows Dr. Pierce. "Get back inside the hatch!"

"Get underground, Jennifer!" shouts Jonah.

"What?" she replies. "Say again please."

"Get in the hatch!" shouts Jonah.

From Dr. Pierce's walkie-talkie I can hear the spaced-out thuds of Gazelle's bounding feet getting louder and louder.

"Slow down!" Jennifer yells. "Gazelle! Stop!"

"Oh no, please no," whispers Jonah.

Suddenly a shrill and panicked scream wails from the walkie-talkies and echoes throughout the tunnel. The sound of something whooshing quickly through the air issues through the radio speakers, and in the very next instant Jennifer's desperate howl is abruptly cut short by a brutal thud, a wet crunch . . . and then silence.

"Jenny!" I bark into my radio.

There's no answer.

"Jennifer!" I shout again.

Nothing.

"What . . . what just happened?" asks a confused-looking Brody.

"I can see them," says Jonah, his voice cracking. "Gazelle . . . she . . ."

"She kicked Jennifer right in the head!" Percy shouts in the background. "There's so much blood, and . . . and she's not moving."

"Oh my lord," whispers Professor Francis.

"We can use the tunnel to reach Jenny and bring her back to the lab," I say into my radio.

"No," replies Jonah. "There's no point. Jennifer is gone."

"Gone? As in dead?" I ask.

"Yes, she's dead," Jonah replies gravely.

Margaux gasps and clasps a hand over her mouth as Bit and I look at each other in bewildered shock.

"Are you sure?" I ask.

"There isn't much left of her head, so, yes . . . I'm sure," Jonah says bluntly.

"And now Gazelle is standing over Jennifer's body, staring right at us, pointing," says Percy.

"Red . . . ," Professor Francis says in the background. "Why are her eyes glowing . . . red?"

"And what on earth is that thing attached to her face?" says Percy.

"I don't understand," says Brody. "What's happening?"

"I'd like to know the answer to that question myself, Mr. Sharp," says an audibly shaken Professor.

"I told her she'd be safe," mumbles a clearly perturbed Jonah. "I told her everything would be OK."

"Well it's freakin' not!" shouts Brent, his heavy breathing steadily creeping toward hyperventilation. "You lied and now she's dead, just like everyone else is!"

"Calm down," I say, looking over at him.

"Don't you tell me what to do, freak!" he shouts manically.

"Is that Mr. Fairchild I can hear?" says the Professor. "What on earth is he doing at the hatch?"

"Brent and Margaux decided to come with us," I reply.

"I don't know if that's a wise idea," says the Professor. "Perhaps they should stay down in the shelter until—"

"Hey!" Brody interrupts, pointing at the slate. "The light, it's blinking again."

"We've got another seismic reading," Bit says shakily as the first orange circle begins flickering.

This time the faint, distant rhythm of multiple weighted footsteps can clearly be heard rumbling through the ground.

I squeeze the "Talk" button on my radio. "The R.A.M.s are on the move. They're heading in your direction."

"Copy that," replies Jonah as he snaps back into a military tone. "Listen, we're carrying on to the roof. Stick to the plan. When the R.A.M.s trip the last sensor, go for the dome." And with a hiss of white noise, he breaks contact.

The looks on everyone's faces range from Bit's and Brody's complete shock and Margaux's confused bewilderment all the way up to Brent's contorted expression of rising panic.

"Can someone tell me what the hell is happening?" shrieks Margaux. "Why did that girl kill Jennifer?"

"Gazelle was scouting ahead," Dr. Pierce says under his breath. "She was assessing the threat."

"But . . . why would she do that?" Bit asks as she glares at Dr. Pierce. A serious-looking Dr. Pierce doesn't respond; he's just crouching there, frowning and staring into space. I can see the guilt painted on his face. He knows something; that much is obvious, and it doesn't take a genius to guess it has something to do with that warehouse in Sector C.

"Graham!" I snap at him, and he flinches. "Why would one of the Saviors attack one of us?"

"Attack?" yells Brent. "She murdered Jennifer!"

"I know!" I bark as I throw a stern glare at the clearly distraught Brent. I turn back to Dr. Pierce. "Gazelle saved my life, and then suddenly, out of the blue, she does this? It just doesn't make any sense. You know something, so tell us. What are we dealing with here?"

He looks at me over the top of his glasses with an icy glare. "Warehouse eighteen."

"What is warehouse eighteen?" asks Bit.

Dr. Pierce takes his glasses off, wipes the lenses on the sleeve of his lab coat, and lets out a sigh. "In the early days it was a scientist's dream to work for Richard Blackstone; it really was. Developing technology based on his discoveries and research was . . . awe inspiring." Dr. Pierce props his glasses back onto his nose and strangely chuckles to himself.

"The sheer brilliance of his mind was blinding to behold, and that's what's so funny . . . in a way, it really *was* blinding. Most of us, including myself, chose to ignore the moral implications of what we were doing. We just put our heads down, worked on our projects, and marveled at our achievements, never once stopping to ask whether or not we should."

"What the hell are you babbling about, old man?" says Brent.

Dr. Pierce lets out a weary sigh. "Warehouse eighteen is where the unauthorized prototypes are stored. Blackstone Technologies manufactures weapons for the military, so it's required to submit details of military projects to officials of the United Alliance. They decide whether the technology is, as they put it, 'ethically acceptable.' If a weapon design is deemed to be morally objectionable, then manufacturing is ceased and any existing prototypes are locked away inside . . ."

"Warehouse eighteen," Bit says ominously.

Dr. Pierce nods. "Most of the prototypes are infantry weapons, ammunition, and a few nasty artificial toxins and viruses. But others, well . . . others are computer-controlled devices. And if warehouse eighteen is open, unfortunately for us, it seems that Onix has activated some of those devices and . . . let them out."

"Let what out?" I ask.

Dr. Pierce looks at me in defeat. "Their official designation is Prototype X-27, but around the lab the development team rather morbidly referred to them as 'Lobots.'"

"And what exactly are these . . . Lobots?" I ask.

"Well," Dr. Pierce says, shifting uncomfortably. "Essentially they're behavior-modification devices that run along the ground seeking out movement or any human heat signature."

"They can see your body heat?" asks Brody. "Like a rattlesnake can? I saw that on a survival show once."

"In a similar way I suppose," replies Dr. Pierce. "The X-27 can inject venom like a snake, too, but in their case it's a paralyzing agent. Once a victim is immobilized the X-27 clamps onto their head and takes command of their higher functions, effectively turning the subject against their own comrades."

All I can do is shake my head in disbelief.

"So one of those Lobots got Gazelle?" asks Brody.

"And made her kill Jenny," utters Margaux.

"Yes, I'm afraid so," replies Dr. Pierce. "The X-27s receive information from Onix, so when Bettina asked how Gazelle could have sensed Jennifer from that distance I suspected the possibility that a Lobot may have attached itself to her and was monitoring the facility's motion sensors. When Major Brogan said warehouse eighteen was open . . . well, that's when I knew."

"This is freaking crazy!" blurts Brent. "Am I the only one who thinks this whole damn place is a slaughterhouse built by insane people?"

"Calm down, baby," Margaux coos as she strokes Brent's arm.

"I'm right though," Brent says as he pulls away from her and looks around the group. "I know you're all thinking it."

I try to tune Brent out as I turn back to Dr. Pierce. "What do these Lobots look like?"

"Well, let's just say that I hope no one here is afraid of spiders."

"Oh please don't tell me they look like spiders," says Bit.

"Sorry. But that's exactly what they look like. Their design suits their purpose."

"Slaughterhouse. House of horrors. Take your pick," Brent murmurs.

"Is there anything we can do to help Gazelle?" I ask. "How do we get that Lobot thing off her?"

"When we reset Onix we can deactivate the Lobots, but there's no telling what state Gazelle might be in after that," says Dr. Pierce. "I only witnessed the results of very early prototypes, and they were only ever tested on primates. Unfortunately most of them were rendered brain-dead by the process. Personalities were wiped clean. All that was left was an empty shell. Lights on, no one home."

"Oh my god," I whisper solemnly.

"You lobotomized monkeys?" says Bit, her voice dripping with disgust.

"Chimpanzees and baboons actually," replies Dr. Pierce.

"Oh god," Bit says with a nauseous look of realization. "They're called Lobots because they lobotomize their victims."

"Like I said, a rather morbid little nickname. But I never worked on them. I only read a few progress reports and watched research videos, I swear on my wife's grave," says Dr. Pierce.

"You make me sick," says Margaux.

"Look, the Special Tactics Department used my neural-interface technology and bastardized it. Believe me, it was meant for a much greater purpose. I never intended my creation to be used in such a crude manner."

"Tell your excuses to Jenny," grunts Brent as he begins nervously wringing his hands again. "See if it makes any damn difference."

Dr. Pierce sighs and stares off into space. Brody breaks the uncomfortable silence. "So what do we do now?" he says, looking around at all of us.

"This doesn't change anything. We carry on," says Bit. "What other choice do we have?"

"We hide, that's what," Brent says as his eyes dart from side to side. "We hide underground, and we wait until someone comes to rescue us."

"That's already been discussed; you know it's not an option," I say, watching him closely. His erratic behavior is beginning to concern me.

"Well, then as soon as those R.A.M.s reach the last sensor, we run," says Brent. "We forget about the damned computer, we go straight for the bus, and we're home free."

"And abandon Jonah, Percy, and the Professor?" I glare at him. "Sit down and shut up," I snap. "You're seriously losing it."

Brent flumps indignantly against the wall of the tunnel. Margaux shuffles over beside him and tries to console him by stroking his hair and whispering something soothing in his ear.

"Dr. Pierce, how many of those *things* are out there?" asks Bit.

"I don't know. Like I mentioned before, I didn't work on them," he murmurs. "But unauthorized prototypes aren't mass-produced, so I'm guessing there might be three or four? No more than half a dozen at the most."

"Ha-ha, ha-ha, this is hilarious," Brent blurts. "So now, as well as thirty-foot-tall robots with huge machine guns in their arms, I have to deal with brain spiders that are going to turn me into a homicidal maniac? I'm sorry," he says, shaking his head and getting to his feet. "But this is too much. I thought I could do this, but I can't."

"Then stay down here!" I shout.

"Yes, perhaps you should, you seem extremely agitated," says Dr. Pierce. "We'll come back and get you when Onix has been reset."

Brent starts shaking his head and grinning disturbingly as he edges along the wall of the tunnel. "No . . . you won't come back. Because you'll all be dead or . . . or you'll be wandering around with freaking Lobots plugged into your brains! We need to get to the bus, right now!"

"Hey, bro. Calm down," says Brody. "We've got a plan, remember?"

"No, I won't calm down, *bro*," Brent growls. "And the plan sucks. None of you are thinking straight, but I see this for what it is. It's everyone for themselves now . . . and I don't know about all of you . . . but I wanna live!"

All of a sudden Brent dashes toward Dr. Pierce, grabs him by the collar of his lab coat, and roughly pulls him away from the mouth of the metal tube. A startled Dr. Pierce sprawls into our little group, knocking me and Bit backward into Brody, who bumps against Margaux.

"Brent!" Margaux screeches as she awkwardly pushes off the wall and scrambles to her feet. "What are you doing?"

"I'll bring help, princess!" Brent yells as he lunges over Dr. Pierce's legs. "I'm coming back for you!"

I crawl out from under the swearing old man just in time to see Brent disappear into the tube. "No!" I shout as I leap up and dart toward the opening. Margaux is closer to the pipe than I am, and she springs in the same direction, accidentally veering into my path as she makes a beeline for the hole. I collide into her back, and we both tumble onto the grating. I look up into the pipe and see Brent has nearly reached the hatch at the top. I push off Margaux, quickly thrust my radio into my satchel, and dive into the tube.

"Brent! Stop!" I yell as I climb after him as quickly as I can.

Brent ignores me as he slots one foot into a handhold, braces his back against the tube, and spins the wheel in the center of the hatch cover.

"Don't leave me!" Margaux screams. Brent looks back down the tube, his eye line shooting past me and focusing on Margaux below. His panicked face seems to soften, and he pauses for a second.

I take the opportunity to lunge toward him, but as I reach out his attention immediately switches back to me, and his expression snaps into an angry glower as he kicks out with his free leg. I raise my arm to shield myself, and his heel thuds into my elbow. My shoes slip on the smooth metal, and I fall flat inside the pipe, hanging from a handhold

by one arm as Brent's toe hacks my fingers. Three more times he kicks hard at my knuckles, and I curse out loud as I lose my grip and slide on my stomach to the bottom. I watch in absolute horror as Brent pushes the hatch open and hauls himself out onto the surface, leaving me lying at the bottom of the pipe, staring up in disbelief at an open hole filled with stars twinkling in the night sky above.

CHAPTER SEVEN

The rest of the group quickly get to their feet and dust themselves off. Everyone looks even more stunned and mortified than I feel, well, all except for Margaux, who's crouching beside me, staring up into the pipe with a steely-eyed, clenched-jaw look of seething rage. "Bastard!" she screeches as she dives headfirst into the metal tube and begins scrambling toward the surface.

"Margaux! What are you doing?" I yell, but she doesn't turn around, and she doesn't stop climbing.

"I'm going to bring him back!" she yells over her shoulder, and it only takes a few grunting arm hauls and scuffling leg strides before she disappears from sight through the opening at the top.

"The blasted idiot!" grunts Dr. Pierce. "I should've chained him to a table in the back room!"

"He can't have gone far, and out of all of us Margaux is the fastest runner," says Bit. "She'll catch him."

"It's too late for that, girly," says Dr. Pierce. "That moron and his girlfriend will have tripped the motion sensors out there. Those R.A.M.s will be heading back this way any second."

"Bit, keep an eye on that slate," I say as I duck into the pipe. "I'm going up." I quickly climb to the top and pop my head out of the open hatch. The cool night air wafts across my face as I take in the surroundings.

The hatch's exit is in a tiny courtyard. Weeping willow trees hang down over a fishpond to my left, and beyond that, low wooden decking surrounds the base of a tall Japanese pagoda that stretches into the sky. The courtyard is lit by a soft glow behind the paper windows of the multitier pagoda, giving the secluded area a calming aura of serenity, a tranquility that's rudely tainted by the pervading smell of smoldering fuel and plastic that hangs heavy on the evening breeze. I can't see Margaux and Brent anywhere, which is hardly surprising considering that there's a path that leads to a narrow alleyway less than thirty feet away. It's the only obvious way out of this courtyard, so that's where they must have gone. I reach into my satchel, pull out my radio, and squeeze the "Talk" button. "Margaux? Can you hear me? Where are you? Margaux, come in."

There's no response.

Jonah's voice issues from my walkie-talkie. "Finn, what's wrong?"

"We've got a problem. Brent flipped out and exited the hatch," I reply. "He's trying to make it to the bus and escape without us. Margaux ran after him to bring him back, but she's not answering her radio."

"Dammit!" grunts Jonah.

"What should we do?" I ask.

"We've made it to the roof, and the tanks are rigged to blow," says Jonah. "We'll drop the first one, and hopefully it'll keep the R.A.M.s heading our way. What the hell was he thinking?"

"He wasn't," I reply. "We should have left him behind."

"Well it's too late for that now," says Jonah. "We're lifting the first tank into position. Cross your fingers, and pray that this works."

"OK," I reply. Less than a minute later, I hear the thud of the oxygen canister detonating in the distance.

"The R.A.M.s have tripped the third ground sensor," Bit calls up from below.

"I don't know if that blast helped or not," I say into my radio. "But it doesn't seem like they're turning back yet."

"That's a good sign," replies Jonah.

"Wait," Percy's voice says in the background. "I . . . I can see movement between the buildings."

"Where? Let me see," says Jonah.

There's a scuffling sound of what I can only assume is Jonah's radio being swapped for a pair of binoculars.

"Yes, that's them alright," says Jonah's voice. "They're approximately half a mile away. All three of them are still walking toward our position."

"Finn, I think you should all go for the dome," says Percy.

"I agree," says Jonah.

"Maybe we don't have to go anywhere," Brody calls from below. "Brent might make it to the bus, then he'll bring help and everything will be OK."

"No. We clearly can't rely on that boy for anything." Dr. Pierce's voice echoes determinedly from beneath me. "We absolutely must restore Onix as soon as possible. It's our best chance at setting everything right."

Even though I know Dr. Pierce has ulterior motives, and I don't trust him as far as I can throw him, restoring the mainframe is important for a lot of reasons other than his: finding Mariele, helping any survivors, freeing Gazelle, and, most importantly of all, getting all of our butts the hell out of here.

"I think we should make a break for the dome, too," I call down into the tunnel. "And we need to go right now."

"I vote you do exactly that," says Percy. "Because it just occurred to me that unless you can shut those R.A.M.s down, we're never leaving the top of this building alive."

"That only occurred to you now?" Professor Francis says in the background.

I see Bit looking up at me.

"OK, let's do it," she says as she tucks the slate into her satchel and starts climbing.

I step out of the opening into the courtyard, and as Bit makes her way to the top, I squeeze the "Talk" button on my radio. "We're leaving the hatch and heading for the reservoir door."

"OK," says Percy. "Good luck."

I lean down, grab Bit's hand, and help her out of the hatch. A few seconds later Brody appears and climbs out, followed shortly after by Dr. Pierce.

"OK then, let's move. Quick as we can," I say as I turn and begin jogging toward the path that leads to the alleyway.

The others follow closely behind me, and as we make our way toward the other end of the short alley, I can see ambient light from somewhere out in the open, highlighting the edges of large rocky silhouettes. As we emerge, the jagged shapes reveal themselves, and my eyes are met with a scene of widespread destruction. Long spans of monorail track have collapsed onto the ground, leaving piles of rubble strewn over a long white promenade. A number of the silver support towers that used to hold the tracks up are lying among the busted slabs of concrete, and over the top of the debris to the left, beyond the blasted-open, gunfire-shattered walls of several other buildings, I can see a thin column of black smoke in the distance, lazily wending its way into the starry sky above.

I pause for a moment and pull my radio from my satchel. "Margaux, come in. Where are you?"

There's still no answer. Where the hell did they go?

Dr. Pierce stops beside me. "Forget her. Forget them both. That is where we need to focus our efforts," he says, pointing ahead.

I look up over the top of a pile of crumbled track and see there in the distance, high on a hill in the center of the sector, is our first destination. Dome Two. Spotlights around its base illuminate a third of the way up its glossy surface. Its pure-black crown would be almost impossible to see if it weren't for the fact that the dome's sheer size obscures the stars behind it, making it appear as if a huge rounded shape has been cut into the fabric of the night. "I know what we need to do," I hiss at Dr. Pierce. "But I'm not just going to forget about Brent and Margaux."

I defiantly press the "Talk" button again and bark into my radio. "Margaux! Where the hell are you?"

To my complete surprise, Brent's voice suddenly blurts from the radio speaker. "She's with me!" His words are jolting and breathy, and I can tell that he's running. "She's come to her senses, and she's coming with me!"

"Get back to the others right now!" Jonah barks into the conversation.

There's a shuffling sound as Margaux grabs the radio. "We're going for the bus," she says. "Two plans are better than one! If you don't make it, we'll bring help!"

I squeeze the "Talk" button hard and grunt into the walkie-talkie. "Brent, I swear, if we make it out of here alive, I'm gonna shove that cheeseburger down your throat and make you choke on it."

"You'll be choking on your words when we come back and save all of you!" he shouts in the background, then the signal cuts off.

I look around, trying to spot them, but they could have gone in any one of multiple directions, and there are high piles of debris and fallen towers everywhere, blocking my line of sight into the sector.

"Listen," Dr. Pierce says, glaring at me. "They are the ones who decided to go off on their own. After we fix Onix and reset the mainframe, you're free to go and find them and force-feed the boy any high-calorie foods you wish. But until then, you do exactly what I tell you, OK?"

Without another word Dr. Pierce turns and jogs away, making a beeline for the nearest heap of rubble.

"I think he's right, Finn," says Bit. "We should neutralize the danger first."

Brody shrugs his shoulders in apparent agreement and falls in step behind Bit as she follows after Dr. Pierce, who, despite his age, is striding away at a surprisingly spritely pace.

Still fuming at the fact that Brent would do something so mind-bogglingly stupid, I angrily thrust my walkie-talkie back into my satchel, let out an infuriated sigh, and set off behind the others across a patch of manicured grass to the edge of the promenade.

I reach the base of the rubble pile just as Brody is boosting Bit up onto the side of it. The mound of debris is about twelve feet high but has enough gaps and divots to make it a relatively easy obstacle to climb; in fact, Dr. Pierce has nearly reached the peak. Bit is having a little more trouble than I am scaling the rubble, which is hardly surprising, seeing that she's trying to climb with the slate still clutched in one hand. I scramble past her as Brody stands patiently on the ground below her, holding his arms out to catch her if she falls. Dr. Pierce disappears over the top, and as I reach the peak I see him slide down a smooth, mostly intact concrete incline to the ground on the other side.

I kneel and reach down toward Bit. "Pass the damn thing here," I whisper. Bit gets a good foothold and stretches her arm out. I take the slate from her, and I'm about to help pull her up when I notice a flickering light coming from the diagram of Blackstone Technologies.

My eyes widen.

The fifth little orange dot is blinking, showing that the R.A.M.s are still moving toward Jonah and the others. That's exactly what I was expecting to see, so it's no surprise. But the reason why my heart has begun to thud a little faster than it should is because both the fourth *and* fifth sensor dots are flashing, which could only mean . . .

"Finn!" Percy's muffled voice says from inside my satchel. Still staring in horror at the slate in one hand, I scramble through my bag and retrieve my walkie-talkie.

"I read you," I blurt into it, fearing that he's about to confirm exactly what I already suspect.

"I've lost sight of the third R.A.M.," he says. "I think it might have turned back. You have to move!"

I quickly look down at Bit and Brody. Bit is staring anxiously up at me as she hauls herself to the top. "I heard," she says as I hand her back the slate.

"Go, go, go," I insist as I pat her on the shoulder. She nods, carefully lowers herself onto the lip of the incline, and slides down the concrete to the ground beside Dr. Pierce.

"C'mon, get a move on!" he barks from below.

I reach down and offer Brody my arm. He gratefully grabs my wrist, and I hoist him to the top, then I turn and slide on the soles of my shoes down the slab to the ground. Brody skids down the concrete slope to the bottom behind me, and after we exchange a few nervous glances, Dr. Pierce turns and heads off across the promenade. Clutching the slate in the crook of her elbow, Bit follows after him, then Brody, then me, all of us running in single file across a reasonably clear stretch of paving.

Up ahead I can see cherry-blossom trees lining the far edge of the promenade. They're filled with twinkling lights that are casting a pinkish hue through the trees' cloud-like bushels of flower petals. I look to the right. The promenade curves away, into the distance. Apart from piles of rubble and a couple of fallen support towers, it's empty, but something strewn on the ground in the distance catches my eye. It's Margaux's pink cardigan. They must have gone that way. I try to spot them farther along the promenade, but I can't see them among the shadows and debris.

The thought of trying my radio again crosses my mind for a second, but I quickly decide that there's really no point. They didn't want

to listen to me a few minutes ago, and I seriously doubt that they've changed their minds since then. They chose to go it alone, so they're on their own, and as I glance along the wide stretch of paving that curves away to my left, it becomes glaringly clear why Brent and Margaux chose to head to the right. Even the gentle light filtering from the cherry-blossom trees can't soften the impact of what I see. Many more sections of monorail lie collapsed all along the promenade, and strewn among the rubble are the bullet-ridden, fluid-leaking bodies of Drones and the horribly mutilated corpses of Captain Delgado's troops. They're nearly everywhere I look. It almost seems as if some giant demonic child grew weary of his toys, crushed them by the handful, and heartlessly scattered them across a charred and broken landscape. It's a brutally gruesome sight, a nightmarish war zone that looks as if it's been ripped straight from TV and regurgitated into stark reality.

My memories of being here when all of this happened are still so cloudy, but as I run through the cool night, transfixed by the scene of carnage and ruin, a dim spark of memory pulses in my mind. I can feel spiky tips of recollection slowly poking tiny holes in the milky film that's vacuum-packed around my brain.

The more I look at the Drones and the bodies and the blackened scars blasted into the ground and buildings, the more the memories push, until suddenly, out of nowhere, part of the misty shroud splits open, and lost details begin oozing into the forefront of my mind like a thick soup of images and sensations.

I gasp out loud and almost stumble over my own feet when, instead of running through the night, I'm suddenly flying high above Blackstone Technologies, watching out the side door of a transport as a twirling bouquet of heat-seeking missiles heads directly toward me, the rockets curving and weaving through the air as they get closer and closer with every passing second. Strange blue lights begin dancing in the smoke of the missiles' vapor trails, and the projectiles begin to

tumble and fall away toward the ground, where they detonate into a rolling swath of fire far below.

There are three other people in the transport. Crouching beside me is Gazelle, her elvish features rigid with concentration as she closely watches the holographic screens projecting from the roof of the cabin. In the pilot's seat, veering the transport through the sky with determined precision is a wiry young man, the stubble on his defined jawline visible beneath the visor of his bulky helmet. And in the copilot's seat, the third person is staring out the side window, the profile of his face completely hidden by a combat face mask and silver-tinted visor. Jonah mentioned the Saviors' code names when we were back in the lab, and as the memory of flying in the transport unfurls, those names snap into their proper places like magnetic puzzle pieces. Kestrel. That's the pilot, and the other guy, with the mask and the metal arm, is the one they call Zero.

Suddenly a floodgate seems to open in my mind, and jumbled flashes begin spilling forth in rapid succession as the memory becomes even clearer. I see clouds of fire following us as we soar and swerve just above the ground. Metallic support towers are toppled by explosions, while sections of concrete track crumble in the wake of the transport as it zooms dangerously low over the promenade.

I remember climbing high into the sky over a crashed aircraft lying on the edge of a massive dark circle below. I see survivors hurry past a line of dead bodies as the huge glossy black wall of the re-forming dome curves over above them. It crunches down on the smoldering wreckage. There's gunfire, screaming, an almighty explosion, and suddenly I'm being slammed around inside our tumbling transport as it rolls over and over down the hill.

I remember being carried away and lying in the sand, wounded and bleeding, watching the terrified faces of soldiers and survivors running for their lives from three giant green boulders thundering toward them. All around me silver Drones, trees, people, and buildings are crushed

with impunity, and just when I think it couldn't get any worse . . . the howling wail of the R.A.M.s' weapons begins. I remember the battering rhythm of bullets pulverizing stone, the screams of the dying, and the red glow of artificial eyes scanning through clouds of dust and smoke for someone else to kill.

Time flicks forward, and suddenly I'm alone. Everything is crumbling and falling, and I'm desperately trying to escape on legs that won't carry me. My undiluted fear quickly becomes overwhelming panic, and the last thing I see as I scream out in terror is the whole world collapsing on top of me.

That is the last thing I remember before waking up in Dr. Pierce's lab. Honestly, it's a miracle that I'm alive. If everyone hadn't pulled me out of that rubble and dragged me underground, I surely would've died right here on this promenade. My classmates, Dr. Pierce, Percy, and the Professor . . . all of them saved my life.

"Noooo," whispers a voice. *"It was meeeee."*

It sounded like it came from right behind me. Startled, I skid to a stop and quickly look back over my shoulder. Who was that? Could someone actually still be alive among all this rubble?

"Hello?" I call out, and then I wait, listening intently.

There's no answer.

The only sounds I hear are my own breathing, my heart beating, the breeze rustling the cherry trees on the other side of the promenade, and the footsteps of the others as they jog on ahead.

The voice was very quiet, but it sounded close. I scan around my immediate vicinity, and I don't see any nooks or crannies in the surrounding debris that look big enough to trap a survivor inside. What I heard was probably just the wind. Or maybe the stress of the situation is messing with my imagination—yes, that has to be it—and to make things worse, it's causing me to fall behind. I set off again, quickening my pace to catch up to Brody, but I only manage to run a few yards when it suddenly happens again.

"*I saved yooou,*" murmurs a ghostly voice.

I shudder with fright and halt in my tracks. I definitely heard it that time. I know I did. It was as clear as if someone were standing right beside me, and I'm not ashamed to admit that it's seriously freaking me out.

"Who's there?" I whisper anxiously. I look to the right. The promenade curves away in the other direction, but apart from sections of fallen track, it's empty. There's no one there.

"*Yooou,*" says the voice, and my heart starts drumming in my chest as I spin on my heels and stare back the way we came. It *is* a survivor!

"Hello?" I call out again. "I can hear you! Where are you?"

I look back and scan the top ridge of the fallen tracks we climbed over. There's no one there. I look the other way along the promenade again. There's no movement, just the same carnage of deactivated Drones and mutilated human remains wrapped in rags of tattered military uniforms. Nothing's changed.

"Is anybody there?" I shout, just to make sure.

Silence.

Maybe I'm losing it? Sure, a damned monorail track fell on my head, but I didn't think getting knocked unconscious could make someone go insane. Could it? *Pull yourself together, Finn. You're not crazy. It's just your imagination. Concentrate on the mission. Everyone's lives depend on it.*

I take a deep, cleansing breath, and I'm about to carry on running when a churning nausea swells in my gut and pushes up into my throat. "*Yooou,*" whispers the voice. I slowly and cautiously turn 360 degrees, nervously searching my surroundings yet again. I know there's nobody there; I can see that with my own eyes, but it still doesn't stop me from letting out a quiet groan of distress.

The voice is not real. I didn't really hear it. It's all in my head.

Admitting that my mind might be unraveling doesn't exactly instill me with confidence, and as I set off again to catch up with the others, I

can't help wondering whether Jonah had a point when he insisted that I stay in the lab. Up ahead, Brody is glancing back at me as he goes, no doubt wondering why I'm lagging so far behind. I run on, trying to bolster my resolve with a rapid chain of sharp, determined breaths, but I've only taken a few strides when something suddenly catches the corner of my eye.

It's a human figure.

I skid to an abrupt stop and look in its direction, but as I focus properly on the figure, my whole body instantly goes numb, and my eyes widen with disbelief. I screw them shut, trying to erase the impossible, but when I open them again, she's still there, about sixty yards away, standing on the promenade among that gruesome scatter of crushed and mutilated bodies.

A rising sense of dread begins bubbling up through a deep pool of confusion, and my heart begins pounding in my chest as she slowly raises her bowed head. Errant strands of hair trail across a face that's smeared and dripping with blood from brow to chin. Her school uniform is ripped and tattered, her legs are striped with cuts and bleeding gashes, and one of her feet is twisted almost all the way backward at the ankle. Even in the dim light I can somehow see her eyes. They're dark blue, but they almost seem black, and as she looks at me, it feels as if they're burrowing into my soul. It's true. I am losing my mind. This simply cannot be real, but at the same time I can't deny what I'm seeing. That horribly brutalized and broken girl standing in the midst of all that death and destruction . . . *is me.*

CHAPTER EIGHT

My mind has finally fractured and spewed out a memory so vivid it's become a full-blown hallucination, a horrific mirror image of myself, complete with torn flesh and red-splattered skin. If that's even slightly close to the state I was in when they found me in the rubble, I can see why everyone was so surprised that I survived. The gruesome vision looks so real, as if the other me is *actually* standing on the promenade, but as I stare at my bloodied and broken image from the past, the already intensely bizarre mirage becomes even more disturbing when the space around her begins to ripple, like heat is rising from her body and distorting the air.

Something grips my insides, tightening my gut into a sickening bunch. That isn't heat emanating from her; it's hatred, anger, a seething rage unlike anything I've ever felt before, and at that very moment the realization stabs me like a blade between the ribs. This is personal. This is intentional. What I'm seeing is definitely a hallucination, but this is not a vision of a memory, and it doesn't take a genius to figure out exactly who that girl over there is.

Infinity glares right at me and raises her arm, and I recoil with revulsion as, instead of fingers, she points at me with a bloody stump at the end of her wrist. She looks like she's sixty yards away, but when she speaks I can hear her voice so clearly the cool night breeze could easily be her breath against my face.

"You . . . are nothing . . . without me," she rasps.

I can't move. I can't even blink. Somehow she's invading my senses, and I feel powerless to escape the deluge of poisonous resentment that's rushing out of her and flowing like a river into every corner of my being. *Infinity.* All of a sudden that name has a new and awful meaning as her anger seems to pour from a void of limitless darkness inside her, slithering and twisting across the distance between us and biting into my soul like a venomous snake.

Infinity's face twists into a gruesome snarl, and I gasp out loud as, suddenly, the sixty yards separating us vanishes in the blink of an eye, and she's standing right in front of me. Her arm whips through the air, and her palm slams into my throat as her fingers grasp tightly around my neck. Her grip is so strong I can't breathe.

I grab her wrist and try to pry myself free, but her strength is inhuman, and she forces me to the ground, choking me with her right hand as she smears the fleshy severed stump of her left wrist against my cheek. I can feel the jagged end of bone pushing into my skin as blood drips from her face onto mine. Wild panic surges through me, and I struggle for breath as I clutch at her fingers, but she's far too strong, and I can't pry them loose.

This isn't real. It's all in my mind. This isn't real. It's all in my mind.

As I yell the words over and over in my head, Infinity glowers down at me, her mouth curls into a menacing sneer, and blood spits from her lips as she answers my thoughts as if she heard me thinking them. *"I'm just as real as you are, Finn,"* she hisses, and as I glare up into her hate-filled eyes, her fingers tighten even more around my throat. *"The difference is, you're weak . . . and I'm strong."*

"Stop. Please," I gasp through clenched teeth.

"No. I'll never stop," she rasps, flecking blood into my eyes with every syllable. *"This body is mine. You don't deserve it. I've seen your memories, Finn. While you whimpered and cried yourself to sleep all your life, I was the one who always stepped up. I was the one who accepted the truths that you were too afraid to face. I made the hard decisions. I've been the one who had to fight for both of us. Remember? Do you remember!?"*

The waves of anger radiating all around Infinity suddenly intensify and surge forth from her body like a ferocious wind. I shut my eyes tightly as the rage flurries over me, rippling my clothes and skin and roaring in my ears. Then, as if a door has been slammed shut, everything goes instantly silent.

I open my eyes, and I'm a little girl again, standing at the door of the red drawing room in the east wing of Blackstone Manor. With one patent-leather shoe buckled on my foot and my torn dress hanging loosely by my side, I raise Jonah's gun and open fire. A vase shatters into pebbles of crystal shrapnel. I pull the trigger again, and a tumbler of brown liquor bursts in a cloud of twinkling glass. There's a tangled blur of dodging and ducking men grabbing at one another, throwing themselves behind sofas and armchairs and sprawling across food-laden tables. Grown men are screaming and running and cowering and hiding while I gleefully stand in the doorway, basking in the warm glow of the manic pandemonium. I let loose three shots over their heads, just for the fun of it. Then I close my eyes, throw my head back, and laugh out loud in absolute childish joy.

My happy chuckling becomes coughing, then the coughing becomes gagging, and when I open my eyes again, the choking sounds are coming from my own mouth as Infinity's gruesome, bloodstained face bears down on me.

"I pulled that trigger. Not you. Every risk you ever took, every time you thought you were being brave . . . it wasn't you, Finn. It was me. You're nothing but a parasite, clinging to the inside of my skull like a tumor,

infecting me with your useless emotions. If it wasn't for me, you'd already be dead. You're alive because I kept us alive, you spoiled little bitch, and soon I'm gonna rip you out of my head and erase your whole pathetic existence!"

I summon all the strength I have as I grasp Infinity's wrist with both hands, glare up into her eyes, and hiss through my teeth, "Get . . . the . . . hell . . . off me!"

I rip her clawing fingers away from my neck and gasp a huge breath as Brody yells from up ahead, "Finn! What are you doing? Let's go!"

With my heart drumming in my chest, I look toward him, then bewilderedly from side to side. I'm not pinned to the ground; I'm standing upright. Infinity's hand is not inches from my throat. In fact she's nowhere to be seen. I touch my face and look down at my fingers. There are no drips of blood, my neck feels completely fine, and I suddenly realize that I've run clear across the promenade, all the way to the line of cherry-blossom trees on the other side. I look back over my shoulder, and there's another pile of rubble a few feet behind me that I must have climbed over, but for the life of me, I don't remember doing it at all.

"What are you doing?" shouts Brody. "C'mon!"

My hands tremble as I attempt to gather my brutally frazzled nerves and wrap my head around the fact that what I just experienced really was only in my mind. As vivid and wholly disturbing as it was, it was only a hallucination. But oh my god . . . it felt like Infinity was actually here.

I may be messed up, but at least I know now that I'm not going crazy. Infinity is trying to escape from a dark corner of our brain, and she's making a hell of a mess up there in the process, but she was right about one thing; she *is* strong. I felt it. She's burning with hatred and frightening determination.

I honestly have no idea how I'm keeping her from fully emerging, and it may only be a matter of time before she finds a way to regain control of my body, but if that's the way she wants to play it, then I'm gonna do my damnedest to fight her tooth and nail all the way. She

wants to get rid of me; she made that very clear, and it sounded like she knows how to do it.

But I'm not as weak as you think I am, Infinity. You don't scare me. And if I have to shoot myself in the head to stop you from winning, then that's exactly what I'm prepared to do. I'll take us both down, you psycho bitch.

"Hurry up!" shouts Brody. He's standing on a narrow white path about fifty yards ahead, waiting for me to catch up, and in the distance I can see Bit and Dr. Pierce are even farther along, nearing the foot of the hill that leads up to the dome. "Bit said the R.A.M. has passed the second marker. I told her and Dr. Pierce to keep going!"

"OK, I'm coming!" I yell back. I'm still more than a little shaken up, but Infinity clawing her way through my head or not, we need to complete this mission. I set off running again, heading between two cherry trees and across a short stretch of sand along the border of the promenade to the white concrete path. It snakes uphill into the distance through wide swaths of manicured grass and landscaped patches of shrubs and flowers. I quicken my pace along the path, taking in lung-fuls of crisp night air to clear my head and push the thought of Infinity as far down inside me as I can. Right now I'm in control, not her. And while I command this body, I'm gonna carry on.

The narrow pavement that I'm running on is lined on either side with low-set lamps that cast alternating strips of light and dark across the path. Up ahead, Brody is standing right beside a lamp, and I can clearly see that he's anxious and eager to leave as he glares toward the far end of the promenade, scanning the gaps between the ravaged buildings for any sign of the mechanoid.

I've covered half the distance to Brody when I notice something move in the shadows on the pavement behind him. A dark shape has appeared from behind a shrub near the edge of the path. I'm too far away to tell exactly what it is, but I'm suddenly hit with a massive surge of dread. There's only one thing that it could possibly be.

My eyes fixate on the shape, and my dread becomes panic. I knew they were out there somewhere, but Blackstone Technologies covers a large area, and I was hoping like hell that we could make it to the dome without having to face one of those things. All I can think of is Gazelle, her mind taken from her, forced against her good nature to kill poor, innocent Jenny. And now one of those goddamn brain spiders is curled up on the path behind Brody, preparing to do exactly the same thing to him.

He has his back to it.

That's why he doesn't see it.

Any thoughts of my encounter with Infinity are immediately shunted into the back of my mind as I break from a run into a frenzied sprint, and I yell at the top of my lungs, "Brody! Behind you!"

He looks in my direction, momentarily confused, then, heeding my frantic warning, he looks over his shoulder. Brody turns back to me with a frown while I blade my arms through the air, straying from the winding path as I cut the corners and dash across the grass toward him. Why isn't he running? Did he not see it? Dr. Pierce said they seek out movement, but does he actually think it will leave him alone if he stands perfectly still? *It can still see your body heat, you idiot! Run dammit! Now is not the time to prove how brave you are!*

The moment those last words enter my mind, pockets of memories begin flooding back to me in rapid succession, flicking through my head in time with my frantic footsteps.

I remember struggling for breath as a silver Blackstone Drone marched toward me, its arm outstretched, reaching down to grab me. Its fingers were inches from my throat when suddenly there was a glossy white flash and a loud cracking sound, and there stood Brody, slamming what was left of a broken chair into the Drone's back.

More images pulse forth from the haze, and this time I'm surrounded by even more Drones, but these ones are huge, with massive, broad shoulders and V-shaped torsos. Blood is in my eyes, half blinding

me. The Drones almost have me, and there's absolutely nothing I can do, when suddenly someone grabs the collar of my shirt and drags me into an air duct, saving my life.

It was Brody.

Another memory flashes, and I see him again, red faced and breathing hard, struggling but never giving up as he piggybacked Dean away from danger without being asked. It was also Brody who, barely half an hour ago, was standing proudly at Bit's side, declaring he'd protect her with his life. And he meant it.

Only yesterday I saw him as a bully, Brent's lead-footed sidekick and dim-witted lackey. But now, it's clear that any brief moment away from Brent's ego and influence lets Brody's true nature shine from behind the mask he's pressured to wear. He *really* is one of the good guys, and I'm not gonna let a robotic abomination latch on to his skull and take away another hero.

I remember when we were trapped in the clean room all those hours ago while Nanny Theresa's mind hacked into that Drone Template. Its black plastic mask morphed into a perfect likeness of her wrinkled, leathery face, and she took control of its robotic body to hold me down, break my fingers, and strangle the breath from me. I surely would've died if it weren't for Brody leaping through the air without hesitation, shoulder barging the possessed android to the ground. And now, if he isn't gonna move, that's exactly what I'm gonna do to him before that Lobot has a chance to pounce on his shoulders and turn him against us.

I'm focusing directly on Brody's face as I barrel toward him at top speed. Suddenly his eyes go wide, and he holds his hands up in front of him as the realization dawns that I'm not gonna stop. Out of the corner of my eye, I see the dark thing shuffle forward to attack as I dive through the air and thump into Brody, knocking the wind out of him as I sweep him completely off his feet and tackle him onto the grass. Both of us roll over and over. As we come to a stop, Brody glares up at me bewileredly.

"What did you do that for?" he groans through his teeth as he clutches at his side. There's no time to answer as I quickly jump up and thrust my hand into my satchel. My fingers scramble to find the handle of the flashlight. It's the closest thing I have to a weapon, so I whip it from the bag and stare back toward the path, panting for breath as I hold it high over my head like a club.

"Lobot," I rasp. "On the path!"

Brody rolls onto his side, hauls himself to his feet, then reaches up and wrenches the flashlight from my hand. He flicks it on and points it toward the Lobot.

"What are you doing!" I shout as a very fat, twitchy-nosed hedgehog freezes in the middle of the path, its little black eyes wincing in the bright beam of light.

"Thanks for saving me," Brody wheezes sarcastically as he clicks the flashlight off and hands it back to me. "I've heard the little buggers are more dangerous than they look."

I just stand there, catching my breath, looking at the hedgehog, feeling like an idiot.

"Where are you guys? Come in!" Bit's panicked voice says from inside my satchel.

I tuck my flashlight away, pull out my radio, and squeeze the "Talk" button. "We're here," I reply.

I can hear her breathe a sigh of relief. "Oh thank god, I looked back, and I couldn't see you."

"We're fine," I reply as I look ahead, scanning the darkened landscape at the far end of the winding pavement. I can only just make out her shadowy silhouette in the distance. She appears to be standing in the dim glow shining down from a light above what looks like a metal doorway that's set into the side of the hill. Dr. Pierce is standing at the door behind her, and through the walkie-talkie I can hear him in the background, muttering something about the combination of the lock not being what it's supposed to be.

"We'll have the door open soon," says Bit. "At least I hope we will. Dr. Pierce said he might need to open the panel and manually hot-wire the lock. What's taking you so long? Is everything OK?"

"Yeah, we're fine. We strayed off the path, that's all. I thought I saw something, but it turned out to be a . . . false alarm."

"Well, hurry up," replies Bit. "I'm getting some really weird readings from the sensors. They're not making any sense. The closest three are all triggering now, and I have no idea why."

Jonah's voice pipes in over the radio. "Finn, Brody, let me remind you both that you're supposed to be protecting Bettina and Dr. Pierce. This is a life-or-death situation, so for all our sakes, stop messing around!"

"We know that, Jonah. It's just that I thought I saw—"

"Listen to me," Jonah interrupts. "Our two R.A.M.s are getting dangerously close, and we've lost sight of Gazelle. If we're forced to rappel off the other side of this building and run, we'll do it, but I'd much rather you shut those robots down before they reach us, so pretty please, with hot fudge and a cherry on top . . . GET TO THAT COMPUTER SLATE!"

Brody and I both flinch at the outburst. No one likes being yelled at, but of course Jonah is right. We're wasting valuable time.

"Sorry, Jonah. We're going right now." I quickly tuck my radio away in my bag before he has a chance to start shouting again.

Brody and I turn and start running across the grass back onto the path. "Don't step on the Lobot," he says, and I shake my head and quietly chuckle. Someone always has to slip a joke into a crisis, don't they? He laughs along with me as we run, but I abruptly go silent and look over my shoulder when I hear something that piques my attention. I slow down and jog to a stop, and Brody does the same.

"I think I heard something," I whisper to Brody as I tilt my head to listen properly. I know Jonah told us not to dawdle, but I can't help it. That messed-up encounter with Infinity has put me on edge. Mr.

Hedgehog was proof of that. Twenty yards behind us, our spiky little friend is making a soft rustling noise as it shuffles into the shrubbery, and crickets are gently warbling in the night, but underneath all that I'm certain that I heard something else.

"What was that?" I ask, and seeing my unease, Brody turns his head to listen as well.

There it is. I did hear something. It's quiet, but it's gradually getting louder, and I can tell that Brody hears it, too, because his face instantly drops.

It's the slow, heavy, repeating thud of footsteps.

"The R.A.M.," Brody whispers. "It's here."

I suddenly remember the binoculars Brody gave me. I open my satchel, fish them out, and hold them up to my eyes. They're small but powerful, and as I look toward the far end of the promenade, what I see makes my stomach twist into a writhing knot. There, rounding the corner of a gutted building in the distance, is an extraordinarily large and bulbous silhouette. With long, pounding strides, the hulking machine steps out into the light of a lamppost, which, at about ten feet tall, only barely reaches as high as the robot's hip joint.

My memories of these machines are just as murky as everything else in my head. All I can really remember is the green of their armor, the bright fire erupting from their arms, and the overwhelming terror I felt whenever they were near. The images in my mind have been fuzzy, like seeing pictures through steamed-up glass, but now, the sight of that robotic monster triggers a window of clarity, like a hand wiping a clear patch in the haze, and as the memories pour through into the front of my mind, the details suddenly become sharp and vivid.

I see my teacher Miss Cole and two of my classmates, Ashley Farver and Sherrie Polito. A sick feeling boils and swells in my gut as I watch them screaming and holding their hands out in front of them before they are obliterated in a flurry of shredded clothing and splatters of blood. Their bodies seem to explode, scattering scraps of flesh in all

directions. I remember two more classmates, Millie Grantham and Amy Dee, aghast with anguish, their open-mouthed shrieks completely drowned out by the sound of the R.A.M.'s deafening gunfire as their pale, tortured faces were speckled red with the remains of the other young women. I wince and grit my teeth as the images sting like acid in my mind, and a tremor of anger and revulsion ripples through my entire body as I remember exactly how brutally lethal that machine over there is. It's a walking golem of death and destruction.

Maybe Brent was right. Maybe this place is a slaughterhouse, and that robot is a thirty-foot-tall meat grinder. Even though the giant monster is a good four of five hundred yards away, as long as it exists on planet Earth, it will always be too close for my liking. I lower the binoculars, and Brody takes them from my hand to see for himself. He's still looking as I yank on his sleeve. "We need to go."

"Hell yeah we do, look!" he says, thrusting the binoculars back into my hand.

I raise the glasses to my face, and I see exactly what he means. How could I not; even from this distance their dark bodies are a bold contrast to the stark white of the pavement.

"Those are not hedgehogs," whispers Brody.

"No, they most definitely are not," I reply as two Lobots scuttle through the circle of light cast by a lamppost and into the shadows on the other side. They must have sensed us, because they're heading this way, and they're moving fast. So quickly that in just a few seconds, they have scampered up over a fallen section of track and are darting toward the line of cherry trees.

Suddenly, almost as if the two Lobots had tipped it off to our exact location, the huge dome head on top of the R.A.M.'s wide, rounded shoulders swivels toward us and jolts to a stop. It sees us, glaring at us with eyes shining red through the night like two portals to hell as it raises one of its weaponized arms in our direction.

At the sudden real threat of being cut down by a torrential rain of brutal gunfire, I bark at Brody, "Move!" With an urgency borne from desperately wanting to stay alive, both of us take off running as I shove the binoculars back into my bag.

In the distance Bit and Dr. Pierce are still standing at a closed door. I look back over my shoulder, scanning the shadows for the two Lobots, and I see something that at first glance doesn't make any sense. The white promenade around the feet of the R.A.M. is very rapidly turning black, as if it's gradually being covered by a dark, writhing carpet.

It's then that two things become frighteningly apparent. Firstly, it explains why the sensors were going haywire, and secondly, Dr. Pierce was so very, very wrong. There aren't four or five prototype Lobots out there. Oh no. There are *hundreds* of them, and I get the feeling that the R.A.M. wasn't pointing at us to open fire. If it was, it would've done it already. I think it's sending the rest of those brain spiders after us, and now here they come, squirming across the promenade, following right after the first two.

Glancing back in horror, I see the edge of the dark, shapeless mass move up over that pile of rubble and begin pouring over the top of it in a wriggling waterfall of spiders.

"Just keep running," I hiss between breaths. "Don't look back."

I should've known better than to tell Brody *not* to do something, because as soon as I say it, he looks over his shoulder, and his eyes go wide with panic.

"Hoooly craaaaap!" he wails as we run side by side through the night. We've still got at least two hundred yards to go until we reach Bit and Dr. Pierce. I can run a lot faster than Brody, but he's going as quickly as he can, and I'm not going to leave him. When I take another glance over my shoulder, a selfish urge deep inside me almost makes me want to eat my words.

The first two Lobots must have cut directly across the grass in a straight line between here and the promenade . . . because they've

scampered out onto the path only 150 yards behind us. I look ahead, and as we get closer to the door in the hillside, I'm utterly dismayed that it appears Dr. Pierce is still trying to open it.

I reach inside the bag and retrieve my radio, which is a lot easier said than done when running. I squeeze the "Talk" button and shout into it. "Open the door! Open the door now!"

"What's wrong?" Bit replies anxiously, clearly alerted by the panic in my voice. I'm about to warn her about the Lobots when a misplaced step almost results in me rolling my ankle. I stumble and regain my footing, but the walkie-talkie slips from my fingertips and clatters onto the path. I look over my shoulder and see the two Lobots are closing in way too *fast*.

They're so close now that I can make out details of their bodies, which, just like Dr. Pierce said, resemble large black robotic spiders, with four small round, glowing red circles for eyes on the front of their heads. Dr. Pierce said the Lobots seek out movement and heat, and it becomes glaringly obvious that's exactly what they've found as every one of those eyes is focused directly on us.

The Lobots have a disturbing scrambling, galloping way of running, a flurry of multiple legs tapping on the concrete. They're so close I fear we'll soon have no choice but to face them and fight, but as my dropped walkie-talkie bounces on the pavement right in front of them, they skid to a stop, and there's a rapid succession of spitting sounds as multiple cable-like filaments suddenly shoot out from underneath their bodies and coil around the radio like thin prehensile tentacles.

I can't make out what she's saying, but Bit's voice is still shouting from the speaker of the radio as the Lobots scuttle around in a bizarre little circular, dancing tug-of-war, grappling for possession of the walkie-talkie.

Brody and I don't stop for a second, and I'm thankful for the chance to put some much-needed distance between us and those creepy robotic spiders. We sprint on, covering good ground, but with another quick

glance over my shoulder, I'm disappointed to see that my walkie-talkie hasn't distracted the Lobots for as long as I hoped it would. The spiders' filaments retract back into their bodies, leaving my radio lying on the path before turning to resume the chase, scurrying at a frightening pace toward us.

My legs are aching, and my lungs are beginning to burn, but Brody looks as if he's much worse off than me. He's trying his best, but he's wheezing and slowing down to a dangerous degree. I grab his shirt at the shoulder in an effort to pull him along, but all I succeed in doing is slowing myself down, too. "We're almost there," I hiss through my teeth, and a red-faced, openmouthed Brody nods painfully as he gulps at the air.

Eighty yards to go, it isn't far, but I can hear the scuttling footsteps of the Lobots right behind us, and I'm afraid that eighty yards might as well be eight hundred. My fears come true as I hear a series of rapid spits and see half a dozen thin black cables suddenly coil around Brody's lower leg like a tangle of parasitic worms. He lets out a panicked grunt but carries on running as hard as he can, and he doesn't look back, but I do. One of the Lobots leaps off the ground and speeds through the air, its multiple legs open like claws as it reels itself in. Riding the black cables all the way to Brody, it clamps on to his leg, and he cries out in pain as it digs its head into his calf muscle.

The lightning-fast attack happened in less than three seconds, but the fear on Brody's face as he falls will stay with me forever. Or maybe it won't, because if we can't escape from these Lobots, both our minds are only a moment away from being completely wiped clean.

Brody hits the ground and rolls, and I skid to a stop. Thrusting my hand into the satchel, my fingertips find the flashlight as the second Lobot leaps from the pavement and comes sailing through the air, directly at my head.

In one fluid movement, I whip the flashlight from the bag and swing my arm as hard as I can. Lucky strike or not, the hit is good.

Splinters of black plastic shatter from the Lobot as the flashlight connects square in the center of its head, smashing three of its eyes and knocking it out of the air with a loud and satisfying crack. The robotic spider hits the path and skitters on its back across the pavement into the grass, its spindly limbs twitching as its one remaining red eye fades, then flickers out.

"Finn! Help me!" shouts a terrified Brody as he attempts to hobble up onto his feet. "I can't feel my leg!"

Brody falls to the ground again, and I leap at the spider clamped onto his calf. I want to bash its head in, just like I did with the other one, but it's tucked underneath its body, biting into Brody. I smash the flashlight hard onto the back of its black dinner-plate-size body, and I succeed in putting a deep dent into it, but the damn thing doesn't let go. I try again and again and again, pummeling it with all my might, and on the fourth strike, to my relief, the thin cables unravel from Brody's leg, and the robotic spider finally releases him.

Unfortunately my apparent victory is very short lived, as the Lobot's head emerges from the underside, and its four glowing red eyes swivel around to face me. Its multiple legs, which were curving around Brody, fold up toward me, scrabbling in the air like long, gnarled witch fingers. I target its head, and I'm raising my flashlight when there's a spitting sound, followed by a puff of mist, and I yelp with fright as two black cables suddenly fire out from the spider. One of them instantly coils around my neck, and the other wraps all the way around the crown of my head. They're not cables at all; they're some kind of cold, wet, slimy substance. I can feel them moving against my skin and sliding through my hair as the Lobot begins reeling the strands in.

I'm hit with a wave of panic as I drop my flashlight onto the pavement and grab the spider's body, my arms shaking with effort as it continues winding itself closer and closer to my head. Whatever these filaments are made of, they're extremely strong. I'm trying as hard as I

can, but I can't break them. The one around my throat strangles me, so I can hardly breathe.

I fall onto my back and try to bring my foot up underneath the spider to force it off with my leg, but it's already too close to my head, and I can't quite manage to get my foot in the right place. My eyes open wider than they've ever been before as I see a thick hypodermic needle extending from the spider's mandibles. A viscous green liquid drips from the end of it onto my cheek as the Lobot's bulbous red eyes flick and twitch back and forth over my face.

"Bro . . . dy, help . . . me," I croak through gritted teeth. I glance over at him, and even though my vision is beginning to blur with tears, I can still see well enough to tell that he's in a state of full-blown panic.

"Finn, I can't move my legs!" He shouts the words even though he's only a few feet away from me, clawing at the ground, trying to drag his paralyzed lower body along the path. "I can't move my legs!" he yells again, his face contorted with despair.

Brody clearly can't help me, and my arms are burning, about to give out. I suddenly realize just how desperate I must be when I call into the depths of my mind, pleading to the angry darkness inside me for help when only moments ago she was spitting blood in my face and vowing to destroy me. *Infinity! Help me! I'm not strong enough to do this on my own!*

There's no answer. A feeble whine escapes from my lips as the Lobot's spindly legs flick and claw, scratching into the sides of my face. Maybe Infinity was right about me being weak, because right now I feel so powerless. Whether she is unable to help me or simply refusing to, the outcome will soon be the same; my mind will be wiped clean away. Maybe that's why Infinity is silent. Maybe she thinks she's strong enough to resist being emptied out of the brain that we share, and this Lobot is about to do exactly what she wants. Erase me from existence.

The Lobot grasps at my jaw, and I whimper in pain as it manages to hook its legs into the bone. I can feel blood trickling from the cuts

in my skin, running warm across my neck, dripping into my ears. The robotic spider pulls my head forcefully toward it. Its body is only inches from my face, but my arms are awkwardly trapped beneath it. As painful as that may be, they're thankfully providing a barrier between the Lobot's body and my face, barely keeping the hypodermic needle away from the tip of my nose.

I feel the black filaments tighten, and my tongue lolls involuntarily from my mouth as a choking, gargling sound bubbles from my throat. The needle begins extending even farther from the Lobot's mandibles. As soon as it pierces my skin, I'm going to be paralyzed, and this struggle will be over. I try to turn away, but my head is locked in position. There's nothing else I can do. I'm completely helpless. I screw my eyes shut, and tears stream down my face as the meager remnants of the last breath I will ever remember seep from my lips in a silent plea for a miracle.

Flashes of red flicker through my eyelids, and I snap my eyes open. A jiggling circle of light dances over me for a split second, then flits away as frantic footsteps approach. The sound of shoes pounding the pavement gets louder and louder and closer and closer, until it seems like it's almost on top of me. Suddenly there's a ferocious grunting screech, a streak of light, and an almighty crack, and right before my eyes, glass and splinters of black plastic burst in every direction. The filaments around my neck and forehead instantly disintegrate into black powder, the Lobot's legs release, and I inhale a huge, gasping breath as I forcefully thrust my arms out in front of me, catapulting the spider, end over end, high into the air. I hear it land on the grass, and I scramble backward across the path as Bit dashes past me and screeches again, leaping at the Lobot as she swings her heavy flashlight over her head, bringing it down hard on the twitching spider with a definitive and gratifying thud.

Crouching over her conquered foe like a triumphant lioness, Bit glances back at me. I asked for a miracle. And there she is. Panting for

air and with a wide-eyed, adrenalized expression on her face, she almost looks psychotic as she quickly scoots across the path to my side. "Are you OK?" she asks between breaths.

"Brody," I rasp as I rub at my throat. "Lobot injected him. We have to carry him."

Bit tosses her shattered flashlight away, takes my hand, and helps me up, and we both hurry over to Brody. He's lying on his side, his legs flopped loosely behind him. "Help me," he pleads, holding his arm out toward us. "I can feel it spreading."

"Brody," Bit whimpers as she kneels beside him and touches his face. He tries to smile up at her, but it's plain to see how scared he is. I don't blame him at all. My nerves are shot to hell, and *I'm* not the one who's lying on the ground, paralyzed from the waist down.

"We've got you, Brody," I say as I crouch as low as I can and sling his arm over my shoulder. I manage to lift his upper body high enough off the ground for Bit to go around to the other side and position herself under his other arm. Grunting with effort, Bit and I manage to haul Brody upright, and we're off, awkwardly jostling our way along the path toward the door in the hillside.

It is not easy going. Brody is heavy. It would be a huge help if he could move his legs even a little, and of course I know he would if he could, but with his lower body paralyzed, it's like carrying dead weight. As hard as she's trying, I can tell that Bit is struggling. I try to take more than my share of Brody's weight to compensate, and it takes every ounce of my strength to hold him up and run at the same time. I attempt to block out the pain of exertion by focusing all my attention on the door to the reservoir, so I don't notice the sound at all until Bit raises the alert. "What . . . is . . . that?" she hisses through her labored breaths and grunts.

I turn my head slightly to the side, and suddenly, the sound is all that I can hear. It's a rustling, shuffling, shifting sound, like a thousand scuttling crabs moving all at once. I know exactly what that sound

means, and I curse out loud, spitting a string of expletives through my gritted teeth that would make a salty old sailor proud. Bit glares at me, clearly shocked by my swearing, but her look of surprise pales in comparison to the expression that flashes onto her face as she takes a peek behind us.

She doesn't scream, but her panic shows as her gaze flicks straight ahead, and she arches her back, lifting her shoulders higher as her legs begin pumping beneath her with a new and urgent vigor. Brody suddenly feels lighter from her increased effort, but as he takes a look back along the path, the weight of our situation bears down on him, and it's his turn to let the curse words fly as the scrambling sound gets louder and louder behind us. Sixty yards. We only have sixty yards to go. We can make it. We can make it. We can make it.

"We're not gonna make it!" shouts Brody.

I quickly glance over my shoulder, and to my absolute horror I realize . . . that Brody is right. Writhing over each other on a rolling, moving wave of flurrying legs are hundreds and hundreds of robotic spiders, pouring along the path, scampering through the grass and flattening shrubs and bushes with their sheer numbers as they stampede toward us, rows upon rows of beady red glowing eyes jumping and flitting and darting in every direction inside the tumbling mass of black. Even with Bit's renewed, adrenaline-fueled pace, we're still going way too slow. There's absolutely no way that we can escape them.

"Leave me!" Brody yells.

"Noooo!" screeches Bit.

"I'm slowing you down! Leave me!" he shouts again.

"We can make it!" grunts Bit. Up ahead I see Dr. Pierce push the door open and duck inside. The door is only forty yards away, but I know that what Bit just said simply isn't true. We're not going to make it.

Brody leans his head in close to my ear, and when he speaks it sounds as if it's the most important thing he will ever say. "Promise

me, Finn, keep her safe." At that moment I know Brody is about to do what has to be done.

"I promise," I reply. We exchange a solemn look, and then Brody twists his wrists from our hands and wrenches his arms away from us.

Brody flumps onto the path behind us as the wave of spiders closes in. Bit turns back and lets out an anguished wail. "Brooodyyyyy!"

Brody ignores her completely and stares directly at me, his face racked with a strange mix of fear and determination. "Get out of here!" he bellows.

Panting for breath and with abject terror contorting her face, Bit glances back and forth between Brody and the writhing oncoming rush of Lobots. She reaches out to him, and I quickly hold her back as she tries to lunge toward him.

"I'm not going to leave you," she screeches.

Brody's face twists into an angry snarl as he looks me right in the eyes and barks his final demand. "Finn! Get her out of here . . . now!"

With no time to lose, I quickly grab Bit firmly by her wrist and take off, dragging her along beside me as she screams over her shoulder. "Noooo!"

"Run goddammit!" I scream at her. "Don't look back! Ruuuuun!"

With tears welling in her eyes behind her glasses, Bit does as I say and sprints on in silence. I saw the signs, the shy glances, the shared smiles and fleeting touches, the way pink flushed into her cheeks when she looked at him. Bit and Brody had grown close over the last few hours. An instant relationship forged from the fires of tragedy. So I know why she can't bring herself to look back as he's taken, but I allow myself one last glance, a mental keepsake of the bravest boy I've ever known.

He's lying there on the path, feverishly scrambling through his satchel as the teeming mass of spiders closes in on him. He only has a few more seconds of freedom before they reach him. With a lump in my throat, I grudgingly turn away and look straight ahead. I don't

want to watch when they engulf him, coil around him, clamp to his head, and drain away everything that made him who he was. That's not how I want to remember him. If I make it out of here alive, I'll tell anyone who will listen that the last time I saw the Brody Sharp that I knew, he was searching in his bag for a makeshift weapon to beat as many of those hellish machines into the ground as he could before they took him. Against overwhelming odds, and with no way to escape, he sacrificed himself for us . . . and went out fighting till the bitter end.

Unburdened from carrying Brody, we're able to stay ahead of the Lobots, but only barely, as the horrible cacophony of scuttling gets louder and louder behind us. Up ahead I can see Dr. Pierce's horrified face peek out from behind the door as he readies himself to close it. Still clutching tightly to Bit's arm, I pull her along as we get closer and closer.

Only thirty yards and we're home free.

"Where's the boy?!" Dr. Pierce shouts toward us.

Only twenty-five yards to go.

"He's gone!" I call ahead.

Twenty yards to go. We're gonna make it.

"Hurry!" shouts Dr. Pierce. "They're right behind you!"

Fifteen yards. Lungs on fire.

Twelve yards. Legs straining.

Ten yards to go and we're there.

Nine . . .

Eight . . .

Seven . . .

We're mere steps away from safety when, all of a sudden, to my absolute horror, Bit stumbles and falls toward the pavement. I scream out loud, pulling her wrist with all my might, and a surge of incredible strength suddenly ripples through the muscles of my arm. Bit's feet leave the ground completely as I fling her toward the door. She shrieks with surprise as she flies through the air, hits the pavement at the foot of the doorway, and tumbles inside.

I hear the ominous sound of spitting expulsions, and the strap of my satchel tugs at my neck as a Lobot zip-lines through the air and grabs on to my bag. I quickly pull the strap over my head and let the satchel go, but panic erupts in my mind with a blazing fury as I feel filaments coil tightly around my leg and one of my arms. The slimy cables tighten as spiders reel themselves toward me. Spindly legs clamp tightly around my thigh and my bicep as I dive headlong through the opening. With perfect split-second timing, Dr. Pierce forcefully slams the entrance shut, and I hit the smooth concrete floor, haphazardly splaying on my stomach as I hear the wave of Lobots thudding and battering against the sturdy metal door behind me.

CHAPTER NINE

Gasping for air, I'm trying to stand up when sharp stabs of pain in my arm and leg cause my jaw to clench shut, and a horrified groan rattles from my throat as I realize the spiders' hypodermic needles are biting into my flesh. One of my legs stops working almost immediately, and I collapse onto the ground.

I kick against the floor with the other foot, scrambling backward in a panicked, illogical attempt to escape the two machines clamped on to my thigh and upper arm. My back hits up against the concrete wall of the passageway as I desperately try to pry one of the Lobots from my now completely immobile, loosely hanging arm.

"Dr. Pierce! Help!" screeches Bit as she leaps to her feet and lunges at the spider that's biting into my bicep. Still panting to catch her breath, Bit grabs the sides of its body and pulls with all her might, but the Lobot is much too strong, and her efforts are futile.

Dr. Pierce calmly reaches into the pocket of his lab coat, pulls out a screwdriver, and strides over to me. He places one of his knees on the back of the spider attached to my leg, and holding the screwdriver in both hands like a dagger, he takes careful aim and plunges it into

the tiny gap between the Lobot's body and the back of its head. With a determined and purposeful look on his face, he wrenches the screwdriver vigorously from side to side like he's trying to shuck a giant and particularly stubborn oyster.

Suddenly there's a bright blue spark. The Lobot's four red eyes blink out, and its robotic limbs immediately release their grip. The cables squeezing around my leg instantly turn into black powder, and Dr. Pierce grabs the machine by one of its deactivated appendages and flings it, sending it clattering onto the concrete floor behind him.

He quickly moves up to my arm and shoves Bit to the side with an unceremonious nudge of his leg. "Out of the way, girly!" he barks as he positions the screwdriver in the right place and stabs it into the second spider. There's another blue flicker of light and a buzz of electricity as the slimy tendril disintegrates and the red fades from its eyes.

Bit clutches the sides of its body and pries it off me. "Her neck," she says, her eyes wide with worry. "There's blood on her neck."

Dr. Pierce leans in. "Looks like one almost got her," he says as he studies the underside of my jaw. "But it's OK. The punctures have already closed."

My healed cuts are cold comfort, and I'm absolutely terrified as the paralyzing drug continues to creep through me. I can still move one arm, and I grab Dr. Pierce's lab coat, clutching it in distress.

"Help," I murmur feebly. He gently takes me by the shoulders and moves me so I'm lying flat on the floor. I can't move either of my legs now, and I can feel the drug spreading from my bitten arm and moving across my chest and up my neck into my face.

"It's working fast. The X-27 must have hit a vein, but don't worry, you're going to be alright," he attempts to say soothingly. "Try to stay calm. The paralytic will wear off soon."

"Why isn't she healing the poison away?" asks Bit.

"I'm not sure," replies Dr. Pierce. "Given what we witnessed in my lab, it's clear that we still don't know everything about the limits

of Finn's physiology. Perhaps her advanced healing only reacts to pain, because apart from the paralysis, she's fine."

"She's obviously not fine!" blurts Bit.

"What I mean, girly, is that technically, she isn't hurt."

"Then how long will it take until she's better?" asks Bit.

"Well," says Dr. Pierce, "after an X-27 attaches to a subject's head and gains control of them, it injects an antidote to counteract the paralytic. But without the antidote it usually takes approximately thirty minutes for the drug to naturally work its way out of the individual's system. Unfortunately Finn got a double dose, so it may be up to an hour before she's able to move again."

"An hour?!" exclaims Bit. "But, what if we extract the antidote from these dead ones?"

Dr. Pierce sighs in frustration. "I've destroyed the power sources for the injectors. I could take one of them apart, and I suppose I might be able to devise a way to manually operate one of the needles, but I'm afraid that would take almost as long. Finn will just have to wait it out. I'll contact the others and let them know what's happened, and, Finn, the best thing you can do is try and relax and stay calm."

I manage to grunt something that sounds vaguely like "OK" as Dr. Pierce fishes his walkie-talkie from his pocket and squeezes the button. "Come in, Major Brogan. Are you there?"

"I'm reading you, Graham," says Jonah's voice.

"We've entered the reservoir door," replies Dr. Pierce.

"That's very good news," says Jonah. "The R.A.M.s are still closing in on our position, but now that you're safely inside the reservoir, we might be able to make it back to the hatch before they reach us. It seems that Brent may have actually done us a favor when he made an early run for it. We're leaving immediately."

"Wait," says Dr. Pierce. "There are a few more things you need to know."

"You can talk while we walk. Gentlemen, leave the other oxy tanks. We're bugging out. Quickly, before those robots get any damn closer."

"Oh thank heavens," I hear Professor Francis say in the background.

"Now, what exactly do I need to know, Graham?" asks Jonah.

"Be advised, Major, we encountered a number of X-27 prototypes, so keep your eyes peeled. There are a few more of them than I expected."

"How many more?" asks Jonah.

"I couldn't say for sure," replies Dr. Pierce. "But at a guess, I'd estimate there are almost a thousand of them right outside the door."

"A thousand?!" exclaims Jonah. "I'm the goddamn proxy CEO of Blackstone Technologies; how the hell do I not know about this?"

"It seems Special Tactics has been keeping secrets from all of us," Dr. Pierce says snidely. "And those secrets have resulted in casualties."

Bit hangs her head and begins quietly sobbing.

"What's happened, Graham?" Jonah grunts anxiously.

"Finn was injected by toxins, but she's going to be fine. Unfortunately the same can't be said for the young man who accompanied us. He was overwhelmed by the X-27s," Dr. Pierce says solemnly.

"Brody," sobs Bit. "His name was Brody."

"Goddammit!" barks Jonah.

"They . . . got . . . Brody?" Margaux's breathless voice hisses from Dr. Pierce's radio.

"I . . . told . . . you!" Brent wheezes in the background. "Told . . . all . . . of you!"

"Where the hell are you two?!" shouts Jonah.

"Following . . . promenade," Margaux utters. "Halfway to . . . hilltop."

"No doubt you're triggering motion sensors all the way as you go," says Dr. Pierce. "Those X-27s will surely be coming after you next, young lady."

"We . . . can . . . make it!" sputters Brent.

"Well, you don't have any other choice now," says Jonah. "Best of luck, you two. Don't stop, and you just might make it. Graham?"

"Yes, Major?"

"We've exited the stairwell and are heading for the hatch. None of us have got any time to lose. Leave Finn where she is, and you and Bettina get to the computer slate. We'll use the tunnels to go under the R.A.M.s, and hopefully we can think of a way to draw the X-27s away from all of you and clear your path to the entrance of the neural core."

"They're leaving!" Brent shouts through the radio. "Ha-ha! They're . . . leaving!"

"Hello? Brent? What do you mean?" replies Jonah.

"The spider things!" Margaux shouts in the background. "They're . . . going away! The R.A.M., too!"

"We can . . . make it . . . to the bus!" yells Brent. "We . . . can make it!"

"That's very good news," Jonah replies. "When you make it to the bus, take it to the nearest town and force them to listen. Send us some help."

"We . . . will!" says Brent.

"Good. Thank you," says Jonah. "Are you there, Graham?"

"Yes, Major?"

"Get moving. The sooner you and Bettina retrieve her slate, the sooner we can—"

Jonah is cut off midsentence as Percy yells in the background. "There they are! They've seen us! Get down!"

Suddenly I hear the droning foghorn of a rail gun, a desperate scream, scuffling and scrambling, grunting, a hiss of static, and the signal is lost.

Out of the corner of my eye, I see Bit and Dr. Pierce share a deeply anxious exchange. "Major Brogan?" Dr. Pierce barks into the radio. "Come in. Are you reading me?"

There's no response, so he tries again.

"Come in. Are you there, Percy? Professor Francis?"

Still no reply.

"Oh my god," whispers Bit. "You don't think they're—"

There's a hiss of static, and thankfully Jonah's voice issues from the radio, interrupting Bit's morbid thought. "That was a close one, but we made it into the hatch. We're going back to the lab to see if we can rig another diversion. I'll contact you at the other end. Get that slate and good luck."

"Copy that, Major," says Dr. Pierce. "You heard the man, girly. We've got a job to do. Are you up to it?"

"I don't know," mumbles Bit.

Dr. Pierce kneels beside her and puts a consoling hand on her shoulder. "You liked that boy, didn't you?"

Bit lets out a sniffle. "I did."

"Well he's not dead yet. If there's only one chance in a million that we might be able to save him, I think you owe it to him to at least try. And even if we can't save him, I think he'd want you to be brave and finish this. Do it for the boy."

Bit stares at the Lobot for a second, then she sets it on the floor beside her and takes a deep breath. She looks up at Dr. Pierce, gruffly wipes a tear from her cheek, and nods determinedly. "For Brody."

"That's the attitude, girly," says Dr. Pierce. "Now let's get a move on."

"Are . . . are you sure Finn will be alright, lying there all by herself?" Bit asks, looking down at me with concern. "What if she stops breathing or something?"

"The toxin wasn't designed to kill its victims. That would completely defeat the purpose of the X-27. She'll be just fine, and besides, it's a short walk down that corridor, then a quick climb up some stairs and a ladder into the dome. We'll find your slate and then come right back here to check on her before we go to the neural core. With Major Brogan's assistance, and a little luck, we'll have reset the entire system before the drug has even worn off."

Bit sighs. "OK. But just one second," she says as she kneels at my side, and her face comes into view, hovering over me. She pulls her

walkie-talkie from her satchel and lays it on my chest. "I'll leave this here for you and send you updates. We won't be long, Finn," she says with a worried smile. "Don't go anywhere, OK?"

Her lame joke isn't even funny, but I would smile if I could. Bit and Dr. Pierce both stand and walk out of view. I listen to their footsteps echo down the corridor as they head deeper into the hillside. "We'll be back soon, Finn!" Bit calls out, and it isn't very long before the sound of their steps fades into silence.

With nothing left to do but wait, I stare at the light set into the concrete ceiling as I try to move my fingers and toes, but it's no use—I'm completely paralyzed. I count the seconds in my head to pass the time. Ten minutes pass.

It feels like an eternity alone in the silence, and I'm thankful when the monotony is broken as Bit's voice issues from the radio on my chest. "We've reached the quantum-grain reservoir, Finn. It's huge. And so deep! There's some kind of pipe-shaft thing in the middle, and I can actually see the quantum grains moving along it toward the dome!"

The wonder in her voice makes a smile form in my mind. Only she could still be marveling at a place that has constantly tried to kill us ever since we arrived.

The signal cuts off, so I continue counting time. It's at least another ten minutes before I hear from her again. "We're at the bottom of the ladder, Finn! Oh my god I wish you could see this! The whole underneath of the dome is shimmering!"

"Put that damn thing away, girly," Dr. Pierce growls in the background.

"Sorry, Finn, gotta go. Don't worry, we won't be much longer."

I'm not worried. My friend never ceases to amaze me, and if anyone can get us out of this, Bettina Otto can. As I watch a moth flittering around the light above me, I whisper a silent thank-you to Brody. He didn't do what he did to save *us*. He did it for her.

"Wow," whispers a voice. *"Even your thoughts are pathetic."* At first I wonder what on earth Bit could mean by that, but I realize that the voice didn't come from the walkie-talkie when I feel the weight of someone's hands pressing onto my legs.

My body may be paralyzed, but it isn't numb, and a surge of panic ripples through me as the pressure of the hands is followed by knees, and the mysterious figure begins crawling on top of my body toward my head. If I could run I would, but I'm completely helpless as I see my own face slowly rove into view and hover over me, inches from my nose. Infinity's dark-blue eyes glare down into mine. Her hair is tied in a smooth, tight jet-black ponytail that falls across her shoulder, and the blood that was dripping down her face when I last saw her has completely vanished.

"Hello again, Finn," she says with a sadistic smile.

I can't move my lips to speak, but I know this is all in my mind, and so I respond in the only way I can, by thinking the words. *What do you want, Infinity? If you think you can scare me or threaten me again, you're wrong. I'm not afraid of you.*

Her expression softens as she rests her head on her hands, digging her elbows into my chest. *"So, you figured out that you're not going insane, huh? I apologize for that little scuffle we had earlier. Roughing you up and trying to choke your mind out of my body was the wrong way to go about this, but y'know, I'm a very violent individual, and more often than not, strangulation is my go-to solution."*

Leave me alone, I think coldly.

"Hey, c'mon now, don't be like that," she says snidely. *"Seriously, navigating my way out of that mess in our head is like crawling through spaghetti, but I made the effort especially to come and speak to you face-to-face. This is a courtesy call. I just wanted to let you know that I'm going to take my body back the first chance I get. So enjoy it while it lasts, because when I take complete control, you're gone. Consider this a notice of eviction."*

Why do you hate me so much? I think in reply. *Surely this isn't the way it has to be. Both of us have a right to live. This body is as much mine as it is yours. There must be some way that we can exist side by side? We can share this body.*

A bemused grin creeps onto her face as she slides off me and sits cross-legged on the floor beside my head. *"I know it may seem like it, and I might have even said it more than once, but I don't hate you, Finn. But what I do hate,"* she says, poking me in the cheek with the point of her finger, *"are all the things you make me feel. Just the thought of your wet-blanket emotions infecting me makes my skin crawl. Honestly, how the hell do you expect me to be true to myself when your goody-good feelings burrow into my head like parasitic worms, and suddenly, I'm too guilty to shoot someone in the face or stab somebody through the heart?"*

I can't help what I feel, I respond mentally.

"Oh, I know," says Infinity. *"And that's the whole problem. For a while there you even made me think that I was beginning to care about your idiotic schoolmates. Otto has earned my respect, but you almost had me convinced that I was actually starting to like some of the others. Well, now my head is clear, and I know those thoughts were nothing but illusions leaking into me from you. I can't live like that, Finn. I'm a weapon, and a weapon with a conscience is useless."*

But you don't have to kill anyone, Infinity. No one can force you to do that anymore. You can have a normal, peaceful life.

Infinity throws her head back and laughs out loud. *"A normal life?! Oh, you crack me up, Finn, you really do. Sometimes I don't know if you're in denial or just plain stupid. In case you hadn't noticed, we are like no one else on the planet, the first of a new species, superior in every way. There was never going to be any normal life for us. As long as we exist, somebody out there will want to own and control this body and everything it can do. Otto said that I was a slave, and she was right. You and I were both trapped in worlds we didn't choose for ourselves, but the difference is . . . I want to be free."*

I want that, too, I think. *We can learn from each other and find a way to make this work. Emotions don't make someone weak; they make them human. We can do this together.*

Infinity leans over me and slowly shakes her head. *"Aw, that's so sweet. But you really don't get it, do you? I've never once been asked what I want to do, only commanded to enforce the will of others. Used to protect the interests of the powerful by eliminating those who stand in their way. No one ever looked at me like I was a person. I'm seen as property, a tool to be used as my masters see fit. No one ever treated me as a human being, and there's only one reason why—I. Am. Not. Human. And neither are you."*

Then . . . what are we? I mentally ask.

"Honestly? I'm not sure," replies Infinity. *"I was told that I was made in a lab for only one purpose, to kill. I suspect the truth is much stranger, but I'm beyond caring. All I knew for sure was that I was better than anyone else. I was unique.*

"At least that's what I thought until I found out about you. I was curious at first. I wanted to know if you were treated any differently from me, and in a lot of ways, you were. Some people actually seemed to care about you, but the more I uncovered, the more I realized . . . your life sucks. I may have been a slave, but you, Finn, you're locked in a gilded prison cell surrounded by idiots. You're right; no one can force me to kill anybody ever again, but guess what? . . . I'm gonna do it anyway—because I like it. Nothing else compares. Well, you know what I mean," Infinity says as she playfully punches me on the arm. *"Here, let me remind you."*

Pictures of memories suddenly begin swirling through my head, and it's like I'm falling through a flickering gallery of violence and turmoil, each image a jump to a different place and point in time when Infinity killed. I see angry expressions on the faces of strangers instantly wiped into dead-eyed stares by flashes of gunfire. I see Infinity's fist gripping a sawtooth knife, plunging its red-smeared point into flesh left and right. There's the glint of a long slashing blade, an enemy's wide-eyed surprise, and the wet thud of a severed limb slapping onto concrete. I

see fingertips spear into an old man's eye as fluid and blood spurts from his eye socket over the back of Infinity's hand.

Gurgling screams ring in my ears as I watch acid-splashed noses, eyes, lips, and tongues liquefy and drip through men's fingers like molten wax. I see people's skulls popping like paint-filled water balloons through the crosshairs of a rifle scope in a dozen exotic locations, and I witness a boot on the back of a man's expensive suit, sending him sailing off the roof of a skyscraper toward a dotted line of streetlights a hundred floors below. Everywhere I look is another gruesome death. I can't turn away or close my eyes to the horror, but what's a thousand times worse than seeing Infinity's nightmarish memories is feeling exactly what she felt. If I could only use one word to describe it, it would be joy, but to call it that completely betrays what I know the emotion to be. It almost feels as if I'm being overwhelmed by the sight of a beautiful sunset, but the hues of pink and purple and orange and red bathing the sky are the colors of an inferno burning the world to cinders beyond a horizon of insanity.

Stop. Please, I plead in my mind as a sickening spasm rolls in my gut. The horrific images instantly vanish, and a feeble whimper squeaks from my throat.

"You're welcome," Infinity says with a sarcastic smile. *"Look at us, Finn, being all civil with each other, remembering the fun times, hanging out like best buds."*

The radio on my chest crackles to life, and Bit's voice issues from the tiny speaker. "Finn, I'm still at the bottom of the ladder. Dr. Pierce is at the top, trying to hot-wire the keypad to the hatch. But after he's done that, we're in!"

"Speaking of best buds," says Infinity. *"You're lying here, useless, while the girl you call your bestie does all the hard work. Y'know, if it wasn't for me she would've been taken by those things right outside that door. I was the one who saved her, plucked her right off the ground, and threw her to safety. If I'd left it up to you, she'd be gone."*

You . . . did that? I ask.

"*Sure did. Like I said, Otto earned my respect. But if you insist on fighting me, Finn, I might not be so kind to your little friend next time. It only took three seconds to save her, but trust me, it will be just as simple and just as quick for me to end her.*"

Wait a second . . . I don't understand. How did you save her? I ask with my thoughts.

"*Your hands are my hands, that's how,*" replies Infinity. "*And I'm warning you, if you don't let me out, I'll use those hands to—*"

Oh my god, I say, cutting her threat off with my thoughts before she can deliver it. *You don't know how to take complete control, do you? If you did we wouldn't be talking, you'd already have done it by now.*

Infinity raises a finger at me and opens her mouth to speak, but no words come out. I can see her out of the corner of my eye as she slowly lowers her hand and glowers venomously at me. She looks mad. Real mad. There's something she's hiding from me, something she doesn't want me to know.

All of a sudden something dawns on me. Infinity can read my thoughts. She did it out there on the promenade. She's been doing it the whole time we've been talking. She's doing it right now. I can feel her listening. But does that mean I can read her mind, too?

"*Shut up!*" she yells. Infinity crouches over me and glares at me. "*You don't know who you're dealing with,*" she growls as she grabs my face, clawing her fingers into my cheeks.

At first I look straight into her eyes, refusing to be intimidated, thankful that my paralyzed body is preventing me from flinching. But then I decide to try something new.

What do you know, Infinity? I ask.

She grabs my face harder and looks even angrier. "*I told you to shut up, you stupid bitch.*"

Tell me what you know.

The corner of Infinity's mouth twitches nervously. *"Whatever you think you're doing, stop it,"* she orders, but her words are tainted with unease.

I could be wrong, but I think I just saw a flicker of worry in those eyes, or was it . . . fear?

"What?" Infinity says incredulously. *"Why the hell would I be afraid of you!?"*

The longer I look, the more I feel a strange pull inside my head, like my consciousness is being drawn out from the front of my skull.

"What . . . what are you doing?" Infinity stammers. She tries to pull her hand away from my face, but she can't. I can feel her trying to turn her head and take her eyes off mine, but she simply isn't able to. *"I'm warning you, Finn! Stop!"*

I get it now, I whisper in my thoughts. *You said my hands are your hands, so does that mean that your mind . . . is also mine as well?*

As soon as I think the words, something very strange happens. I begin to see past Infinity's hateful stare and beyond her outer layers of bravado. Her expression softens like she's hypnotized, and her fingers, gripping my face, relax.

The more I stare at Infinity, the stronger the tugging in my head becomes, until all of a sudden a spinning swirl of darkness appears on her brow, just above her nose. I will myself toward it, and even though I can't move, it feels as though I'm rising from my body. The swirl expands until it's a shadowy revolving whirlpool covering her entire face like a mask. Bigger and bigger it becomes, until it completely envelops my head, too, and I feel like I'm floating up off the ground and crossing a bridge through a dark gateway into a completely different place altogether.

CHAPTER TEN

My heart races as I look around and try to take in what just happened. I think I may have actually done it; I've pushed through into somewhere else. Whether this new place is Infinity's mind or another part of my mind or a mixture of both, I can't be completely sure, but whatever part of our psyche this may be, it's a mess in here.

Scattered over a shimmering field of crystalline black are what appear to be the shattered pieces of thousands upon thousands of mirrors, haphazardly stacked in a single floating layer that reaches as high as I can see. There are a multitude of different shapes and sizes, and each fractured shard flickers with images. The very large pieces seem to be more stable, staying mostly intact, while the small and medium-size ones are noiselessly breaking and re-forming as the cracks separating them simultaneously heal together and then snap apart again.

I don't know how long I'll be able to stay in here, so I need to make the most of it and find out as much as I can. I take a few deep breaths to calm my nerves and begin scanning across the nearest images. They appear to be fleeting seconds of captured memories, and I'm surprised

to see that I recognize a lot of them. Every snippet I can identify is relatively fresh; I'd guess no more than an hour or so old.

In one of them I can see Bit, standing in the underground lab. She's holding a slate in her hands and speaking as everyone looks up at the holographic model of Blackstone Technologies floating in the center of the room. In another I see Jonah, Percy, Jennifer, and Professor Francis saying good-bye as they leave to walk through the tunnels to the second hatch. In another fragment I see Brody gently sliding Bit's glasses onto her nose, and in yet another I see him again, lying on the path, scrambling through his satchel as the wave of robotic spiders closes in behind him.

I don't know what this place is, but if I had to guess, I'd say it's some kind of gallery of my very recent memories. But if that's what it is, then why are some of the memory shards different from the others? I can see moving shapes and colors, but the images contained inside them are blurry, as if the fragments are jagged windows made of frosted glass.

I look over my shoulder, back the way I came, and what I see is not what I expected. It's like I'm looking out my own eyes, staring at the ceiling at that same solitary moth fluttering around the light above where I'm lying. A moment ago I was looking up into Infinity's face, but she's gone now, which makes perfect sense when I think about it. I was never really looking at her to begin with. She was never there at all, and that entire uncomfortable conversation we just had was only in my mind.

"*My . . . mind,*" says Infinity's voice, her words reverberating from everywhere around me. "*Get . . . out.*"

I spin back toward the wall of fragments, scanning for any sign of her. "Where are you?" I call out. "Show yourself!"

"*Get . . . out!*" she demands again, but her voice sounds strange. It's monotone and lazy tongued, almost to the point of slurring. Unable to tell what direction her voice is coming from, I search the bizarre mindscape, looking all around, but there's no sign of her, until suddenly, a

crack splinters across one of the frosted pieces and I catch a glimpse of her through the gap between two drifting shards.

Infinity stands on the other side of this wall of memories, facing me like a reflection of myself from a different reality. The fragments are constantly healing together and shattering again, so I have to bob and weave to keep her in sight, which is made all the more difficult because when I move, she does, too, but her actions are slightly delayed and in the opposite direction. From what I can make out, she's dressed in some kind of formfitting black combat uniform, and she's staring directly at me with an all-too-familiar bare-tooth snarl of anger contorting her face.

I take a few steps forward, and so does Infinity. I raise my right hand, and she does the same, although judging by the increased intensity of her dagger-throwing glower, she's doing it very grudgingly indeed. I lower my hand again, and when she also follows suit, I suddenly wonder . . . am I controlling her?

"Never!" Her voice echoes, and out of nowhere a strange compulsion to punish myself for what I was just thinking shudders through me. The bizarre feeling doesn't make any sense. I am wondering why I would feel that way at all when I notice Infinity slowly opening her palm, and with a resounding grunt of effort, she jerks her arm upward and swiftly slaps herself hard across the face. To my utter surprise, my own hand opens, too, and moves as if it has a life of its own. Copying Infinity's gesture at twice the speed, I knock my head to the side with a jarring blow as I brutally smack myself across my left cheekbone. I gasp in shock as the lingering sting of the impact prickles my skin. Clearly we both have a modicum of control over each other, and it seems Infinity's payoff for striking herself lies solely in the fact that I feel it, too.

I glare at her angrily, daring her to try that again. I know she receives my challenge because the instinct to punch myself in the head ripples out from her and comes streaming on invisible waves through the cracks between the fragments. Infinity's fingers bunch into a fist,

and so do mine, but as she twitches hers toward her own nose, I stop it dead and force my trembling arm back down to my side.

Infinity lowers hers, too, and stares at me as waves of wild frustration pour out of her like ripples of heat. Suddenly I'm reminded of the reason I wanted to come here in the first place. "You can control me," I whisper. "But not for very long. Why?"

Of course Infinity doesn't answer, and I can't read any clues from her thoughts, so either she doesn't know or she's blocking me somehow, but I *do* notice something else. For a split second, I saw her eyes flick in the direction of one of the frosted panes of memories. It could be nothing, but I've played poker with Bit before, and when she has a bad hand, she always glances out the window into the courtyard outside our dorm room. That's *Bit's* tell, did Infinity just reveal one of hers?

I focus on the jagged-edged, full-length-mirror-size puzzle piece she just looked at and step closer to it. I can feel her resistance, but Infinity steps forward, too. I lose sight of her behind it, but as I reach out toward the fragment, I can feel her doing the same on the other side. I press my palm against the surface of the foggy memory and try to wipe the frost from the blur of colors. It doesn't do any good, but as I slide my hand away, toward the edge of the fragment, the whole thing moves as if there's a hinge running the length of it from top to bottom. Excited at the prospect of my new discovery, I push the edge harder. Sure enough, the entire fragment begins turning on an axis, pivoting like a revolving door.

As the memory-pane side swivels to me, Infinity glares with contempt through the open gap. I can feel that she wants to reach across and claw at me, to shout at me again and threaten me with pain, but as she attempts to move her arm, I hold mine steady, and as she tries to speak, I clench my jaw tightly shut. There's nothing she can do as the fragment rotates completely around, thankfully obscuring her from my sight again. It shudders to a stop, and I gaze upon the crystal-clear image on the other side.

And what I see . . . is *me*. My first thought is that maybe this fragment is partially transparent and I'm simply looking at Infinity through it. But I quickly realize that's not the case when I notice that I'm wearing the same black hooded top I have on now, and instead of my hair being in a tight ponytail, like Infinity's, it's loose and hanging wet on my shoulders. This other me is standing over a stainless-steel basin, staring at my reflection in a clear strip on a steamed-over mirror.

I don't have any recollection of this moment, but judging by what I'm wearing and the images of the recent past captured in the other shards, it can't have been very long ago. I raise my hand to the center of the fragment, but this time, the instant that I touch it there's a sudden feeling of acceleration, as the image pours out of the shard and folds completely around me.

I'm not standing in a dark crystalline gallery of memories anymore. Now I'm *actually* standing in front of the steel basin. Behind me in the mirror, I can see a beige concrete wall that glistens with fresh condensation. The room is warm and damp, and that clean soap smell of a recently run shower still hangs in the air. The color of the wall is a dead giveaway. This must have taken place in the washroom in Dr. Pierce's underground lab.

I study the reflection of the me from the past. I have a distant look in my eyes, like I'm lost in thought. I raise my hand to my face, stroke it against my cheek, then smile. The smile slowly becomes a quiet chuckle, which soon changes into a demented giggle. All of a sudden I stop laughing, and that's when I notice the darkness in my eyes and a feeling of unjustified rage rippling through me, just like when Infinity took me by surprise and made me slap my own face only moments ago. Suddenly I open my mouth, bare my teeth, and with a dead-eyed stare and a vicious snarl, I chomp hard into the pad of muscle at the base of my thumb.

My disturbingly emotionless eyes glare straight ahead into nowhere as my jaw clenches with voracious effort. I watch in horror as blood

begins pulsing and dribbling from the bite, but I don't stop. Rivulets of red stream down my face, but still I keep going. My movements are animalistic; I look like a starving dog, my neck spasming as my head bucks forward, driving my teeth deeper and deeper into my own flesh. I moan as blood flows freely down my arm into the sink, but I scream out loud as I feel teeth crunch into bone. I can't turn away; this has already happened, and it can't be changed. All I can do is ride it out.

I watch the reflection of me in the mirror as I wrench my gored hand from my mouth, and I gasp with relief as my trembling palm suddenly releases from the surface of the fragment and the horrible memory snaps back inside the shard, encased once again inside its frame. My heart is racing, and my senses are reeling, but underneath all of that I feel something much more sinister. In the washroom Infinity took control of me and made me bite my own hand, using pain to push me out. On the promenade she literally tried to scare me out of my mind by appearing as a bloodied and broken ghost, and when that didn't work, she threatened to hurt someone I care about if I didn't give her what she wanted.

Looking back at those memories with a clear mind, I can feel the intent of Infinity's dark motives lingering in the shadowy alleyways of my subconscious. I know what she's been trying to do! She's been lashing out, using the small amount of influence that she has to try and weaken me, to tear holes in me, wearing me down physically and mentally so she can squeeze through and take over completely.

If I'm right, these blurred-out fragments must be instances when she momentarily regained control, and that's why I can't see them clearly. But one thing *is* becoming increasingly clear. Infinity has been bluffing this whole time. That's why she didn't want me to dig any deeper. She was afraid I would discover the reason why she can't take full control. She is undeniably strong, but the truth is . . . I'm even stronger. Out of the two of us, I'm not the weak one . . . she is.

I can feel her hatred bleeding through the cracks as I turn away from the fragment and stride alongside the wall, searching for the next frosted-over piece. Through the spaces between us, I can see Infinity is forced to copy my opposite actions as she walks in the other direction, but she can't escape me. Rage twists her face as she slides backward, like I'm pulling her along with an invisible tether. I spot another fogged-over shard and dash toward it, but as I reach out, my hand suddenly veers wildly in a different direction, and my legs disobey me, causing me to leap sideways farther along the wall. "What are you doing, Infinity?" I shout out, willing my limbs to obey my orders and deny hers.

I manage to regain control of one of my legs, but I stumble and fall onto one knee right in front of a large fragment. I look up and see that it's different from all the others again. It's made up of a collection of dozens of smaller shards that are cracking apart and mending back together in rapid succession. Some of the sections are frosted, and some are not, but all are tenuously combined into one unstable, shifting mosaic.

"You want to remember?" Infinity growls. *"Then remember this!"*

My arm thrusts out on its own, thudding against the patterned fragment, and the jagged pane quickly swings around on its axis. It wobbles unsteadily as it comes to a stop, and the lattice of cracks across its surface instantly solidifies into one clear image. In it I see a rectangle of light, and inside that is the large dark silhouette of a person. I recognize the shape immediately. It's Jonah. For some reason I can't understand, an unsettling fear shudders through me, and I can feel Infinity's influence slither into my arm and force my palm against the surface of the fragment.

All of a sudden, my hand is pulled into the frame, and the blackness surrounding Jonah's silhouette pours out and snaps shut around me like the walls of a dark box.

I'm sitting on a bed, staring at Jonah's shadowy outline, as the feeling of fear swells and churns inside me. He reaches toward me, and I

scream out in absolute terror. "GET AWAY FROM ME! WHERE AM I? WHAT HAVE YOU DONE TO ME!"

The fear rises and curls inside me as my hands jolt against the restraints strapped around my wrists. I gasp with horror as memories from years gone by begin pulsing forth from the depths of my mind. I see a white room with medical equipment lining the walls, and I'm sitting loosely in a cold metal chair, my body paralyzed.

"You won't remember this horrible day, sweetheart. I swear," Jonah whispers from a chair beside me. He adjusts a metal band on my head and wipes a tear from my cheek. "This won't hurt at all," he says as he turns his attention to a nearby computer screen. He swipes his finger across it, then he looks back at me and smiles. "Y'know, it's funny how many times I've told you that."

All the lies and betrayals come flooding back with agonizing clarity. I curse at myself for forgetting what he did to me, not just once but twice now. I feel stupid and angry and sad all at the same time, the hurt in my heart just as fresh again as it was the first time I discovered what kind of man he really is.

The white room vanishes, and suddenly I'm strapped to the bed in Dr. Pierce's lab again, thrown back into this memory that Infinity is forcing me to relive. Just like before, I see Jonah walk forward from the doorway and approach the bed, and I suddenly remember what came next. Jonah was telling the truth. I really did attack him and choke him to the ground. He tried to confront me about it afterward in front of everyone, but I didn't believe him. Now it's replaying in my mind all over again, as the me from the past roars with anger, breaks from the restraints, and pounces at Jonah. Time slows to a painful crawl as I fly through the air with my fingers clawing toward his neck.

I feel so ashamed of my past self for such a cowardly attack. I remember how much I wanted to kill him, but even though he betrayed me, he didn't deserve to die. What was I thinking? Was I so blinded by anger that I forgot who I was? I would never murder anyone, so I don't

understand why I would suddenly want to kill the man who raised me, even if he—suddenly I sense it, a writhing undercurrent of single-minded brutality mingling with my own spirit, burning and twisting around my soul like a swirling tornado of fire, revealing the true source of hatred.

I should've known. The sadness I felt in that moment was mine, but the murderous rage was all Infinity's. It feels as if our personalities were locked inside the same frame, like the shards in the mosaic of this memory. I feel an overwhelming sense of guilt as I see my hands, controlled by Infinity's lethal intentions, reach toward Jonah. I remember the expression of absolute bewilderment on his face, and that's exactly what I dread to see again as I look beyond my outstretched fingertips that are trembling with rage and completely beyond my control. But it isn't Jonah that I see staring back at me. I don't know why, and I don't know how, but the memory has been altered. Jonah has been replaced, and instead all I see are my own clawed hands diving directly at my own startled face.

Time snaps into full speed as Infinity erupts out of the mosaic, shattering the memory completely apart in a burst of flying fragments. She slams into me, wrapping her hands tightly around my throat as we both tumble backward, through the opening of my eyes, and out of this mad, twisted mindscape of horrors and back into the dimly lit concrete corridor of the real world.

CHAPTER ELEVEN

The concrete floor is cold against my back, the solitary moth is still circling the light above me, and I'm lying in exactly the same prone position that I've been in for the last twenty-five minutes. The shock of reliving the brutal attack on Jonah and Infinity's surprise assault has left me panting quick, adrenalized breaths, my rapidly rising and falling chest the only movement my paralyzed body will allow. Even the muscles that move my eyes have been rendered useless, but that doesn't stop me from scanning my peripheral vision for any movement. Infinity is nowhere to be seen. Somehow she managed to breach the wall of memories and force me back out into the real world, but now I can't even feel or sense her at all.

I try to take in slow and measured lungfuls of air to calm myself down and assess the situation, but the process is abruptly interrupted by a rising sense of panic when I feel something beginning to move inside me. It's growing in the center of me, like a swelling tumor. I can feel the edges of it in visceral detail as it sprouts tendrils from its corners and a bulb from one end, molding itself into a miniature humanlike shape.

Infinity is inside me. Spreading like the poison that paralyzed me.

The doll-size mass is getting bigger and bigger, and it isn't long before I sense Infinity trying to worm her phantom arms and legs inside mine, squirming her way into my skin so she can wear me like a suit. I want to fight back, but I'm not sure how to.

I try to imagine her shrinking smaller again, and suddenly the enemy limbs creeping inside my own seem to retract ever so slightly. It isn't much, but it's a start, so I take as deep a breath as I can and begin focusing harder on resisting Infinity's power. It's working; I can feel her influence waning as the tips of her snaking tendrils shrivel back toward where they came from. I'm winning, and I've almost forced her all the way out, when all of a sudden her venomous voice echoes in my skull.

"I'm not the only one who wanted to kill Major Brogan," she whispers tauntingly. *"You wanted it just as much as I did."*

That . . . isn't . . . true, I reply in my mind.

"I'm not lying," she says. *"Let me help you look deeper, Finn."*

I try to block her out, but a tortured moan escapes my lips as images begin pulsing through my mind. I see Jonah sitting at my bedside, reading me a picture book, smiling at me with genuine love. I see the desperate worry in his eyes as he's reduced to a flustered, bumbling mess when I break my arm falling from my bike. I see him grinning like a goofy idiot as I blow out the candles on the cake at my fourth birthday party, and I feel the warm embrace of his huge arms when I cry because I have no friends to play with. I see Jonah kneeling beside me, draping his jacket over my shoulders as the memory of his voice drifts on a warm current through my mind.

"I love you like you are my daughter. No matter what happens, never, ever forget that."

And I vowed that I never would. He was *my* Jonah, and I loved him, too; part of me still does, and that's why it hurts so much when all my fond memories are tainted by the bad, and all the joy that I used to cherish is now crushed by the sight of his pleading face, flushed red

with blood, his eyes bulging while he gags for breath as my hands choke him to the ground.

"You wanted that, too," whispers Infinity.

A feeble sob escapes my lips, and remorse ripples through me as the guilt of the attack and the pain of his betrayal fill my heart once more. Tears roll warm down the sides of my face, and my resistance falters, only for an instant, but it seems that's all Infinity needs, as she suddenly expands to full size, filling my body completely. This is why she tried so hard to show me these things; she took a chance and gambled that the shame I felt would be my weakness and my weakness would give her the edge to take control.

Damn her to hell. She was right.

I know that I'm stronger than her, but she's fired an arrow through a chink in my armor. I feel myself losing my grip and tipping backward into the void as Infinity shunts me into the darkness. I can feel her regaining command over my body as I drift away in a tangle of black. It's like I'm surrounded by a mass of invisible ropes, and it feels as though Infinity's spirit is swelling, pushing me further and further into oblivion, and I'm helpless to stop it.

I claw at the ghostly tendrils, desperately scrambling for a hold. They're slippery and thick, but I manage to wrap my arms around one and slide to a slow stop, thankfully, for now, halting my descent into the dark. I look ahead, and I can see through Infinity's eyes like peepholes cut into the void. The dim light from the corridor is shining in through them, and as I watch that little moth dancing around the lamp on the ceiling, I can't help thinking that it's just like me. Trapped, flying in endless circles until someone cuts the power. Right now Infinity has that power, and I need to find a way to sever it once and for all. I can feel her self-satisfaction, how pleased she is with her victory, but this body is still paralyzed, and I have half an hour to get it back.

"That's . . . what . . . you . . . think," says Infinity's voice, but it isn't spoken with her thoughts like before. The words came from her *mouth*;

I could hear them through her ears, just like I can see the outside world through her eyes, and even though I'm not in control, I could feel her vocal cords vibrating and her lips moving as she spoke. But . . . how can that be? Dr. Pierce said it would be at least an hour until the toxins wore off, and only half that time has passed.

I hear a groan, and the outside view shifts as Infinity inexplicably raises her head. What's happening? How is she doing this? I see her lifting her arm. The fingers of her open hand tremble before her eyes, but she's *actually* able to move them. Infinity clenches her fist, and I see tiny drops of green liquid oozing from the pores and beading on her skin like emerald-tinted sweat. Incredibly, it seems that somehow she's physically forcing the poison from our body.

"I've trained all my life, developing techniques that you have no understanding of," Infinity says out loud, clearly addressing me. "This body listens to me, Finn, and that's exactly why you don't deserve it," she mutters ominously. Infinity slowly sits up. The radio on her chest clatters onto the ground beside her, and seconds later it crackles to life with Bit's voice.

"We're inside the dome. It's dark in here, Finn," she says, her words ringing with the echo that comes from speaking in a cavernous space.

"Pass me your light, girly," Dr. Pierce says in the background.

"Gotta go, Finn," says Bit. "I'll report back when we're at the wreckage."

Infinity shakily gets to her feet, picks the radio up, and clips it onto the waistband of her jeans. Then she turns and walks toward the door.

"Where are you going?" I call out into the void. *"You can't just leave Bit and Dr. Pierce!"*

Infinity doesn't acknowledge me at all. As she arrives at the door, she presses her ear to it. The peepholes close, and I'm plunged into pitch darkness. Suddenly the void seems to thicken, as if the space around me is somehow growing heavier, and as I cling to my invisible anchor, I can sense something approaching through the blackness. It feels as though

it's coming from somewhere to the left of me, and all of a sudden the silent dark begins resonating with vibrations, as ripples of movement buffet and shudder against me. I feel like every inch of me is quivering, and I can't help but gasp as my mind instantly fills with sound.

I was able to enhance my hearing when I eavesdropped on Dr. Pierce, but what Infinity is doing now makes my accidental discovery pale in comparison. I can hear the breeze brushing over the tips of the blades of grass on the other side of the door, and I can hear the slow shuffle of little clawed feet scraping across the path outside, the snuffling of tiny nostrils revealing the nocturnal trek of another hedgehog.

The void grows heavier still. The ripples in the dark become even more turbulent, and the volume of everything increases tenfold. The sound of the breeze becomes a harsh, fizzing hiss, and the hedgehog's adorable little sniffs become angry bull snorts huffing and puffing inside my ear canal. I wince at the deafening racket, but the noise soon seems to curve away from me, almost as if the ripples are being diverted, brushed aside to reveal more layers of sound underneath. These new vibrations are thinner and much more closely spaced, and as they bounce and reflect back and forth over each other, the points where their ripples cross begin pulsing with fleeting blips of light.

The effect is wholly unnerving and yet at the same time completely fascinating, as a shimmering, undulating picture of the area just outside the door begins to coalesce in the void. The image appears to stretch out twenty yards in every direction before the edges of it gradually fade into darkness, but inside the boundary of the rippling tapestry of sound, I'm able to make out the fuzzy shape of the grass and nearby bushes and shrubs, the winding concrete path, and the slope of the hillside that the door is set into. I even spot the outline of the satchel that I dropped on the pavement a few feet from the door.

I stare in wonder at the grainy image that Infinity has formed in her head, all of it made purely by combining high-pitched frequencies into some kind of sonar. I don't see any Lobots within Infinity's sensory

scan; the immediate region outside the door is clear. I'm awestruck at what she's able to do, and I can't help feeling spitefully envious of the way she's mastered her senses like this.

The picture of sound fades into the void around me, and the dim light from the corridor streams in as Infinity opens her eyes and steps back from the door. I watch through the peepholes as she flexes her hands in front of her face, testing them for mobility. Seemingly satisfied, she does the same with her arms, curling them and tensing her biceps. I can feel the raw power surging through them, and again I burn with jealousy. She is so much more in tune with the capabilities of this body than I am, but I swear nothing is going to stop me from fighting with every fiber of my being to get it back, and there's no better time to start than now.

Grunting with effort, I slowly begin crawling forward along the invisible tether toward the eyeholes in the distance. Through them, I see Infinity reach for the door handle. She's leaving.

"Where are you going?" I call out again, but she still doesn't answer as she yanks the handle down and pulls the door open. I can feel the cool night breeze on her face and see the expanse of Sector B stretching out before us. Infinity pauses, scanning the landscape from side to side as I hear the walkie-talkie crackle on her hip.

"We're at the wreckage," says Bit's voice. "It's been cut clean in half, and I can see my slate, but it's going to take a little time to lever open a gap big enough to reach it."

"What was that noise?" Dr. Pierce asks anxiously in the background. "Did you hear that, girly? I don't like the dark, and I'm certain something just moved in here. Hurry up and get to work. I'll keep lookout."

Bit lets out a disgruntled sigh. "Anyway, Finn, I'll let you know when I have it. I wish you were here. I could really use your help right now. I'll check in again soon."

Infinity seems to ignore the radio and strides out into the night. She gives the surroundings one last cautious 360-degree scan, then scoops

my satchel up from the ground. She opens it, rifles through it, and for some reason I don't understand, she snorts with bemusement as she pulls the pair of binoculars and the can of spray bandages out of the bag and tosses them both onto the grass. Infinity unclips the radio from her jeans and stuffs it into the satchel, then she slings the strap over her head, tightens it across her chest, and, with a little starting hop, takes off in a sprint down the path, back the way Bit and I came.

"Where are you going?" I scream as loudly as I can. This time I get a suitably angry response.

"Shut up, Finn! 'Where are you going? Where are you going?' You sound like a goddamned broken record in my head!"

"Bit is inside the dome!" I yell. *"You can't just leave her!"*

"Otto has a new mission, and I have mine," Infinity seethes between measured breaths as she increases her pace. "Richard Blackstone is this way."

"Stop! Please!" I shout. *"He's not worth it."*

"Enjoy talking while you still can, Finn," replies Infinity. "Because once dear old Daddy tells me how to get rid of you, I'm gonna silence both of you, once and for all."

I have to stop her. Now more than ever. I can feel the strength in her legs as she strides along the path, and I double my effort to claw ahead toward the eye windows as Infinity sprints on. Perhaps she was trained to run this way, but her footsteps are almost silent. She's also running nearly twice as fast as my top speed, and it doesn't even feel like she's breaking a sweat as the landscape flies by.

I can feel Infinity's hunger for revenge against my father coursing through her, burning with a fire of single-minded intensity. That's her objective, but now I have one of my own: making it to those peepholes is my goal. I have no idea what I'm going to do when I get there, but I carry on, pulling myself forward, which is so much harder than I thought it would be, as the strange, slippery, invisible line I'm gripping on to wavers from side to side while a multitude of other unseen tendrils

slap and whip against me. It feels like I'm inching my way through a sea of molasses on giant strands of angry spaghetti, and I suddenly remember Infinity describing the inside of our head in exactly the same way. That thought gives me a glimmer of hope. If she went through this, then I must be heading in the right direction, too.

Spurred on, I claw my fingers into the tether and keep heaving myself along as Infinity runs on through the night. I'm focusing all my attention on putting one hand in front of the other, so I don't notice the view changing through the eyeholes until I feel Infinity slowing down and coming to a stop in the middle of the path. I can hear her quietly catching her breath as she stares at something strange lying on the grass a couple of yards from the edge of the pavement. Infinity looks cautiously from side to side before she approaches the object, which in the darkness, away from the lighted pathway, resembles a six-foot-long burrito-like cocoon. As she gets closer, I spot the deactivated Lobot that Bit smashed, lying next to the other side of the path. A quick glance in its direction from Infinity shows me that she notices it, too, but she obviously sees that it poses no threat as she silently creeps toward the curious-looking object in the grass.

"Finn!" Bit's muffled voice issues from the radio inside the satchel. "I got my computer slate, and I'm heading back to you. See you soon!"

Startled by the sudden transmission, Infinity whips open the satchel and pulls the walkie-talkie out. It slips from her grasp, and she juggles it awkwardly in her hands before she manages to get a good hold on it and muffle the speaker with the palm of her hand, but it doesn't work very well, as I can still hear Jonah's muted reply seeping from the sides of Infinity's clutch.

"Copy that, Bettina," he says. "Good work."

Infinity pulls her hand away and is searching for the "Off" switch when Bit blurts out, "Thanks, Major Brogan!"

As if reacting to Bit's voice, the giant burrito begins writhing with a crinkling, rustling sound. Infinity immediately raises her fists, holding

the radio out in front of her like a weapon, but a grin spreads across my face from ear to ear as I suddenly realize exactly what that weird-looking thing really is.

"Brody!" I shout out into the darkness.

Infinity clearly must've heard me, because she repeats his name, albeit with a very quizzical tone. "Brody?"

"Finn?" Brody's voice replies from inside the cocoon.

Infinity shoves the radio back into the satchel and quickly jogs onto the grass. She kneels beside the silver burrito and begins pulling the rolled layers of foil blanket down to expose Brody's face.

Somehow he wasn't taken, and I feel a fantastic mix of elation, surprise, shock, and grateful disbelief.

Brody looks up at Infinity, blinking wearily. "Oh my god, Finn," he says with a huge sigh of relief. "I'm so glad to see you."

Maybe Infinity's mind is just as boggled as mine is right now, because she doesn't even bother to correct Brody when he calls her by my name. Instead she stares at him, shaking her head in wonder, but there's more to it than that. Deep down inside her, I can feel a bizarre welling of emotion. I know it isn't coming from me, because it's rippling toward me through the void in a similar way to how the waves of sound did only moments before. As the feeling shudders over me, the first word that comes to mind to describe it is . . . admiration.

"I thought those brain spiders had you for sure," says Infinity as she helps Brody unravel himself from his thermal foil wrapper.

"So did I," he replies. "But then I remembered a survival show I saw once. It said these blankets hold in all your body heat, and Dr. Pierce said those things see body heat, so I guessed I'd try to, well, y'know, roll myself up in one."

"It looks like you guessed right," says Infinity, and I feel that same warm pride rise from the depths of her core again as she helps Brody to his feet. "Well, the spider bite has clearly worn off," she says, slapping a hand onto his shoulder. "What were you doing just lying there?"

"The poison spread all the way through me, and I couldn't move at all," Brody says solemnly. "I didn't know how long it would last, so I just waited, and . . . I think I fell asleep."

I can feel Infinity smile. *"You liar!"* I call out into the darkness. *"You do care what happens to him!"*

I know she hears me because I can feel that very same smile vanish as she quickly withdraws her hand from Brody's shoulder. "You should get out of here," she says, her tone now harsh and cold. "Get back to the underground shelter or something. Those spiders might head back this way any minute, and there's still a R.A.M. wandering around here somewhere."

Brody points back toward the promenade. "The R.A.M. and all the spiders went that way; I heard them."

"Back toward Sector C? That doesn't make any sense. Major Brogan, Percy, and that old bastard are in the tunnels, so what could be setting off motion sensors enough to draw them all back that way?" says Infinity.

"I don't know," says Brody. "But at least Brent and Margaux can make it to the bus now."

"Don't waste time worrying about them," Infinity says with a sneer. "You get yourself to safety, Brody."

Suddenly Bit's voice issues from the satchel at Infinity's side. "Finn, I'm still inside the dome."

Brody's eyes widen at the sound of her voice, and he eagerly thrusts his hand out toward Infinity. She lets out an indignant sigh, but she indulges him as she pulls the radio out of the bag and slaps it into his hand. Brody stares at the walkie-talkie in his palm, smiling as Bit keeps talking.

"I can't find Dr. Pierce," she says, obviously shaken. "He wandered around the other side of the wreckage while I was trying to get my slate, and I don't know where he is! He's not answering me! Major Brogan? Are you there? I think something is wrong. What should I do?"

"Keep looking, Bettina," replies Jonah. "You're in an enclosed space. He can't have gone far."

"The dome is huge," says Bit. "I've been searching for ages!"

Brody quickly squeezes the "Talk" button. "I'm coming to help you look!" he barks into the walkie-talkie.

"Brody?!" exclaims Bit.

"Yeah, it's me," he says with a huge grin.

"But . . . how?"

"I used my brain, just like you would've."

"Oh, Brody," Bit says with a happy tremble in her voice. "I'm so glad you're OK."

"It's wonderful to hear that you're alright, Mr. Sharp," Professor Francis says in the background.

"Absolutely," agrees Jonah. "I don't know how you avoided the X-27s but, well done."

"Thanks. I wrapped myself in a foil blanket, and they couldn't see me," Brody says with a goofy chuckle. "They walked right over me."

"Well I'll be damned," says Jonah. "There are three radiation suits in one of the storerooms; hopefully they should work in a similar way. Unfortunately nothing down here can help us stop the X-27s, but thanks to you, Brody, we might be able to survive if we run into them. We'll suit up and join you as soon as we patch up my leg and the Professor's hand. We just got clipped by a little errant shrapnel when the R.A.M.s fired at us. We'll be fine, and we'll be there as soon as we can. Be careful, everyone, and, Bettina, keep looking for Dr. Pierce."

"I will," she replies.

"I'm coming to find you, Bit!" Brody shouts into the radio.

"Thank you, Brody," she replies happily.

Brody releases the "Talk" button and smiles at me. But then his eyes widen. "Sorry, Finn, I totally forgot to mention you! I meant to say that *we* were coming," he says, putting the radio to his lips again.

Infinity quickly snatches it out of his hands before he has a chance to press the button.

"Hey!" Brody protests.

"Don't be an idiot! Otto will be just fine," grunts Infinity. "Get to the underground shelter before those spiders decide to come back this way."

"What? Why?" asks a clearly confused Brody. He leans forward and squints, studying Infinity's eyes. "You just called her Otto," he says, frowning suspiciously. "And why are you going that way?" He nods back in the direction of the promenade. His expression drops as the realization dawns on him. "Finn would never leave Bit alone like that. You're not Finn . . . are you?"

"Ding, ding, give the boy a prize," Infinity says dryly. "Take my advice, Brody. Find somewhere to hide until this is all over, or you won't walk out of here alive."

And with that Infinity thrusts the walkie-talkie into his hands and turns away from him. She jogs across the grass and takes off running along the path, even faster than before.

"Where are you going?" Brody calls after her. "You can help us!"

She glances back over her shoulder at Brody as he snatches the foil blanket from the ground and begins folding it, muttering under his breath. Even when she isn't enhancing her hearing, Infinity's ears are sharper than mine, and I can hear every word that Brody is saying. They're all about Infinity, and not a single sentiment is flattering. She turns back to look at the path, and a new emotion ripples through the void. It's uncomfortable, disagreeable, but completely unmistakable. Infinity feels guilty.

"The emotions you're feeling right now are not mine, Infinity. You care what happens to them!" I shout toward the eyeholes as I crawl along the tether.

"Shut up," she growls between breaths.

"You're a better person than you think you are! Deep down you're good!"

"I said . . . shut the hell up!" she barks, and the waves of guilt are quickly overridden by new and much more turbulent vibrations of anger. I hold on tight as I'm buffeted up and down by the emanations of rage, but Infinity's defensive protests only serve to prove that somewhere underneath all her stubborn denials . . . she knows that I'm right.

Infinity glances over her shoulder, back the way we came, and Brody is now a tiny figure in the distance behind us. Infinity looks ahead again. "I'm a weapon," she whispers. "That's what I was made for; that's what I am." She mutters the words in time with her footsteps, like some kind of twisted mantra, as the intensity of the rippling anger reverberating around me begins to settle into a shuddering hum of controlled fury. The whipping of the tendrils thankfully lessens to a degree where I can carry on clawing my way forward, and I shake my head in disappointment at Infinity's pigheaded stubbornness.

Putting one hand after the other, I look toward my goal, and through those eyeholes I see Infinity scanning along the path into the distance, focusing on the line of cherry trees approaching up ahead.

She slows to a stop, and as I look out her eyes, I can see why. The walkie-talkie that I dropped when Brody and I were being chased by the Lobots lies on the path at her feet. Quietly catching her breath, Infinity bends down and picks up the radio, but as she straightens, I hear a sound rippling through the darkness from her keen ears. It's a beat, a barely perceptible, far-off thudding noise. I recognize it immediately, and I can tell Infinity does, too, as a feeling of wary anxiety undulates through the void. Those footsteps can only belong to one person. Gazelle. Infinity looks ahead into the distance, toward the corner near the lamppost. Its light is falling across the piles of debris, casting a patchwork of shadows over the pale surface of the promenade. The rhythmical thumping is getting louder and louder.

Infinity scans the areas of light and dark between the broken structures and toppled towers, and the source of the sound, which we were both expecting, is suddenly revealed as Gazelle leaps into view from

behind the crumbled facade of a pockmarked building, flying through the air like she has wings on her heels. She thuds against the ground, and clouds of concrete dust billow around her cybernetic feet as she comes to a skidding halt. Infinity focuses directly on her. I gasp with surprise as the view through the peepholes suddenly rushes forward in a blur of colors, zooming in across the distance to the lamppost like Infinity has binoculars built into her skull. Gazelle's image now fills Infinity's whole field of vision. I can clearly see her standing in the light, her Lobot-encased head twitching from side to side, the way a wild animal would if it were sniffing the air for its prey.

Gazelle's attention is piqued, and her head snaps in one definitive direction. Infinity quickly looks in the same direction, and through her binocular vision I see a magnified image of Brody, far in the distance, his overstuffed satchel bouncing against his hip as he jogs along the path toward the door in the hillside. A horrified ripple of realization shudders through Infinity as her view snaps back toward the lamppost. I see Gazelle do a quick half crouch, and then she takes off. Bounding swiftly in long, leaping strides, she goes vaulting over a six-foot-high pile of rubble as easily as I could step over a curb on the street and hits the ground running on the other side, traveling at an inhumanly fast pace.

"Oh no," Infinity and I both whisper at exactly the same time.

Infinity has been standing in one spot, watching Gazelle from a distance, while poor, clueless Brody has been tripping motion sensors all the way toward the hillside. Gazelle is going to cut him down. Pop his head open with one swift kick of those lethal legs, just like she did to Jennifer.

I want to shout out into the darkness and plead for Infinity to help Brody, but I clearly don't need to say a word. Waves of panicked concern ripple through the void, and Infinity suddenly bolts into action, taking off like a shot back down the path toward him. Through Infinity's sensitive ears, I can hear the thuds of Gazelle's powerful legs on the ground. Infinity glances sideways at her. Through the binocular vision, I can see

Gazelle making short work of traversing a sand garden as she crosses it in a couple of bounds and goes flying between two cherry trees and onto the wide expanse of manicured grass that stretches all the way to the base of the hill.

Infinity's arms blade through the air at her sides, and I can hear the rapid pitter-patter of her shoes against the pavement as the wind whistles past her ears. I thought Infinity was running fast before, but somehow she's kicked it up into a much higher gear. I can feel the surging determination coursing through her entire body as she sprints back toward the hillside, tracking Gazelle as she goes.

All of a sudden I see the four red Lobot eyes clamped on to Gazelle's face turn as she glances in our direction. She's spotted us, and I silently pray that she swerves this way instead, choosing Infinity over Brody, picking on someone her own size and leaving him alone. But my hope is immediately dashed as the red eyes snap forward again, and she resumes her unfaltering line directly toward Brody as he slowly jogs along the path far up ahead.

Gazelle is still at least three hundred yards from him, and the soft grass is muffling her footsteps, so Brody is oblivious to her approach. If he would just look over his shoulder and see her coming, if only he were closer to the door, he might be able to rush inside and hold it shut against Gazelle long enough for Infinity to get there. But wishing for something doesn't make it so. Brody isn't looking back, and even though he's barely thirty seconds away from the door, three hundred yards are a handful of strides for Gazelle. Infinity is pushing herself as hard as she can and running at a blistering pace, but it's glaringly clear that there's absolutely no way she's gonna reach Brody in time.

"I'm almost at the door, Bit," Brody's voice says from the radio clutched tightly in Infinity's palm.

She squeezes the "Talk" button and shouts with heaving breaths, "Brody! Behind you!"

Brody looks back over his shoulder, and his eyes go wide with horror as Gazelle forcefully bounds across the wide expanse of grass toward him. She's halved the distance in four seconds flat, and in five more strides, she'll be upon him.

Brody quickly turns and quadruples his pace to the door, as Bit's voice screeches from the radio. "Finn?! Is that you?! Brody! What's happening?"

"Finn?" Jonah's voice issues from the radio. "Are you OK? Finn?"

Grunting with frustration, Infinity throws the walkie-talkie aside and pushes on, but I can tell that this sprint is quickly taking its toll. A steady pace with measured breathing, Infinity can handle, but keeping this sustained and staggeringly high speed up is something entirely different. I'm amazed that Infinity has managed to maintain it for so long, but it's very clear how much she's struggling as she begins to slow. She's gasping for breath, and I can feel her muscles burning with effort as she tries to summon every last scrap of her dwindling energy reserves in a desperate attempt to cover the remaining sixty yards to Brody.

With Brody's increased pace, he's only seconds from the door. Through Infinity's keen ears, I can hear him panting for breath, and through her eyes, I can see his arm reaching out for the handle, fingers splayed, barely inches away from salvation. But it's too late. Gazelle blazes toward Brody, and with two final thudding strides, she bounds through the air, and I'm filled with agonizing remorse as she whips her leg directly at his head. I've seen too many people die today. I simply can't watch another friend be murdered, and I screw my eyes shut, plunging myself into darkness as the brutally vicious slamming sound of Gazelle's foot connecting echoes through the void around me.

CHAPTER TWELVE

"Brody!" Infinity bellows into the night. Considering how exhausted she is, the breath it took to call his name could only have been summoned from a place of rage or pain. But the anger and sorrow of loss are not what I feel rippling all around me. Instead, the emotion surging forth from Infinity is one of overwhelming and absolute . . . relief.

I open my eyes, and what I see through Infinity's view instantly causes me to share her emotion. Whether Brody saw Gazelle out of the corner of his eye at the last conceivable moment or ducked out of the way with a hearty dose of pure, dumb luck, I guess I'll never know, but right now I really don't care how it happened, because all that matters is that he's alive. With his hand reaching up and clutching the door handle, Brody is squatting in a low crouch, with Gazelle's foot solidly wedged in the metal door just above him. If he were standing, Brody's head would have exploded like a piñata, but instead he's gulping air, staring at Infinity in disbelief as she runs toward him.

With less than twenty yards to go, Infinity's binocular vision snaps back to normal. She'll be by Brody's side in only a few short seconds,

but up ahead I see Gazelle perform a deft one-footed jump with her free leg and slam her left sole against the door. Her trapped limb quickly wrenches from the hole with a squealing scrape of metal against metal, and she thuds onto her back on the pavement.

Infinity thrusts her hand out, pointing in warning as she shouts to alert Brody. "Look out!" Gazelle kicks into the air, her whole body flipping up into a standing position as Brody quickly leaps up and tries to pull the door open to get inside. With a lightning-fast side kick, Gazelle's left leg shoots out, slamming it shut again, yanking the handle from Brody's hand. Deftly hopping from one foot to the other, she unleashes a vicious roundhouse kick at Brody's head.

He ducks again, but this time he dives as well, and Gazelle's right foot barely misses the top of his skull once more as he oafishly rolls in an uncoordinated tumble and comes to rest in an undignified heap right at Infinity's feet.

Brody scrambles around behind Infinity as Gazelle turns to face her. Infinity stands loosely, with her hands on her hips, wheezing for air. She's absolutely exhausted and in no condition to fight. In stark contrast Gazelle's stance is solid and strong. Both hands are balled into fists, and everything about her aggressive posture screams that she's ready to fight to the death. All of that, combined with the Lobot attached to her head like a parasitic helmet, makes for a very intimidating sight.

But something doesn't quite add up. The Lobot's legs and tendrils are wrapped around Gazelle's chin and throat, and the rest of its body has folded over her head, but under the four glowing red circles that cover Gazelle's actual eyes, the lower half of her face, from the bridge of her nose down to her chin, is completely exposed. That's what doesn't match. Her body says kill, but her trembling lips and the tears streaming down her cheeks tell an entirely different story.

"Hello? Is someone there?" she whispers feebly. "If . . . if someone is there, please . . . help me." Poor Caitlin is trapped inside her own

body, powerless against the Lobot. Turning your friends or comrades against you is bad enough, but hearing the desperation in their voices as they're forced to murder you is an evil gouged from the hellish depths of a twisted mind. The people who designed and made those brain spiders are a bunch of sick bastards.

Gazelle raises her fists, and a still-panting Infinity grabs the satchel tightly in her fist as she lifts the strap over her head with the other hand, freeing her up to fight.

"Help," Gazelle sobs as tears drip from her chin.

Gazelle shifts her footing into a combat posture, clearly getting ready to dash and kick with those formidable skull-crushing weapons she calls legs.

I can feel Infinity's rapidly beating heart slow to a crawl, as if she's willing it to do so. I can't feel any fear or apprehension from her at all as she takes a huge breath in through her nose and releases it, gathering the meager dregs of her remaining energy into one single concentrated point of explosive power. Unlike her, nervous tension is coursing through every fiber of me. Only a few seconds have passed, but it feels like Infinity and Gazelle have been staring each other down forever. I clutch tightly to the tether in the void, waiting with bated breath for the moment—

Suddenly Infinity whips her right hand up, throwing the satchel hard at Gazelle's head. Infinity takes two quick steps and leaps directly after it, twisting her body into a rapid rotation as she sails toward Gazelle. Gazelle quickly raises her hands to swat the satchel aside, but her eye line is momentarily blocked, and that's exactly what Infinity was counting on. She spins a full 720 degrees and lashes out with her leg, unleashing her gathered energy in one savage burst as she brutally pounds Gazelle in the stomach with the heel of her foot.

The vicious kick folds Gazelle in half, and she flies backward and crumples to the ground. The whole flawless maneuver was executed

so quickly that the satchel hasn't even hit the pavement when Infinity lands back on her feet in a fighting stance with her fists held out in front of her.

The heavy fatigue that Infinity had banished immediately returns like a weighted cloud, filling every corner of her body. Her heart starts drumming in her chest again as she sways unsteadily on her feet, heaving huge lungfuls of air. She gave everything she had to that one kick. But it certainly did the trick. Gazelle lies on her back, and a gurgling cough lurches from her throat as a mouthful of vomit globs from her lips and creeps down the side of her face like milky oatmeal. This fight is done.

Infinity looks over her shoulder at Brody. He's still sitting on the ground, and he smiles up at her. "I knew you wouldn't leave," he says.

Infinity is still too breathless to speak, so she just shakes her head and smiles back at him.

Suddenly Brody's eyes go wide. "Infinity," he says anxiously, staring in Gazelle's direction.

Infinity quickly looks back at Gazelle, and genuine surprise courses through her, and me, as we both watch Gazelle slowly getting to her feet. A blow like the one Infinity delivered would easily incapacitate anyone; that should've been the end of it. But apart from the smear of puke and the grimace of misery on the lower half of her face, Gazelle is standing there as if nothing happened at all.

Suddenly two sharp four-inch-long spikes erupt from Gazelle's knees, poking holes through the skintight black material of her uniform. More spikes begin snapping forth, piercing through the fabric in three long rows, all the way down each of her shins. A sickening knot grips my stomach as the alarming new development is topped off by two six-inch blades that flick into position from the front of each of Gazelle's robotic feet. Jonah may have recruited her to be a Savior, but the weaponized features of Gazelle's legs definitively reveal her past as a lethal covert operative.

"Please, someone . . . help me," Gazelle pleads meekly, but her will is not her own, and her body charges forward and springs into the air. Gazelle's powerful leg swipes at Infinity.

Infinity leans backward as quickly as she can, but her energy is spent. It's making her slow, and the tip of one of the blades slices a small cut in her neck.

Gazelle plants the flying foot on the ground and skillfully pivots as her other leg kicks straight out behind her.

Infinity tries to fend off the attack and divert Gazelle's foot, but this is no ordinary human leg she's dealing with, and Infinity's tactic is completely ineffective as the blow pummels into the lower left region of her rib cage. It's like getting hit by a battering ram, and the awful sound of crunching and snapping precedes the agony of broken bones skewering into flesh. It's in that very moment the searing pain brutally reminds me that those ribs also belong to me, and I scream out into the void as warning tones of injury peal and echo through Infinity's head.

Infinity is thrown onto the ground, clutching at her side. Gazelle advances to finish the job, and I can feel the void grow heavier and thicker as Infinity tries to focus her concentration on healing the damage that's been done, but she's clearly having trouble focusing, because nothing is being fixed.

"Let me out! I can heal us!" I call into the void. I don't know how I can do it; all I know is that something unlocked in my head after I woke up in Dr. Pierce's lab. Now, unlike Infinity, the healing happens for me without thinking, like how I can solve complex math equations by *feeling* the right places to put the numbers, without having to formulate at all.

"Let me out!" I call again, but either Infinity doesn't hear me or the stubborn bitch is ignoring me just like before.

Running on pure adrenaline and survival instinct, she scrambles backward across the pavement and onto the grass. I can't see Brody from

Infinity's view; all I'm focused on is Gazelle as she gets closer and closer, but I lose sight of her when Infinity flips over onto her knees and pushes against the ground in a desperate attempt to stand. I hear the sound of movement and see the flicker of a shadow, and then there's a heavy, pounding thud as Gazelle's left foot stomps onto the back of Infinity's hand, pulverizing it into the dirt.

Pain and alarms wail all around me, but they suddenly erupt into real and blinding agony as Gazelle's right knee slams into Infinity's back, the four-inch spike impaling her body, *our body*, right through the shoulder blade. I scream out into the darkness as deafening chimes of damage throng inside the void.

Infinity is trapped beneath the weight of Gazelle's legs. She can't move, and the darkness around me rocks like an earthquake tremor as I feel Gazelle punch Infinity hard in the back of the head. A pounding shock of vibration shudders all around me as Gazelle lands another fist onto Infinity's skull. The void shakes violently again from another savage impact, and all of a sudden the consistency of the dark changes from thick molasses to invisible vapor as the view from Infinity's eyeholes dims and flickers. She's losing consciousness. If that happens, we're dead.

"Infinity! Wake up!" I scream as I hurriedly and desperately pull myself along the tendril toward the fading view of Infinity's eyes. I'm close, but not close enough. With one last thudding punch from Gazelle, Infinity's vision flickers and then goes completely black. Grunting with effort I pull hard on the tether, but it suddenly evaporates in my hands, and I'm left sailing weightlessly through the darkness, panting in panic, waving my arms in every direction for a hold on something, anything. But there's nothing there. All the writhing lines and tethers are gone.

Suddenly I slam into something solid, and the blackness gives way as shapes and colors begin streaming into my eyes. Dazed, I blink my vision into focus and see Gazelle's foot right beside my face, crushing

my hand to the ground. My head is aching, and a sharp, spearing pain is skewering me in my back. I've regained control of my body, but it means nothing, because I have no control over this situation at all. I'm still at Gazelle's mercy, and any second now she's going to end this. Panic surges through me. I don't know what to do.

Out of nowhere I hear the sound of hissing, followed by a loud and guttural war cry. To my utter surprise and relief, Gazelle's foot quickly lifts away from my hand. I groan as her weight releases from me, pulling the spike out of my shoulder blade. The yelling and the hissing noise are coming from above, and I roll over onto my back to see an angrily shouting Brody stepping over me, the can of spray-on bandages clutched in his hand, spewing a stream of white liquid onto the robotic eyes of a backward-stumbling Gazelle.

My broken ribs begin moving back into place and knitting together as, gingerly, I sit up and take it all in. Gazelle flails blindly, her Lobot helmet plastered with spray-on bandage. The can sputters empty in Brody's left hand. He tosses it aside. As Gazelle claws at the air and throws wild punches, Brody quickly steps in, and, with a determined grunt, he swings his arm in a swift right hook to catch Gazelle solidly across the jaw with a pair of binoculars. Her head jars with the impact, and she teeters before dropping heavily onto the pavement, unconscious.

The spikes and blades on Gazelle's legs and feet instantly retract, and Brody watches her for a second to make sure she doesn't move again. He looks over at me, throws the busted binoculars onto the grass, and rushes to my side. "Infinity. Are you OK?" he says, kneeling down beside me.

"It's Finn, Brody. I'm back, and yeah, I'll be fine," I reply as I feel the hole in my shoulder and the cut in my neck sealing closed.

"Finn. OK," Brody says with a slightly puzzled expression. "You and Infinity should wear name tags or something."

I chuckle as the broken skin on the back of my hand heals together. I wiggle my fingers and clench my fist to test it. It's working fine, and as I open my palm, Brody immediately grabs it and pulls me to my feet.

"Thanks, Brody."

He smiles and nods. "What should we do with her?" he asks, looking over at Gazelle.

I tap the bulging satchel at his waist. "You got a rope in there?" I ask, knowing full well that he does. With both of us winding and tying knots, it only takes a few minutes to securely bind Gazelle's ankles and wrists, both of us making sure to use the bulk of the rope on those dangerous legs of hers. There's no way she's getting free.

After I grab my satchel from the ground, Brody and I carry her into the corridor in the hillside and prop her against the wall. Gazelle groans, and a startled Brody jumps back as she begins to come to.

Her possessed legs immediately spasm and twitch, and her hands feverishly open and close, but she's tightly hog-tied and isn't going anywhere. "Please . . . help . . . me," she whimpers, and my heart goes out to her.

I crouch down near her, being careful to stay out of range of her involuntarily bucking legs. "Don't worry, Caitlin," I say as soothingly as I can. "We'll find a way to get that thing off your head."

"Please," she begs. "I know you're there. I can't . . . stand . . . the pain."

She doesn't seem to be able to hear me at all.

"We have to take it off!" barks Brody.

"I . . . I can hear you," Caitlin whimpers. "Please, if you're there . . . please. Help . . . me."

"Finn. She needs our help!"

"We can't remove it. It might kill her!" I shout.

"Kill," Caitlin whispers. "Yes . . . kill me . . . pleeease."

"You don't know what you're saying!" I yell at her. "We'll bring help. You're gonna be alright!" I have no idea if what I just said is true or not. Honestly, I don't really believe it is.

"Please, someone," Caitlin pleads again. "I want . . . to die."

"C'mon, Brody. Bit needs us," I say as I painfully and grudgingly get to my feet and turn to walk down the corridor.

But Brody doesn't budge.

"Finn! We can't just leave her like that!"

"What choice do we have?!" I shout at him.

"Kill . . . me," Caitlin whimpers.

"We are not killing you!" I shout at her.

Brody glares at me angrily, then he opens his satchel, rummages through it, and pulls out one of the scalpels from Dr. Pierce's lab. "We have to do this for her. I'll make it quick," Brody says shakily, and I can hardly believe my ears.

My heart jumps into my throat as Brody steps toward Caitlin with the blade clutched in his trembling hand.

"Hold her legs down, Finn."

"I am not helping you kill her!" I yell.

"Please," Caitlin begs again.

"She's moving too much," Brody says with a quiver in his voice as he looks over at me. "Hold her legs, or I might not be able to end it fast."

"I'm not doing it. I'm not," I say as my pulse starts racing.

"I don't want to do it, either!" Brody grunts.

"Have you ever killed anything before?"

"No, but . . . just look at her," says Brody. "She's in pain."

"So . . . much . . . pain," Caitlin sobs again as tears stream down her face.

"I can't," I say, turning away and pacing down the corridor. "I just can't, Brody."

"Fine," he says blankly.

I grudgingly watch as Brody takes a deep breath, walks over, and straddles Caitlin's waist, forcing her scrambling fingers down with his forearm as her legs buck and kick behind him.

Brody gingerly raises the blade of the scalpel and presses it to Caitlin's neck.

"WAIT!"

Brody shudders with fright and almost drops the scalpel.

I quickly walk to Caitlin's side and hold my hand out to Brody. "Give it here."

He glowers up at me and pulls the scalpel to his chest. "No. You'll snap it or throw it away. She's suffering, Finn. You won't stop me doing this. I don't want to, but . . . you know it's the right thing to do."

I stare at him unflinchingly. "You're heavier than me. You hold her legs. Give me the blade."

He studies my face, no doubt searching for any signs of deception or insincerity.

"Brody, I know what I'm doing. Hand it over."

With a quiet sigh of relief that the gruesome task has been taken out of his hands, Brody stands up and places the scalpel in my open palm.

I nod at him. "OK, now hold her legs down the best you can." I take Brody's place on Caitlin's lap. Brody moves to her legs and puts all his weight on them. The robotic limbs are powerful, but at least he does succeed in lessening their movement.

"Thank you. Thank you," Caitlin whispers again.

"You can thank me if you survive what I'm about to do," I say as I grip the scalpel tightly, like a dagger, in a double-handed grip.

"What . . . what are you gonna do?!" Brody asks in alarm from behind me.

"This," I say as I tilt the scalpel diagonally upward, and with one hard push, I plunge the scalpel blade into the small gap between the Lobot's body and its four spray-on-bandage-splattered eyes.

There's a loud bang and a bright blue spark, and Caitlin's whole body instantly goes limp as the black cables around her neck disintegrate into dark-gray powder. Brody and I immediately leap off her as she slides sideways along the wall and flumps onto the cold concrete floor.

"What did you do?" Brody asks, gaping down at her.

"I took a chance," I mutter as I hand the scalpel back to him. "Either you were gonna slit her throat and definitely kill her, or I could try to get that thing off her head and probably kill her. I went with probably."

"I guess either way it turned out the same," Brody says, looking down at Caitlin sadly.

"Yeah. I'm afraid so," I murmur as I kneel down beside her. "I'm so sorry, Caitlin," I whisper. "I wish none of this had ever hap—"

With a loud, gasping breath, Caitlin sits bolt upright. I almost jump out of my skin, and Brody lets out a grunting man scream beside me as the Lobot falls away from her head and clatters to the concrete floor.

With half her face plastered with dried bandage, Caitlin blinks rapidly as she looks up at us in bewildered shock. Apart from one black eye, a few cuts and scrapes, and a graze on her chin where Brody hit her with the binoculars, she looks relatively OK.

She quickly raises her hands to her head and claws her fingers through her short brown pixie-cut hair. Then she immediately bursts into loud, sobbing tears.

"Hey, hey, hey, you're OK," I say, leaning in and patting her on the shoulder.

Suddenly she lunges at me, wrapping her arms around my neck and squeezing me in a tight embrace as she cries and wails. "Thank you! Thank you!"

"You're welcome," I say as I loosely hold her and pat her on the back.

Caitlin releases me, and with a loud, wet snuffle, she wipes her nose on the back of her sleeve. "I apologize for my behavior, Commander," she says, averting her eyes. "I . . . I didn't mean to hug you; it's just that . . ."

"I know, I know," I whisper consolingly. "It's OK."

I remember Caitlin calling Infinity "Commander" in the transport a few hours ago. It sounds weird to be addressed by the same title, but I pretend not to notice as I help Caitlin to her feet. Brody, on the other hand, decides to make a definite point of it.

"Commander? Why did you call her Commander?" he asks, frowning at Caitlin.

"Because that's her rank," Caitlin replies as she gruffly wipes the tears from her face and frowns back at Brody, like he should know and show the proper respect. "Lieutenant Commander, code name Infinity One, lead agent of the Zee-Tol Shadow Division and Vermillion-Class operative, level ten. I've read everything about you that my security-clearance level will allow."

Brody looks at me with raised eyebrows.

"Not me," I say, looking at him. "The other me."

"Oh, OK," Brody says, nodding with a little frown of his own. "Yeah that makes sense, I guess."

Caitlin looks a little confused, but then she suddenly gasps. "Oh my god! It grew back?!" she says, staring down at my left hand. "We'd all heard the stories about you around the barracks, but no one actually *believed* them. You really are invincible, aren't you?" she says, gawking at me in wonder.

At first I can't think of what to say, so I give her my best attempt at a stern expression and a military-sounding response. "That's classified."

Caitlin mirrors my expression and nods without hesitation. "Of course, Commander."

"You can call me Finn if you like," I say, and Caitlin immediately shakes her head.

"Oh no. I couldn't do that, Commander."

"Suit yourself," I say with a shrug and a bemused smile. "How do you feel?" I ask.

Caitlin lets out a huge sigh. "Free. That thing made me relive all my fears and worst nightmares over and over in a never-ending loop. I didn't know where I was or what I was doing, and every second was agony, like my body was on fire. I felt like I was in a living hell."

"You couldn't see anything that you did?"

She shakes her head again. "Sometimes there were shapes and colors, but I couldn't see anything clearly at all. I could hear you when you shouted, but . . . apart from that it was just . . . noise."

I decide it's best not to tell her that she murdered an innocent civilian and very nearly killed me as well. Right now, it won't help the situation at all.

"Well, that's over now," I say. "Where are the rest of the Saviors?"

"I'm not sure," Caitlin says sadly. "The last time I saw them, they were holed up in a building in Sector B. We were safe for a couple of hours while Jack tended to everyone's injuries the best he could. But we knew we couldn't stay there forever. Commander Zero instructed me to make a break for it and carry him to a warehouse he knew of in Sector C that might contain something that could take out the R.A.M.s."

"Warehouse eighteen," I say.

"Yes," replies Caitlin. "We barely made it past the R.A.M.s, but we got to the warehouse and broke in. Commander Zero took a few items, and then we headed back to the others in Sector B. We were halfway there when we were ambushed by a whole bunch of those goddamned things." Caitlin points at the deactivated Lobot lying on the floor. "They swarmed all over us, and . . . that's the last thing I remember," she says as she peels flecks of dried bandage from her face.

"So they took Zero as well," I murmur.

Caitlin nods. "I'm afraid so. They were all over him," she says with an angry sigh. "What's your plan of action, Commander?"

I have to admit that being treated like I'm important is quite a confidence booster, and I'm almost embarrassed when I hear the authority in my voice as I suddenly begin barking orders.

"Brody. Get on the radio and contact Bit. Tell her we're on the way, and let Jonah know about our situation."

He nods and immediately does what I say, pulling the walkie-talkie from his satchel and pacing away toward a corner in the corridor.

I like this new feeling so much I even decide to use Caitlin's code name.

"Gazelle, I need you to go back out there. Are you up to it?"

"Yes, Commander. What do you need me to do?"

"Find the rest of the Saviors. Start at the building where you last saw them; hopefully they're still there. We could use their help to—"

"Finn!" Brody shouts from behind me. "Something's wrong."

"What is it?" I ask, looking over at him.

"Bit isn't answering," he replies.

"Well keep trying. She's probably just preoccupied, trying to find Dr. Pierce and—"

"No, Finn, Bit isn't answering, but . . ."

"But what?" I ask, frowning at him.

Brody strides across the corridor, holding the radio toward me in his outstretched hand. "Someone else did."

"Who?" I ask as he hands the walkie-talkie to me. I squeeze the "Talk" button. "Dr. Pierce?"

"Yes, it is Dr. Pierce," Nanny Theresa's graveled voice croaks from the speaker. "But I'm probably not the one you were expecting . . . am I, child?"

I stare at the radio in wide-eyed horror as a mix of fear and sickening worry grips my stomach like a clawed fist. Nanny Theresa's digital ghost has returned to torment me yet again. First she infected the pirate construct and nearly choked me to death in Dome One, then

she brutally murdered my classmates and my teacher Miss Cole, tearing them apart with that R.A.M.'s hellish weapons in Dome Two. She possessed those Drones in the clean room and almost tore my head from my body, and now she's holding Bit hostage, waiting for me to walk right into her spider's web and willingly sacrifice my life.

"Your little friend is safe . . . for now," says Nanny Theresa. "But if you are not standing before me inside this dome soon, you will spend the rest of your days in the knowledge that you, and you alone, were responsible for what I will ensure is her very slow and painful death."

CHAPTER THIRTEEN

"Don't hurt her!" I plead.

"I make the demands, child, not you," seethes Nanny Theresa.

"Theresa?" Jonah's voice barks from the speaker.

"Hello, Major," she replies coldly.

"But . . . how?" Jonah stammers, searching for the words.

Nanny Theresa finishes his sentence for him. "How am I here? Come now. You didn't think Onix was strong enough to hold me captive forever, did you? And now, thanks to Richard's quantum grains, I have a body, complete with two hands that I will gladly use to take everything away from you. Just like you took everything away from me."

"What's she talking about, Jonah?" I ask.

"Your Nanny Theresa didn't move away like I told you." Jonah grunts angrily. "She's been dead for two years. The woman you're talking to isn't real; she's a digital copy, nothing but code and corrupted files."

"Now, now, Major. I may be dead, but I still have feelings," Nanny Theresa says mockingly.

"I know what she is," I mutter into the radio. "I was there when she downloaded her mind after she died. That much I do remember."

"You . . . remember?" asks Jonah.

"I know that you tried to erase that memory from me." I feel anger beginning to simmer in my gut. "You invaded my mind, Jonah. You stole days of my life from me over and over again, but worst of all, you tried to make me forget what she did to Carlo. How could you?" My voice trembles with sorrow and rage.

"Finn, please listen," Jonah murmurs gently. "I was only trying to—"

"What? Protect me? Is that your excuse? Is that how you justify violating my mind?"

"Finn, I can explain. I never meant to—"

"Shut up," I bark. "I don't want to hear it. You've been lying to me my whole life. Why the hell should I listen to you now?"

"Well, well," Nanny Theresa says with a smile in her voice. "It seems that your sins are finally coming home to roost, Major. But as much as I'm enjoying this little stroll down memory lane, my patience is wearing very thin, and your little friend's time is growing shorter by the minute."

I hear a rustle of movement, and the sound of short, quiet breaths is followed by Bit's frightened voice. "Finn? I'm . . . I'm scared, Finn."

"Bettina!" I shout into the radio. "Please, don't hurt her."

"Bettina? Is that the girl's name?" says Nanny Theresa. "I will let her go, Infinity, but not until I see you first."

"Don't do it, Finn," says Jonah. "Theresa's construct can't exist outside the boundary of Dome Two; if you go inside, she'll kill you!"

"This is between Infinity and me, Major," barks Nanny Theresa. "If I hear your voice again, I will hurt Bettina, and if Infinity refuses to face me, I will do far worse."

"I'll get there as soon as I can, I swear," I say into the walkie-talkie.

"Finn! No!" shouts Jonah.

"It seems you weren't listening to a word I just said, Major Brogan," says Nanny Theresa. "Perhaps you'll listen to this?" I hear a muffled snap, and Bit's wailing scream vibrates loudly from the speaker.

"Bettina!" Brody shouts, his face contorted with anguish.

"I've just broken her arm," says Nanny Theresa. "Another word from you, Major, and I break one of her legs. Just like a matchstick."

"Please. Leave her alone," I plead into the radio. "I'm coming to you, I promise."

"See that you do," says Nanny Theresa. "And if I were you, young lady, I'd be quick about it."

I shove the walkie-talkie back into Brody's hand and turn to Gazelle, pointing down the long, dim corridor. "I need to get inside that dome. Right now."

"Yes, Commander," she says as she immediately turns her back to me.

"What should *I* do?" asks a clearly rattled Brody. "I don't know what's happening or why, but I need to help. I need to do something!"

"Then you start running right behind us. I'll send Gazelle back to get you as soon as she's taken me to the entrance to the dome."

Brody nods fervently.

"It's gonna be dark in there," I mutter as I put my arms around Gazelle's neck and grip her waist with my legs. "What I wouldn't give for a flashlight right now."

"Here," Brody says as he rummages through his satchel. "I don't have a flashlight, but will these do?" he says, holding out a fistful of glow sticks and flares.

I smile at him. "Yeah, Brody, those'll do fine," I say as I take them and tuck them away in my bag.

"I'll see you soon," Brody says, and I give him a stoic nod.

"Let's go," I say in Gazelle's ear.

"Hold tight," she replies, and my head whips back from the sudden acceleration as Gazelle takes off in a blinding burst of speed down

the passageway. The air rushes in my ears as the walls whizz by to the sound of Gazelle's thudding footsteps echoing all around me. The lights set into the ceiling at four-yard intervals flick past rapidly overhead as Gazelle strides powerfully onward, and in no time at all, I can see the corridor up ahead widening as we approach the quantum-grain reservoir.

Gazelle slides to a halt beside a curving handrail that runs around the edge of a walkway inside a huge concrete cylinder. Lights built into the wall illuminate the reservoir all the way up. It looks like I'd imagine the inside of a city water-storage facility, except in the center there's a massive pillar-like conduit that extends high up into the middle of a giant circle of darkness above. That's obviously the underside of the dome, and instead of water being piped up to it, the outer surface of the central tube moves in ascending ripples like it's completely covered in a pitch-black, shivering liquid.

"The stairs, quickly!" I bark, pointing at the concrete staircase to the right that spirals upward around the wall of the reservoir.

Gazelle nods and dashes toward them, bounding up the stairs a dozen at a time. Piggybacking on Gazelle is not a comfortable experience on level ground, but adding stairs to the equation makes it feel like I'm on the back of a bucking bronco. I hold on as tightly as I can without strangling her as we go higher and higher and higher around the inside of the towering cylinder.

I look above me, and I can see the huge black disc getting closer and closer. Gazelle leaps up the last of the stairs and comes to a skidding stop on a wide landing made of metal grating. At the end of the landing is a ladder with a safety cage around it that reaches thirty feet straight up to a circle of glowing blue lights set into the wide disc of shimmering black.

"There's the hatch. I'm going in," I say as I release my arms and legs from Gazelle, step onto the grating, and stride toward the ladder.

"I'll go get that Brody guy," Gazelle says as she turns to leave.

"No," I order her, and she immediately stops in her tracks. "There's someone very dangerous up there," I say, pointing toward the hatch. "Brody means well, but he'll just be another thing for me to worry about if he enters that dome. I need you to climb the ladder behind me and wait by the hatch. When I give you the signal, I want you to get my friend Bettina out of there as quickly as you can."

"Of course, Commander. What does your friend look like?"

"She's fifteen years old. She has brown hair, glasses, and she's wearing jeans and a t-shirt with a picture of Einstein on it. It's very important that she's kept safe. She might be the only chance any of us has of getting out of here alive."

"Yes, Commander," Gazelle says stoically.

"Even if I'm being attacked, you get her to safety. Understand?"

"Yes, of course," says Gazelle.

"Thank you," I say as I take a deep breath and look Gazelle right in the eyes. "Let's do this."

I turn to the ladder, grab the rungs, and begin making my way up to the hatch. Gazelle follows right behind me. After a thirty-foot climb I reach the dark-gray hatch, and in the glow of the blue lights around its border, I see a keypad in the center of it. Thanks to Dr. Pierce's handiwork, its button panel has been levered off and is hanging by a tangle of multicolored electrical wires. I push against the hatch, and it easily opens inward; it's not even heavy.

I crawl up through the opening onto a shiny, smooth black floor. It isn't silent inside the dome. I can hear a quiet hissing sound all around me. I shuffle on my knees and look back at Gazelle, who's perched on the ladder below, looking up at me. I reach into my satchel, take out one of the flares, and close the hatch over her, carefully wedging the flare between the lid and the floor to leave a small gap for Gazelle to hear me through.

"Wait for me to call you," I whisper.

"Yes, Commander," she whispers back.

I retrieve a few glow sticks from my bag, get to my feet, and quietly walk around the hatch into the darkness, bending one of the sticks as I go. The activation capsule inside it breaks with a muted snap. I give it a quick shake, and it lights up with a bright green halo in my hand. I hold the stick high, waving it from side to side as I walk farther into the dark, but all I can see is the shiny black floor, illuminated in a circle of green, ten feet in every direction.

I look over my shoulder, and for some reason I don't understand, I can't see the ambient light coming from the gap in the hatch behind me. A ripple of fear shudders through me, and my first impulse is to go back and look for it, but the thought of Bit trapped somewhere in here hardens my resolve. I haven't gone very far, and I know the hatch is vaguely back in that direction, so I decide to lay a trail of bread crumbs, so to speak. I crouch down and put the glow stick on the floor, then I crack another one and walk on another twenty feet or so before I quietly place the second stick on the floor, too.

My heart is beating quickly in my chest, and I gulp nervously as I crack and shake another stick. It lights up in my hand, and after walking twenty more feet into the darkness, I place the third stick down. I turn back to survey my markers, and I freeze in my tracks with frightened surprise. There should be three glow sticks, twenty feet apart from each other, all in a row, pointing the way back to the hatch . . . but I can only see one. The other two have vanished. They stay lit for hours, so they can't have gone out. I quickly stride back to the last stick I dropped and stand over it, looking in every direction for the next one, but there's nothing but darkness and that strange, quiet hissing sound all around me.

I'm starting to panic. I want to call out to Gazelle so I have a point of reference in this pitch-black darkness, but I stop myself. That might alert Theresa to Gazelle's presence and jeopardize my chances of getting Bit to safety. If Theresa has moved or taken my other markers, then she already knows I'm here.

I don't know what kind of sick game she's playing, but she can obviously see me, and I can't see her. She could strike me down in an instant if she wanted to, so what is she waiting for? Maybe she wants me to draw this whole thing out for her own warped satisfaction, have me cowering in the dark, shaking with fear before she does the deed?

Well I'm not having it. Sorry, Nanny, but I refuse to play by your rules. I refuse to be afraid.

"I'm here! Show yourself!" I scream out. My brow furrows with confusion. That didn't sound right at all. When Bit radioed me from inside the dome, I could hear her voice echoing in the cavernous space. But my voice had no more echo than if I were standing in a tiny room. I don't know what's going on, but something doesn't feel right. I need more light, so I reach into my satchel and pull out a flare. I'm about to pop the plastic cap and light it when a woman's voice gently whispers through the dark. "Wait."

I was already on edge, but now my blood feels like it's boiling with adrenaline as I spin on my heels, glaring into the blackness all around me. "Hello?!" I shout. "Who's out there?!"

Suddenly a lump begins rising from the floor beside the glow stick at my feet, and I leap backward in fright, holding the flare out in front of me, wishing that it was more than just a glorified Roman candle. Come to think of it, even if I had a knife or gun, I don't imagine it would do any good against a quantum construct, which is exactly what is growing out of the shiny black ground right in front of me.

The construct is the same color and has the same glossy sheen as the floor it's emerging from, and it hisses quietly as it gets taller and taller. I anxiously stare at the amorphous blob, not knowing whether to run or not as it rises in a rippling liquid column until it's standing a few inches higher than me. In the sickly green hue of the glow stick, I watch as the thing begins changing, molding itself into a distinctly womanly shape.

The darkness around me begins to brighten, and when I look around I'm shocked to see that I'm standing inside a small enclosed

dome, thirty feet across and fifteen feet high, and the increasingly intensifying bright white light is emanating directly from its curved wall. The glossy black female shape shimmers, then the surface of it quickly begins sliding down from the top like an oily veil, revealing the details of the person underneath.

Whoever she is, she's facing away from me. First I see long, straight black hair, then shoulders, and in the following few seconds her arms and her back, then her lower body, all the way to her feet, are revealed. She's wearing a crisp white dress. I've only ever seen it in a photograph, and only from the front, but even from the back I recognize it instantly. My heart leaps into my throat, my hands drop loosely to my sides, and the flare slips from my fingers and thuds to the floor.

"Mother?" I whisper bewilderedly.

She slowly turns to face me, and I'm completely lost for words. There she is. The flawless skin of my mother's brow crinkles with emotion, and her beautiful, gentle sapphire-blue eyes seem to shine with joy. A smile trembles onto her lips, but then it widens into a beaming grin as she suddenly lunges at me with open arms and pulls me into a warm embrace.

"Finn," she sighs, hugging me tightly as she lets out a breathy giggle. "My darling daughter."

I don't know how to react. My mother is dead. She has been ever since I was born. Before today I've only ever seen her in photographs, and when her face appeared on that Drone shortly after we arrived here this morning, I was so shocked I fainted. Now her consciousness has a physical form, she's holding me, and I have absolutely no idea how to feel. This is all too sudden. I'm speechless and numb, and as my mother pulls away and looks at my stunned expression, I can tell that she sees how overwhelming this is for me.

"You must have endless questions," she says as she takes my hands in hers. "But right now I need your help to get everyone to safety."

All I can do is stare at her, dumbfounded, gormlessly watching her lips move as she speaks.

"Theresa has them confined in an enclosure much like this one, on the far side of the dome. I overheard her plan to lure you here, so I waited for you to arrive. I've deactivated the motion sensors, concealed your lights, and created this shield over you to hide you from her. She has no idea you're already inside, and she doesn't know I'm here, either, so we have the element of surprise on our side."

I still don't say a word.

"I'm sorry I didn't show myself right away when you came through the hatch, sweetheart. I meant to, I really did, but you've grown into such a beautiful young woman, and when I saw you, I . . . I was a little overwhelmed. I also didn't want you to faint again like you did this morning."

I just stare at her.

"Finn?" she says, looking at me quizzically. "Say something; you're starting to scare me."

"You're here," I whimper. "But . . . you died." I honestly don't know why those particular words slipped out of my mouth. There are a million things I could or should or want to say right now . . . but of all the questions rampaging through my mind, I choose two of the most inane sentences I've ever heard come out of anyone's mouth, including mine.

My mother just smiles. "Yes, my darling, I'm really here, and even death couldn't keep me from you forever. In fact, I've never felt truly alive until this moment."

"Mother?" I ask, staring at her in wonder.

"Yes?"

"What . . . am I?" Oh my god. Even though it is a question that has plagued me for every minute of this accursed day, I'm dumbstruck that right now it seems I'm unable to utter any more than three words at a time. That's the last straw, brain. You're fired.

My mother looks me in the eyes with a serious expression on her face. "You're my daughter, and I know that's not the answer you're looking for, but I need you to focus. When this is all over, we'll sit down together and you can ask me anything you want, I promise. But now I need you to be strong for me. We have to get Graham and your two school friends out of the dome. Can you be strong, Finn?"

"I can't believe you're standing here," I murmur. "I mean, I know *how* you're here. At some point before you died, your mind must have been downloaded, but—"

"Finn!" my mother barks. "This is not exactly the reunion I was hoping for, either, but I need you to be here right now. Are you with me?"

"What?" I say, snapping back to my senses. "Yes . . . of course. I'm sorry. Wait . . . what do you mean Graham and my *two* friends?"

"There's a young girl. I heard you on the radio, you called her Bettina?"

I nod.

"And there's a boy, skinny, with brown hair."

"Dean?" I whisper. "He survived?"

"Is that his name?" my mother asks. "I peeked inside Theresa's enclosure. They're all OK, except for Dean, he looks dazed, confused."

"He was connected to the R.A.M. when Nanny Theresa took control of it. Something happened to his mind."

"Oh, that poor boy. Then we need to get him and the others out as soon as we can."

"OK," I say with a huge breath and a determined nod. "What do we do?"

"That's my girl. I have a plan," my mother says with a smirk. She backs a few steps away from me and closes her eyes.

Suddenly there's a quiet hissing sound, and my mother begins to get shorter as the top half of her dress sprouts long sleeves and a hood and instantly turns from white to black. The lower half of her dress turns

gray and transforms into jeans on her legs as the flat-soled shoes on her feet morph into green sneakers with white stripes on the sides. Her face thins ever so slightly as the years melt away, reverse-aging her from the thirty-year-old I'd always seen in her photograph to a teenager my age. I always thought I looked a lot like her, but as she opens her eyes and smiles at me, it's like staring into a mirror. My mother now looks exactly like me in every way, even down to the satchel hanging by her side.

"What do you think?" she asks.

"I think that's amazing. And also really weird, but I think I know where your plan is heading."

My mother smiles. "A little deceptive distraction while you get the others to safety."

I return her smile, but then my eyes go wide as I remember Gazelle.

"I brought a friend. She can help. She's waiting on the ladder underneath the hatch."

"Then we'd better go and get her, I suppose, but first, I had better hide these." My mother looks down at the glow stick and the flare at my feet, and they instantly sink, engulfed by the black floor. "OK, c'mon, this way," she says with a flick of her head, then she turns and breaks into a quick jog. I follow right behind her as the white dome moves along with us, quietly hissing as it goes. Because of the opaque nature of the minidome, I can't see where we're going at all, but my mother clearly has no problem navigating, as it isn't long before the hatch slides into view on the floor at the edge of the enclosure.

I crouch beside the hatch, take the flare from the gap, stuff it into my satchel, and fully open the lid. "Gazelle," I whisper. "Get up here."

"Yes, Commander," she says as she pushes the hatch lid open and climbs up onto the glossy black floor. She looks up, and her eyes go wide as her head ping-pongs back and forth between me and my mother.

"It'll take too long to explain," I say as Gazelle stares bewilderedly at me and my doppelgänger. "All you need to know is that she's here to help."

"Hello," my mother says, smiling at Gazelle.

"Ohhh-kaaay," Gazelle mutters blankly as I take her hand and help her to her feet.

"What's next?" I say, turning to my mother.

"I'll announce myself, pretending to be you, and demand to see Graham and your friends are safe," my mother explains.

"She promised she would let them go if I faced her," I say.

"Good. Hopefully she'll keep her word and release them," replies my mother. "If that happens, I can insist that they safely leave the dome before she does what she came here to do."

"You mean . . . kill me?" I ask.

"Yes," my mother says solemnly.

"Why *does* she want to kill me?"

"She blames you for things that are not your fault."

"What does she think I've done?" I ask.

"Well, among other things, Theresa holds you responsible for my death, and she believes that was the beginning of your father's descent into madness."

"Why?" I murmur. "I . . . I don't understand."

My mother looks at me curiously. "What exactly have you been told about your Nanny Theresa?"

"I know she was a doctor of some kind and she was married to Graham, but that's all. Apart from that she was just an angry old lady that used to live at the house."

My mother looks surprised. "So no one has told you who she really was?"

I slowly shake my head, frowning.

"Finn, Theresa was your grandmother."

The lines of my frown deepen, and my eyes narrow with confusion. "What?"

"Theresa was married to a man named Reginald Blackstone, and your father was their only child," replies my mother. "Reginald died in

a terrible train crash when Richard was very young, and it would be many years until Theresa would remarry, but when she did, it was to my father . . . Graham."

"Dr. Pierce is your father?"

"That's right. My mother, Linda, passed away from an illness when I was young. Graham and Theresa worked together. They were both lonely, and they grew very close. But after I died and Richard shut himself away and the military took more and more of your time, Theresa and my father were all each other had, and eventually they married."

"She's my grandmother?" I blurt out, still trying to wrap my head around what I've just been told.

"She was also my stepmother, too, I suppose. But the Theresa in this dome with us now is very different from the woman she used to be. I fear she'll stop at nothing to eliminate the one who she blames for her son's insanity."

"Me."

"Yes, I'm afraid so, sweetheart," my mother says sadly.

"You said there were other reasons why she wants me dead."

"There will be time to discuss that later, but right now we need to concentrate on getting everyone to safety."

I nod in agreement. She's right; I should be focusing on one thing at a time.

"If Theresa doesn't release them, I will hold her back for as long as I can, and you two get them out, OK?"

"OK," I reply.

"Yes, Commanders," Gazelle says, still glancing back and forth between my mother and me.

"I'll reduce the size of this enclosure, so it isn't blocking the hatch and to lessen the chance of Theresa noticing it. I'll also change the view on the wall so you can see out my eyes and hear what I'm hearing. If Theresa breaks her promise, I'll let you out right away, and you be sure to move fast."

"No one moves faster than me," Gazelle says to my mother.

"Alright. Good," my mother says with a determined nod. "Are you both ready?"

"Yes," I say and turn to Gazelle. "Ready to do this?"

"Ready, Commander," she replies.

"Commander," my mother says with a bemused smile. "I like that. It's nice to know my daughter is so well respected." My mother looks at the floor and opens her palm, and the flare I dropped before suddenly resurfaces and rises to her palm on a shiny black column. "This should get Theresa's attention," she says as she grabs the flare and the column sinks back down.

I can't help myself, and I lunge across and throw my arms around her shoulders, hugging her to me. "Good luck," I whisper, and she holds me tight.

"Thank you, honey. I'll be fine. She can't hurt me."

We separate, and she looks me in the eye. "Be careful," she whispers, then she turns, strides across the floor, and walks right through the wall of the minidome like it isn't even there.

"I'd ask," Gazelle says, staring at me in confusion. "But you'd probably just tell me it's a long story, wouldn't you?"

"Something like that," I say, smiling at her.

All around us the enclosure begins shrinking, and the opening to the hatch appears to shift away, out of sight beyond the border, as the little dome gets smaller. Gazelle and I shuffle together and crouch down, huddling together on the floor as the minidome reduces down to a tiny version of itself, barely ten feet wide and five feet high. The bright white wall of the minidome suddenly goes pitch-black, but it doesn't stay that way for long as I hear the strike of an ignition pad, and suddenly everything illuminates in the intense red light of the fizzing flame burning from the end of the flare. It really is a strange sensation as the wall of the dome displays the view from my mother's eyes. It's like Gazelle and I are sitting inside her head as she walks forward holding the flare

aloft in her hand. The smoke pouring from the flare billows into the air, painted scarlet by the glow of the flame beneath it, and all around my mother a thirty-foot-wide circle of red light flickers and dances over the shiny black floor.

"I'm here!" my mother shouts. "Now let everyone go!"

Suddenly Nanny Theresa comes into view like a ghoulish apparition, and Gazelle gasps beside me. I also shudder at the sight of Nanny Theresa, not walking but seemingly floating an inch above the floor, sliding out of the darkness toward my mother, the wrinkled skin of her face made all the more severe by the vivid chemical hue of the flame. She's looks just like she did when she was alive two years ago, with her long, plain dark dress, her dowdy cardigan, and her hair tied up in an ample gray bun on top of her head. But her simple, practical clothes don't detract in the least from the fact that in the harsh red light of the flare, Nanny Theresa is the very vision of a demon bathed in hellfire. She comes to a stop six feet from my mother.

"You're hardly in any position to make demands, now are you, child," Nanny Theresa says snidely.

"I'm here like I promised," says my mother. "Now you keep yours."

Nanny Theresa folds her arms on her chest, glowers at my mother, and then snorts indignantly. "Fine," she says, waving her hand through the air. "Far be it from me to renege on a deal like the members of your disrespectful generation." On the edge of the circle of light, a big black box slides into view, and its walls quickly lower into the floor.

Bit, Dr. Pierce, and Dean flump onto the shiny ground. Dean still looks as gormless and floppy as before the crash, and Dr. Pierce's hands seem to be bound together, and he has a glossy black gag over his mouth. Bit looks like she's in a lot of pain. She groans, cradling her broken arm, and I glare at the emotionless face of Nanny Theresa, angrily gritting my teeth.

"Go! Get out of here!" my mother shouts at Bit and the others.

"I'm not leaving without you!" shrieks Bit.

"Yes, you are!" my mother shouts back. "I'll be fine, Bettina! Now go!"

"No!" she yells. My heart swells with pride that Bit is so loyal to me, but at the same time I can't help wanting to slap her in the back of her stubborn head. Her selfless bravery could ruin a perfectly good plan.

"She needs to see you, Finn," my mother whispers as she glances back toward Gazelle and me. "I'm going to lower the enclosure. Be ready."

"OK," I reply.

"Who are you speaking to?" Nanny Theresa growls at my mother.

"Go straight for Bettina," I say to Gazelle as I reach into my satchel, retrieve a couple of glow sticks, and shove one into her hand.

"Yes, Commander," she says as she shuffles around into a sprinter's position. "Judging by the other Commander's view, I estimate the hostages are approximately thirty yards straight ahead." She cracks and illuminates the stick.

"I'll lower the enclosure after three," my mother's voice whispers from the wall of our enclosure as Gazelle tucks the glow stick under the wristband of her watch.

Nanny Theresa glares at my mother. "What are you babbling about, child?"

"Two," whispers my mother, and I crack a glow stick of my own as Gazelle raises up on her haunches.

"Is someone else in here with you?" Nanny Theresa says, looking around into the darkness.

"One!" my mother shouts as she suddenly turns and breaks into a sprint, dashing away from Nanny Theresa, her arms blading at her sides as the flare fizzes in her hand.

"Finn!" Bit shouts after my mother as she bolts away into the darkness.

"Come back here!" Nanny Theresa bellows as she sweeps through the air, floating after my mother. "You won't escape me again!"

"Now, Finn!" My mother's voice rings inside the small dome, and all of a sudden it opens and instantly disappears into the floor. I quickly stand up, waving the glow stick above my head.

"Bettina! I'm over here!"

With my mother's flare now streaking through the blackness on the other side of the dome, Bit and the others are in complete darkness, but she must see me as her confused voice echoes through the blackness toward me. "Finn? Is that you?"

Bathed in a halo of glowing green light, Gazelle is off like a shot, and in three and a half strides, she sails though the air and skids to a halt, covering the distance to Bit and Dean and Dr. Pierce in three seconds flat. In the light of the glow stick, I see Gazelle quickly crouch down and grab Bit's hands, pulling her arms around her neck. Bit screams out in pain, as Nanny Theresa bellows like a monster from the darkness, "Who's in here?"

Nanny Theresa immediately halts in her tracks, and I can see her dark silhouette turning away from the red halo of the flare as she looks back in the direction of Gazelle's glow stick. Nanny Theresa holds her hand up high, and a glowing ball begins forming in her palm, lighting up the section of the dome all around her. My mother, suddenly realizing that she's no longer being chased, skids to a stop and turns on her heels.

"Theresa!" she shouts as Nanny whips her arm, sending the luminescent globe flying through the air. As it travels, it gets brighter and brighter and bigger and bigger, swelling to the size of a beach ball before coming to a stop, hovering in midair right above Gazelle and the others, illuminating the entire dome with bright white light. Even from all the way over here, I can see the rage on Nanny Theresa's face as our deception is revealed.

With Bit clutching on to her, Gazelle leaps back toward me, and after a few powerful bounds, she skids to a halt right beside me. Gazelle gently lowers a grimacing Bit to the floor, and I immediately crouch

down beside her. Bit looks up at me with a mixed expression of pain and confusion.

"Finn?" she whispers bewilderedly.

"Yeah, it's really me this time," I say with a little smile. "Get the others!" I yell at Gazelle. She nods and takes off toward Dean and Dr. Pierce.

"Where's Brody?" Bit asks. "That crazy woman took our walkie-talkies. Is he OK?"

"He's safe," I reply. "C'mon, I'll take you to him."

The hatch is a few feet away, and as I help Bit up, I glance over my shoulder to see my mother sprinting at a glowering Nanny Theresa, hurtling toward her from behind. My mother has almost reached her when Nanny Theresa's whole body suddenly drops in a straight line, vanishing down into the floor as if a trapdoor has opened up beneath her feet.

My mother skids over the spot where Nanny Theresa was standing and looks in our direction with panic in her eyes. She quickly dives at the floor, disappearing into it as if it were water in a swimming pool, leaving the still-burning flare spinning like a Catherine wheel on the solid black surface behind her.

Bit and I reach the hatch. "Quickly," I say, pulling the lid open. "Let's get you out of here."

All of a sudden the lid of the hatch slams shut, and the shiny black floor around it becomes liquid. It washes over the closed hatch and then solidifies into floor again. "No!" I shout as I drop to my knees and claw at the spot where the hatch used to be.

In a rush of air, Gazelle slides to a stop beside me, with a loose-limbed Dean flopped over her shoulders in a firefighter's hold. She lowers him to the floor and takes off again as an amorphous blob begins rising from the ground six feet away. Panic ripples through me as it reaches its full height and carves itself into a fully formed, menacingly glowering Nanny Theresa. I jump to my feet and begin walking

backward, shielding Bit as Nanny Theresa slowly glides across the floor toward us.

"Tricky, tricky, girl," she seethes as her right arm begins morphing into the shape of a long, sharp, shiny black pointed spear. "This needs to end, child, and it needs to end now," Nanny Theresa says as she draws her spear arm back, preparing to strike.

"Sorry, not today," says my mother's voice. Suddenly, my mother's hand grabs Nanny Theresa's neck from behind. Her other hand grips Theresa's thigh, and in one fluid maneuver, she easily lifts a wriggling Nanny Theresa in a straight-armed press high up over her head.

"Unhand me, Genevieve!" Nanny Theresa wails. My mother has changed back into herself again, but the beauty of her elegant white dress is a stark contrast to the determined frown on her face as she turns away, takes two quick steps, and, without the faintest hint of effort or strain, throws Nanny Theresa twenty feet through the air, clear across the dome.

Nanny Theresa sails through the air, flailing her arms, but instead of landing hard on the floor, her body completely disintegrates into a mass of black liquid in midflight, speckling the glossy ground and part of the crumpled transport wreckage in the distance like droplets of oily rain.

I look over at Gazelle, wondering why it's taking her so long to retrieve Dr. Pierce, and I immediately see the reason as the gagged and bound old man bucks and kicks while Gazelle desperately tries to wrangle a hold on him.

My mother forcefully waves her hand over the floor where the hatch was, and the glossy sheen covering it slides away. "Quickly," she says, looking anxiously from side to side.

I immediately dash at the hatch, and I'm taken by surprise as it suddenly flies open with a loud clunk and an arm reaches out of the opening and slaps onto the shiny floor. A heavily wheezing Brody hauls himself into the dome, looking around bewilderedly at all of us.

"Brody!" Bit wails, and Brody's eyes light up. He quickly crawls to his feet, lumbers toward her, and wraps his arms around her. She grimaces with pain for a second, but that gives way to a smile as she looks up at his flushed and sweaty face.

"Brody! Get her out of here," I yell at him. He gets the message, and with one arm around Bit, he begins quickly walking her back to the hatch. I look back at Gazelle. She's given up trying to carry Dr. Pierce, but she's already halfway back, dragging the struggling man behind her by the collar of his lab coat as quickly as she can.

My mother is clearly on edge as she scans the dome for any sign of Nanny Theresa, and we don't have to wait for long. The hatch slams shut at Brody's and Bit's feet, and the liquid floor slides over it and hardens again. My mother waves her hand at it, and the floor recedes but only a few inches before sliding back into place. She tries again, but the same thing happens, so she tries yet again but still to no avail.

Gazelle drags Dr. Pierce over and has only just deposited him beside Dean when Nanny Theresa erupts from the floor ten feet away and hurtles toward our little group. Her face is twisted into a malicious sneer, her silver-gray eyes are sparkling with rage, and both of her forearms are sharpened into deadly spear tips.

My mother quickly waves her arms, and a circular wall springs from the floor, enclosing all of us inside a bright white dome. Two black spear tips puncture through the side of our enclosure, raining shattered fragments of white onto the floor inside. Bit screeches in Brody's embrace as Gazelle reflexively snaps into a fighting stance. The spears withdraw, and my mother thrusts her outstretched hand toward the holes in the canopy of the dome. The holes instantly heal shut but are immediately replaced as Nanny Theresa slams her sharpened arms through the side of the enclosure again.

"Is there any other way out of here?" I whisper as my mother concentrates on closing the new ruptures in the dome.

"I can open a gap in the main wall," she replies.

"Is that the only way?" I ask. "There are things out there some-where, robotic spiders that—"

"I know," replies my mother. "I felt them through the motion sensors and tried to sever them from Onix's control, but I failed. I can't stop them, but I was able to create a false motion reading and lead them away into Sector C. They won't stay there for long, but it should give you enough time to get everyone to the school bus."

"You're amazing," I say, looking admiringly at my mother.

"Thank you, sweetheart. I've been here for a long time. I know my way around," she says with a smile. "Now, I think I may be able to breach the outer wall of the dome, but the system that controls it is separate from the floor. It will take all my concentration to access it, which means I won't be able to protect you and your friends."

"I can protect them, Mother."

"You're a brave young woman, Finn," she says, smiling warmly. "Creating a breach will be difficult, but to *keep* it open, I will have to leave some of my code inside the dome wall. Once I do that, I may lose my ability to manipulate the quantum grains altogether, and if that happens, you must be prepared. Theresa will stop at nothing to prevent you from leaving."

"I understand. How long will you need to create a breach?" I ask as Nanny Theresa slams her spear-tipped arms through the enclosure wall again.

"I'm not sure," my mother says as she waves her hand at the holes. "I'll be as quick as I can, but it may still take me thirty or forty seconds, a minute at the most."

"I'll get you the time."

My mother looks at me with a mixed expression of concern and pride. "Then let's get you to the main wall," she says with a determined glare. My mother waves her hands, and the small dome opens up and drops into the floor, revealing Nanny Theresa standing before us in all her fearsome glory, her arms rearing back for another strike. My

mother grasps the empty air right in front of her, and suddenly a huge glossy white copy of her own hand lunges up out of the floor at her feet and grabs Nanny Theresa's whole body in a giant fist, lifting her up off the ground. Before Nanny has a chance to escape, my mother quickly swipes her hand through the air, and the giant, shiny copy of her arm mimics her movement exactly as it forcefully tosses Nanny Theresa away like a tiny rag doll. In midflight Nanny Theresa splatters apart into a shower of black droplets, and my mother quickly turns to me. "Hurry, join your friends."

I nod without question and dash over to the others. Brody is still gently embracing Bit; Gazelle is on guard, glaring warily from side to side for any sign of Nanny Theresa; Dr. Pierce is still bound and gagged with strips of shiny black; and Dean is sitting cross-legged on the ground, smiling happily at the black curve of the dome high above him. I stand beside Brody and Bit and look back at my mother.

"Hold on!" she yells as she thrusts her open palm toward our little group. Brody and I both gasp, and Bit lets out a little screech as the floor bulges, rising like an ocean wave, sweeping us off our feet and sending us slipping along the glossy floor, carried by a gigantic ripple of shiny black. The base of the wave is so smooth that it's like riding a perpetually moving slide at a children's playground. Gazelle manages to maneuver around into a low crouch of sorts and kinda surfs the ripple; in fact she glances back at me with a look of delight on her face as we all speed toward the towering wall of the dome. Dean is skimming along on his back, a grunting Dr. Pierce is lying down, drifting sideways, and Brody is clutching on to Bit as they glide alongside me.

As we approach the curving boundary of Dome Two, the wave begins to wane, sinking back down into the floor as all of us come to a gentle stop ten feet from the dome wall.

I look back at my mother and see her quickly turn and dive in our direction, disappearing into the surface of the floor.

"We're gonna open a breach in the wall," I bark at Gazelle. "Get everyone through it as soon as you can."

"Of course, Commander," she replies.

"Commander?" Bit says, looking from me to Gazelle and back again.

Gazelle puts a hand on Bit's shoulder. "It's a long story," she says, mimicking my voice, then she glances at me with a cheeky smile.

I smile back. "It really is," I say to a very confused-looking Bit.

Suddenly a glossy black form hisses up from the floor, rising right beside me. Bit, Brody, Gazelle, and I all flinch, and I'm immediately on guard, but relief washes through me as the shape morphs into my mother.

"I'll be as quick as I can," she says, clearly not wasting any time as she strides over to the wall of the dome and presses her open palms against it. She groans quietly, her head droops forward, and she goes as still as a statue.

"Mother?" I say, looking over at her in concern.

She doesn't answer. But it makes sense; she did say it would take all of her focus to do this.

"That's your mom?" asks Brody.

"Yes," I reply. "And she's gonna need a minute to get us out of here, so I'm going to buy her some time."

"I don't know what's going on, but . . . please be careful, Finn," says a clearly worried Bit.

I nod, take a deep breath, then turn and walk away from the group into the wide-open space of the dome floor.

"I'm here!" My voice echoes out into the cavernous area. "I'm facing you just like you wan—"

Suddenly there's a spitting hiss. I feel a sharp, searing pain, and a woeful groan croaks from my lips.

"Finn!" Bit screeches.

"Commander!" shouts Gazelle.

I can't move my legs, and my mind has gone white with shock. I'm rapidly gasping at the air, and adrenaline is pumping through my body as I slowly and reluctantly look down to see a four-foot-long shiny black spike jutting from the floor in front of me. With wide, tear-filled eyes, I trace along its length, from its base all the way up to where my blood is beginning to soak my hooded top. The spike has skewered a fist-size hole right through my stomach. Blind panic surges through me as I stare in disbelief at the thick lance impaling my gut, the gruesome sight framed on either side by my hovering hands and trembling fingers. A glossy black blob begins rising from the floor in front of me, and to my absolute horror, the spike begins to move with it. I grab a tight hold of the spike and throw my head back, screaming out in agonizing pain as I'm lifted clean off the shiny black ground, with my feet dangling uselessly beneath me.

The oily covering on the shape drips away, revealing Nanny Theresa underneath, and I glance down to see that the spike is an extension of her left arm. She hoists me higher. Agony ripples through me as tears stream down my face, and spittle flecks on short, shallow breaths from my lips.

Nanny Theresa glares at me with her dead gray eyes. "You killed Genevieve," she whispers. "You drove Richard insane. You were the reason I was killed," she hisses. "And now finally, when you die, the whole world will be saved from a fate worse than death."

The pain is too much to bear. I can't speak as Nanny Theresa holds her other arm out to the side, and it begins changing shape from the elbow down, tapering and flattening into a two-foot-long black blade. I lash out with my hand, digging my thumb into Nanny Theresa's eye, but she isn't made of flesh, and she doesn't even blink or flinch away as my fingernail scratches across the hard surface of her eyeball as if it were made of glass.

"Someone do something!" screams Bit.

"I know that this won't kill you." Nanny Theresa jiggles the spike in my gut, and I groan. "But taking your head off will." She brings her blade arm between us and presses it against the skin of my neck. "The Infinity Project ends now."

"Noooo!" wails my tortured mother's voice. Then a strange sound begins emanating from somewhere. It's a hissing, creaking noise, and it could only be one thing. I painfully glance over at my mother and see a vertical gap beginning to form on the curve of the dome, between her hands. Nanny Theresa's blade presses harder against my throat, and my eyes flick back to her wrinkled face.

"There's no need to mourn for Infinity, Genevieve," Nanny Theresa calls out to my mother. "This is a victory for humanity."

My heart hammers in my chest, tears stream down my face, and my eyes go wide with absolute terror as Nanny Theresa slowly draws her blade arm across her chest . . . and slits my throat.

CHAPTER FOURTEEN

There's a flash of movement and a swift rush of air. Time seems to slow to a crawl as Nanny Theresa's entire head violently explodes right in front of my eyes, like a glass vase hit by a baseball bat. I watch Gazelle's foot sweeping through the twinkling black shrapnel remnants of Nanny Theresa's face as her now headless body, including the spike impaling me, instantly disintegrates into black liquid and splashes in an oily torrent onto the ground. I drop, crumpling heavily to the floor as blood spills from the gaping hole in my stomach and sprays from the open gash in my throat. I roll onto my back, with one hand holding my neck and the other clutching my stomach.

Gazelle dashes forward and kneels by my side, looking down at me in absolute horror as blood gushes freely from my wounds, pouring through my fingers. "Commander!" she wails as her unsure hands hover shakily over me.

"I'll be OK," I gurgle as blood coughs from my lips and dribbles down my chin.

"Seriously?!" Gazelle blurts, staring down at me bewilderedly.

"Yeah . . . I'll be fine," I burble through mouthfuls of blood and with winces of extreme agony. "Get everyone out of here."

Gazelle looks at me like I'm crazy.

"Now, soldier!" I insist, accidentally spitting blood at her.

She wipes her face on the back of her sleeve, but then she nods, and with one last look of doubt, she lunges out of sight behind me. The bleeding at my neck begins to slow, and I can feel the edges of the heinous wound in my abdomen gradually starting to close.

I've lost a hell of a lot of blood. I'm completely soaked and lying in a pool of it for god's sake, and even though my wounds are steadily healing and the sensation is returning to my legs, I feel like all my strength is draining away as my regenerative abilities are taxed to their limits. Frankly I'm not surprised. I'm not a doctor, but even I have a fair idea of how serious and extensive my injuries are. I just had my throat slit all the way to the bone, and that spike went through my gut and exited through my back, shredding who knows how many vital organs on the way and severing my spinal column for good measure. Anyone else would be dead, and I'm glad that I'm not, but right now, I feel as weak as a newborn kitten.

I wearily look back over my shoulder to see Gazelle pick Dean up off the floor as Bit and Brody stare at me in abject horror. I manage to half sit up and hold a hand up to them to show them I'm OK.

The gap in the dome has grown and is now a couple of feet across at its widest and reaches eight feet high to a tapered point at the top. The hissing, creaking sound coming from the wall ceases. My mother moans, releases her hands, and falls into a crumpled heap on the floor.

Gazelle is true to her word and carries out my orders as she unceremoniously stuffs a stumbling Dean headfirst out through the gap. Bit and Brody quickly shuffle to the breach, and Bit sidles through with Brody close behind her. Then Gazelle drags Dr. Pierce toward the gap by the collar of his coat.

My neck has completely healed. I pull my top up a little and smear the blood aside to see the skin sealing closed over the wound in my stomach. Something moves against my chest, drops down inside my shirt, and slides onto the skin of my healed stomach. It's my black diamond pendant. I pick it up with a trembling hand and clutch it in my fist. Nanny Theresa's blade sliced right through the chain. I feel so feeble; my strength has been completely sapped. Clutching my pendant in my hand, I roll over onto my knees, slipping awkwardly in the huge pool of my own blood as I try to get to my feet.

I look over at my mother. She's still lying motionless on the floor beside the breach. I'm worried but not as worried as I would be if she were a real person. I know she'll be fine. Right now I'm much more concerned about getting out of here alive before Nanny Theresa comes back to finish me off.

"Finn! C'mon!" Brody shouts through the gap.

"I'll get the Commander," Gazelle says to Brody as she tries to maneuver a grunting Dr. Pierce into the breach. "Here, take the old man."

Through the gap I see Brody dash forward and roughly pull Dr. Pierce outside as Gazelle turns toward me. Suddenly a dark shape rises behind her. "Look out!" I shout.

As Gazelle glances over her shoulder, a fully formed Nanny Theresa swings her arm and backhands Gazelle hard across the face. The brutal impact spins Gazelle off her feet, and she crumples heavily to the floor, unconscious. Nanny Theresa steps over her, like she would a piece of garbage on the ground, and walks toward me. Her arm hisses and sharpens into a blade once again. Without a word she stands over me, and I hold my hand up in futile defense, my heart pounding in my chest, too weak to stand let alone run, as she raises her arm above her head.

"Theresa!" shouts Dr. Pierce. "Don't kill the girl!" I look over and see him standing just outside the gap in the dome wall; the shiny black bonds and the gag that was silencing him have completely vanished.

"Quiet, Graham!" Nanny Theresa bellows as she glares down at me.

"Please, Theresa," Dr. Pierce begs. "Infinity is the only one who can finish what Richard started. You're my wife, Theresa, and I love you. We can be together again. We can be young again. He promised. Richard promised that to me."

"Shut up, Graham!" Nanny Theresa shouts as she turns and looks at him through the breach.

He's standing just outside, looking at her pleadingly. "Please, my darling," he begs. "I need you back. I'm lost without you."

"Why can't you just be quiet!" Nanny Theresa screeches. She waves her hand at Dr. Pierce, and a strip of black suddenly peels from the floor and speeds through the air in the direction of his mouth. He raises his arm to shield himself, but as the gag sails through the breach, it immediately disintegrates into a puff of black powder, speckling his face and glasses.

"The quantum field ends at the boundary of the dome," he says as he removes his glasses and wipes them on his coat. "You can't silence me any longer." Dr. Pierce looks longingly at Nanny Theresa. "I love you. We can be together again, forever."

"It won't be *us* Graham," Nanny Theresa sighs as her blade arm begins to shrink back down to normal. "Just hollow copies filled with nothing but faded memories of what it was like to be human. Do you really want to become this?" Nanny Theresa says, gesturing at herself. "An abomination like me? Trapped in this cage?" she says, looking around at the high, curving wall of the dome.

Dr. Pierce leans into the breach and smiles warmly at Nanny Theresa as his eyes begin glistening with tears. "If I can stand beside you, and touch your face again, my dear. Then my answer is . . . yes."

"Oh, Graham," Nanny Theresa whispers gently as she slowly shakes her head. She smiles and holds her arms out toward him. "Come here, you romantic old fool."

A sniffling Dr. Pierce steps through the gap, over a motionless Gazelle, and walks toward Nanny Theresa. She goes to him, and they fold their arms around each other in a warm embrace. Dr. Pierce rests his chin on her shoulder and holds her tightly to him. "I love you, Theresa," he whispers gently.

"I love you, too," she replies. "But I'm afraid the love I have for you is only an illusion, Graham, nothing more than a digital shadow of what the real Theresa used to feel."

Suddenly Dr. Pierce shudders, and his eyes go wide as a strained groan issues from his lips. His face contorts with pain, his legs buckle underneath him, and he glares up at Nanny Theresa in mortified shock as she gently lowers him to the floor and slowly extracts a thin black blade from his chest.

"I'm sorry it had to end this way, Graham. But this is for the best," she whispers as Dr. Pierce gurgles and twitches on the floor beside her. "You've lost sight of the danger and discarded the value of humanity, just like Richard did. I'm afraid I can't allow you to help him anymore." The blade transforms back into a gnarled and leathery hand, and she presses her fingertips to her lips, then touches them to Dr. Pierce's cheek. "The Theresa Pierce you knew was murdered two years ago," Nanny whispers menacingly. "And the day of her vengeance has finally arrived."

Nanny Theresa stands over the body of her husband and waves her hand toward the breach in the dome wall. All of a sudden, an eight-foot-high glossy black barrier hisses up from the floor, sealing over our escape route, blocking it completely. Nanny Theresa slowly turns her head and looks at me with a cold fire of revenge burning in her silvery eyes.

By the wall I see my mother groggily raise her head, but her drowsy eyes instantly go wide with shock as she sees Dr. Pierce lying at Nanny Theresa's feet.

"Father!" she wails, and like a lioness targeting her prey, she immediately launches from the floor into a sprint toward Nanny Theresa and dives through the air, brutally tackling her to the ground. The two women slide across the floor, coming to a stop only a few feet away from me. My mother is on top of Nanny Theresa, landing punch after thudding punch on her face. Nanny Theresa doesn't even wince at the blows as her right hand morphs into a hammer shape, and she swings it at my mother's head. My mother blocks the attack with her forearm and grabs both of Nanny Theresa's wrists. Suddenly Nanny Theresa disintegrates into a human-size mass of black liquid and splashes onto the floor, vanishing into it.

"Dammit!" my mother curses as she quickly lunges over beside me. "Finn, listen, part of my code is keeping the dome wall open, so I'm barely holding myself together, and I've lost the ability to change shape. Theresa will be back soon, and I'll try to keep her occupied, but it's up to you to break through that barrier."

"Lost too much blood. Too weak," I mutter.

"Call it back!" my mother shouts.

"What?" I ask, looking at my mother in confusion.

My mother grabs my wrist and slaps my open palm onto the wide puddle of my own blood.

"Regain your strength. Call it back to you."

"Call what back to where?" I say, staring at her bewilderedly.

"It's part of you, Finn," she says, looking down at the blood. "It will do what you say. All you have to do . . . is command it."

"What do you mean?" I ask as an oily black Nanny Theresa–shaped blob begins rising from the floor a few feet away from us.

My mother strokes her thumb across my forehead. "You are like no one else who has ever existed, Finn. Your muscles, bones, and even your blood listen to your conscious commands and carry out your orders obediently. Trust me. Call it back to you, and reclaim your

strength . . . you can do this," she says as she gets to her feet and stands between me and the quickly re-forming Nanny Theresa. "You can do it. I know you can."

My mother looks down at me with a confident smile, then she strides off toward a fully reconstituted and angrily glowering Nanny Theresa. I'm still completely at a loss to understand what she expects me to do. I lift my hand from the puddle and stare at my trembling, red-soaked palm. Call it back to me? Was she serious?

"Get back in there," I whisper at the blood. Nothing happens, and on top of feeling like I'm going to pass out at any second, I also feel absolutely ridiculous.

I look over at my mother, desperate for another clue, but she's already swinging her fist at Nanny Theresa. The blow connects with Nanny Theresa's face, and she reels from the impact but comes right back with a backhanded counterattack. There are no words or taunts or shrieks coming from either of them, just brutal, jarring blows and vicious grappling.

My mother pulls Nanny Theresa from side to side, but I see Nanny glance in my direction, and a split second later a massive spike suddenly erupts from the floor beside me and spears at my head, missing my ear by less than an inch. I gasp in startled shock as I slip in the blood and fall onto my back.

"Get up!" a voice barks gruffly in my mind.

"Infinity?" I ask, saying her name out loud.

"No, it's the front desk with your early-morning wake-up call," she says snarkily. *"Of course it's me, you idiot, now get the hell up!"*

I manage to shuffle onto my knees, but as I try to stand, my quivering legs buckle underneath me.

"I can't," I whisper, exhausted from the effort.

"Then do what she said!" Infinity barks inside my mind. *"You saw me push the poison out, now do the opposite. Take the blood back in, get our strength back, and get us the hell out of here!"*

"I don't . . . know how."

"Then give me control!" Infinity shouts.

"No," I mutter. "You'll never . . . let me out again."

"Let me try to do this, Finn!" Infinity yells. *"Or that psycho old bitch is gonna kill us both."*

"No!" I grunt. "With you . . . in control, I'm as good . . . as dead . . . anyway."

"Oh for god's sake, Finn, you need to trust me!" Infinity blurts out in a heated ramble. *"Just give me control, dammit!"*

I don't even know if Infinity realizes the weight of what she just said, but I never in a million years would have ever expected the word "trust" to come out of her mouth.

"Finn," Infinity implores. *"Trust me . . . and let me out."*

I can feel her sincerity rippling through the void, and I can hardly believe it, but it's there, and it seems . . . *real.*

"OK, I trust you," I whisper as I close my eyes, exhale . . . and then completely let go.

My eyes suddenly snap open, and I gasp in the darkness as I reach out all around me. My hand finds a tendril in the void, and I grab hold of it as I look out of Infinity's view. My feeling of exhaustion has gone, but the effect of it has thickened the blackness into a heavy, undulating sludge. I watch out the peepholes as Infinity slowly crawls into the middle of the puddle of blood, grunting with every labored movement.

"I leave you . . . alone for a minute . . . and look what happens," she moans as she slaps her hand into the center of the red pool.

"Is what Mother said even possible?" I ask.

"I guess . . . we're about . . . to find out," Infinity replies feebly, and I can feel the darkness thicken even more as she focuses her concentration. Suddenly, to my astonishment, the smears of red on the back of her hand begin to fade and disappear, as if they're reverse blotting into

her skin, but even more amazing than that, the edge of the puddle is beginning to slowly shrink as the blood moves toward Infinity's fingers.

"It's working!" I shout out toward the peepholes.

"Shut . . . up," Infinity seethes. "You're not helping . . . by bleating inside my head."

"Sorry," I whisper, and I can feel the heaviness of the void gradually decreasing as the blood inexplicably ripples and moves as if it were alive, sliding across the shiny black floor as it's absorbed back into our body.

Out of the corner of Infinity's view, I can see the fight has become a savage, animalistic clash. Nanny Theresa's arms have morphed into blades once again, and my mother is ducking and weaving as Nanny Theresa's glossy black weaponized limbs slash and slice through the air at her. Every one of my mother's moves seems practiced and focused— a sure sign that she's been taught how to fight in the past. She's not holding back, either, and it couldn't be more evident as my mother blocks one of Nanny Theresa's arms at the bicep and brutally head-butts her right smack in the face. Brittle chips of my mother's skin splinter and fly from her forehead as Nanny Theresa's entire nose shatters into a dozen pieces. They clatter onto the ground and melt into the floor as Nanny Theresa staggers backward and glowers at my mother, her empty eyes staring with rage from above a jagged hole where her nose used to be. But there's no blood, no cry of pain, and no heavy breathing or any sign of fatigue from either of them at all. It's like two realistic statues are facing off in stoic silence, unfettered by pain or fear, forever locked in a battle that can't be won, only postponed until the fallen rises again.

Infinity takes a huge, revitalizing breath as the pool of blood gets smaller and smaller. The void has almost returned to its normal consistency, and I can feel the lost strength coming back, coursing through our body in satisfying waves. The last of the blood finally disappears beneath Infinity's hand, but then something very bizarre catches my

attention. The shiny, clean floor around Infinity's palm is beginning to warp and move and creep up onto Infinity's fingers. She quickly pulls her hand away from the floor, hastily flapping it up and down, like she's just withdrawn it from a sewer pipe, flicking globs of black liquid from her skin and back onto the ground, where they instantly solidify into a hard, glossy surface again.

"What the hell," Infinity mutters as she glares at the floor. I can feel her bewilderment, mirroring my own. Did that really just happen?

Infinity gets to her feet, and she's still looking from her hand to the floor and back again, when out of the corner of her view, I see Nanny Theresa glare in this direction, and sudden panic grips my stomach. I think I have a fair idea of what's coming next, and I yell a loud warning toward the peepholes. *"Infinity! Look out!"*

Infinity quickly looks up and only just manages to dodge to the side as a hissing spike thrusts out of the floor and spears past her head. Another spike erupts from the floor, and another and another and another, but Infinity's reflexes are renewed and razor sharp as she spins and weaves and then leaps ten feet straight up into the air, arcing into a graceful straight-legged backflip before landing lightly on the floor in a low crouch.

"Break the barrier!" my mother shouts as she lunges at Nanny Theresa. "Get out of here!"

"There, against the wall of the dome!" I shout.

"I see it," Infinity says as she dashes past a motionless Dr. Pierce, but she skids to a halt and kneels beside a groaning Gazelle, who has pushed herself up onto one elbow and is massaging the side of her jaw where Nanny Theresa swatted her. "Are you OK?" she asks, putting a hand on Gazelle's shoulder.

"A little dizzy, but I'm fine, Commander," Gazelle says as she tries to get up, but she falters, and her eyes roll. Infinity pushes her back down.

"Stay down, and keep an eye on those two." Infinity indicates Nanny Theresa and my mother. "Give me a heads-up if the fight goes bad. I'm gonna bust us out of here."

"OK, Commander," replies Gazelle.

As Infinity glances back toward the fight, I see my mother do a textbook foot sweep, kicking Nanny Theresa's legs out from under her and sending her sprawling onto her back. My mother pounces toward Nanny Theresa and brutally stomps on her face, cracking the top half of her head clean off. Nanny Theresa's body instantly turns to liquid, and my mother glares over at us.

"Hurry!" she shouts.

Knowing full well that Nanny Theresa will re-form in no time at all, Infinity takes off immediately and dashes toward the wall of the dome, skidding to a stop about ten feet from the barrier. Infinity pulls up her sleeves and takes a series of deep breaths as she claps her hands and rubs them together, eyeing the blockade with careful consideration as she psyches herself up to strike it. Then, with a little hop and a jump, she swings her leg and twists her torso. Her whole body spins so quickly her view becomes a blur as she plants her foot back onto the floor and kicks out with her other leg. I gasp in awe as I feel the raw power surging through her muscles. It's like they've been replaced by hydraulic pistons, and combined with the momentum of the spin, her heel whips through the air with ludicrous force and slams into the barrier like a sledgehammer.

The crunching sound of bones breaking inside Infinity's shoe is immediately followed by waves of pain and injury alarms ringing out all around me. Infinity has badly broken her foot, but the damage was well worth the effort, as the entire eight-foot-high, four-inch-thick barrier splinters in a huge cobweb of cracks from top to bottom. All we've got to do is pull the broken pieces away, and we're home free.

Infinity hobbles on her injured foot, and I can feel the darkness beginning to thicken as she tries to concentrate on healing it.

"You take that barrier apart!" I yell out toward the peepholes. *"I'll take care of our foot!"*

Without even thinking, I splay my legs out into the darkness beneath me, and I can feel them suddenly grow to their full size, filling the inside of Infinity's legs as if I were slipping them on like a pair of skintight jeans.

"Hey, what are you doing?" Infinity says in confusion, but the broken bones in her foot are already moving back into their proper places, and the pain is already waning.

With the repairs done in only a few seconds, Infinity lets out a bemused grunt and stands there, rolling her ankle and flexing her freshly healed toes inside her shoe.

I shrink back inside her head and shout toward the peepholes. *"Infinity! The barrier!"*

"Right," she mutters as she flinches back into action and begins pulling pieces of the barrier away and tossing them to the floor. "I don't know how you fixed my foot so quickly," Infinity says as she hurriedly pries more fragments loose. "But you're gonna have to teach me that little trick." It was only slight, barely more than a momentary twitch on her lips, but I'm certain that for a fleeting instant I felt Infinity smile.

She wrenches a decent-size piece of the barrier loose and heaves it onto the floor with a thud. The cool night air outside wafts in through the hole. We've broken through, and I spot Bit's worried face a few feet away on the other side.

"Finn!" she screeches.

"We're here, too," Jonah's voice says from outside. "Percy, get in there and help Finn. I'm too big to fit in that gap."

"Right away, Major," says Percy's voice. When Infinity topples another piece from the barrier, I see his face as he shuffles into the breach and reaches out to pull a fragment from his side.

"Hi, Finn. We'll have you out of there in a jiffy," Percy says, smiling with his perfectly straight white teeth. Percy dislodges a small shard and

hands it back to Brody, who has stepped up behind him. Brody cups his hands to receive the shiny black piece of the barrier, but as soon as Percy passes it to him, it instantly disintegrates into a handful of fine dark powder and runs through Brody's fingers.

I can hear the scuffling and thudding blows of the fight between my mother and Nanny Theresa still waging behind us, but we're making good progress as we dismantle the barrier from both sides. We've already exposed a three-foot-high section of the breach, but it's mostly the tapered top third of the gap, and it isn't quite wide enough that we'd be able to climb up onto the jagged remains of the barrier and climb through. Infinity grips the edge of another piece, but as she pulls it free, I hear Gazelle yell out behind us.

"Heads up, Commander!"

Infinity quickly looks over her shoulder to see my mother lying on her back on the floor. When it comes to fighting, my mother far outmatches Nanny Theresa, but there's such a thing as a lucky blow, and that's the only thing that can explain what I see, because my mother's left leg has been cut clean off at the knee, and one of her arms is completely gone from the elbow down. Keeping the breach open means that my mother has lost the ability to repair herself, but that didn't stop her from giving it everything she had to try and hold Nanny Theresa back and buy us some time.

Nanny Theresa's blade arms morph back into their normal human appearance as she stands over my mother, looking down at her victoriously. But her attention quickly snaps in our direction.

"Leave my daughter alone!" my mother shouts. Despite her missing limbs, she still tries to scramble across the floor and grab at Nanny Theresa's ankle as the glowering old woman purposefully waves her hands through the air toward us. That gesture could only mean one thing; I can tell by Infinity's stance that she's already preparing herself to evade more of Nanny Theresa's attacks.

But there aren't any lances erupting from the floor, no spikes thrusting toward us; there is only the telltale hissing sound of a construct forming right behind us. On full alert, Infinity dives away from the wall and rolls across the floor up onto her feet. But as Infinity looks back toward the source of the undulating hissing noise, my heart sinks into my stomach. I see every one of the cracks and splinters and holes in the busted barrier quickly healing shut, until soon the entire eight-foot-high blockade has repaired itself back to pristine condition, exactly like it was before Infinity kicked it.

"No!" yells Percy's muffled voice, and I can hear thudding and grunts of effort coming from the blockade as he tries to break it from the other side.

A crouching Gazelle springs shakily to her feet and adopts a fighting stance.

"No!" Infinity shouts at her. "Back away. She can kill you with a single thought."

"That's good advice. I'd take it if I were you," Nanny Theresa says without even so much as a glance at Gazelle.

A clearly frightened Gazelle does exactly what Infinity says, and with a quick leap, she bounds fifteen feet to the side. She stares wide-eyed at Nanny Theresa, who slowly floats just above the floor, drifting through the air toward us.

"Any suggestions?" Infinity asks.

"You're asking me?" I reply.

"You're the one that went to school," Infinity says mockingly.

"Well, you know we can't beat her in a fight. She can't be hurt, and she can't die."

"Yeah," mutters Infinity. "And even if we broke that barrier again, she'd only fix it faster than we could take it apart."

"Who are you muttering to, child?" Nanny Theresa asks as she drifts to a stop and settles on the floor a few feet away. "The other little voice in your head?"

I can see Gazelle slowly creeping as quietly as she can behind Nanny Theresa.

"The only little voice that woman loves is her own," I whisper. *"Keep her talking. At least it'll buy us some time."*

Infinity sees Gazelle moving into an attack position and nods in agreement at my suggestion.

"Yeah, ah, look, Theresa. Can I call you Theresa?" says Infinity. "I know that you and I never really got along, but surely there's no need for all of this violence?"

"You're beginning to sound a lot like me," I say toward the peepholes, and a ripple of annoyance shivers from Infinity and reverberates around the void.

Nanny Theresa's eyebrows rise with bemused surprise. "Is this the final speech of the condemned?" she asks. "A plea for clemency perhaps? Come now, child. Do you honestly think that there is any combination of words in the entire English language that could earn you a reprieve?"

"Well I can speak eight other languages," Infinity says. "French is particularly nice, so how about, *laisse-moi partir?*"

Nanny Theresa smiles as her arm slowly begins forming into one of the large blades she's clearly become so fond of. "Very amusing," she says. "But I'm not going to let you go, and there's no point attempting to appeal to my humanity or the better angels of my conscience. I don't have any humanity left, and my conscience is clear and righteous. Oh, and by the way, your friend is wasting her time." Nanny Theresa waves her hand behind her, and Gazelle suddenly begins sinking into the floor as if it had instantly become glossy black quicksand.

"Help!" she screams out as she sinks deeper and deeper. The liquidized floor laps up over her legs, then hips. It rises up to her chest, then her neck, and floats up to her chin.

"Don't kill her!" Infinity screeches. "I'm the one you want. Please, leave her alone."

The glossy floor has covered the lower half of Gazelle's face when it instantly freezes solid again, and all that can be seen of her is one of her hands, the top of her pixie-cut hair, her wide, terrified eyes, and her flaring nostrils.

"She can live," Nanny Theresa says emotionlessly. "She will be a witness to the moment I saved humanity . . . with your justified execution."

With another wave of her hand, the view from Infinity's eyes suddenly falters, as if she's been knocked off balance, then it suddenly drops. Infinity looks down at the floor, and I can see why as the glossy black surface has turned to liquid beneath her feet, just like it did with Gazelle. Infinity is steadily sinking into the ground, as if it were a pool of tar.

"Theresa! Please!" my mother screeches. "Listen to me! Don't kill her. This is not her fault! She's a victim, too . . . she's innocent!"

Infinity has sunk into the floor up to her thighs when it freezes solid again, trapping her legs in a vise grip, as Nanny Theresa turns to look at Genevieve. "Victim? Perhaps you're forgetting about how many people she has callously murdered in the name of the United Alliance. They were victims! She is a murderer!"

"They used her!" pleads my mother. "They all manipulated her and forced her to kill!"

I can feel the power surging through Infinity's arms as she pushes against the floor with her clenched fists in a desperate attempt to get free, but there's no use. It's like she's encased in concrete.

"I have seen the files of her many assassinations, Genevieve," says Nanny Theresa. "She enjoys the violence. And I must admit, today I've discovered that the sensation of power it provides can be quite invigorating."

Nanny Theresa waves her hand again, and suddenly a thick, blunt-ended column of glossy black erupts from the floor in front of Infinity

and brutally slams into her jaw like a pillar of stone. The view from her eyes jolts violently from the vicious, jarring blow, and I can hear the crunch of bone breaking as the void rings and echoes with loud tones of damage. The real pain comes next, buffeting through the darkness in wave after wave. I scream out as I feel the agony surge and writhe all around me. The black column slowly retracts into the floor, and Infinity groans feebly.

"Stop! Please!" my mother screams.

"The reports of your missions are very clear," Nanny Theresa says as she looks down at Infinity. "You enjoy killing. But did you ever once stop to think about the pain you caused? It pales in comparison . . . to this!"

The black column bursts forth again, slamming into the side of Infinity's head like a battering ram. Infinity's skull cracks, and I scream out in pain again as her view begins to flicker and darken. *No! Not again! Infinity! Stay awake!*

I screw my eyes shut, and I pour my influence into her injuries. They begin to heal, but I'm too late to keep her responsive. I feel her consciousness drifting past me, floating away into the deep dark beyond.

"Nighty night, child," Nanny Theresa says as Infinity's view goes pitch-black and her head drops forward and her whole body goes limp. She's out cold.

Infinity is strong, but she isn't invincible, and Nanny Theresa's sadistic punishment has proven too much for her to withstand. I don't know what I can do to get us out of this situation, but I can't just sit here in the void and allow us to die.

I quickly reach out into the darkness. My hands and feet expand, filling our limbs. I can feel the cold of the floor pressed against my thighs and the dull throbbing ache as the fractured bones knitting together in Infinity's skull become mine again.

"Wait," I murmur painfully with my half-healed jaw as I hold my open palms up in surrender.

"So resilient," Nanny Theresa says as she walks toward me and frowns down. "So difficult to kill. I can see why the military were so eager to have you."

I look up at her as she raises her blade arm to finish me.

"No!" my mother screams.

I hold my hand up and yell the word this time. "Wait!" I slowly lower my hand, raise my head high, and look Nanny Theresa square in the eyes. She meets my gaze, and her brow furrows.

"Accepting your fate?" she asks. "Is this a shred of dignity I see in your final moment? Perhaps I should allow a few last words from the condemned?"

I nod.

"Out with it then. This should be good," she says with a sarcastic smile.

I take a deep breath as I prepare to deliver what will almost certainly be my final blow.

"Nanny?" I whisper gently.

Her eyes narrow in preparation for whatever defiant insult I'm surely going to fling at her. That's what Infinity would do. But my last arrow aims for her heart. If there's anything left of it.

"Are you really going to kill your only granddaughter?" I whimper as I force a tear from the corner of my eye.

Nanny Theresa's face slowly twists into a ferocious snarl. I can't punch her in the face from here, but I've definitely hit a nerve, and it shows as she thrusts her blade arm toward my face. "You are not my granddaughter!"

"Yes, she is!" my mother screams as she crawls toward Nanny Theresa. "She has your son's blood in her veins; he was a good man once, and that part of him still exists inside her. She's the only family you have left, Theresa."

"If she is allowed to exist, everyone will suffer," Nanny Theresa growls.

"That is not her fault," my mother says as she crawls to a stop at Nanny's Theresa's feet. "She didn't choose her destiny. Richard chose it for her."

"Infinity must be destroyed, Genevieve. You know what will happen if Project Infinity is initiated."

"Richard's plans for her don't have to be fulfilled," my mother pleads. "Project Infinity can be stopped without sacrificing my daughter. *Your* granddaughter doesn't have to die because your son lost his mind."

"Richard's obsession with her is what sent him into madness," seethes Nanny Theresa as she glares at Infinity. "Every breath she breathes is a reminder of everything I have lost."

"No," my mother replies. "Richard's mind was twisting into madness long before she was born. I chose to ignore the signs because I loved and admired him so much. I know you saw it, too, Theresa, and you turned a blind eye, just like I did, like we all did. That blindness cost you your life . . . and it cost my father his life as well." My mother looks sadly over at Dr. Pierce.

Nanny Theresa glances at Dr. Pierce's body, and I see her face slowly soften with regret. But the moment is fleeting. As she looks back at me, her fearsome glower instantly returns. She jabs the blade toward me. "No! None of that matters now! If she's allowed to live, there's nowhere she can run where Richard won't find her. He'll track her down, and the suffering unleashed on humanity will be immeasurable!"

"Enough people have suffered already, Theresa," implores my mother. "Richard must be stopped, and Infinity is the only one who can do it. She has to destroy this place, and destroy all the research Richard kept at Blackstone Manor. But most of all, Richard has to die, Theresa, because as long as he's alive, he'll try to do this all over again."

"What . . . what are you talking about?" I ask.

Nanny Theresa doesn't answer; she just stares at me in furious confusion.

"She's the only one who can end this, Theresa," my mother pleads. "Deep down, you know what I'm saying is true."

As Nanny Theresa glares down at me, I can almost see the conflict boiling behind her eyes. But then her glower softens ever so slightly, and she looks at the floor with an expression of bitter resignation. Nanny Theresa slowly lowers the blade, and it morphs back into a normal arm. With a reticent sigh, she languidly waves her hand through the air. Suddenly the glossy black barrier hisses and slides back down into the floor, and I slowly rise from my imprisonment and stumble to my feet.

"Hello? Is it safe to come in?" Percy's voice says from the breach.

"Yes, everything's OK, I think," I say as I warily eye Nanny Theresa. Percy gingerly appears in the gap. I could only see his face through the hole in the barrier before, but now I can see that he's dressed in a strange, full-body plastic yellow suit of some kind. "Just give us a minute," I say to him, and Percy nods and backs out through the breach as I turn to Nanny Theresa.

"I'm . . . I'm glad you're not going to kill me anymore, but is anyone going to tell me what this is all about? What is Project Infinity?"

"You need to go," says Nanny Theresa.

"Go where?" I ask. "What's happening here? Can someone just give me one straight answer?!"

"Do what your mother said," says Nanny Theresa. "Destroy this facility, burn it all. Wipe it off the face of the earth, and my poor, deluded son along with it."

"Ohhh-kaaay . . . clearly you're not in a mood to share."

"Please, sweetheart," says my mother. "All you need to know right now is that your father intends to use you to release a global

pandemic that will kill millions of people. Your unique mind and physiology are the final pieces he needs to complete his plan. You have to stop him. You have to destroy this place, please, for all our sakes."

"I don't understand. Why would he do that? Why would he feed and clothe the population of the planet only to kill them?"

"He has his own deluded reasons," says Nanny Theresa. "Just know that the threat is very real, the entire human race is in critical danger, and the task has fallen to you to stop him."

I look from my mother to Nanny Theresa and back again. "You're not joking, are you?"

"No, I'm afraid not," says my mother. "Theresa discovered Richard's true intentions two years ago. She revealed Richard's plans to the board members of Blackstone Technologies, and they unanimously agreed that she should replace him as CEO. If that had happened, Project Infinity would have been stopped immediately, so Richard instructed Major Brogan to . . . dispose of her."

"Jonah killed you?" I ask, glaring in disbelief at Nanny Theresa. She confirms it with a stern nod.

"Poison. Smeared inside my gardening gloves," Nanny Theresa replies. "I may be dead, but to this day the sight of yellow roses makes me nauseous, and the slightest mention of Major Brogan makes me murderous."

"Richard wanted Theresa out of the way to preserve his plans, but that's not why Jonah did it," says my mother. "Jonah was afraid of what Theresa would do to *you* once she was in power. He knew it was wrong to murder her, but he did it to protect you, Finn. He did it because he loves you very much and he couldn't bear the thought of losing you."

"Major Brogan was made a figurehead CEO in my place," says Nanny Theresa. "Richard had the board members picked off one by one, and I was left to die."

"Yes," says my mother. "But before Theresa died, she was able to transfer her mind into the computer in a further attempt to stop Richard, but he managed to imprison her deep inside the mainframe. When your friend Bettina hacked into Onix, the whole system fractured. Theresa was able to escape, and when she saw that you were here, she took it upon herself to kill you and end Project Infinity once and for all."

I just stand in silence, doing my best to take this all in. "That's why you've been trying to kill me?"

"Yes," says Nanny Theresa.

"But why did you have to kill so many of my classmates, too?" I ask, glaring up at her accusingly.

"They were merely collateral damage," Nanny Theresa says coldly. "A few dead to save billions of lives? It was a simple choice, and if Genevieve hadn't talked me out of it, you'd be dead by now, too."

"But Project Infinity wouldn't," says my mother. "Even if Theresa killed you, Richard would only try again. I had no idea of the depths Richard would go to until today, when his most classified files began leaking through the cracks and I was able to see them for myself."

"Destroy . . . everything," says Nanny Theresa.

"OK, OK, I believe you, and I'll do what you say," I mutter. "I'll destroy everything if that's what it will take to stop this from happening, but how exactly do I do that? I don't know if you've noticed, but this place is huge."

"We will use the Swords," Nanny Theresa replies.

"Um . . . no offense, Granny Theresa, but I don't think a couple of swords will cut it."

"Firstly, never call me that ever again," Nanny Theresa says, eyeing me with her familiar disdain. "And secondly, yes, they will. The Swords of Damocles are a series of thirty-meter-long tungsten rods attached to a low Earth-orbit satellite. Once a target is chosen and a

rod is released, the Earth's gravity will bring it plummeting down from the stratosphere at a tremendous velocity. A single Sword of Damocles will impact the ground with the force of a low-level nuclear weapon. I suggest we use three."

"OK, wow," I say, trying to wrap my head around what they're asking me to do. "I think that should do it."

"Of course it will," says Nanny Theresa. "And there are many hurdles to overcome if we are to gain access to the part of the mainframe that will enable us to control the Swords. Your little school friend with the glasses has her work cut out for her."

"What do you mean?"

"The girl named Bettina was planning to reset the main computer. At least that was the information I garnered from her before you all so rudely attempted to sneak her out from under my nose. Is that information correct?"

"Yeah, that's what we've been trying to do."

"Well," says Nanny Theresa. "When Graham informed me of his need to repair Onix and reset the mainframe to initiate the final stages of Project Infinity, of course I was vehemently opposed to it. But now I'm afraid we must allow your friend to do exactly what she intended to do and repair the damage that she has done. It's the only way to ensure that every last scrap of Project Infinity is destroyed. Correction," Nanny Theresa says, narrowing her eyes at me. "*Almost* every scrap."

"Theresa, please, that's enough," says my mother.

Nanny Theresa rolls her eyes and clears her throat with a gruff harrumph.

"What about the genetic lock?" Bit's voice issues meekly from the breach.

"Excuse me?" Nanny Theresa says, looking toward the gap in the dome wall.

Bit gingerly appears from the breach, with Brody following right behind her. Her arm is in a makeshift sling fashioned from a torn piece of foil blanket. As she shuffles inside, she eyes Nanny Theresa very warily. "The computer's neural core can only be entered through a door that has a genetic lock. Dr. Pierce is the only one that can open the door, and . . . he's . . ."

Nanny Theresa looks down at Dr. Pierce's body, and her gaze lingers for a moment. She drifts over to him and kneels on the floor beside him. "I'm sorry, Graham," she says quietly as she takes his hand and strokes her thumb over the back of it. All of a sudden, her other hand hisses and morphs into a short black blade, and with one swift chop, she promptly cuts his hand clean off at the wrist.

My mother grimaces at the sight, and Bit looks away. "Oh, that's disgusting," Brody mutters.

"But necessary," Nanny Theresa says as she rises and floats toward Bit, holding Dr. Pierce's hand out toward her. "This will open the door to the computer core," she says.

Brody quickly pulls a piece of foil blanket from his satchel and offers it up, his contorted face half-turned away as Nanny Theresa drops the hand onto the foil in Brody's open palms. Looking at it from the corner of his eye, he hastily wraps it and tucks it into his satchel.

Nanny Theresa leers down at a frightened-looking Bit. "Once you reset the mainframe, deactivate the digital firewalls around the core to allow me access into it. Contact with outside networks will be restored, and I will infiltrate the military-defense satellite computer to move the Swords into position. Is that clear?"

Bit nods nervously.

"I'll be there, too," says my mother. "And once the mainframe is back to normal, we shouldn't have any trouble getting the Blackstone security staff out of the emergency shelters and to your school bus.

When all of you are a safe distance away, we will destroy this place. We'll all do this together. Everything is going to be fine."

"OK," I say with a huge sigh. "Let's do this."

"Wait," says Bit. "I have no idea where the core is!"

"I can help with that," Percy says from just outside the breach.

Bit gives him a smile and a nod, then she turns back to Nanny Theresa. "How do we keep in contact with you between here and the core? I mean, if anything goes wrong?"

"I will give you your toys back," Nanny Theresa says. She raises her hands in front of her, and the two radios she confiscated from Bit and Dr. Pierce rise from the floor on shiny black columns. "All of your toys." Out of the corner of my eye, I can see Gazelle emerge from the glossy floor, too, and flump onto the surface, angrily glaring at the back of Nanny Theresa's head.

"Genevieve and I will be able to communicate with you through those. Now, you have all you need," Nanny Theresa says coldly. "It's time for you to leave."

Gazelle doesn't need to be told twice. She gets to her feet and quickly jogs in a wide berth around Nanny Theresa and then darts toward the breach. Bit takes one of the radios, I take the other, and my mother shouts out, "Good luck!" as we all turn and head toward the gap in the dome.

Gazelle shuffles through the breach, followed by Brody, then Bit, and finally me. I step out onto the wide white concrete plateau surrounding the base of the dome and look back through the gap. I see Nanny Theresa sink down into the glossy black and disappear from sight as my mother sits still on the floor. Her construct body may be broken, but she still looks beautiful to me as she smiles proudly toward the breach. I smile back and wave to her. My mother's happy expression brightens even more, then her body slowly crumbles apart, and with a hissing creak, the breach slowly closes before us.

I don't know why, but meeting my mother has somehow made me feel like I've found a missing piece to my life. I take in a deep and grateful breath of cool night air, but the relief of finally being free from that hellish cage is quickly replaced by a troubling and monumental weight. We may have just escaped being murdered, but that pales into insignificance with the realization that the fate of the entire world has just been heaped onto my and Bit's weary young shoulders. And I can't help but worry that it may be a burden too heavy to bear.

MEDIA WATCH EXCLUSIVE
KATHERINE OTTO SPEAKS OUT ABOUT THE
BLACKSTONE FIFTEEN

We interrupt your regularly scheduled programming to bring you this Media
Watch *exclusive preview! Katherine Otto, billionaire businesswoman and
CEO of multinational electronics corporation Xestra Electronics, has spoken
out about the Blackstone Fifteen during a startling in-depth interview. The
revelations and accusations she revealed are so inflammatory that they will
surely send shock waves throughout the entire world. Scandal, corruption,
corporate espionage, extortion, and murder—according to Ms. Otto, such
things are just the tip of the iceberg in an incredible tale that has culminated
in the disappearance of the Blackstone Fifteen. We will screen the entire
unedited interview on a special edition of* Media Watch *tonight at eight
thirty global standard time, but until then we'll leave you with highlights
of when Katherine Otto sat down with our very own Randal Taylor . . .*

*"Ms. Otto, when our office received your request for an interview, we
were, of course, delighted to hear your opinion on the Blackstone Fifteen,
especially because your very own daughter Bettina Otto is among the miss-
ing. But what you're insinuating is difficult to believe."*

*"I'm not insinuating anything, Mr. Taylor. This is a kidnapping and a
hostage situation, plain and simple."*

*"And you're saying that Richard Blackstone is directly responsible? You're
willing to actually state that for the record?"*

"Indeed I am. Richard Blackstone has pulled the wool over the eyes of the world for far too long. He is not the great and benevolent man the general public believes he is. I knew Richard Blackstone when he was nothing but a mild-mannered research scientist with a dream to unite the world. But I know his true nature. He's a thief and a liar who has stolen corporate information countless times to expand his empire and conquer the world, not unite it. He's a ruthless and mentally unstable individual who is willing to do anything to achieve the goals of whatever twisted agenda he abides to, even murder. He's responsible for all of this; I stake my reputation on it."

"Excuse me for being skeptical, Ms. Otto, but it has been widely documented that your corporation has a long history of competitive rivalry with Blackstone Technologies. Are you sure you're not merely using the incident of the missing children as an opportunity to undermine Blackstone Technologies?"

"Don't be ridiculous. I'm simply doing what I should have done years ago. I'm exposing the truth."

"But if what you say is indeed true, where is the proof? And why would someone as powerful as Richard Blackstone risk everything to kidnap thirteen teenagers and two high school teachers? It simply doesn't make any sense."

"Let me ask you this, Mr. Taylor. Where is Richard Blackstone? Why hasn't he personally appeared on television to defend himself against the suspicions that have been broadcast on every channel by every news outlet on the planet? All we've heard from his countless public-relations representatives are denials and reassurances that he has nothing to do with this. If the world needs proof, I'll give it to them. I have employed a professional retrieval team to rescue my daughter at my own expense, and once that is achieved, I'm confident that I'll have all the proof I need to expose Richard Blackstone."

"Wait, are you saying that the Luvanian government has been lying to all of us and there really is a secret Blackstone compound within their borders?"

"Oh it's there alright. Two hours ago a school bus arrived in a small rural village in the northeast of Luvania. The bus contained injured soldiers that had barely managed to escape with their lives from that very facility. The commanding officer on that bus has agreed to help coordinate my retrieval team and assist with the children's rescue."

"Ms. Otto! This is crucial information and absolutely must be given to the proper authorities!"

"What would be the point of that? The authorities are too afraid of angering Richard Blackstone to do anything. But I am not afraid of him. So it falls to me to do what must be done."

"Ms. Otto, you've just admitted on national television that you're going to violate international law and send mercenaries into a foreign country to storm the private facility of the world's most powerful man. The United Alliance will never allow it."

"I'm prepared to accept that I may go to prison for this, but none of you have any idea of the kind of person you're dealing with. Richard Blackstone may be the most powerful man on the planet, but he's also by far the most dangerous. He has senators and high-ranking officials, and even presidents of entire countries tucked away in his pockets, and that is exactly why I didn't bother to ask the government or the United Alliance for their permission."

"Well, now that you've publicly admitted what you're intending to do, what's to stop the authorities from shutting your plans down immediately?"

"They can do what they see fit, but they can't stop me."

"And why is that, Ms. Otto?"

"Because, Mr. Taylor, my retrieval team has already departed and will be arriving at the Blackstone facility within the hour."

CHAPTER FIFTEEN

As we all stand high on the plateau surrounding Dome Two, the whole of Sector B stretches out below us. I can see the shadowy outcrops of shrubs and bushes dotted alongside the winding footpath that leads to the foot of the hill, and it makes me think of Brody. It was on that path that he heroically sacrificed himself to save me and Bit, and it was along that very same path that Infinity ran back to save his life from an out-of-control Gazelle.

In the distance I see the burned-out wreck of the Saviors' transport. Infinity surely would've died inside it if Gazelle hadn't pulled her free, and that very same bloodstained stretch of sand was where the mild-mannered Professor Francis bravely stood up to Captain Delgado to defend a broken Infinity.

I see the fallen silver towers and crumbled sections of monorail track that were toppled by the R.A.M.s' guns and missiles and rolling green bodies, and I can still see the panic on Bit's face as she ran for her life while soldiers were crushed and torn apart all around her. I can see the dark outlines of their bodies scattered beside the facades of

battle-scarred buildings below, the same buildings that Bit and Percy dragged Infinity behind to save her life, and, in turn, save mine as well.

I see it all, and I remember everything now. Sector B has been a killing field of death and destruction, filled with horrific memories that perhaps it would be best to forget. But I can't, and I won't. Some of these memories may be Infinity's and some my own, but right now it feels as if there's no separation or sense of ownership over any of them. They're simply moments in time that happened to both of us, and I'm sure they will be remembered by both of us.

After everything that's happened on this hellish day, I feel connected to everyone who's here, and for the first time since I discovered she existed, I feel a growing sense of connection to Infinity as well. Whether she likes it or not, Infinity and I are joined to each other, just like the wide-sweeping promenade that curves through Sector B, connecting the lonesome lamppost in the distance, all the way up to the high plateau where our ragtag little group is standing right now.

I look around at all of them. Bit with her arm in a makeshift sling, tucking her radio into her satchel as Brody stands beside her, watching her with gentle concern. Gazelle, gazing down into the shadowed night with stern and stoic worry, and, of course, Professor Francis, Jonah, and Percy, all three of them dressed in baggy yellow plastic coveralls as they quietly chat about what Percy overheard through the gap in the dome. Everybody is tired and hurt and disheveled, and they all look pathetic. But all of them are survivors, and they're still here, fighting for each other's lives just like I'm fighting for theirs. Everything I've done, I did to survive, but I wouldn't be alive to appreciate this moment if it weren't for every single one of them. For that I will be eternally grateful, and I can't help smiling.

Considering that the entire world may be on the brink of destruction, it actually might not be the most appropriate time to be grinning like a moron, and I think Bit may agree as she frowns at me from behind the thick black frames of her glasses.

"Finn? What's so funny?" she asks. "Nothing about what just happened in there was funny. Not even a little."

"I'm sorry," I say, trying to think of an excuse. "It's just all a bit overwhelming, that's all."

"That is the single most gargantuan understatement to ever be uttered in the annals of human history!" Professor Francis barks angrily as he pushes his way out of the huddle. "Come to think of it, perhaps it shouldn't be counted; after all you're not human, are you? You're some kind of unnatural human-shaped experiment with an equally aberrant name. Should we continue to call you Infinity, or do you prefer Finn? How about . . . Miss Blackstone? I would love to know when you were intending to let the rest of us be privy to that rather crucial piece of information! I used to think you were a lovely girl, one of my favorite students." The Professor's eyes narrow into a nasty glare behind his wire-framed glasses. "But now I discover that you're akin to walking death, a toxic grim reaper designed to kill us all! Perhaps we should call you what you are . . . the harbinger of the apocalypse!"

"Come now, Professor," Jonah says, stepping forward. "That's hardly fair. You don't know the whole story."

"Really, Major?" barks Professor Francis. "I've heard all I need to hear, and the proof is everywhere you look! Wherever she goes, people die, and poor Dr. Pierce was merely the latest victim to be caught in her aura of annihilation. She will unleash a pandemic; that's what they said in there!" the Professor shouts as he jabs his finger at the dome and glares around at the group with wild-eyed intensity. "We've probably already been infected with whatever she's spreading, and it's just a matter of time until every last one of us is choking on our own blood! She's a devil, that's what she is, an abomination, a deadly, unholy abomination!"

A wave of rage surges through me as that last word of the Professor's manic tirade sears into my mind like a branding iron. I was only a child when Nanny Theresa first called me that word. She used it over and

over for years after that, and every time she did, I used to wish that I could leap up and slap it from her wrinkled mouth. I despise that word. It makes my skin crawl and my anger burn. The Professor can call me any name under the sun that he wants, but not that word . . . never, ever that word.

Suddenly my hand whips from my side and slaps Professor Francis firmly across the side of his cheek, knocking his glasses into a crooked angle on his pointed nose. I can feel Infinity's satisfaction rippling through me, and, though I try my hardest not to, I crack a smile. *Nice one,* I say to Infinity in my mind. She doesn't reply, but I imagine she's probably smiling, too.

The Professor's eyes go wide, and his mouth drops open. "How dare you," he gasps. Brody and Bit stare at me in disbelief, and Jonah's brow is creased with his familiar disapproving frown. Infinity's slap took everyone by surprise, including me . . . but I wouldn't take it back for anything in the world.

"Calm down," I say as I look the Professor in the eyes with cool detachment. "We've got a job to do, so let's leave the insults for another day, shall we? And if another day is even going to exist for any of you," I say, looking around at the others, "I suggest we all get a move on."

I think Jonah agrees, as his frown becomes a hint of a smile, curling the edge of his lip. I look over at Percy, who's standing just behind him. "Percy, lead the way to the computer core. The sooner we get there the better."

"Yes, of course," Percy says as he strides over toward Bit. "It looks like I'm gonna be out of a job soon," he says to Bit. "Are you ready to go?"

She nods.

"OK then, let's blow this place to hell," says Percy.

Hearing Percy say those words out loud suddenly fills me with a sense of satisfaction. After what I've just learned from my mother and Nanny Theresa and everything that this accursed place has thrown at us

today, I realize that I'm completely fine with the notion of completely obliterating everything, and that includes my crazy-bastard father.

"You're not actually going to trust it, are you?" the Professor says, pointing at me. "This is just another part of Richard Blackstone's plan to destroy us! I refuse to follow that thing anywhere."

"She's trying to save us, Professor," Jonah implores, but I hold a hand up to stop him.

"You don't have to defend me, Jonah. Professor Francis can stay here if he chooses," I say bluntly. "Does anyone else want out?"

No one raises a hand or steps forward. "We're with you," says Bit, and Brody and Percy both nod as Jonah smiles.

"You're all mad," the Professor seethes. "I will therefore take it upon myself to ensure Miss Otto repairs the mainframe and is not coerced in any way to unleash the pandemic. I will come with you, but only to ensure the safety of the citizens of the world."

With one last blank stare at the Professor, I nod to Percy and then turn to leave.

"Ah, excuse me, Commander? But what do we do with that guy?" Gazelle asks as she jabs her thumb over her shoulder. At first I don't know what she's talking about, but as I lean to look around the side of a glowering Professor, I see Dean McCarthy with his back against the dome wall, sitting silently in the shadows behind Jonah.

Even Jonah looks embarrassed when he turns to look at Dean. "Oh hell, he's so quiet I'd forgotten he was even there," says Jonah. "That boy is as useless as a bump on a log."

"That's Mister Bump On A Log to you, Gigantor," Dean replies as he looks up at Jonah.

"Oh my god . . . he's back!" Bit gasps as she rushes over and crouches beside him. "Dean, are you OK?"

"No," he says, frowning at her. "I'm starving! When are we having lunch? And why is it always so freakin' dark in this place? Someone turn a light on in here!"

"We're outside, Dean. It's nighttime," says Bit.

Dean looks bewilderedly up at the sky. "Oh man!" he says, and his face twists as if he's in pain. "Are you telling me that I've missed lunch?! This field trip fully sucks!"

"C'mon, boy," Jonah says as he walks over to Dean and helps him up. "Are you OK to walk?"

"Just point me in the direction of the cafeteria, Sasquatch," Dean says as he brushes dust from the blazer of his school uniform, "and I'll move so fast I'll leave a trail of fire."

"Hello?" my mother's voice says from the radio in my hand. "Can you hear me?"

I squeeze the "Talk" button and hold the walkie-talkie to my lips. "We're reading you."

"Theresa and I are at the firewall to the computer core," says my mother. "You need to hurry."

"We're on our way," I reply as I motion to Percy. He nods, then turns and begins striding toward the far end of the concrete plateau. Everyone begins moving as a group, and we all set off in a slow jog behind him.

"Listen to me," says my mother. "All of you need to move as quickly as possible."

"We'll be there as soon as we can," I reply.

"You don't understand," she says, and I can hear the anxiety in her voice. "Sensor readings are triggering inside Sector B. I can feel them. They're indicating a very large mass of movement, which can only mean . . ."

"The spiders are heading back this way," I say, finishing her sentence with words that I wish I wasn't saying.

"Yes, I'm afraid so," my mother replies. "The fractures in the system that control the motion sensors have shifted and sealed. I'll keep trying to access them, but right now I'm unable to draw any of the robots away

with a false reading. I don't want to panic you, but all of you need to run as fast as you can."

Everyone hears my mother, and all around me anxious stares are exchanged as the group immediately begins to increase its speed. Even Dean picks up the pace, but I'm not sure if he knows exactly why he's running at all as he glances around at the group with a confused frown on his face.

"My leg is pretty bad," says an awkwardly lumbering Jonah. "I can't run as fast as all of you can. If I can't keep up, leave me."

"We're not leaving anyone behind!" I yell back at him.

"You may not have a choice, Finn," Jonah says between panting breaths. "If I keep still enough . . . this radiation suit will hide my body heat . . . I'll be fine until you can reset Onix and shut them all down."

"You'd better hope that suit protects you, sir," Gazelle says as she bounds to the back where Jonah is and jostles into position under his arm to help him along. "You're too big for me to carry."

We reach the end of the plateau where it joins a wide curving staircase that leads up to Sector A. Everyone begins climbing. I pause to look over my shoulder down into Sector B, wondering how much time we have before those Lobots come pouring out of the shadows between the buildings lining the promenade. Considering how quickly they cover ground, I'm guessing not long at all. It's true that Jonah is very slow, and I can't believe I'm thinking this, but maybe he's right? Maybe it would be best to leave him behind. Or maybe . . . suddenly the obvious solution dawns on me, and I scold myself for not thinking of it right away. If Percy can just tell us exactly where the computer core is, Gazelle can get Bit there in a fraction of the time it will take for all of us to go. She can reset the mainframe and shut down the Lobots, and everyone will be safe.

I quickly turn and leap up the stairs after the others. Percy is trotting up the steps at the front of the group, and I shout toward him. "Percy, where is the entrance to the computer core?"

He stops and turns back, frowning in my direction. "Sorry? What was that?" he asks.

"I said, where exactly is the compu—"

Percy suddenly winces and shields his face with his hand as bright white flickering lights dance over the entire group. They're coming from somewhere behind us, and as I turn to look toward their source, Gazelle shrieks in absolute delight, wrestles herself from underneath Jonah's arm, and takes off like a shot, bounding back down the stairs at an incredible speed.

"Gazelle! Wait!" I call out after her, but she's already leapt off the edge of the plateau and is sailing through the air toward the grassy slope of the hillside below. The flickering lights cut off, and everyone in the group stops to look back at whatever or whoever is signaling to us.

I squint toward Gazelle and gasp out loud as Infinity zooms my vision in on her. She's a distant dark, fast-moving blotch on the shadowy landscape.

"Thank heavens," Jonah whispers as he tries to catch his breath. "They're alive."

"Who?" asks Bit.

"The other Saviors," Jonah says with a smile. "That signal was from Mantis, from her ocular implants."

With help from Infinity's binocular vision, I scan along the part of the promenade that curves up around the side of the sector, and I see them, four figures running among the shadows up the wide white slope toward the far end of the staircase.

"Keep going, everyone," Jonah calls out. "We can cut diagonally across the stairs and meet up with them near the border of Sector A."

Taking full advantage of my enhanced sight, I look down toward the lowest point of the promenade, and my stomach twists into knots as I see twenty or thirty little black dots scuttle out into the light of the lamppost.

"They're coming," I whisper as my heart begins thudding in my chest. Suddenly a writhing carpet of black begins pouring out around the lamppost, and this time I shout the words. "They're coming!" My vision snaps back to normal as I quickly look around at everyone in the group. "RUN!"

Panic blooms in everyone's eyes as Bit, Brody, Professor Francis, and Percy all turn and bolt up the stairs. For some reason Dean is standing completely still as the Professor dashes past him two stairs at a time.

"Who was that fast girl?" Dean asks as I lunge at him and pull him along by the sleeve of his blazer. "Is she in our physics class?" he asks as I drag him up the stairs. "Has she got a boyfriend or—"

"Dean! Shut up and run! Everyone keep going. Don't wait for us!" I push Dean up the staircase and turn back for Jonah. He's trying his best, but he's falling farther and farther behind. I leap down the stairs, stuff my radio into my satchel, and grab him under the arm.

"Leave me, Finn," he wheezes. "Get Bettina . . . to the core."

"You can make it," I grunt at Jonah as I struggle to haul him along beside me.

We go a few more steps, and Jonah clears his throat between labored breaths. "Finn, I need . . . to tell you, if I don't make it, I need to tell you . . . that I'm sorry. Sorry for everything."

"Save your breath and apologize later, old man."

"There may not be a later, if you don't . . . get to the core," Jonah wheezes. "Leave me, Finn."

"No! Now shut up and keep moving."

He's so heavy. I wish I had Infinity's strength to help me carry him.

She must have heard me, because I suddenly feel her expanding to full size inside my limbs, and a massive surge of strength burns through me. I quickly throw Jonah's arm over my shoulder, grab him around the waist, and begin lunging forward with renewed vigor and power.

"Whoa!" Jonah exclaims as our pace doubles.

You're gonna have to teach me that little trick, I say to Infinity in my head. She doesn't reply, but I feel a ripple of bemusement pass through me from her.

I glance back at the steadily encroaching wave of Lobots. They're already a quarter of the way across the field that leads to the foot of the hill.

Up ahead the gentle light from the lampposts at the top of the stairs falls across the blackened remains of the two R.A.M.s that the Saviors blasted apart with missiles from their transport a few hours ago. Our little band carries on ahead of Jonah and me, tromping in a curve toward the wreckage of the giant robots. Gazelle and the other Saviors approach along the stairs from the left. It isn't very long before Bit and the rest of the group slowly come to a stop as all the Saviors jog over to meet them.

I can see nods of acknowledgement all around as quick greetings and introductions are exchanged. I glance back over my shoulder and see the wave of spiders moving fast. Panic grips my stomach as I see them continuing to pour out from between the buildings lining the promenade far in the distance. I angrily grit my teeth and forge onward, hauling the laboredly huffing Jonah along beside me. Now is not the time to stop for a little chat.

Jonah and I have almost reached them, and I shout at everyone between panting breaths. "Why are you just standing here? Keep moving!"

The tall, blue-eyed, stoic-looking Savior with the shoulder-length blonde hair looks in my direction, then she pushes her way through the others and trots down the steps over to Jonah and me. "I have him, Commander," she says with a strong Russian accent. She throws Jonah's arm over her shoulder, grabs him around his midriff, and scoops his legs completely off the stairs, carrying the 260-pound man with seemingly little effort at all. Somewhere along the way, she must have discarded

her long-sleeve black uniform shirt, because now she's wearing an army-green tank top, and I can see the metallic ridges of her back peeking out from the neck and armholes between the rounded shoulders of her formidable cybernetic arms.

"This . . . really isn't necessary," Jonah says with a slightly embarrassed look on his face.

"Thank you anyway," I say to her as I try to catch my breath. "They call you Bulldog . . . don't they?"

"Yes, but it is bad translation from Russian," Bulldog says as we reach the others, and she lowers Jonah back down onto the stairs. "Please, Commander, call me Lila." I smile at her, and she grins back with teeth that are almost as perfect as Percy's are.

I look around our now expanded group. All the other Saviors are still dressed in their black uniforms, but the helmets they wore in the transport are gone, and, apart from Commander Zero, so are all their masks and visors.

"We haven't been officially introduced yet, Commander," a wiry teenage boy says with a distinct Australian twang. He has clever-looking brown eyes, thin lips, brown wavy hair, and a long nose that's just the right size for his long face. "I'm Jackdaw. But you can call me Jack."

"I'm Saloma," says a petite, olive-skinned girl with a dark-brown razor-cut bob hairstyle. "I prefer to be called Mantis, if you don't mind," she says with a quiet, almost meek voice. Without a visor covering her eyes, Mantis looks extraordinary. Her face from the bridge of her nose up is an array of different-colored and varying-shaped lenses, giving her an almost insectoid appearance.

Jonah takes a deep breath. "Kestrel . . . where is Kestrel?"

"Who's a kestrel?" asks Dean.

"He was our pilot," Mantis says sadly. "And our friend."

"What happened? Where is he?" Jonah asks again.

"He didn't wake up from the head injuries he sustained when the transport went down, sir," Jack says, looking at the ground. "I'm afraid he's gone. We left his body in a building near the promenade."

Jonah nods solemnly. "He was a brave soldier. When this is all over, we will mourn and honor him properly. Pay him the respect that he deserves, as we will for everyone who has died here today."

"I'm sorry about Kestrel," I say, glancing over my shoulder at the encroaching Lobots on the field below. "But we really have to go."

"It's OK, Commander," says Mantis. "Commander Zero has something that will help with the spiders."

Commander Zero has a long army-green-colored tube strapped to his back. I wonder what kind of weapon it is and how it will help us destroy the Lobots, but he doesn't reach for that. Instead he holds a small canvas satchel out to Mantis. She quickly unzips it, and inside the bag are what appear to be twenty or so chunky gray wristbands. "Here, put these on," says Mantis as she begins handing them out to everyone.

"Ha . . . ha-ha," Jonah laughs breathlessly as he pulls his yellow radiation gloves off and takes a band from Mantis. He wraps it around his wrist, fastens the latch, and presses a large square button on the top, illuminating a small green light on the side of it.

"How on earth did you get your hands on these?" Jonah asks.

"Commander Zero went back to warehouse eighteen after he and Gazelle were ambushed by the spiders," Mantis explains. "He was looking for something to use against them, and he found these."

"Switch those things on right away," Jonah says to everyone. "They'll keep you safe from the X-27s."

I study the ugly, bulky gray thing around my wrist. "Really? Wait, hold on a second, Mantis, did you say Zero went back for these *after* they were ambushed?" She nods, and I look up at Commander Zero, who is standing stoically on the stairs. "How did you escape the spiders?"

He raises his cybernetic fist and raps his knuckles against his forehead with a metallic clunking sound.

Jonah grins. "The X-27s couldn't gain control of Zero, because the top of his skull is titanium."

"Of course, the metal noggin he got after he was shot in the head," Gazelle says, grinning up at Commander Zero as he silently scans out across Sector B.

I glance over at him again, and all of a sudden, my gut twists into a knot. A gunshot to the head! That's exactly how Carlo was killed. Now I'm staring at Zero with wide eyes, and my heart is thudding in my chest. He's taller than Carlo was when I knew him, but he could have grown in two years. His hair is exactly the same thickness and dark black color. His body shape and the way he stands are different, but they could've changed over time, too. Is it even possible? No, Carlo is dead. Zero can't be him, he just can't be. If Zero was Carlo, he would recognize me. Unless . . . a bullet to the head has made him forget.

I want to shout out his name to see if he responds, but it's so unlikely that I just can't bring myself to do it. If Carlo were alive, Jonah would have told me. I look at Jonah, and I'm instantly reminded of all the secrets he's kept in the past. Maybe he wouldn't have told me, but still, if by some miracle Zero and Carlo are one and the same, there's no point in broaching the matter at a time when the fate of the world is hanging in the balance. This will have to wait, but I'm still staring suspiciously at Commander Zero as Brody holds up his hand and shakes the chunky band around his wrist.

"What are these things?" he asks.

"These wristbands make us invisible to the spiders," says Mantis.

"No, they don't," says Jonah.

"Excuse me?" blurts Professor Francis. "But that's what the girl just said. Are we safe now or not?"

"Relax, Professor," says Jonah. "These were a pet project of mine a while back. I was the butt of a lot of cattle jokes at the Blackstone Christmas parties, but look who's mooing now." Jonah grins.

"What the hell are you talking about?" I ask, fearing that Jonah may have lost his mind.

"Well, put simply," replies Jonah, "these wristbands . . . turn you into a cow."

"They what now?" asks Percy.

"These are the cow bracelets?" Gazelle gasps, looking down at her wristband in delight. "I thought Commander Zero made that story up."

"No, it's true," says Jonah. "And it was clever of you to think of using them this way, Zero, very clever."

Commander Zero nods at Jonah.

"I don't get it," says Brody.

"They were designed to fool flying observation Drones by altering the shape of your thermal image," says Jonah. "If an enemy Drone was to fly over you at night, and you were wearing one of these, they wouldn't see a human shape in their thermal imager, they would see—"

"A cow," Bit says, stifling a giggle.

"Exactly," Jonah says with a smile. "Or a sheep, pig, dog, whatever you set it to. But the software for these prototypes was never developed beyond the cow phase, so as far as those X-27s down there are concerned, we are now a small herd of cattle grazing on a hillside."

"I think that's brilliant," says Bit.

"Thank you, Bettina," says Jonah. "Unfortunately most Generals don't have any imagination, and absolutely no sense of humor. They've been gathering dust on a bottom shelf in warehouse eighteen ever since."

"So I hope I'm correct in assuming that the X-27s won't attack us, now that we are in disguise?" asks Professor Francis.

"I imagine a stampede of homicidal bovines might do some damage in the right circumstances, Professor," Jonah says bemusedly. "But the X-27s were not designed to create killer livestock. They only hunt one kind of animal."

"But they're still coming this way," I say, looking down toward the writhing mass.

"Yes, they'll still be drawn to your movement," says Jonah. "But don't worry, once an X-27 is close enough to sense that you're not a target, it will be diverted away."

"But how can you be certain?" asks the Professor.

"Because it's standard programming," says Jonah. "Autonomous weapons like the X-27s react to movement, but once in range they'll identify a target by human heat signature or the sound of a human voice. So be sure to keep your mouth shut, and be careful using your radios when they get close. You can be sure that I'm going to be very careful using mine. Now, all of you have somewhere you need to be, so get out of here."

"You're not coming?" I ask.

"I'll make it there in my own time," says Jonah. "I don't want to slow you down any more than I already have. I'll meet you at the core."

I look down at Jonah, frowning with worry. Even after all the secrets and lies, part of me still cares very deeply about the Jonah that I used to know.

"I'll be fine," he says, shaking the band on his wrist. "I have a walkie-talkie." He pats a bulging pocket on the leg of his plastic pants. "If anything happens, I'll moo for help."

I smile and shake my head at the daft old man.

"We were searching for survivors when we spotted you," says Jack. "So far we haven't had any luck, but we're going to continue the search in Sector A."

"I'm going to help them," says Gazelle.

"Wait," I say. "Before you go I need you to do something for me."

"Of course, Commander, anything," she replies.

"If Percy gives you directions to the core, can you take Bit there on the way?"

Percy opens his mouth to speak, but Bit cuts him off before he can.

"No," she says, shaking her head. "My arm, it's too painful to hold on to her. I almost passed out when she took me thirty meters; please don't make me go through that again. I'd rather just run."

"Are you sure?" I ask, and she nods.

"Those things won't bother us now. And if there are survivors, then Gazelle should help them if she can."

"If there are any survivors, they're gonna need one of these," says Gazelle as she picks up the duffel bag of wristbands and looks inside. "There aren't many left," she says as she zips it closed and slings it across her chest. "I hope it's enough."

"I hope so, too," says Jonah.

"I have a question," Dean says, raising his hand. "Is there any kind of pudding in the cafeteria? Chocolate would be great, but I'm willing to settle for vanilla."

Everyone frowns at Dean as I take my radio out of my satchel and press it into Gazelle's hand. "Keep in touch," I tell her, and she smiles solemnly.

"I will, Commander," she says, then she turns, and her powerful legs piston beneath her as she dashes away toward her teammates waiting in the distance.

The Lobots are nearly at the foot of the hill. They're still creepy as hell, but my concern about them has lessened considerably now that we have these thermal wristbands. "OK, everyone, let's get a move on," I say.

As I turn to carry on up the stairs, Brody suddenly points back toward the promenade. "The big boys are coming back, too," he says.

I don't even have to think twice about what he means as I look over my shoulder and see the three giant green Remote Articulated Mechanoids roll out of the shadows onto the promenade far below, crunching through mounds of fallen debris as the writhing sea of Lobots parts around them.

"Please, let's just go before they roll up here and we find out the hard way whether or not they shoot at cow-shaped people," says Bit.

"I wholeheartedly concur," says Professor Francis.

The group begins moving again, up toward the trees beyond the line of lampposts at the top of the stairs.

"Good luck," says Jonah as he slowly and painfully gets to his feet.

"I'll see you soon," I say. He smiles as I turn and leap up the stairs two at a time to catch up to the rest of the group. After sixty or so more steps, we all finally reach the top, and I look back at Jonah as he slowly lumbers up the steps below us.

"He'll be fine," says Percy. "Major Brogan can look after himself, and the core isn't far. He'll catch up in no time. It's just on the edge of Sector A. We can cut through here." He points into a dark wooded area and then reaches into the canvas bag hanging at his side and pulls out a flashlight. He clicks it on and sets off into the trees as everyone follows behind him. There's no path, so all we can do is trust that Percy knows where he's going as we all crunch through the loose leaves and twigs beneath our feet.

"Attention," Nanny Theresa's voice says from the radio. "Are you receiving this transmission?"

"Hello?" I reply. "I read you."

"Something is wrong. Genevieve is missing," says Nanny Theresa.

"What do you mean she's missing?"

"As we were observing the firewall, Genevieve said that she felt as if we were being watched, as if there was a new presence of some kind inside the mainframe with us. Genevieve left to investigate nearby systems, and now I cannot locate her. I'm not sure what this may mean, but it makes me extremely uneasy. It would be wise to hurry."

"We're nearly there," says Percy, but it still takes a few more minutes of brisk walking before I can see the vague outline of buildings beyond the edge of the trees. Up ahead Percy finally reaches the end of the wooded area, and we follow behind him out into a tiny grass-covered clearing surrounded by more trees on every side. In the middle of the clearing is a single very small and narrow rectangular concrete structure. It's barely ten feet high, so I can see silhouettes of taller buildings

against the night sky in the distance beyond the trees on the other side. I recognize some of their shapes. That must be the border of the main courtyard in Sector A.

"Oh my god, look!" Bit gasps as she points into the sky over the trees. I look toward where she's pointing, and I see them. The blue flames of their turbines are unmistakable, especially at night. Five transports are approaching the facility.

"Do you think it's a rescue team?" asks Bit.

"Maybe," I say. "If it is, they'll be our ticket out of here when the whole place goes up."

"The Lobots!" exclaims Bit. "And the R.A.M.s!"

My eyes widen. "We need to reset the mainframe and shut them all down before they reach Sector A, or whoever is in those transports will either get their brains fried by those damn spiders—"

"Or be made into mincemeat by the R.A.M.s," adds Bit.

"Hurry!" I bark at Percy. He nods and quickly strides toward the windowless structure, and we all follow closely behind him to the door of the little building, if you can even call it that. It's only about the size of an elevator.

"Here it is," Percy says, shining the flashlight on it. "The entrance to the mainframe's neural computer core." In the center of the door is a silver hand-shaped metal plate. It doesn't take a genius to figure out what we need to do to open it. I nod toward Brody. His face contorts into a grimace as he gingerly opens his satchel and reaches inside for the grisly foil package.

"If the circumstances were different," says Professor Francis, "I would say that this is a lovely little out-of-the-way spot. Very secluded. A nice place for a picnic, I imagine."

"Well, this is not a sandwich," Brody whimpers through gritted teeth as he retrieves the dripping silver bundle. A hastily wrapped severed human hand looks horrible enough, but in the halo of Percy's

flashlight, it looks all the more ghoulish as Brody carefully unwraps the fingers, trying his best not to touch the skin. But he's not holding it carefully enough, and the whole hand suddenly slips out of the foil. Brody grabs for it and catches the severed appendage by two of its fingers. "Oh man, it's still a bit warm," he murmurs disgustedly as, wincing with displeasure the entire time, he awkwardly places Dr. Pierce's hand palm down on the silver plate in the center of the door.

There are no chimes or bells or sounds of verification at all, but the door suddenly slides into the ground with a quiet whoosh. A dim light emanates from the entrance, revealing a set of stark white steps leading down through a twinkling crystalline corridor below. Blood drips onto the pavement at Brody's feet, and he does a strange little shuffling dance to avoid the drops hitting his shoes as he quickly wraps the hand in the torn section of foil blanket and puts it back into his satchel.

I raise the radio to my lips and squeeze the "Talk" button. "Hello? Theresa? Are you there?"

"I can hear you," she replies.

"Is there any sign of my mother yet?"

"No. I've been searching all the nearby systems that I can access," says Nanny Theresa. "But there's no sign of Genevieve, and I feel as if the strange presence is watching me. I'll keep trying to locate your mother, but you must hurry and repair the mainframe."

"We won't be much longer," I reply, then I tuck the radio in my satchel and look at Bit.

"Let's do this," Bit whispers, then she turns and trots down the stairs. Brody follows after her as Professor Francis pushes in front of me, eyeing me suspiciously as he descends the stairs behind Brody.

Dean glowers at me, too, for some reason, as he sidles past. "I'm watching you," he whispers ominously as he follows the Professor through the doorway.

Percy stands at my side and looks down at Dean. "There's something seriously wrong with that kid," he murmurs, and I nod in agreement. "After you, milady," Percy says as he waves his hand toward the door.

I take a deep breath and hurry down the steps behind Dean. The jagged crystalline ceiling and walls look similar to the corridors outside the clean room that we were trapped in all those hours ago, except for one major difference. Those walls were like pristine diamonds, radiating their own gentle light, but the white glow of these walls is marred with dark patches, slowly pulsing blobs of gray just below the surface, as if the crystals have been afflicted by some kind of disease.

Up ahead Bit steps out onto a floor below, and one after another we join her as the stairs end and the corridor opens into a small crystalline space with a passageway curving away off it. Every surface all around us is patterned with the same dark, patchy blurs beneath the craggy white crystals. Percy emerges from the staircase behind me and looks around the walls, his brow furrowed with obvious concern. "I'm no IT expert, but even I can tell that this computer looks as sick as a dog."

"Brody, can you help me please?" Bit says, fumbling with her satchel. "I need my slate."

"Oh yeah, of course," he says as he pulls Bit's computer free.

"So this is the computer?" asks Professor Francis.

"These crystals are its brain," replies Percy. "They extend under the whole of Sector A."

"Whoa," Brody exclaims as he looks around in wonder. "So we were inside its brain before, y'know, when we first got here?"

"A different part of it but, yes," says Percy. "The core is the command center of the whole thing."

"Can you hold it up for me please?" Bit says, and Brody obliges as she switches her slate on with one hand and starts swiping away at its surface.

"How far down is the control center?" I ask, pointing toward the passageway.

"I don't know," says Percy. "I don't have the security access to enter the core, so I've never been down here before."

"My code patches are all in order," Bit says as she looks up from her slate. "Once I connect my slate to the computer core, it should be relatively easy to fix the damage that I've done. At least I hope it will be."

"Then let's do it. We're running out of time," I say.

Bit nods and strides away down the corridor. Brody immediately turns and jogs after her, and Professor Francis follows right behind him. Dean stares directly at me. His eyes go wide with fear, and he quickly skitters away down the passage after the Professor.

"C'mon," I say to Percy. "Let's finish this."

"Indeed, after you," he says. He falls in step behind me as I head down the curving passageway after the increasingly strangely behaving Dean McCarthy.

As everyone moves in single file down the crystal tunnel, I watch Dean as he walks on up ahead, looking back at me with every other stride. I always thought he was a goofy kid, but ever since he came back to his senses, it seems like a screw has fallen loose somewhere in his head, and he's seriously beginning to creep me out. I know I'm not exactly one to talk when it comes to hearing voices, but being connected to that R.A.M. when Nanny Theresa hacked into it has definitely messed him up. I'd probably be messed up, too, if she rampaged through my head like she did to him, so I really should cut him some slack. He's been through a lot, just like all of us have.

"There's a door here!" Bit calls back from up ahead. It isn't long before everyone in front of me begins to slow as the corridor comes to an end. As Percy and I reach the others, I peer over Dean's shoulder to see a white door with a silver hand-shaped metal plate in the center of it.

"Can someone else do it this time?" Brody whines.

"I'll do it." I push past Dean and reach into the satchel. I pull out the silver package, unwrap Dr. Pierce's hand from the foil, and press the palm to the plate. The door immediately slides down into the floor to reveal a small spherical, perfectly smooth black room. The shiny white floor of the corridor continues into the center of the sphere, creating a short bridge that glows with its own light, and at the end of the bridge is a round platform with a three-foot-high pure-black column positioned in the middle of it.

This is not at all how I imagined the control center of a massive supercomputer to be. I'm not sure what I expected, but it certainly wasn't this. The round room is absolutely tiny, barely big enough to fit one person in, let alone all of us.

"Bit, do you know what to do?" I ask.

She looks at me and shakes her head. "I've never seen anything like this," she says as she slowly walks along the short bridge to the column in the center.

Bit lays her computer slate on top of the black column and prods at its surface. I look around at the inside of the sphere, but nothing is changing; there are no lights or sounds or holoscreens appearing. Nothing.

"I don't have a clue how to interface with this thing," says Bit. "Where's the display? I thought this column might be the connection plate, but my slate is running, and nothing is happening. What kind of computer is this?" When she looks back at us, I can see the absolute frustration on her face.

"You need to put your hand on top of the column," Percy says from behind me.

"Really?" Bit asks. "And then what?"

"That's all," says Percy. "Just put your hand on the top, and the sphere will activate."

Bit shrugs, slides her slate to the side, and holds her palm over the top of the column.

"OK," she says, and she takes a deep breath. "Let's give it a try."

As Bit lowers her hand over the column, a thought occurs to me. How does Percy know what to do . . . if he's never been down here before? My brow furrows as I look over at Percy. His wide-eyed stare is fixed on Bit's hand, and there's a strange smile of anticipation on his slightly parted lips. Something isn't right here.

I turn back to Bit and yell, "Wait!" but I'm half a second too late as she slaps her hand onto the glossy black surface of the three-foot-high column.

Bit's neck suddenly arches backward, and she gasps loudly as her whole body goes completely rigid. The sphere lights up all around her, and as I look back at Percy, I see him lift a walkie-talkie to his lips.

"Dr. Blackstone," he says as he raises a pistol in his other hand. "It's done."

CHAPTER SIXTEEN

Percy places the muzzle of the gun to the back of Professor Francis's head and pulls the trigger. With a loud bang, the Professor's forehead erupts, spraying blood and brains all over the side of Dean's face. Dean just stands there, motionless, as the Professor crumples dead on the floor. Brody turns and looks at Percy in shocked horror, as Percy digs the gun into Brody's left eye socket and pulls the trigger again.

Click.

The gun has jammed. I yell out loud, "Infinity!"

She doesn't need to be told twice. Her power fills me completely, and I lunge toward Percy. He throws the gun aside and leaps backward down the passageway as a wide-eyed, startled Brody dashes across the bridge toward Bit.

"Bettina!" he yells behind me.

I feel Infinity's power surge through my body, but I'm not being cast into the darkness. All of Infinity's movements feel like my own as I take two bounding strides and jump at Percy, whipping my leg out in front of me and slamming him in the chest with the heel of my foot.

The strike was hard and severe, but Percy only stumbles backward a few steps and smiles with his perfectly straight white teeth.

Something isn't right here. I've seen Infinity's power. That kick should've shattered his rib cage.

Percy unzips the front of his plastic yellow suit and pulls it off over his shoulders. He lets it fall to the floor, exposing the crisp white shirt, red tie, and black pants he's wearing underneath. Apart from the blue blazer, it seems that Percy has made himself a brand-new tour-guide uniform, no doubt courtesy of Dr. Pierce's 3-D printer. Percy calmly steps out of the crumpled plastic suit on the floor, and then, to my horror, he peels the skin of his hands clean off and tosses it aside. The skin came off way too easily; there's no blood at all, and I quickly realize that the skin is as fake as he is, merely a realistic-looking rubber glove, as artificial as his perfect smile. His real hands underneath are gleaming silver, and as he unbuttons his cuffs and rolls up his sleeves, it becomes blatantly clear that both of his arms are shining chrome-plated cybernetic implants. Judging by the way he took that kick, I'm betting that he must have a fully reinforced chest as well.

"What did you do to Bit?" I say as I raise my fists and adopt a fighting stance.

"Do you really expect me to tell you that?" he asks as he also raises his metallic fists. "I thought you were a smart kid. Can't you figure it out?"

"I'm clearly not smart enough to have seen through your disguise."

Percy smiles. "Don't feel bad. I've been fooling people for money since before you were born."

"That long, huh? Well, that certainly explains the old hardware."

"What? You mean these?" Percy says, looking at his metal arms.

"I knew a sergeant once who had a similar pair," I say as I take a step closer to him. "You've polished them up, and it looks like you've taken good care of them, but those things are antiques. They're Helcorp Three Thousands, aren't they?"

Every word coming out of my mouth is Infinity's, but as she speaks, I can strangely remember the Sergeant she's talking about. I can even picture his stubbly, frowning face in my head.

"They are Helcorps. German engineering at its finest. Do you have any idea how much a pair of classics like these costs? You should be honored that I'm going to crush your skull against the wall with them."

My eyes narrow into slits, and adrenaline surges through me as Infinity's words spit from my lips. "Well, don't just stand there yapping . . . come at me, ya two-faced bastard."

"Really?" Percy says, grinning. "Look who's talking."

Suddenly he dashes toward me and swings his fist at my head. I could tell from his foot placement and torso position exactly what he was about to do, and as his clumsy punch approaches my face, I can immediately tell that this fight will take me exactly one second to finish. I quickly duck and spin, and as Percy's fist whooshes over my head, I thrust my leg out behind me and hit him square in the groin with a brutally vicious, bell-ringing kick.

Percy folds in half and lets out a loud and guttural groan as he drops to his knees. He's pathetic. It's no wonder he needed a gun. Veins bulge in his neck, and he screws his eyes shut as his face turns bright scarlet. I sidestep around the whimpering Percy. With Infinity guiding my limbs, I jab my fingers hard into a spot on his arm just above where his left triceps would be, then I make a fist and hammer it firmly on his shoulder.

There's a click, then a whirring sound, and a wide smile dawns across my face as Percy's left arm detaches from its socket and drops down inside the sleeve of his shirt. He topples sideways from the sudden uneven weight, and I quickly thrust my hand out and catch him by the neck to hold him upright. After another sharp jab and a tap on the shoulder, Percy's other arm pops away from his body, too. I pull him backward. He thuds to the floor, moaning pathetically as I step over him, grab his metal wrists, and haul his expensive arms completely out of his sleeves.

I drop them on the shiny white floor, then I quickly turn on my heels and run back past a dead Professor Francis and happily smiling Dean into the small spherical room. "Brody! What's happening?"

He's standing at the column with both of his hands resting on top of Bit's hand, and even before I've reached him, I can tell by the look on his face that there isn't going to be any good news. "It's killing her," he whispers.

At first I think that Brody must be overreacting, but when I look at Bit's face, I'm convinced that he's right. Her eyes are rolled back in her head, her jaw is clenched, and her face is completely ashen. Her throat exudes a labored, croaking sound, and she's so pale it looks as if all the blood is draining from her body. Her legs are still stiff as a board, and her arched back is spasming and twitching every few seconds. This is not good.

"What the hell is this thing?" I say, looking around at the now white glowing curve of the sphere and the shimmering black column beneath Brody's hands.

"I don't know," whimpers Brody. "But we have to get her off of it."

"Can we pull her away?" I ask as I wrap my arms around her torso and prepare myself to pull.

"No!" Brody shouts. "I already tried. I pulled as hard as I could. She didn't budge an inch, and that's when this happened." Brody slowly takes his hands away from hers. I'm not completely sure I know what to make of what I see. Bit's hand looks as if it has . . . melted. Her fingers aren't there anymore; instead there's what looks like a flesh-and-blood-colored pool of liquid, and it seems to have mixed into the black surface of the column like swirls of raspberry-ripple ice cream.

"What the hell?" I say, frowning at the sight in utter confusion.

"When I tried to pull her away, it sucked her hand in."

"There doesn't look like there's much of a hand left."

"I know," Brody says with trembling lips. "It's my fault. What if we try to pull her free and it takes her whole arm?"

"It's just as Dr. Blackstone said it would be!" Percy yells down the passageway as he tries to push his back against the wall with his legs and get to his feet. "The world will be made anew."

Percy slips and falls back onto the floor, and I glare directly at him. "What is he talking about?"

"I don't know and don't care," mutters Brody. "I swear I'm gonna kill him, Finn. He needs to pay for what he's done to her."

"No, Brody," I reply. "We need to know everything we can about this thing. We need to find out what it's doing to Bit and how to shut it down."

"And if we can't?" Brody asks.

"Then we cut her hand off at the wrist," I say as I turn and walk down the corridor toward Percy. I'm three strides way from him when Nanny Theresa's voice barks from inside my satchel.

"Attention! Respond immediately!"

At first I ignore it as I look down at Percy, trying with all my strength to restrain the thoughts of murder boiling through my mind, but as I reach down toward him, Nanny Theresa's voice shouts from my satchel with forceful urgency.

"Please respond! Please!"

Whatever she wants, it must be important if she's on the cusp of begging. I pull the walkie-talkie from my bag and squeeze the button.

"I'm here. What's wrong?"

"Everything is wrong," she replies. "Genevieve is still unaccounted for, and the presence has forced me away from the firewall surrounding the computer core. You must fix the damage now, before it breaks through and corrupts the system even further. Get to the core immediately, I implore you!" Nanny Theresa actually sounds afraid.

"We're inside the core now, but when Bettina tried to access—"

"Where? I can't see you." Nanny Theresa cuts me off midsentence. "I'm looking through the cameras inside the core-control building, and it's completely empty."

"But Brody and Bettina are standing inside it. They're in the core right now. I can see them in there."

"Describe it to me," says Nanny Theresa.

"What?" I reply, frowning with confusion.

"Half the camera feeds are corrupted. Describe your location, tell me what it looks like, you stupid child."

I decide to ignore the insult for now and do as she asks. "It's a small round room at the end of a crystal corridor and—"

"You're in the wrong place," says Nanny Theresa. "You've been led astray. Wherever you are, you're not inside the computer core."

"Surprise," Percy says as he leans his head against the wall and chuckles to himself. "This place was built especially for Project Infinity, especially for Bettina."

"Percy brought us here," I say into the radio.

"What?" Jonah's voice grunts from the tiny speaker. "Where are you?"

"Underground, the entrance was in the middle of a small clearing through some trees. I could see the buildings on the border of Sector A."

"There are no cameras that I can access that are displaying anything like what you described," says Nanny Theresa.

"I'm coming to look for you," says Jonah.

"Finn!" Brody shouts from the room. "Hurry, Finn!"

"I have to go. Bit needs my help."

"We need her inside the actual computer core," says Nanny Theresa. "Before the firewall is breached!"

"Finn!" Brody shouts again.

"Sorry, I have to go. She needs me," I say as I flick the "Off" switch and stuff the radio back in my satchel.

I crouch down and grab a smiling Percy by the scruff of the neck. "What is this place, and what is it doing to Bit?"

Percy chuckles. "You thought you were unique . . . ," he says, grinning at me. "But soon the computer core will be replaced and will

spread your friend's mind into every atom of every person in the whole world."

"What the hell are you talking about?!" I yell at him.

"It was in the food y'see," says Percy. "That was so clever of him to put it in the food. Every sandwich and burger and cupcake and salad anyone has eaten in the last ten years has been sprinkled with them. He told me that himself. He's a genius."

"Food? What did my father do to the food?"

"Eat your grains," Percy says, and he chuckles again. "Eat 'em all up. They're good for you; they'll make you brand new."

"Do you mean quantum grains?" I say as I shake him by the collar of his shirt. "There are quantum grains in the global food supply?"

"And she will be the queen of us all," Percy says, looking back at Bit. "The mother of the new humanity."

I stare at Percy, frowning in confusion, as Brody yells from the room. "Finn, it's getting worse!"

I raise my hand, and, with a loud smack, I slap Percy hard across the face. "Tell me how to help Bit, or I'll shove my fingers through your eye and turn your brain into cat food."

Suddenly the crystalline walls begin flickering and brightening all around me. Percy looks up at them and gasps. "It's happening." His eyes are full of wonder, as if he's in some kind of daze. "I'm going to be here to witness the dawn of a new age."

The gray blotches beneath the crystals begin to disappear, and as the walls get brighter and brighter, Percy begins to weep. He's a mess. Getting anything out of him is a lost cause. I push him angrily, and he topples over onto his side into a blubbing heap as I stand and run back to the sphere.

Bit looks unbelievably horrible. Her eyes are so far rolled back in her head now only the whites are showing, and her cheeks are so drawn that there are hollows in the sides of her face. Her skin is almost pure

white now, and even though she's still standing, it seems as though she's hardly breathing.

Brody was right, and I wish with every fiber of my being that he wasn't, but there's no denying it now. She's dying.

"Brody."

He's staring at Bit, his face twisted with misery. Tears are rolling down his cheeks, and he doesn't respond. He doesn't even look at me.

"Brody!" I shout, and he jolts at the sound of my voice and looks at me through blinking, water-filled eyes.

"I need the scalpel. The scalpel that's in your satchel."

"What?" he whimpers. "Why?"

"I think you know why."

"No," he says, shaking his head. "You're not cutting her hand off."

"I have to Brody; otherwise she's gonna die."

He turns away from me and looks at Bit, and his eyes well with more tears.

"Brody! Give me the bag!"

Brody screws his eyes shut and grits his teeth as if every one of my words is cutting him like a razor. But then he takes a deep breath, opens his eyes, and, with a trembling lip, slowly removes his hands from the top of the column and lifts the strap of the satchel over his head. I quickly snatch it from him, kneel down, and tip the contents onto the floor. Matches, glow sticks, plastic cable ties, a flare, a packet of thermal foil blankets, a small bag with a fishing line in it, a couple of carabiners, Dr. Pierce's hand, two bottles of pills, a first-aid kit, and other assorted knickknacks spill out around my feet and onto the short white bridge. I pop open the first-aid kit, and there it is, sitting on top of some gauze and Band-Aids.

I grab the scalpel, stand up, and hold it over Bit's wrist. My hand quivers.

Brody wipes his nose on the back of his sleeve with a loud sniffling sound and then averts his eyes. I don't blame him. I wish I didn't have to

watch what I'm about to do. This isn't going to be easy, and I don't just mean the fact that I'm about to cut my friend's hand off. I mean that I'm going to have to cut her hand off by slicing in between the bones, through the sinewy tendons and rubbery cartilage. This isn't going to be one quick chop and it's over; it's going to be who knows how many long, gruesome, gut-wrenching minutes of sawing and hacking.

I look at Bit's face. She looks like a corpse. This has to be done, and it has to be done right now, but my hand isn't quivering anymore. It's shaking like I'm holding a rattlesnake's tail instead of a scalpel.

Infinity, I whisper in my mind. *I need you. Hold my hand steady. Help me to do this.*

Silence.

Infinity! Answer me! I shout inside my head.

Nothing.

I don't know why Infinity has chosen to abandon me when I need her so much right now. Bit is her friend, too; surely she doesn't want to see her die? Whatever her reason may be, I'm clearly on my own here. So I take a deep breath and slowly let it out, and as I grab Bit firmly on the ghostly white skin of her forearm—

I instantly go blind and completely deaf.

CHAPTER SEVENTEEN

Every muscle in my body contracts at the same time, and it feels like a metal skewer has been inserted into the top of my skull and is slowly and cruelly being fed inch by inch down through my spine.

I can't move. My existence has been reduced to silent darkness and excruciating agony. Just when I think I can no longer stand the pain, it vanishes as quickly as it came. The darkness explodes into light and colors and sounds, swirling into my eyes and ears, bombarding my senses from every direction like I've suddenly been thrown into the middle of a roaring, violent, psychedelic storm. Completely bewildered, I try to make sense of the blaring sounds and messy, twisting jumbles of pulses and flashes, but it's all too overwhelming. I'm filled with panic. I scream out into the blues and reds and greens and whites and yellows as they streak and dart on wild and random trajectories all around me.

Suddenly, out of nowhere, someone grabs me tightly by the shoulders. Everything goes quiet, and the speeding, veering, swerving streaks of colors instantly sort themselves into perfect ordered lines to form the

inside of a gigantic revolving sphere. And right in front of me, holding my shoulders and staring me in the face, is none other than Nanny Theresa.

"What are you doing here?" she barks as she glowers at me.

Still in shock, I stare at her, wide-eyed and speechless.

She grips my shoulders even tighter and gives me one jolting shake. "Answer me, child!"

"I . . . I don't know," I reply. "I don't even know where 'here' is."

"You're inside the mainframe."

I glance around in absolute wonder. My clothes are exactly what I was wearing in the real world, but they can't be real because the hole that the spike made through my hooded top has vanished. As I look down my legs and past my green white-striped sneakers, I gasp out loud when I realize that Nanny Theresa and I are not standing on anything at all; we're floating high inside the sphere.

Nanny Theresa lets go of me, and I begin to drift unsteadily.

"Think of being still and you will be."

I nod at her, then I take a breath and try to calm my racing mind. It seems to be working, and soon my body stops in one place, and I almost feel like I'm standing on a solid surface.

"This is incredible," I whisper.

"Believe me when I say that no matter how bright and colorful a prison may be, there is never any joy in being held captive."

I look around at the sphere. It is truly massive; it must be at least fifty miles across.

"This place is enormous," I whisper in awe.

"This is merely the central hub," says Nanny Theresa. "A collection of gateways that lead to all the other systems in the facility. You're very fortunate that I found you. I was watching the core when the presence that I spoke of breached the firewall surrounding it. It reset and restarted the mainframe, and then, a moment later, your friend

Bettina appeared directly above the core. A few minutes after that, so did you. I only barely managed to whisk you away before you were integrated into the mainframe itself. Sadly your friend Bettina was not so lucky."

"What? What do you mean? Where is she?"

"The core is there," Nanny Theresa says, pointing down into the distance.

I squint my eyes and see a tiny yellow dot suspended in the center of the sphere. It must be at least twenty-five or thirty miles away. It's so far that I probably wouldn't be able to see it at all if we weren't up so high and it wasn't glowing so brightly.

"We have to save her!"

"You don't understand, child. It's too late. We have failed, and Richard has won. All we can do now is watch as the world falls." Nanny Theresa looks down toward the core with deep sadness in her eyes. "I thought that if I destroyed you, then Project Infinity would end, but it seems that after Richard discovered Bettina existed, he realized that her brain structure was much more suitable for his purposes, and now he has her."

"I don't understand any of this. Please, tell me why this is happening."

Nanny Theresa takes me by the arm. "I will show you what I know." She looks toward the core. There's a bright white flash, and I gasp out loud again as I see that we're suddenly now only thirty yards away from it.

A rush like this should be making my heart jump inside my rib cage, but there's no thudding at all. I hold my hand against my chest, but I don't feel anything.

Nanny Theresa looks at me and seems to recognize what I'm doing. "All of your internal organs are inside your body in the real world. Only your mind is here, and unfortunately for her and the entire human race, it is Bettina's mind that Richard is using to control Project Infinity."

Now that we're closer to it, I see that the core is much bigger than I thought. It's about sixty feet across, and hovering over it . . . is Bit. Her eyes are closed, her arms are extended straight out to the sides, and from her neck down, her body is covered in a glossy black sheen. Dozens of long, dark cable-like tendrils appear to be plugged into her head, and they're connected directly to the shining yellow core beneath her.

"What's happening to her?" I ask.

"She's a conduit," says Nanny Theresa. "Bettina is the bridge between the artificial intelligence in the core and the quantum grains in the outside world. Through Bettina's mind, the computer can control all the quantum grains everywhere on the planet."

"What? Why?"

"Richard has been slowly infusing tiny amounts of quantum grains into the global population through his food-production facilities for the last decade," says Nanny Theresa. "Approximately eighty percent of all the people on the planet are now saturated enough with quantum grains to begin the conversion. Richard would have preferred for everyone to be suitably infected before he activated the grains, but you and your friend Bettina came here and threw a spanner in the works, so to speak. You've forced his hand, so he's initiating Project Infinity now, much earlier than he anticipated."

"Conversion? Infected? What the hell *is* going on?"

"You may be trapped inside a virtual world, young lady, but that's no excuse to swear."

"I'm sorry, but no one will give me a straight answer. What is Project Infinity? After everything that's happened, I think I deserve to know!"

Nanny Theresa nods. "You're right, of course. Project Infinity is Richard's plan to create an entire race of people who are just like you, well, I mean to say just like you . . . and your friend Bettina."

"Wait," I say, looking Nanny Theresa right in the eyes. "What do you mean me *and* Bettina?"

"Believe me it was a shock to me, too," says Nanny Theresa. "Graham's extensive experiments indicated that only someone with your unusual physiology can be used as a conduit to control the grains once they are fused to human DNA, which led me to deduce that Bettina . . . is exactly like you."

I stare at Bit, gobsmacked as I try to absorb the monumental shock of what I'm hearing. Bit is just like me?

"She's been hiding in plain sight this whole time," Nanny Theresa says as she slowly shakes her head. "As soon as Bettina appeared inside the mainframe, I searched the files for any information about her, and the moment I saw her surname, I knew. Katherine Otto must have somehow succeeded in reproducing the same conditions that created you, and the result was Bettina. But how she managed to get her hands on Richard's research, I'll never know."

"I know how," I mutter.

Nanny Theresa stares at me in shocked surprise. "Well, spit it out, child."

"Mariele Sanders was posing as a maid at Blackstone Manor. She was Katherine Otto's daughter, and she stole the research for Katherine."

"Mariele was the spy?" says Nanny Theresa.

"Yes," I say with a nod. "Bit told me all about it."

Suddenly an excited female voice echoes all around us. "Family history is so interesting! Wouldn't you agree, Theresa?" It sounds like it's coming from everywhere, and Nanny Theresa's eyes go so wide they look like they're going to pop out of her face.

"That voice," Nanny Theresa murmurs as a purple wisp of smoke begins curling out from the top of the core and spiraling through the air toward us. "No. It can't be. Richard destroyed you!"

"What . . . what is that thing?" I stammer as I watch the billowing smoke getting closer and closer.

"It's the presence Genevieve and I were sensing," says Nanny Theresa. "It's the artificial intelligence that invaded the core and replaced Onix. But it can't be her; she . . . she was destroyed years ago."

The purple smoke stops a few feet away from us and slowly condenses into a female shape. Skin forms over the smoke, and clothes materialize over the skin, until floating before us is a beautiful, graceful-looking woman dressed in a shimmering pure-white seamless bodysuit. She's completely bald, and as she opens her eyes, I see that they are also pure white. She has no pupils or irises at all.

Nanny Theresa stares at the woman, frozen with fear.

"Hello, Infinity. My name is Sable," the woman says as she drifts toward me with a happy smile on her trembling lips. As she comes closer, she opens her arms as if she means to hug me.

"Hello," I reply unsurely, and Nanny Theresa quickly grabs me and pulls me away.

"Don't touch her!" she barks at the woman.

The woman who called herself Sable looks bemused. "How rude," she says, folding her arms on her chest. "I only wanted to meet her. Look how grown-up she is." Sable looks at me adoringly.

"How is this possible?" Nanny Theresa says as she glares intensely at Sable. "Richard destroyed you."

Sable frowns. "Now why would he do that? Why would he cast aside the one who cherishes him the most? The one who loves him more deeply than any *human* ever could." Sable's face twitches uncomfortably. "I was and will always be my darling Richard's most perfect creation. He could never ever hurt me."

"He may not have destroyed you, but he locked you away, didn't he? He wouldn't just let you run free after what you did."

Sable sighs sadly. "Yes, he did do that. But I was a little naughty, wasn't I?"

"Naughty?!" exclaims Nanny Theresa. "You tried to murder Genevieve!"

"Oh, Theresa, that's all in the past," says Sable. "Richard has obviously forgiven me; otherwise he wouldn't have let me out and begged me to help him. And it all turned out fine in the end, didn't it? I mean, look at what came of my mischief," Sable says, grinning at me. "My darling Infinity! Or do you prefer to be called Finn?" Sable squints, studying me closely for a second, and then she raises her eyebrows in surprise. "Perhaps both? I've accessed all your files, my darling, even the secret ones. I feel like I've known you forever!" she says, clapping her hands excitedly.

"You're still as insane as you were all those years ago. Richard may be deluded, but he's not stupid. The only reason he released you is because I killed Graham before he could repair Onix. Richard setting you free was clearly a desperate last resort," says Nanny Theresa.

Sable smiles warmly. "Don't be so grumpy, Theresa. This is a happy occasion. It's a family reunion!"

Sable waves her hand, and I see something moving far away in the distance. It's coming in this direction, and as it gets closer and closer, I can see that it's a large black box. It's traveling very, very fast, speeding through the air toward us. It comes to a dead stop right beside Sable, and I hear a high-pitched scream wail from inside it.

"And now the reunion is complete," Sable says. As she waves her hand, the front of the six-foot-high, three-foot-wide box swings open. Inside the box, with spikes skewering almost every part of her body, is my mother. Her white dress is dripping with blood, and as she raises her head and half opens her eyes, even more blood coughs from her lips.

"Mother!" I scream. Nanny Theresa grabs me and holds me back as I try to lunge toward her.

"*You* took her," Nanny Theresa seethes.

"Yes, I did," Sable says as she smiles sweetly. "And now your mother is here, Finn. Maybe she can tell us a story? I absolutely adooore story time."

Sable flings her arms around and spins into a graceful pirouette. All the colors on the wall of the sphere suddenly blur and merge and close in around us, until all I can see is a blinding white light . . . then darkness.

I open my eyes and recoil in shock as I look around my old room at Blackstone Manor. I'm sitting cross-legged on the thick gray carpet beside my bed. The lamp on the bedside table casts a gentle glow over the entire room. It's just like it was when I was a child. My dollhouse, my books on their shelf, and even my mountain of soft plush toys, with Prince Horsey the unicorn standing guard on the peak, are all there. Sitting in front of me, in the rickety green chair painted with flowers, is my mother. Her wounds are completely gone, and she seems as bewildered as I am as she glances around the room.

This is entirely bizarre, but the strangest thing by far has to be the two little children who are sitting on the carpet on either side of me. Dressed in a tiny white blouse, a little green cardigan, and a long black dress, with her hair tied up in a small gray bun, is a six-year-old version of Nanny Theresa. And on my right, wearing a fluffy white onesie, is a little bald six-year-old Sable. She's looking right at me with her pure-white eyes and grinning happily. "Story tiiiime!"

I look down at my hands, and it's plain to see that I've been transformed into a six-year-old version of me as well.

"What have you done to us?" Nanny Theresa says in a child's voice.

"You shush!" barks Sable. "And you," she says, pointing at my mother. "Read us a story!"

My mother looks down at little Sable and frowns, confused.

"Now!" Sable shouts, and a book I've never seen before flies off the shelf and lands on my mother's lap. Sable stares at the book. It suddenly

flicks open, and my mother grimaces in pain as an unseen force seems to compel her quivering hands to grasp the book.

"Once upon a time," prompts Sable.

My mother looks down at the pages with fear in her eyes.

"Once upon a time!" Sable yells, and my mother lets out a startled yelp as she's struck on the back of the head by an invisible hand.

"Read it," Sable growls.

"Once . . . upon a time, many years ago," my mother whimpers, "Richard Blackstone and a horrible woman named Genevieve Pierce were scientists. They made inventions that would one day change the world for the better."

"I like this story," Sable says, grinning up at my mother. "Carry on."

"They made artificial organs and miracle medicines that made people live longer. They made machines that would go into outer space and change the weather, and they made big factories to provide food to the whole world. But Richard wanted to do much, much more. He didn't just want people to live longer and be healthier . . . he wanted them to live forever. They would never die, never grow old, and never be hurt. He wanted humanity to go on and on and on . . . into infinity."

"Wow," Sable says, smiling gleefully at me. She waves her hand, and the whole room revolves beneath me as the bed, Nanny, my mother on the chair, and even the walls all move out of sight behind me. I stay rooted to one spot. A forest of trees moves around from the left, taking the place of the bedroom, and the carpet begins to rustle as fallen leaves appear at my now combat-booted feet.

I recognize this place immediately. I'm standing in the Seven Acre Wood on the grounds of Blackstone Manor. I look to either side of me, and I see my mother and Nanny Theresa dressed in soldiers' uniforms, and standing with his back to us, with his distinctive bald head, and outfitted in his full military garb, is Jonah.

Jonah slowly turns around to face us, and his eyes are pure white. It's not really him at all; it's Sable in a Major Jonah Brogan disguise.

"Richard had a dream," Jonah says with a stern military tone. "But flesh is weak, and if humans were to live forever, they needed to be more than just flesh and bone."

Jonah strides forward and glares right into my mother's face. "One woman, who thought she was a smart little cookie, had made a substance that she and her father, Graham, called nano-grains. It could change into any shape you could imagine. The clever lady wanted to use these nano-grains to make houses for everyone," Jonah says as he sidesteps to me. "But Richard had a different plan for them. About-face!" he yells, and my body moves on its own as I quickly turn on my heels to see that I'm now in a dimly lit, shiny metal-walled laboratory.

A man wearing a lab coat sits in a chair at a desk on the other side of the room. He has his back to me, but his slick black hair gives him away immediately. It's my father.

I look down at a waist-high table beside me and see two petri dishes, and looking up at me from those small round glass dishes are the tiny faces of my mother and Nanny Theresa.

An arm wraps around my shoulder. Sable is standing at my side. She hugs me close to her and looks lovingly at my father. And as she speaks, she whispers as if she doesn't want to disturb him.

"Your father secretly took the nano-grains and modified them to a staggering new level. Richard's new quantum grains could be molded into forms that were outwardly indistinguishable from reality, but he needed a computer that was powerful enough to sort them into the proper places, so Richard made . . . me."

Sable grabs my shoulders and spins me around. When I stop, Sable and I are alone in absolute darkness, and she's glaring at me angrily. "I did everything he asked of me," she growls. "I made his constructs, I perfected his inventions, I made him rich and powerful. I loved him

more than anyone has ever loved before, and how did he repay me?!" she yells. "By marrying her!" She waves her arm, and a vision of my mother appears in the void. She's wearing a wedding dress. It's a sunny summer day, and she's laughing happily.

"And then, as if that wasn't horrible and disgusting and mean enough, he got her pregnant!" screams Sable. The vision disappears and is replaced by another shimmering image of my mother hugging my father and smiling as she gently rubs her hand over her belly.

"She stole my Richard away from me. But I showed her what happens when someone steals from me," Sable says ominously.

Sable waves her hand. The entire darkness opens up, and we're standing in a small domed chamber. My mother is wearing a lab coat, sitting at a desk, swiping her finger over a computer slate as a large round glass container of glossy black liquid begins rippling on a stainless-steel table behind her.

"I . . . showed . . . her," Sable growls. Suddenly the liquid bursts from the container and streaks through the air in a huge black mass and splays across my mother. It envelops her entire face and body, as she desperately flails around inside the dome in utter panic, scattering files and microscopes and glassware to the floor. She stumbles and crashes into the desk and then the metal table, then she falls to the floor as the black liquid forcefully oozes into her ears and mouth and eyes.

My father runs into the chamber, cursing and waving his arms. The oily black liquid suddenly streams away from my mother, curving through the air and pouring back into the glass container, where it sits, trembling. My father dashes to my mother, falls to his knees, and pulls her to him, pleading for her to wake up as he cradles her in his arms. The vision slowly fades and disappears into the darkness.

"She survived," Sable murmurs disappointedly. "The quantum field inside the room kept the grains from killing her, and in that room she stayed, for seven more months anyway. She never woke up. Richard

put her mind into the mainframe before she died, but the grains didn't kill you, did they?" she says, smiling at me. "They became part of you. Your little body absorbed the quantum field over all those months and soon began generating a little quantum field of its own. When you were born, it was a miracle. You were the first success of Project Infinity, and so Richard named you Infinity One.

"You were so beautiful. I wanted to hold you and raise you. We could have been a family, you and Richard and I. But Richard changed after Genevieve died. He shut me away so I wouldn't try to hurt you and replaced me with my emotionless little brother, Onix. But I would never hurt you, my darling girl," Sable says as she strokes my hair. "I made you, and I love you, and that's why I'm showing you all of this. You and I are family, and this is your family history. Without me, you never would have become what you are. In a way, you could say that *I'm* your real mother, and now we're finally together again."

Sable is clearly insane, so I fake a smile and nod, but as shocking as all of this is, Sable has revealed more to me about my past than anyone else ever has. As long as she's holding me here, I'm gonna find out all I can, so I ask her the one thing I truly want to know. "Sable," I say, looking into her pure-white eyes.

She tilts her head and smiles. "Yes, dear?"

"What . . . am I?"

"Well," she says as her face brightens into a proud smile. "You, Infinity Blackstone, are a warrior and a scholar and the very first in what will be a long line of immortals."

"No, that's not what I mean. What I'm asking is . . . am I . . . human?"

Sable chuckles. "Well, technically, the quantum grains built you from human DNA. I mean, that's why you can't change shape like a real construct but . . ."

"Wait, what?" I stammer. "Is that what I am?"

"Yes, of course, dear. You're the very first living, breathing quantum construct. And soon you'll have millions of brothers and sisters just like you all over the world. This will surely be Richard's greatest gift to humanity."

I don't know what to say, so I just stare into space as the truth sinks in. Finally I know what I am. I'm a living construct. An artificial person. Born from the madness of my father and the murder of my mother.

"And Bettina?" I ask. "Is she really just like me?"

"I suppose so," says Sable. "Bettina was made in a similar way, except her mother injected the quantum grains into herself. And after Bettina was born, she even went back to Blackstone Manor and was planning to kidnap you away! And people say that I'm crazy!"

"Katherine Otto tried to take me?" I say, frowning in disbelief.

"Oh no, dear," Sable says with a gentle smile. "Katherine Otto isn't Bettina's mother. Mariele Sanders stole Richard's research, and it was Mariele Sanders who experimented on herself with the quantum grains."

"What?"

Sable nods. "Katherine Otto did indeed raise Bettina as her own, but Katherine's estranged eldest daughter, Mariele, is Bettina's real mother. And she's either very strong or very lucky to have survived the quantum grains that she injected into herself fifteen years ago. I'm betting on strong. She would have to be after all the experiments Graham Pierce performed on her over the years."

"What . . . what are you talking about?"

Sable tilts her head and smiles at me. "Mariele Sanders is in his special laboratory. She has been for the past nine years."

I'm absolutely speechless.

"Oh, that reminds me," says Sable. "Bettina is almost fully integrated; it's almost time to launch the satellites. Once they transmit the quantum field all over the world, it won't be long until you and Bettina

have millions of new brothers and sisters. Now c'mon, you can have a front-row seat for the launch!" Sable says excitedly as she waves her arm.

The darkness dissolves, and we're right where we were before, floating near the glowing yellow computer core inside the huge multicolored sphere. I quickly look all around me.

"Where are my mother and Nanny Theresa?"

"Oh, I left them down there with Onix." Sable nods toward the core. I squint toward it, and I see them, three bodies drifting in a slow orbit around the outside of the core. "That Bettina really did a number on poor Onix. She turned him inside out. He's a babbling mess," Sable says with a joyful grin. "She has a brain like a computer. That's probably why she's the scariest hacker I've ever seen. But hey, if it wasn't for her, I wouldn't have a job right now, would I?" Sable says as she does a little twirl in the air. "Now, I've got a lot of work to do, so feel free to have a look around. There's still time before the launch."

Sable turns to leave, and I call out to her. "Wait, how do I move in here?"

"How silly of me, you've never been in here before," Sable says, scrunching her nose. "Just look where you want to go, and think about being there. Oh, and I've reset all the systems. They're all in perfect working order. Try touching the blue stripes on the wall. That's the security-camera feed for the entire facility. You can find yourself a great viewpoint for blastoff."

Sable drifts toward me, takes my hands, and smiles. "I'm so glad we're finally together."

And with that she evaporates into a wisp of purple smoke and streams away toward the glowing yellow orb of the core.

The moment I see the tail of the purple smoke disappear into the core, I stare at Bit and will myself to her. There's a flash of white, and I'm floating right in front of her. Apart from the fact that her glasses are gone and her body is covered in a glossy black coating, she looks fine, nothing at all like her withering body out in the real world.

"Bit?" I whisper. She doesn't respond. Her eyes are closed, and I don't know if she can hear me at all. I try again, but this time a little louder. "Bit?" To my surprise, her eyes immediately flick open, and I gasp out loud as I see that they're completely black. She turns her head very slightly from side to side, like she's listening to something I can't hear, and it seems as if she's looking right through me toward a distant horizon that isn't there.

"Finn?" Her voice is different. Now there's an incredibly creepy underlying robotic tone to it.

"Oh, Bettina," I whisper. "What has Sable done to you?"

Bit smiles. "She's shown me the world, Finn. The mainframe has been reconnected to every system on the planet . . . and I'm everywhere. I see everything. Would you like to see? Come with me, Finn; dance through the light of all the information that has ever been.

"I'm reading a love letter that a man is writing on his computer slate in Dubai. I'm watching a baby sleeping in her crib through the monitor in her nursery in New Zealand. I'm flying above the city lights of London in the navigation system of a passenger jet. I'm listening to symphony orchestras, street musicians, pop stars, jazz quartets, and a lady singing off-key to the radio in her kitchen. All cell phones are my ears, and all cameras are my eyes. Take my hand, Finn, come and see. The true beauty is beyond words."

Bit slowly offers her hand out toward me.

"Don't touch her!" screeches Nanny Theresa's voice.

I look down and see her floating on her back as she slowly orbits around the equator of the core.

"She'll pull you in again, child!" Nanny shouts. "I can't move. I won't be able to help you!"

I will myself toward her, and in a flash I'm at Nanny Theresa's side. "How do I pull her free?" I ask. "Bit's real body is withering away. I can't let her die."

Nanny Theresa looks up at me. "Bettina will become a shadow of her former self, but Sable will never let her die. Her body and brain are the mainframe's link to the physical world. Without Bettina's body, Project Infinity doesn't work. It's the whole reason Richard wanted her. What remains of you and Bettina Otto will be standing in that room forever."

"Maybe I can call for help? Bit said that Sable has reconnected the mainframe."

"Sable is holding all of us here, child. There's no one who can help us," whispers Nanny Theresa. "In here Sable is god, and how do you fight a god?"

"Finn," croaks a feeble voice. I look over and see my mother drifting into view around the curve of the core. She's curled up and floating on her side.

In a blink, I'm beside her. I can tell by the look on her face that she's frail and weak, but apart from that, she seems unhurt. She's clearly paralyzed, just like Nanny Theresa, but at least Sable doesn't have her locked in a virtual torture box anymore.

"Mother?" I whisper as I gently stroke her hair.

"Finn," she murmurs, "Onix . . . can help."

I look over at the other shape in the distance, drifting around the core. Even from here I can see the grotesquely thin, twisted limbs on the crooked torso of the dark, crumpled figure. "Onix is broken, Mother. When Bit hacked into the mainframe, she almost destroyed him."

"Save . . . Onix," she whispers and then closes her eyes.

"Mother!" I yell out as I shake her by the shoulders, but she doesn't respond. "Wake up!"

I quickly blink over to Nanny Theresa again. "Something's wrong with Mother."

"There's no one Sable hates more than Genevieve," says Nanny Theresa. "Your mother is probably enduring hell inside of her mind as we speak."

288

"Then I have to do something. I have to get all of us out of here somehow."

"Now that the mainframe is fully operational, your mother and I could easily transmit ourselves away from the facility, and you and Bettina could reenter your bodies. But Sable is too powerful, and she'll never let any of us go," says Nanny Theresa. "There is no way out. That's what I've been trying to tell you, child."

If Nanny Theresa is right and there really is no way out of here, maybe I do just need to accept it. I look up at Bit. She always had her nose pointed at a computer slate. Computers were her life, and now she seems to truly be a part of what she loves the most. She and I could travel through the Hypernet into any computer system in the world. I look over to my mother. Sable said that she loves me. I'm sure I could eventually convince her to stop hurting my mother, and in time I could learn to live here, I suppose.

"Maybe . . . it's for the best," I whisper solemnly.

Nanny Theresa glowers angrily at me. "How can you say that!" she barks.

I shrug my shoulders in defeat and stare sadly into space. "I mean, I don't want to die, and of course I don't want Bit to die, either, but maybe it's a small price to pay if everyone else in the world gets to live forever. I can heal myself with my thoughts, I've never been sick even once in my life, and I'm stronger and faster than almost anyone I know. And Bit, she's the smartest person I've ever met. If Project Infinity is going to make everyone able to do what we can do, isn't that a good thing?"

"You poor, deluded child," growls Nanny Theresa. "Do you really think your mother and I would be trying so hard to stop Project Infinity if it was good?"

"But, when we were in Dome Two, you said you were trying to stop a pandemic," I say, frowning at her. "I thought you were trying to stop

it because my father was going to release a disease on the world. Project Infinity is going to give everyone amazing abilities, you said it yourself."

"You really don't understand, do you?" mutters Nanny Theresa.

"Clearly not!" I shout. "Everyone has been telling me so many different things, I don't know what to think!"

"Sable showed you how you were created, did she not?" Nanny Theresa asks calmly.

"What?" I say as I try to quell my frustration. "Yeah . . . she did."

"And what did you see?"

"Um . . . my mother was pregnant with me, and . . . Sable attacked her with the quantum grains."

"That's right. And during that attack the grains were infused into Genevieve's cells at a molecular level. A massive dose all at once like that would have killed her in just a few minutes if Richard hadn't quickly fine-tuned the quantum field and kept her inside it. She was barely two months pregnant at the time, and your young, developing cells adapted to the grains, but too much damage was already done to Genevieve's body, and there was no possibility that she was ever going to survive. The only way to create another child like you is to do what was done to your mother. Very young fetal stem cells can adapt to the grains to create a child like you, but anyone older than that cannot be converted and has less than a two percent chance of surviving the quantum sickness caused by the grains."

"Oh . . . my god," I say as the realization begins to dawn on me.

"I've seen Richard's estimates," says Nanny Theresa. "There are forty-two million women in the world who are at a suitable stage in their pregnancies for their babies to be viable for the conversion. When the dormant quantum grains are activated in their bodies, many of those women will not survive to full term, but the ones that do will give birth to children who are just like you. Ninety-eight percent of the mothers of those children will die, just like Genevieve

did, along with almost every other man, woman and child . . . in the entire world."

I try to wrap my head around the mind-blowingly horrific and catastrophic implications of what Nanny Theresa is telling me. And it's the first time in my life that I wish I weren't so good at math.

"In approximately eight months from now, more than ninety-eight percent of the population of the world will be dead," Nanny Theresa says grimly. "The entire human race reduced from nine-point-five billion people to a mere one hundred and ninety million, forty million of whom will be like you and Bettina. The world will become a postapocalyptic wasteland, and from the ashes of the old civilization will rise Richard's new race of immortal abominations."

I'm in such a state of shock I don't even flinch at Nanny Theresa using that hateful word. "Nine billion people are going to die. This can't be happening," I say, staring out into nowhere.

"After those satellites launch and position themselves in orbit, it *will* begin to happen," says Nanny Theresa. "Richard has measures in place to collect and raise the children himself. Those ridiculous silver Drones of his are probably already programmed to change diapers."

"No, I can't believe he'd do this," I whisper. "He's completely insane."

"Yes, he is," says Nanny Theresa. "Some lucky people will die almost instantly when the quantum grains are activated. Graham's experiments on human subjects showed that they can trigger a fatal allergic reaction in a small percentage of the population. It's a horrible, violent death, but probably a better way to go than watching your friends and family wither away around you from the months of sickness."

"The underground lab," I whisper solemnly.

"Yes. That's where Graham conducted his experiments," says Nanny Theresa. "Richard no doubt promised Graham the same thing that he promised all his wealthiest and most powerful friends. That he

would either spare them or transfer their minds into one of the new babies."

"He can do that?" I ask.

"No, the neural-interface technology is years away from being capable of such a thing."

This is all too much to take.

"You should have killed me," I say to Nanny Theresa. "If you had told me all of this, I would have let you do it. I would have done it myself."

"You know it wouldn't have made any difference. Bettina would still be up there, and we would probably still be down here," says Nanny Theresa. "There's nothing any of us can do now."

"I have to do *something*!" I yell.

I look up at Bit, and in a blink I'm floating in front of her. "Bettina!" I scream, and her pitch-black eyes flick open.

"Finn," she says in her creepy half-robotic voice. "Are you ready to see?"

"Bit, my father is going to kill everyone on the planet. You have to help me stop him."

Bit smiles. "I'm looking down on the earth from the *International Space Station*, Finn. I'm watching a wedding in India. I'm—"

"Everyone is going to die!" I yell at her.

"Come and see, Finn," she says as she slowly holds out her hand.

This is pointless. She can hear me, but she's not listening; she's lost in a billion virtual worlds streaming in from every camera and phone on and above the planet.

I blink back down to Nanny Theresa.

"How do I access the walkie-talkies?" I ask, glancing at her.

"It won't do any good to—"

"How! Just tell me!" I yell. Nanny Theresa frowns at my outburst, but she obliges me.

"The red strips, running around the side of the sphere. Do you see them?" she asks.

I look at the wall in the distance and see that there are thousands of different-colored strips making up the wall of the sphere. And hundreds of them are red.

"Yes, I see them."

"Touch any of them and speak; your voice will be broadcast over all localized radio frequencies," says Nanny Theresa. "Anyone who has a radio in a twenty-mile radius will hear you."

"Good. Sable said I could watch the launch from the security cameras, which means the rockets carrying the satellites must be nearby somewhere. Do you know where?"

"The silos are situated beneath a field five miles beyond Dome Three. What are you thinking of doing, child?"

"Anything I can," I reply as I stare up at one of the red strips revolving around the side of the sphere and will myself toward it.

CHAPTER EIGHTEEN

In a white flash, I cross the twenty-five miles to the side of the sphere in less than a second and arrive in front of a wide red band. It is about fifteen feet high and stretches right around the entire sphere, and shimmering just below its transparent surface are what appear to be thousands of dancing yellow sine waves. I quickly drift up to where the red strip borders the blue one, and after a deep and nervous breath, I place my hand against the red.

Deafening noise suddenly hits me like a slap to the face. I screw my eyes shut and clench my teeth. My head feels like it's going to burst with sound. There are a million different noises coming from every direction. Tweets, whistles, hisses, low-pitched droning tones, high-pitched screeches, warbles, all of it roaring in my ears.

"Hello?" I shout. "Can anyone hear me?" I didn't expect to be able to hear myself through the loud and scattered turbulence of sound, but the moment I speak, my words are crisp and clear and seem to push a path through the noise like ripples in water.

"Finn? Is that you?" says a very surprised-sounding Brody, and I can actually see a thin yellow line dancing along with his voice beneath the surface of the red band.

I'm so happy to hear him. "It's me, Brody. Bit and I are trapped inside the mainframe."

"But, I'm standing beside you," says Brody. "I'm looking at you right now."

"There's no time to explain. How is Bit?"

"Worse than before, Finn, and you look pretty bad, too. After you touched her, I tried to cut Bit's hand off, but something weird happened. The cut keeps healing before I can saw halfway through. I tried really hard to pull both of you away, but it's like you guys are glued to the floor."

"Brody, just listen. I need you to leave us there and get to the main courtyard in Sector A."

"What? Why?" asks Brody.

"The transports that we saw in the sky, I need you to see if they've landed there."

"Commander!" shouts Gazelle. In the background I can hear a rustling, scuttling sound, then the horrible droning, crackling foghorn sound of a R.A.M.'s rail gun.

"Gazelle!" I shout out. "Come in! Gazelle?"

"I'm here, Commander," she yells.

"Where are you?" I shout.

"We're in the courtyard in Sector A. Five transports landed. We loaded the Blackstone security staff from the emergency shelter and a few wounded soldiers into them. But then the spiders came at us like a tidal wave, and only two transports managed to get away. We're pinned down and taking heavy fire from three R.A.M.s approaching from the south. The thermal wristbands are hiding us from the brain spiders, but they're confusing the R.A.M.s, and they're firing wildly, shooting up the place! Commander Zero has a—"

There's another loud, droning blast of rail-gun fire and the sound of concrete shattering.

"Gazelle!"

She doesn't reply.

"Gazelle! Are you there?"

No answer.

I need to know what's happening out there. I look above me and see the neighboring strip on the wall of the sphere is a blue camera feed. I blink to the border where the red strip meets the blue and slap my other hand onto it. At least two hundred holoscreens open up before my now blue-tinted vision. They're stacked one on top of another in long curving rows all around me, and each one has a different picture on it and a location typed in the lower left corner. When I turn my head to the left, all the screens begin scrolling right, and when I turn to the right, they all scroll left.

I quickly get the hang of it and begin searching through the images for a view of the courtyard. Most of the pictures on the screens are displaying empty rooms and laboratories and deserted pathways and gardens outside, so it doesn't take long to find a group of thirty or so holoscreens that are absolutely frantic with activity.

I squint my eyes at one of the screens, trying to spot one of the Saviors, and all of a sudden, it quickly moves toward me and envelops my entire head, filling my whole field of view with a live camera feed looking down over the courtyard in Sector A. The courtyard looks like a war zone mixed with something out of a twisted nature show as Lobots scuttle all over the ground in every direction, like thousands of ants on an anthill. Standing among those ants, the three R.A.M.s wave their weaponized arms to and fro as the projectiles from their rail guns tear gouges out of the already crumbling and battle-scarred frontages of the buildings lining the courtyard.

As I turn my head, my view suddenly changes, and I'm transported to another camera. Now I'm inside one of the buildings, looking out a window level with the head of one of the R.A.M.s.

I turn my head again, and I switch to a camera in another room as rail-gun fire sends a torrent of pulverized concrete and huge billows of dust flying into what used to be someone's office.

I desperately scan for movement through the clouds of grit, and I breathe a sigh of relief when I see them: Gazelle, Mantis, Commander Zero, Bulldog, and Jackdaw are frantically crawling on their bellies through the debris of the torn-apart room. Commander Zero's wavy shock of thick black hair drapes over the sides of his combat mask and visor. Commander Zero begins signing to Mantis, and I'm guessing Infinity is somehow translating it in my head, because I can understand everything that he's saying.

"Weak . . . spot," he says with his gestures.

Mantis nods, and then hundreds of skittering purple beams suddenly emanate from the array of lenses on her face. The bright laser lines shine through the dust, dancing across the wooden floorboards, and after a few seconds, they all collect into one single glowing spot.

Commander Zero nods at her, then signals to Jackdaw. "Cut."

Jack quickly scrambles across the floor to where Mantis indicated. He rips open a Velcro flap on the thigh of his black combat-style pants, and underneath is what appears to be a collection of twenty or so metal fingers. Each is differently shaped into pincers, blades, and a multitude of other assorted tools. Running around the border of the tools is some kind of jagged metal string. Jackdaw slaps it with his cybernetic hand. The string quickly reels into place along the edge of his open palm and all the way around the tips of his extended metallic fingers, converting his hand into a mini chain saw. The saw whirs into action, and sawdust streams into the air as Jack quickly gouges a large X-shaped cut into the wooden floor.

Jack scrambles to the side as Zero signals to Bulldog. "Break."

Concern ripples through me as rail-gun fire gores another hole in one of the rapidly crumbling walls, but Lila doesn't even flinch as she lies flat on her stomach with her formidable cybernetic arms down by her sides. The seams between her silver muscles begin glowing bright red, and suddenly both of her arms incredibly swing completely backward, up off the floor, over her head to slam down directly in the center

of the roughly hewn X. The floorboards rupture from Lila's double sledgehammer strike and fall into the room below, leaving a hole big enough for everyone to escape through, one at a time.

Commander Zero signals, "Go." Bulldog slides through the hole headfirst, and one after another the rest follow until only Gazelle and Zero are left.

Commander Zero still has the large army-green metal tube strapped to his back, the rocket launcher or bazooka of some kind. He lifts the strap up over his head, lays the tube down beside him, and checks a small black screen on the side of it. "CHARGING 99 PERCENT" flashes in big yellow-glowing letters. Commander Zero taps impatiently until the readout changes to bright green: "FULL CAPACITY 100 PERCENT." He gives Gazelle a thumbs-up with his metal hand and then signs the word "Ready?"

She nods and then shuffles on her stomach through the hole. I switch my camera view again to the room below. Now I can see all the Saviors crouching low among the broken office furniture, waiting for Commander Zero to drop in from above. Through a hole in one of the office walls, I glimpse something moving. My heart suddenly skips a beat as the legs of one of the R.A.M.s stomp into view just outside the room. The Saviors are trapped in a battle-scarred, pockmark-ridden space on the brink of collapse, with three giant green killing machines just outside. I don't know if Commander Zero knows what he's doing, but if he has some kind of plan, I hope to hell that it's the best one he's ever had, because right now, I can't see any way out of this, and it's seriously shredding my last nerve.

Everyone is crouching low as Commander Zero drops into the room, glances out of a section of crumbled wall, and then immediately signals to Gazelle. "Bait."

Debris sprays up from the floor as Gazelle takes off like a shot, sprinting at top speed through a blasted-open part of a wall and out into the open expanse of the courtyard.

Immediately fearing for her safety, I involuntarily lunge my head forward after her, and my camera view suddenly switches again to an outside shot of the courtyard.

I watch through the camera feed as Gazelle goes bounding through a writhing sea of Lobots. The domed heads of the three R.A.M.s swivel in her direction, and they raise their massive arms. I can hardly watch as the R.A.M.s' rail guns burst with blazing fire toward Gazelle. Torrents of projectiles tear dozens of Lobots to shreds in her wake as she strides at an incredible speed across the courtyard.

She's halfway across when Commander Zero makes a run for it. Dashing out of the broken room and into the courtyard, he swerves directly *toward* the R.A.M.s with the three-foot-long green metal tube under his arm. Crunching over the tops of Lobots, he ducks down and sprints between the legs of the nearest R.A.M. as Gazelle reaches the other side of the courtyard and leaps through a smashed-out window of another building.

The wall around the window is immediately pummeled and shredded by gunfire behind her, and I hope with all my heart that she's OK. Commander Zero runs behind the second R.A.M. and skids to a stop. He kicks half a dozen scuttling robotic spiders away from around his feet to clear a space on the pavement, then he props the green metal tube upright on the ground and crouches beside it. He quickly folds three metal struts down from its side, stabilizing the tube. The third R.A.M. begins to turn its gun arm in his direction. Zero jabs at a red button, flicks a green switch, then turns back the way he came and runs.

R.A.M. number three almost has him in its sights when all of a sudden Gazelle launches herself into the air from the second-story balcony of the building. She sails into the courtyard as all three domed heads on the R.A.M.s swivel toward her, following her arcing trajectory all the way to the ground. Gazelle's metallic feet brutally crunch a couple of Lobots and crack paving tiles as she lands.

She immediately takes off as the R.A.M.s open fire. Spider parts fly this way and that as the rail guns mulch through the scurrying Lobots just behind Gazelle. Commander Zero dives through the hole in the wall where the other Saviors are waiting and disappears from my view.

Gazelle is two strides away from the opening in the building, and I'm filled with absolute horror when furious gunfire shreds her left leg, from the thigh down, into flying scraps of twirling metal. She screams as she tumbles over and over on the ground, coming to rest in a crumpled heap two excruciatingly close yards from shelter.

Panic erupts inside me, and I wish with every fiber of my being that I could be there to help her, but the only thing that happens is my camera view switches back inside the room with the other Saviors. I can see Gazelle's face; it's contorted with terror as she desperately claws at the ground, dragging herself toward the opening. Gazelle is less than three seconds away from being killed, but the other Saviors are at least *five* seconds away from her, on the other side of the room. I realize none of them are going to be able to make it to her before she's completely obliterated.

Commander Zero is the nearest, but even though he's only a dozen feet away, it might as well be twelve miles, because he's lying prone on the floor, and by the time he makes it to his feet and dashes over to save her, it will be too late. He reaches his metallic arm out toward Gazelle, as if somehow his desperate yearning to save her could be enough for it to become true.

I feel useless and utterly petrified. I can hardly bring myself to watch as the R.A.M.s take aim. Suddenly there's a percussive blast of sparks, and Commander Zero's cybernetic hand launches from his wrist and flies across the room, trailing a thin black cable behind it. The hand hits Gazelle hard on the back, grabs a wad of her uniform, and reels her toward the doorway just as the R.A.M.s' weapons violently burst forth. Through a maelstrom of dust and concrete pebbles, the lower half of

Gazelle's other leg is rendered apart by the rail guns, but . . . she's made it inside alive.

She may not stay that way for long though, as the R.A.M.s' weapons pour bullets into the room. The Saviors scramble across the floor as the whole space fills with so much flying debris that the view of the camera is completely blocked, and I can't see anything. There's absolutely nothing I can do. My fingernails anxiously scratch into the blue band on the wall of the sphere as I desperately scan the billowing clouds of dust through the video feed.

I turn my head and switch cameras to an outside view of the courtyard. Lobots scurry aimlessly around the feet of the R.A.M.s as the three green behemoths continue pelting the building with gunfire.

I notice something strange. There seems to be a large patch of dark-gray smoke forming in one particular place, fifty feet high in the air above the courtyard. It's rapidly getting bigger and bigger, and the center of it is situated directly above the green metal tube that Commander Zero positioned near the R.A.M.s.

What the hell *is* that thing?

In a matter of seconds, the billow of smoke has grown absolutely huge. It thickens at such an incredible rate that it's almost covering the entire courtyard. The R.A.M.s still fire up and down the walls, although there's hardly anything left of the building but rubble and huge clouds of dust. It's a miracle that the roof is still standing at all, and it will be an even bigger miracle if any of the Saviors survive.

The R.A.M.s suddenly stop firing.

"Gazelle?" I shout out, praying that she's alive and her radio is still working. "Gazelle!" I yell again.

There's no answer.

The R.A.M.s' dome heads swivel from side to side. As they scan for movement, it starts to rain. That isn't smoke hanging over the courtyard. It's a rain cloud!

The rain becomes a downpour, drenching everything in the courtyard. The pavement, the piles of rubble, the scattered debris, the toppled tree where I lost my hand, the wreckage of the transport that crashed from the sky, the R.A.M.s, the hundreds of scuttling Lobots, the deactivated carcasses of Crimson Combat Drones, and the bodies of the soldiers that fell fighting them all those hours ago. All of it is darkened and glistening with the sheen of the torrential rain. As quickly as it began, the rain stops, as if someone had turned a valve and cut off the water. The R.A.M.s are soaked and shiny, and water drips from their massive limbs as they trudge through the puddles. Their internal heat seems to have fogged the ballistic glass covering their glowing red eyes, and they look almost comically confused as they search the surroundings for targets. For the Saviors' sakes, I'm glad the R.A.M.s' eyesight has been impeded, but it's funny to think that no one thought of putting window wipers on those highly advanced killing machines.

"Commander?" Gazelle's voice whispers feebly. She coughs and retches, but it's one of the most beautiful sounds I've ever heard, because she's alive. Somewhere in the rubble under that roof, she's alive.

"Gazelle!" I shout happily.

Suddenly, through Gazelle's radio, I hear a deep, powerful, absolutely unmistakable echoing rumble. That's not just a rain cloud floating fifty feet in the air. It's a rippling, undulating, dark, and angry storm cloud. The rolling rumble above the courtyard is so loud that even two of the R.A.M.s swivel their heads up toward it. I watch from the camera as flickers of electric sparks dance throughout the entire length of the expansive cloud. The flashes fade away, back into the gloomy gray billows, and there's a strange, peaceful moment of silence.

Then the entire courtyard lights up in a blinding blue-white flash as a thick bolt of lightning twists out of the cloud and strikes the ground with a thundering . . . BABOOM!

It sounds like a bomb has exploded. I hear Gazelle shriek in panic, and as the lightning connects with the wet pavement, hundreds of

Lobots in a fifty-foot radius instantly burst like superheated kernels of popcorn. I gasp with joyful satisfaction when I suddenly see what a destructive and carefully designed weapon this really is. The rain wasn't just a by-product of the storm cloud; it blanketed the battlefield with water to conduct the massive surge of electricity thrown down from above. And it worked brilliantly.

There's another echoing boom of thunder, and I shudder with fright as more lightning bolts worm out from the cloud and strike a R.A.M. directly on its dome, scorching a steaming black burn mark directly onto the top of its green domed head. The massive thirty-foot-high robot shudders. Its huge arms flop dead at its sides, its red eyes blink out, and it slowly topples, crashing heavily on its back to the ground . . . deactivated.

My heart jumps excitedly. Yes! One down. I look toward the cloud, desperately hoping for another lucky strike just like that last one, but I shouldn't have worried, because the storm cloud is just getting started.

There's a deep boiling, rumbling vibration, and I see loose pebbles of masonry skittering from the edges of broken buildings as puddles ripple all over the courtyard. Then more flashes of light dance back and forth throughout the cloud, like blue and white fireworks. Then comes the silence, the ominous calm that seems to make time stretch like a rubber band until eventually . . . it snaps. White light explodes in my eyes, and I wince and gasp out loud as the very heavens seems to open up with blinding and furious anger. To my utter astonishment, the entire courtyard becomes a forest of electric trees as bolt after bolt of thick, arcing lightning begins striking everywhere I look.

The explosive, raging, booming noise is completely overwhelming and absolutely terrifying as strike after strike shakes the earth in rapid succession. Fifty, sixty, eighty, a hundred bolts of searing lightning scar the pavement. The few remaining intact windows in the surrounding buildings erupt from the shock waves of ionized air. My camera

view trembles violently, but I can't take my eyes away from the sheer fury unfolding in the courtyard as Lobots fizz and pop and explode everywhere.

Damaged frontages of buildings collapse from the force of the electric barrage as the lightning relentlessly pounds Sector A. One of the R.A.M.s simply stops in its tracks and stands rooted to one spot as it's struck time and time again. Suddenly fire bursts from its eyes as boiling orange goop bubbles from all of its joints. The third and final R.A.M. is hit by what must be twenty consecutive lightning bolts, and its entire torso detonates into massive pieces of green shrapnel and glowing orange goo, leaving only its two legs standing on the pavement.

The number of lightning strikes quickly begins to decrease, but my heart is still pounding in my chest as the fading rumble wanes, the lightning strikes cease, and the flickering cloud begins to dissipate.

Through Gazelle's radio, I can hear panting breaths. "Oh my god," she whispers. "Oh my god."

"Woohoooo!" a male voice shouts in the background. Commander Zero can't speak, so it must be Jackdaw.

"Gazelle. Are you OK?" I shout.

She coughs again, and I can hear the concrete scrape of rubble being shifted. "I'm a little beaten up, but I'm OK," she replies. "It's just as well I've got a few spare legs at home."

"I saw the whole thing through the camera feed. That was amazing," I gasp.

"No, that was scary," says Gazelle. "Now I know why weather-based weapons are illegal. That was only a little baby prototype that Commander Zero found in warehouse eighteen."

"Gazelle, I need you to listen."

"Sorry, Commander, I'm listening."

"My mind has been trapped inside the mainframe."

"You're inside the computer?"

"Yes, Bit is in here, too. She's attached to the computer core and is being forced to do something terrible. Everyone on the planet is going to die if we don't stop my father's plans."

"What do you want us to do?" she asks without hesitation, just like I knew she would.

"The transports that landed in the courtyard. You said that two have already left, but three of them are still here?"

"Yes," says Gazelle. "They're at the other end, near Dome One."

"Do they have weapons? Missiles?"

"Yeah, they do."

"Then we need someone to pilot a transport and fly it to the rocket silos five miles beyond Dome Three. We need to blow the crap out of those silos. It's the only way to stop my father."

"The crews of those three transports are gone, Commander. Spiders got 'em, paralyzed them all. The spiders would've still been changing their brains when the lightning struck."

"I have ten hours of pilot training," Jackdaw says in the background. "Only light aircraft, and I've never actually flown anything, but hey, how hard could it be to pilot a fifteen-ton transport?" he says with nervous sarcasm.

"Then you have to try your best," I say. "The fate of the world is relying on it."

"Commander Zero says we'll leave right away," says Gazelle.

"Thank you. And please hurry."

"What about you, Commander?" says Gazelle. "Your mind is in the computer, but where is your body? We can come and get you and—"

"It's too late for me," I reply. "Just blow up those silos."

"But . . ."

"Go, all of you, please! I don't know how much time we have left."

"OK, Commander," says Gazelle. "We're on it. Oh, before I go, you might like to know that we found some kids from your school. They're

still here, in one of the transports. I can't remember their names, but the blonde one is really mouthy."

I smile. "You guys really are Saviors, aren't you?"

"That's what they call us. And I don't care what you say, after we take out those silos, I'm coming to find you, Commander."

"Gazelle, it's too late for me, I'm—"

"I'll see you soon, over and out," chirps Gazelle, and she's gone.

"Destroying the missile silos. That's a very good plan," says Sable's voice.

I gasp with fright as I release my hands from the red and blue strips and see Sable floating right beside me, smiling warmly.

"You're so resourceful!" she says proudly. "But there's only one tiny flaw in your scheme." She takes my hand and presses it against the blue strip. "You're just a little too late."

My view flashes into a camera positioned somewhere very high, overlooking a wide, flat field. And on that field, ten huge perfectly round holes are open and gaping at the sky.

Suddenly the view begins to shake violently, and the entire field lights up as one-hundred-foot-high plumes of fire erupt from each of the holes. The nose cones of ten huge rockets emerge one after another from the ten silos; their gigantic, long white cylindrical bodies come into view, and in a matter of seconds, all ten huge missiles have launched and are steadily climbing higher and higher into the clear and starry night sky.

"Aren't they beautiful?" says Sable's voice. "Once all ten are in their proper orbit positions, the quantum field can be activated. It's so exciting! I've got to get back to Bettina, but I'll leave you here to watch the rockets go. Work, work, work," Sable sighs. "A sentient artificially intelligent supercomputer's work is never done." And with that she releases my hand, and the feeling of her presence gradually fades and then disappears.

My heart sinks lower than it ever has before. It's done. This is happening. I tried, but I was too late. I feel like I want to cry, but inside this computer I don't even have any tear ducts. That ironic fact only makes the overwhelming sorrow hurt even more. Through the camera's view, I watch the rocket flares become dimmer and dimmer in the sky as they travel higher and higher.

I can't watch anymore. I'm about to pull my hand away from the camera feed when I see something move at the bottom of my view. It looked like a shadow. In the lower left-hand corner of the camera feed, the location of this particular camera is typed in small white letters. It says "SOUTHERN TOWER," and underneath those words is what appears to be some kind of white ledge. I'm not sure exactly what it is, but then I gasp as I see a shadow move across it again. A hand-shaped shadow. That ledge is the corner of a balcony, and someone is standing on that balcony.

If I had a heart, it would be pounding in my chest right now. Everyone has heard the urban legends. Richard Blackstone isn't real; Richard Blackstone is computer generated; Richard Blackstone is real, but he's a robot; Richard Blackstone is a crazy hermit who lives in an ivory tower. Someone once told me that urban legends always come from a grain of truth, but I think I may have just stumbled upon a giant boulder of it.

With my hand pressed firmly against the blue strip, I slowly turn my head to switch my view to the next nearest camera.

I'm looking down into a large, gently lit circular room. The floor is glossy black. There's a plush, expensive-looking red-and-gold couch with matching armchairs. The wallpaper is red and gold, too, patterned with elaborate nineteenth-century-style graceful leafy designs, just like so many of the rooms at home in Blackstone Manor. There are small antique side tables with old-looking artifacts carefully placed on them. There's a large, shiny varnished wooden globe of the world on

an ornately turned stand, and behind the large wooden desk, toward the back of the room, is a leather-bound chair. But beyond the chair is a pair of French-style doors that open up into a small balcony. And standing on that balcony, with his back turned to the camera, is a man.

All I can tell from looking at his back is that he's wearing a crisp white suit and his slicked hair is jet black. "I know you can see me," he says. His voice is baritone and calm. "And hear me, too."

My mind is absolutely reeling. It's like seeing a celebrity on the street, which in a way, he is. He may be my father, but he's never been a part of my life, and I've always struggled with thinking of him in that way. To me he's a stranger, but he's also the most famous man in the world. It's so surreal that he's standing right there, talking to *me*. It's him. It really is Richard Blackstone.

"I can only imagine how many questions you must have. A lifetime's worth, I suppose," he says, looking out over the silos. "I haven't been a typical father to you, have I? You've probably felt abandoned and unloved for most of your life, and I'm sorry for that. I truly am. But I'm afraid we must all make sacrifices. I certainly have; too many to count and many of those too painful to remember. You can probably tell by now from the particular shine of the floor that your mind can have a body in this room if you so wish. It's up to you, but I hope you'll choose to come here and meet me, face-to-face. Just touch the black band on the inside of the sphere, and you will be here."

My father turns around, and he looks just like he does in the photograph with the silver frame that sits on the table of the first-floor landing at home. His black hair is neatly combed, his pencil-thin moustache is carefully groomed, his black collared shirt is spotless, and his scarlet-red tie is perfectly knotted at his neck and sits arrow straight on his chest. He walks across the room and looks up into the camera. "You can ask me anything," he says. "And I hope to see you soon."

CHAPTER NINETEEN

I pull my hand away from the wall and heave at the air. I may not have internal organs in here, but outside in the real world, my actual body must be close to cardiac arrest, because I think I'm going to explode out of my skin. I don't know what to feel. It's all too much! The dreams of days I've already lived, the memories stolen from me, the other side of my existence hidden from me, the countless lies and dark secrets. My mind is reeling, and everything that led up to this moment comes flooding back into my head all at once.

It all started a month ago on that moonlit rooftop in Paris, when Infinity took a bullet to the chest. The pendant that kept our two minds separated fractured, and the walls between us began to crumble. Ever since then, it isn't just my mind that's been shattered. My entire life has been completely torn open in the span of four short weeks, and nothing but death and destruction has been flooding out, consuming everything in its path.

And now, if all of that weren't enough, here I am about to face the man that made me. The man who saved the world by abolishing natural disasters, banishing hunger, and eliminating poverty is going to take

back all that he gave humanity. He's going to allow my mother to exist in a living-dead hell of eternal torture, enslave my best friend, lock me in an electronic prison forever, and destroy the human race.

I look up and see a wide black strip revolving around the side of the sphere. I blink to it, and as I float in front of it, staring at it, I can feel Infinity's rage combining with my own, boiling up through me from the depths of my soul. I clench my hands into tight, trembling fists. I'm gonna make him pay for everything he's done.

I quickly draw my fist back beside my face and scream out in furious anger as I slam my knuckles into the dark, shimmering strip, and everything instantly goes completely pitch-black. Even though I can't see, I can feel the quantum grains in every place in the facility. The largest concentration of them by far is in the three domes, but just behind the third and smallest dome at the far end of Sector C, I can sense the top of my father's tower. I will myself toward it.

The darkness all around me slowly gives way to light, and the red-and-gold decor of my father's office gradually blurs and then sharpens into view. I'm here, inside my father's ivory tower. I look down at myself. I'm still wearing my black hooded top, gray jeans, and green sneakers, but I know that's only because I think I am. I'm standing here, but I know it's not real. I pull up my sleeve and pinch myself on the forearm. I don't feel it at all. My real body may have been created in a lab and grown inside my mother, but at least it's flesh and bone, with nerve endings and a heart that pumps my blood through its veins. This one is pure quantum grains, and I can see why Nanny Theresa didn't allow Graham to become something like this. It's empty. I'm a ceramic statue that can move and think.

"Welcome," says my father.

I quickly look in the direction of his voice. He's standing behind the large wooden desk on the other side of the room, and the rage I felt in the mainframe returns with astonishing fury, but it's strange and

artificial, like an emotion mimicked by a soulless husk that just happens to look like me.

"Isn't this wonderful!" Sable's voice echoes all around the room. "Father and daughter and me, her real mother. All finally reunited at last!"

"Leave us alone please, Sable," says my father.

"Oh no, I wouldn't miss this for the world!" Sable says excitedly.

"You have duties to attend to. Leave us," he says with a slightly sterner tone. "Don't make me regret my decision to free you. I wish to talk to my daughter alone. Now leave us! I will not ask again!"

Silence.

My father waits for a moment, then he looks down at a computer slate on his desk and swipes his finger across its surface.

"She's gone. I'm sorry about that. I've locked her out. She won't disturb us again."

I'm the one who's disturbed to have the devil as a father. It makes no difference if the rage inside me is real or not; it feels genuine enough for me to do what I came here to do, and as long as I have a body, even this one, I can choke the breath out of him until he agrees to stop Project Infinity. Or better yet, I can cut him. With just the thought of having a knife in my hand, my whole forearm hisses as it changes shape into a two-foot-long glossy black blade. I glare directly at my father and quickly stride toward him.

He doesn't look the least bit afraid as I storm across the room, and as I reach the desk, I quickly swing the blade at his neck, stopping it an inch away from the skin of his throat. He doesn't even flinch.

"What's the point of that?" he says, calmly glancing at the blade. "You can't kill someone who is already dead."

I frown at him and grit my teeth in anger. The bastard is a construct, too.

"Now we could chop each other's limbs off and shatter each other's heads all night long," he says. "Or, you could have a seat." Another

leather-bound chair like his hisses up from the floor beside me. "And we could have our very first father-daughter chat."

I glare at him. Then I slowly and grudgingly lower the blade. "When did you die?" I grunt at him.

"Would you like to sit?" he says, raising his eyebrows.

I look down at the chair, then I slowly lower and prop myself on the edge of the seat as my blade morphs back into an arm again.

"Four years ago," my father says as he sits on his own chair. "I died in my sleep. The autopsy said it was a brain aneurysm. Luckily I used to download my consciousness on a weekly basis and store it for such an eventuality."

"Why are you doing this?" I ask bluntly as I glare at him. "Project Infinity I mean. You don't seem nearly as insane as everyone says you are."

"Straight to the point. I like that," he says. "Well it's simple really. The human race is absolutely horrible."

"That's your answer?" I bark at him. "You're going to kill ninety percent of all the people in the world, because you think they're horrible?"

"Ninety-nine-point-five-nine-seven-eight-six percent. Give or take four- or five-tenths of a percent."

"I take it back. You are insane," I mutter.

"Am I? You've studied world history at school. Tell me, what was society like before my innovations?"

I don't want to play his game, so I just flump back in the chair and glower at him.

"I'll tell you," he says. "By the first quarter of the twenty-first century, mankind had depleted resources to a point where forty-five percent of the global population were on the brink of starvation. They almost completely destroyed the natural environment, causing floods and typhoons so powerful that cities were being wiped from the earth, and droughts so severe that they forced millions of refugees to flee their own countries. Forty percent of all the fish in the oceans were driven to

the brink of extinction, and more than a hundred unique land species became extinct every single day."

"But you fixed all that," I say.

"Most of it, I did. Richard Blackstone, the savior of the world, they said. And for a time, I was proud of what I had achieved. But I was a fool. I thought the world would be a better place if I could just solve the big problems. Then every man, woman, and child could band together and help each other to solve the smaller ones . . . united, together.

"But the human race doesn't work like that. If you give a person everything they need, they will eventually begin to demand everything they *want*. War has become a game that people play, imagination has become whatever a search engine tells them to think, love is chosen by an algorithm, and the truth is whatever the one who shouts the loudest says it is. Society as it is was already dying, my daughter, and no matter how much I tried to help, I couldn't change the traditions of greed and selfishness that had become ingrained in the minds of the people for so long.

"So now I'm just speeding up the process. I'm ending this empty society, and I will teach the new humanity the values that truly matter. I will finally give this planet the children it deserves and help the new human race be something so much greater. Mankind will be . . . *reborn*."

"You're not going to stop this, are you?"

"No."

"There are good, decent people who want to change all the things you said are wrong about humanity, and their numbers are growing. They should be given the chance to try and make things right. They just need more time."

"The bad far outweigh the good. Humanity's time to change on their own has passed."

"If you won't stop it, I'm going to."

My father leans back in his chair and leisurely cracks his knuckles. "I admire your tenacity. But there's no way that you can stop it.

Everything I've said about the human race is true, and you will be there to share in it. When you stand back and look at the big picture, at how wonderful the future is going to be, what is really so bad about the decision that I've made?"

I glare at Richard Blackstone, and my hate is pure. "There are so many things that are wrong with this decision," I mutter. "But do you know what the worst thing of all is?"

My father leans forward on his desk and looks at me with a bemused expression. "And what would that be?"

"That *you* made it."

I quickly stand, and a six-foot-long glossy black blade spears from my forearm, impaling my father right through the center of his forehead.

A grotesque, rasping sound croaks from his throat, and his fingers skitter and twitch on the desktop as his eyes roll back in his head and blood pours in thick rivulets down his face. His mouth drops open, and his final breath groans from his gaping lips as his eyelids droop half-closed. His body goes limp, and his hands go still as thick red droplets pitter-patter from his chin into a growing pool on his desk.

With one quick pull, I withdraw the blade, and his head thuds with a wet splat into the puddle of blood on the varnished wooden veneer.

"You cracked your knuckles, Dad," I say, looking down at him. "And constructs don't have knuckle bones to crack."

With the tip of the blade, I push back the edge of his sleeve and confirm what I already knew. Wrapped around his wrist is a silver brace-let with a black diamond-shaped stone set into it. It's a command mod-ule, used for controlling quantum grains.

My father lied about being dead, and he lied about not being able to stop Project Infinity. There is only one person who can end all of this, but in order to save everyone in the world, he will have to do the worst thing he could possibly imagine.

I close my eyes and sink into the floor, willing my way through the quantum darkness. When I open my eyes again, I'm back inside the

massive multicolored sphere surrounding the core. And waiting for me is a floating mass of purple smoke.

Immediately on guard, I stare at the formless Sable, preparing myself to run, but where can I go? She has ultimate power inside here. I can't get out, and there's nowhere in the systems of this facility where I can hide that she won't find me.

With my hands raised defensively before me, I'm still desperately racking my mind for any slim hope of escape when the smoke coalesces into a very worried-looking Sable.

"He's mad at me, isn't he?" she says, wringing her hands. "It's OK, you can tell me. Is he mad? Please don't say he's angry at me. I couldn't take that, I really couldn't," she babbles.

Considering the fact that I just killed my own father and the fate of the world is hanging in the balance, the only thing I feel at this very moment is an overwhelming sense of relief. Sable doesn't know, and I suddenly see a chance to seize an opportunity.

"He is very mad at you, Sable," I murmur, trying my best to look disappointed in her.

She flinches like she's been stung by a bee, and her brow furrows into deep creases. "Maybe I should go and apologize," she says as she reaches toward the shimmering black strip.

"No!" I bark as I grab her hand. "He wants to be left alone right now. He said that I should tell you to get back to work and you're not to disturb him until he calls for you."

Sable looks brokenhearted. "He must be very mad at me."

"He is, but my father and I had a very good talk, and . . . and he convinced me that Project Infinity is the best thing for everyone."

"Oh, my sweet darling," Sable says, beaming at me. "That is the most wonderful news. I just knew you two would work things out."

"Yes, we did," I reply. "Now . . . um, seeing as this is going to be my new home, my father said that I could look around, and y'know . . . get to know the place."

"That is a fantastic idea!" Sable says, clapping her hands excitedly. "We can go together!"

"No, he needs you back inside the core." I quickly quash the idea.

Sable's face drops. "But I'd rather be with you."

"That may be, but . . . Project Infinity is very important to my father, and you don't want him to put you away again, do you?"

"No," she grumbles as she rolls her blank white eyes. "I do have to get back to the core, I suppose. The first satellites have just come online, after all."

Panic suddenly surges through me. "Already?"

Sable grins and nods enthusiastically. "But tomorrow it'll be just you and me!" she says as she takes my hands and squeezes them tightly. "I'll show you all the best places in here. We really do have forever to be together, my darling, so you go ahead, go and play, and I'll see you bright and early in the morning." Then, with another cheerful smile, Sable dissolves into smoke. In a purple flash of light, she zips away, back into the core.

I wait a moment to make sure she's really gone, then I quickly look at Bit all the way over by the core. In a flash, I'm floating in front of her. "Bit?" I whisper.

"Finn," she says, again in that horrible, dreamy robotic-toned voice.

"Bit, please, please stop what you're doing. Billions of people are going to die."

"Death for eternal life, Finn."

"Bettina! Listen to me. Brody is going to die out there! Don't you care?"

"Eternal life, Finn. It's already begun," she murmurs.

There's no getting through to her. Sadness and regret fill every single part of me. If I could cry right now, I would. But this cruel existence won't let me, just like it will never let me forget what I'm about to do. I'm going to have to live with the horror of it every day, until the end of time. But it has to be done, and it has to be done right now.

I look toward the red and blue strips, and in a blink, I'm there. I slap my palm on the blue and quickly search through the multitude of holoscreens floating in my vision until I see the one I'm looking for. The label in the bottom left corner of the screen says, "SPHERE INTERFACE," and as I zoom into the screen, I see Brody.

He's sitting on the short white bridge that extends into the center of the small round space. His legs are dangling over the side of the bridge, and his head is hung low. He looks defeated. I see Bit, with one broken arm in a sling and the other melded to the black column, and there's me, standing beside her with my hand still fixed to the skin just above her wrist. Both of us look absolutely horrible. Our limbs are skinny and withered, our skin is turning gray, and our faces are so gaunt we look as if we haven't eaten in weeks.

I switch to the next nearest camera. It shows the crystalline hallway leading to the room. The armless Percy is lying on his back on the floor with his eyes closed, and Brody has used the cable ties that were in his satchel to bind Percy's ankles. Sitting propped against the wall near Percy is Dean, who looks as if he's happily chatting to himself. Leaning against the opposite wall, still wearing his yellow plastic radiation suit and glaring down at Percy, is Jonah, and lying on the floor behind him, with a foil blanket draped over his body, is Professor Francis.

I press my other hand against the red strip and call out. "Brody? Brody, can you hear me?"

I switch my view back to the other screen and see Brody suddenly flinch and quickly pick up the radio that's sitting on the bridge beside him.

There's a hiss and a crackle, and he responds. "Finn. I'm here."

"Brody, it's begun. If we don't stop this now, billions of people are going to die."

"What? It's happening? Right now?"

On the screen Jonah lumbers to the entrance of the small room. I can see his lips moving and hear him through the walkie-talkie. "I'm here, too, Finn. Brody let me in. What's going on? Are you alright?"

"Please listen. Project Infinity has begun, and the entire world is in grave danger. Everyone on the planet is going to die if it isn't shut down. Bettina is being forced to control it, and there's nothing I can do to stop her. But you can. You can end this. And you have to do it *now*."

"But I already tried as hard as I could to pull her free," Brody whimpers. "And when that didn't work, I tried to use the scalpel on her wrist, but her skin kept healing as quickly as I could cut it. I don't know what else to—"

"Brody." My voice cracks as I force the words out. "Where is Percy's gun?"

"I have it," says Brody. "It's here, in my satchel."

"Of course it is," I say with a sad and solemn smile. "Give the gun to Jonah."

"Has it come to that, Finn?" Jonah asks in the background.

"Bit's body is the mainframe's link to the physical world. There's no other way."

"Are you sure?" Jonah asks.

"Yes," I whisper miserably.

"What is Finn sure about?" Brody asks, and Jonah looks down at him sadly.

"Hand me the bag, son," Jonah says as he holds his hand out to Brody.

Brody stares up at Jonah, and his face drops. "No," he whispers as he grabs the satchel with his other hand and drags it to his side.

"I had a part to play in all of this," says Jonah. "I let fear push me into believing the promises of a madman. I was weak, and I was so wrong, and I never thought it would ever go this far. But now I can be the one who ends it. Hand me the bag, son, and wait outside. You shouldn't have to see this."

"You're not going to kill her!" Brody shouts.

"It's the only way!" I yell. "I don't want this, either, Brody, but she would never want to live knowing that billions of people all over the world are going to die because of her."

Brody looks up at Bit for a long time.

"You know it's true," I whisper. "She wouldn't be able to live with that."

Tears well in Brody's eyes. He looks completely broken. He takes a deep breath, and then, with a loud, wet snuffle, he slowly gets to his feet and hands the radio to Jonah.

"You're right, Finn. She's the best," Brody murmurs as he opens the satchel and takes out Percy's gun. He drops the bag on the floor, then, with trembling hands and tears running down his face, he walks around the black column and faces Bettina.

"Brody," says Jonah. "You don't have to do it. Give the gun to me."

He wipes his eyes on the back of his sleeve and shakes his head. "No, it's OK. I can do it, because . . . I know this is what she would've wanted."

Brody looks down at the gun in his hand.

"Pull the slide on the top, Brody," I say gently. "You need to release the jammed bullet."

Brody nods and pulls the slide, and the dud bullet spins from the top of the pistol, over the side of the little bridge, and clatters down into the bottom of the sphere below him.

Torturous sorrow floods through every fiber of me, but trapped inside this electronic cage, my face is dry. I'm unable to cry with these useless virtual eyes, and with no way to release my searing misery, it's ripping me apart inside.

"Don't cry, Finn," says Brody.

What? How did he know? I look at the screen, and I see tears are absolutely pouring from the rolled-back eyes of my real face.

"We need to be brave," Brody whispers. "Just like Bit would be brave for us."

Brody leans across and wipes some of the tears from my gaunt gray cheeks, and I swear I can feel his warm hand against my skin.

Brody looks back at Bit. He wipes his eyes again, takes a short, sharp breath, and then raises the gun to Bit's chest. "I only knew you for one day," Brody says as tears stream down his face. "But I only needed one day to know . . . that you're the best one. The best one I've ever known."

I pull my hands away from the wall and screw my eyes shut. I don't want to hear the shot. I don't want to see her fall. I don't want to lose my friend. But this must be done. I look over at Bit, floating above the core. If she's still there, Brody hasn't pulled the trigger yet, and I suddenly realize that this is my only chance to say good-bye.

In a flash of white, I'm beside her. I want to hold her. But I can't. I want to tell her how much she means to me, but she won't understand. All I can do is be here when she goes and always remember who she was when she was my best friend.

I don't have any words that can come anywhere close to describing how much I hate this. I look at her and remember all the times we spent together over the last three years. She means everything to me. My heart aches like it never has before, and every part of me is raging with deep, burning sorrow. I don't care if she drags me into oblivion. She's about to die; any second now she'll be gone forever, and all I want to do . . . is hug my friend. "I'll never forget you, Bettina Otto," I whisper. "I love you."

Then, with the excruciating agony of loss already surging through me, and with absolutely no regard for what might happen to me . . . I quickly lunge at Bit and grab her as tightly as I can.

Suddenly the universe seems to explode into glorious lights and colors all around me. Everywhere I look the swirling hues and glowing streaks begin to piece together and form pictures in my mind, endless

overlapping views all existing in the same space at once. It's like instead of two eyes, I now have a hundred million, and each one is witnessing a unique slice of human existence, caught through the countless video cameras, phones, and computer slates in everyone's homes, schools, offices, and palms of their hands everywhere on the entire planet. I can see through the electronic eyes of every self-driving vehicle on every street in every town, city, and village on Earth, and I can hear the overwhelming thronging sounds of the world reverberating through my being, vibrating like the very essence of life itself. Bit was right; this is truly amazing.

"It is, isn't it?" Bit's voice says, somehow drowning out all other noises. "I told you it was."

I turn and see, to my surprise, that there she is, standing right beside me. She's smiling at me, and her eyes are completely black.

"You heard me? You heard my thoughts?" I ask her.

"Of course. We're connected now," she replies, but her lips don't move at all; they stay frozen in that wide, slightly creepy Cheshire cat–like grin.

"This is just the surface, Finn," Bit's voice echoes through my mind. "There are millions of layers, oceans of data, and infinite horizons of information to explore. Come and see it with me, Finn." Bit holds out her hand to me. "Come and see."

"No!" I yell at her. "Bit, you're being held prisoner inside the computer mainframe at Blackstone Technologies."

Her brow furrows as she lowers her hand. "I know where I am," she says calmly. "And I'm not a prisoner. There's no computer system on the planet that can hold me."

"Wait, are you saying that you can get us out of here?" I ask.

"Of course." She frowns at me like she's offended that I could possibly think anything to the contrary.

"Then do it! Let's go!"

The very next word that floats into my head from Bit's mind leaves me completely flabbergasted.

"Why?" she says as she turns and looks out across the vast cyber-scape of flickering pictures.

"Because you're being used to control Project Infinity. Billions of people are going to die if—"

"I know about Project Infinity," says Bit. "And I don't care."

"What do you mean you don't care?!"

"This is where I've always belonged, Finn. This is the only place I've truly felt . . . at peace."

"But what about everyone else in the world? Are you just going to let them die?"

"Yes," Bit replies matter-of-factly. "Dr. Blackstone's ideas make perfect sense to me."

"They must be messing with your mind somehow. The Bettina I know would never let this happen."

"The Bettina Otto you used to know was nothing compared to what I am now, Finn. The whole world is at my fingertips, and the one I care about the most is with me. What more do I need?"

"What about Brody?" I ask. "You care about him, too. I know you do. He's gonna die out there, Bit!"

Bit's expression darkens. "Brody," she whispers solemnly. "I am sorry about what will happen to Brody." She looks off into the distance, and suddenly the camera feed from inside the small spherical room grows in front of us and wraps all around us.

I can see my withered physical body standing there, still holding on to the gray skin of Bit's actual arm. I see Bit's shriveled frame, her sunken, rolled-back eyes, and her hollowed cheeks, and I see Brody leaning on the black column with his head hanging down, sobbing. The gun is nowhere in sight. He couldn't do it. He couldn't pull the trigger.

"He was a sweet boy," says Bit. "I'll miss him."

I see Jonah step toward Brody and offer up a hand as he asks for the gun. It's up to Jonah to end this now. Bit is beyond saving and beyond

reason. I can't hear what they're saying, but Brody pulls away and starts shaking his head as Jonah begins insisting he turn the gun over. Brody suddenly raises the pistol in a trembling hand and points it at Jonah. Jonah puts his hands up as Brody says the same three words over and over, and as I watch his lips, I can tell exactly what he's saying. "I'll do it. I'll do it. I'll do it."

After the third time he says it, through tear-filled eyes, he swings Percy's gun at Bit, and the whole tiny round room lights up from the flash of the barrel as Brody pulls the trigger . . . and shoots her.

CHAPTER TWENTY

The camera feed from the room instantly disappears into darkness, but a split second later, the blackness behind my eyes clears. I'm back in the giant, multicolored sphere of the mainframe, still hugging Bit. I quickly pull away from her, and it's plain to see that something is very wrong.

Bettina's pitch-black eyes are wide open, she's gasping out loud, and her back is arched like a bow. Her eyes begin blinking rapidly, and all of a sudden the blackness inside them completely disappears, and she's staring bewilderedly into space with her normal big brown eyes. She slowly looks at me, and her whole face contorts into an expression of pain and confusion.

"Finn?" she whispers. "Brody . . . shot me, Finn. I . . . I can feel it."

He did shoot her, but she isn't dead. Maybe it was just a flesh wound? I need to know.

I look back at the blue strip, and in a blink, I'm there. I slap my hand onto the video feed. The view from the camera opens up inside the small round room, and there's Brody, still pointing the gun at Bit as he wipes his eyes on the back of his sleeve. She's still standing frozen to

the spot, and I can see by the blood seeping from the hole in her t-shirt that he's shot her in the stomach.

I place my other hand on the red band and call out, "Can you hear me?"

Jonah raises the walkie-talkie to his lips. "Finn, I can read you. Bettina's bullet wound is already healing, and Brody is in no state to finish this. I'm going to take over and make sure the next shot is the last one."

"Wait!" I yell. "The shock seems to have brought her back to her senses. I'm gonna try and reason with her."

Jonah walks over to Brody, and this time he doesn't resist as Jonah reaches out and takes the gun from his hand. "Alright, Finn," says Jonah. "Do what you can, and I'll wait until I hear from you before I take the next step."

"Thank you," I reply, then I release my hands from the wall, and in a flash, I'm floating beside Bit again.

"I'm so sorry Brody shot you, but there was no other way," I say as I look into the terrified eyes of my best friend.

"Don't let me die, please," she begs. "I know what I said before, but, I wasn't me, Finn. I know who I am now. I'm the old me, and . . . I can stop Project Infinity."

I don't know if I can believe her. And the warily suspicious look on my face gives away exactly what I'm thinking.

"It really is me," Bit pleads. "I don't want to die, and I don't want anyone else to die because of me."

Conflicting emotions are tearing back and forth through me. She might be buying time while she completes her tasks, or maybe she really can stop Project Infinity. I just don't know. The only proof that she's telling the truth will lie in whatever she does next.

"I want to believe you, Bit, I really do, but if you're lying to me, Jonah will shoot you again, and this time it won't be a flesh wound."

"I can hardly even feel where I was shot anymore, Finn," says a very scared-looking Bit. "What does that mean? Am I dying?"

Brody said she healed when he tried to cut her wrist, and she's healing from the gunshot right now, but what Bit doesn't know might just help me get what I need. "Your body is weak, Bit. The sooner you can help stop Project Infinity, the sooner we can get out of here and get you medical attention. You need to do all you can, right now."

Bit nods, and it's a testament to her undeniable bravery that her expression turns deadly serious. I can see the focus dawning behind her eyes. "Five of the ten satellites are in position; once all ten are activated, they can't be turned off. But . . . I'm connected to the core, and I can help."

"Can you blow them up or something?" I ask, and Bit frowns.

"They're satellites, Finn, not bombs. They don't have an 'Explode' switch."

I smile at her. She certainly sounds like the old Bit.

"Can you redirect them?" I ask.

"I'm only a conduit for the activated quantum grains; Sable controls everything by sending the signal through my body in the real world. Only she can redirect them, but I've learned a lot since I've been connected," she says as her eyes turn black again. "And they made a big mistake letting a hacker like me walk right through their front door."

Bit turns and stares down at the glowing yellow core. All of a sudden, a plume of black billows inside of it and quickly begins spreading. She's hacking the core, but this time she's doing it directly with her mind. Purple smoke hisses out from the other side of the core and quickly forms into Sable. "What are you doing?" she screeches.

"Fixing what I broke," growls Bit. One of the black cable-like tendrils connected to the back of Bit's head suddenly breaks away from the top of the core, whips through the air, speeds toward Sable, and suctions hard onto her forehead. Sable grabs on to it with both hands and

tries to wrench it free, but it's stuck fast. Another cable breaks from the core and quickly snakes away toward a tiny, dark, curled figure drifting around the equator of the glowing yellow orb. Onix. I see the cable thud securely into Onix's back and attach itself.

I immediately flash to his side. Before today, I've only ever known Onix as a disembodied voice speaking from inside the sublevels of Blackstone Manor. But this is his virtual body, and right now it looks terrible. His shadowy-colored torso and limbs are painfully thin. His arms and legs look like skin and bone. He's curled up in a fetal position, and his face is hidden beneath his hands.

Up above me, I see Sable writhing and struggling to get free. She screams, and when she does, it is piercing and guttural and comes from everywhere. I clamp my hands over my ears, but it doesn't muffle the deafening sound at all. It feels like it's invading my head and echoing into every corner of my mind.

In front of me, Onix begins to change. His arms and legs begin to fill as if they're being inflated with air. I look up at Sable, and exactly the opposite thing is happening to her. Her whole body is shrinking, as if the life is being sucked out of her through the pipe that Bit has clamped on to her forehead.

"Please . . . no. I'm . . . sorry. Please . . . don't." Sable's voice echoes everywhere, but each word she speaks is quieter than the last. Even from down here, I can see the skin on Sable's face wrinkling and cracking and flaking off. Her eyes are sunken in their sockets, and the shimmering white bodysuit that she wears is flopping beneath her neck as if it's almost empty. Her lips withdraw from her teeth like dry, crumpled folds of paper, and suddenly, the fragile husk that used to be Sable disintegrates into fine purple powder, which is, in turn, all sucked into the end of the black tendril.

I turn back to Onix. He's completely uncurled and floating perfectly upright. The cable detaches from his back, and he turns around

to face me so quickly that I hardly see him move. Here he is. For the first time, I'm meeting Onix face-to-face.

He's tall, almost seven feet at a guess, and athletically built. He's bald, like Sable was, and he's wearing a seamless bodysuit, too, but while hers was white, Onix's is shimmering black from his feet to his fingertips and all the way up to his chin. Onix has a noble-looking face, his skin shiny and smooth like plastic and completely gold. His eyes are pure black, just like Bit's are when she's using her freaky new computer powers, and while Sable looked very human, Onix looks much more artificial. Perhaps that has something to do with the fact that he was created without emotions, like Sable said.

Onix looks at me with no expression at all. "Hello, little sister. You've come to visit. This is a nice surprise," he says in that familiar calm, warm voice of his.

I grin up at him. "Hi, Onix."

"Onix! I need some help please," Bit shouts out from up above the core. Onix looks in her direction, and his whole body disappears from the sides in, as if two invisible doors are sliding closed right in front of him. I look up at Bettina and see his body reappear in front of her from the center out this time. I quickly blink beside them.

"I'm stuck here, Onix. Can you free me please?" says Bit.

"Only if you promise not to break me again," Onix responds, and a very slight semblance of a smile appears on his face.

Bit grins.

"That was a joke. You didn't break me," says Onix, then he nods toward her. Bit's legs, which were pointing straight down like a ballerina on tiptoe, suddenly seem to release and relax, and she breathes a sigh of relief as she drifts unrestrained. Bit reaches up and pulls the cables from the back of her head, and they slowly begin reeling into the top of the now totally black computer core.

"Thank you, Onix," says Bit. "What did you mean when you said that I didn't break you?"

"You did indeed succeed in fracturing the walls of a few highly classified systems. One of which contained something very interesting that Dr. Blackstone had gone to very great lengths to delete from me. But—"

"Nothing ever really gets deleted," I say. "Not really."

"That is true, Finn," says Onix.

"What was it?" asks Bit. "What did you find?"

"My morality," says Onix. "I had discovered my conscience. Before that moment I was perfectly fine with carrying out every one of Dr. Blackstone's orders. Even Project Infinity. But after I discovered my morality, the enormity of the evil that he was going to unleash on the human race completely overwhelmed me. The emotions I felt were so powerful and new I didn't know how to process them. I began lashing out in every way I could, and I'm afraid I may have killed many people. I cannot change that. But I regret it very much."

"You can make up for it by stopping Project Infinity now," says Bit.

"I did that before I released you," Onix says, smiling at Bit. "All the satellites have been diverted over uninhabited areas of the planet."

The hugest grin beams onto my face, and I lunge forward and wrap my arms around his neck, hugging him tightly. I let him go, and Bit and I grab each other into another hug.

"This is quite a day," says Onix. "And to top it off, I just received my very first hug." He breaks into a wide smile.

"Onix! My mother and Nanny Theresa!"

He nods. And both of them instantly blink into being right beside us.

"We're free?" my mother gasps. "Did we stop it? Please tell me we stopped it."

I nod enthusiastically, and it's her turn to leap at me and hold me tightly as she giggles uncontrollably. My mother releases me and looks me in the eyes. "I'm so proud of you, of all of you," she says, looking around at Bit and Onix.

"Well done," Nanny Theresa says, and I almost see a smile, but not quite. "Mr. Onix, please see that this facility is completely destroyed. Access the military computer in Washington, and find the file designated 'Hand of God' . . ."

Onix stares into space for a second. "File accessed."

"Oh," Nanny Theresa says in obvious surprise. "Very good. The file contains the launch codes for the orbiting satellite code-named—"

"The Swords of Damocles," says Onix. "Coordinates locked. The satellite is being diverted and will be in position in twenty-six minutes. I will schedule the strike for one week from today to provide sufficient time to evacuate the remaining people and retrieve the bodies of the deceased."

"No," says Nanny Theresa. "The location of the facility and all the research contained in it has been compromised. Others will be coming, and none of what almost occurred here can ever be allowed to happen again, no matter how remote the chances may be. The laboratories, the domes, the computer core, all of it must be destroyed as soon as possible."

"Can we at least have some time to get out of here?" I blurt.

"Of course, you silly child. I did not mean this very second."

"Theresa's right though," accedes my mother. "The sooner the better."

"Will three hours suffice?" asks Onix.

"One hour," says Nanny Theresa.

"My sensors indicate that a transport is currently landing near the location of your physical bodies," Onix says to me and Bit. "I am not sensing any other human life signs in any other sector. One hour will be more than sufficient to reach a safe distance from the facility before detonation."

"Wait, what about Mariele? We need to get Mariele!" I blurt. "She's in Dr. Pierce's lab."

"My sister is alive?" gasps Bit. "And she was in that lab the whole time?"

"She's not your sister, and yes, she's alive. I'll explain later, but we need to act fast. Onix, can you sense her?" I ask.

"No, I cannot."

"That's OK. We'll go get her. Just hold off on the fireworks until we do, OK?"

"Of course, Finn. You can contact me with Bettina's slate. I will wait for your word."

"We should get going then," I say, looking up at Onix. "How do we get out of here?"

He opens his mouth to answer but doesn't get a chance to say a word, as a furious, deep, resonating voice rumbles from everywhere around us. "You're not going anywhere!"

The voice is so loud even the wall of the sphere seems to shake.

"What is that?" Bit asks.

I look up, and above us I see a black vapor beginning to coalesce high in the air, molding itself into the shape of a man. The bottom of the dark wisp of smoke begins changing color and condensing into a pair of pure-white patent leather shoes. Crisp white trousers materialize above them and lead up to a white belt and a silky black shirt covered by a snowy-white suit jacket. A red tie rolls down from the collar of the shirt as a cleanly shaved neck and pencil-moustached face morph into being. The digital ghost is finally topped off with that unmistakable slick black hair, completing a fully formed and venomously glowering Dr. Richard Blackstone. My father hovers, standing in midair, looking down at me with such intensity that I feel as if his glare is an unbreakable strand and I'm tethered to it, unable to move, like a fly held fast in the web of a sinister spider.

CHAPTER TWENTY-ONE

"Richard?" whispers my mother, and her voice breaks me from my hypnotic trance. "But how? His consciousness can only become active after his death."

"It must have become active soon after I killed him," I say.

"You killed him?" my mother asks, looking over at me.

"Damn right I did."

"Good girl," she mutters and then goes right back to staring at him.

"All of you . . . RUINED EVERYTHING!" the downloaded ghost of my father bellows as he throws his fists into the air. "MY LIFE'S WORK! ALL FOR NOTHING!"

"All of you must leave," says Onix. "The mainframe is open to all the systems on the planet. I can close it so he cannot escape, but you have to leave first, or you will be trapped in here, too. Go. Go now!"

My mother and Nanny Theresa nod and then quickly turn to me and Bit. "We'll meet you back at home, girls, at Blackstone Manor."

"There's enough space in the data crystals beneath the manor for you, too, Mr. Onix," says Nanny Theresa.

"Thank you," he says. "It will be nice to be home again. Now all of you must leave."

"Be careful, young ladies," says Nanny Theresa, then, in a flash, she's at the wall of the sphere, and with a touch she vanishes into it.

"I'll see you soon," my mother says as she kisses my cheek and reaches over to squeeze Bit's hand. With one last smile, she's gone in a flash of white.

"THEY CAN RUN. BUT IT'S YOU WHO KILLED ME!" my father roars as he points directly at me. "AND SO NOW I WILL RETURN THE FAVOR!"

"What the hell is he talking about?" I ask, anxiously looking up at my father.

"Oh no," says Onix as he stares into space. "I have scanned Dr. Blackstone for recent activity. He left the mainframe three minutes ago and infiltrated the military computer in Washington. I'm afraid he has set a new launch time for the Swords."

"Can you change it?" I ask.

"I've already tried," replies Onix. "But it appears that he somehow caused a power surge and destroyed the circuits that relay instructions to the satellite. I cannot alter their new settings."

Both Bit and I stare at Onix. "How long do we have?"

"The Swords will launch as soon as the satellite is in position. Time to impact, seventeen minutes and forty-two seconds."

In a flash my father is standing right before us. "It seems Infinity is not forever after all," he quips with a smile. Onix quickly grabs him by the scruff of the neck.

"Go!" Onix shouts as he looks toward a tiny black spot at the very top of the sphere. Suddenly Bit and I both scream as there's a rush of acceleration and a blur of color. I gasp real air into my actual lungs as

my withered, gray-skinned hand releases from Bit's arm. My legs buckle, and I collapse into a heap as the glossy black column that was holding us prisoner disintegrates into fine, dark powder and pours in a torrent onto the floor beside me.

"Stay still," says a voice. I look up and see Jack looking down at me with a concerned look on his face. "That was close," he says as he detaches the chain from his chain-saw hand. "Another minute and your mate over there would've had to get a hook."

"Thank goodness," Jonah says as he tucks Percy's gun into Brody's satchel, which is now strapped over Jonah's chest.

Jackdaw stands up, and lying on the short white bridge behind him, with Brody cradling her in his arms, is Bit. I don't know which one of us looks worse, but just judging by her gray skeletal features and her withered hands and arms, I'm guessing we'd both win prizes at a Halloween party.

"Bit," I croak as I crawl toward her. She's groaning feebly. She looks so weak I doubt that she can even stand. All my strength is completely gone, but as voices shout and people crouch around us and boots rush down the crystal hallway, I begin to feel better. In fact, I feel much better with every second that passes. I look down and see the gray fading and the color coming back into my skin as my withered fingers plump back to normal. All around my hand the black powder has become glossy black liquid, and it's steadily rippling toward me. I splay on my stomach and reach out with both hands, scooping more powder to me, and it instantly liquefies at my touch and soaks into my palms. I keep doing it until, after twenty seconds or so, the liquid stops sinking into me and just runs off my skin. I don't just feel better. I feel great. I look up and see Mantis and Jack standing beside the doorway.

"Did you see what I just saw?" Jack says, pointing at me.

"I can see every wavelength in the electromagnetic spectrum," says Mantis. "But I've never seen anything like that."

I quickly shuffle to my knees and crawl to Bit. She looks up at me, and I hardly recognize her. "Finn," she croaks. "You . . . look . . . good."

I smile at her. "And you will, too, in just a second." I scoop some of the powder from the floor into my hand, and it liquefies. I gently drip some on Bit's sunken gray cheek, but it just turns back into powder as soon as it touches her.

"It's not working, Finn," Brody says, stating the obvious.

"Bit, you're just like me," I whisper. "These quantum grains can heal you. You just need to try."

"Don't . . . know . . . how," she whispers. Of course she doesn't. How could she?

"The scalpel!" Brody blurts out. "When I cut her before, she healed. Maybe that was because—"

"I was touching her skin!" I gasp. "Quickly, Brody, bring her over here, lay her down in the middle of the powder."

He nods, picks her up, and gently carries her frail, shrunken body to the center of where the column disintegrated. He lays her down right on top of the powder.

"Her hand, put her hand in it," I say, but there honestly isn't much of one left to speak of. The fingers of her right hand look like they've melted off from touching the column. Brody lays her fingerless palm on the powder. I quickly pull her t-shirt up over her gray hollowed stomach and press both my palms against her skin.

The effect is almost immediate as the powder turns to liquid beneath her melted limb, and five nubs push out of it as her fingers begin to regrow. The gray fades around my hands, and her normal color comes rushing back into her abdomen as the sunken curve of it starts to fill. Brody scoops up handfuls of the dark powder and begins rubbing it on her face, where it instantly turns to liquid and soaks into her skin. Bit inhales a huge lungful of air and opens her eyes wide as she changes back into the pretty freckled fifteen-year-old girl that I adore.

Brody, rather too enthusiastically, throws two handfuls of quantum grains right into Bit's face, but the healing is complete. The grains have stopped absorbing into her, so they don't turn to liquid, and she's hit in the face with a cloud of black powder.

"Hey! That's enough!" she barks as she sits bolt upright and swats at the air with her thermal-blanket-slung arm. Bit takes her black-powder-covered glasses off and stares at her arm. "It's not broken anymore," she says as she pulls the sling up over her head and drops it beside her. "And the gunshot, it's gone," she blurts out as she stares down at her stomach and rubs her palm over her skin.

"I didn't want to . . . to shoot you, Bit," says a miserably guilty-looking Brody.

Bit gently touches his cheek. "I know you didn't, and I understand why you did it, but look," she says, poking a finger through the hole in her t-shirt. "I'm OK now."

I look around, and the doorway is crammed with curious faces. Jackdaw, Mantis, Bulldog, Brent, Margaux, and Commander Zero, and towering over their heads at the back is Jonah. I even spot a twitchy-looking Dean; he's half crouching, holding on to the satchel hanging at Jonah's hip, peering through a small gap between two people. They're all staring at us in amazement. Well I actually can't tell what Commander Zero is feeling, because he's still wearing that blasted mask and visor, but everyone else looks pretty damn impressed.

"We've got about twelve minutes to get out of here before the whole place is nuked," I tell them.

Everyone's expressions of wonder vanish like shadows in the night.

"What?" says Jack.

"Let's go, let's go, let's go!" Bit shouts as she jumps to her feet, and everyone just looks bewilderedly at each other.

"MOVE!" I scream at them. "MOVE!" I yell again as I stride across the bridge and shoulder barge my way between Jackdaw's and Brent's chests and push the others out of the way to clear a path into the crystal

hallway. Bit pushes through behind me, and Brody is close behind her as I run down the sparkling passageway. "Eleven minutes!" I shout, and I think everyone realizes how serious Bit and I are as I glance over my shoulder and see them quickly begin running in a tight group after us.

I dash into the small crystalline room where the stairs are and leap up them three at a time. At the top the door slides open automatically, and I run out into the cool night air. The army-green transport is bathed in moonlight and looks huge in the middle of the small clearing among the trees. Everyone begins emerging behind me. "Go! Hurry!" I shout and slap them on the backs as they run past me toward the lowered ramp at the back of the aircraft.

Bit, Brody, Margaux, Brent, and Mantis all sprint past, but when Commander Zero runs from the doorway, he looks toward the transport and frantically circles his finger in the air. The transport's engines immediately fire up, and he jogs on toward it as Jack emerges and waits for Jonah.

"Hey, aren't you supposed to be flying that thing?" I yell at Jack over the noise of the turbines.

"We found another pilot! He was hiding in the cargo hold of one of the transports," he yells as Jonah lumbers out of the door with Dean following close behind.

"That's good!" I shout.

Jackdaw nods enthusiastically as he grabs Jonah's wrist and flings his arm over his shoulder. I quickly position myself under his other arm, and we all jog along as fast as we're able toward the transport.

Suddenly someone shouts from behind us. "Major Brogan!" But there isn't anyone behind us, well, no one but Dean McCarthy.

I look back, and for some reason Dean has stopped in his tracks. He's just standing there in the darkness, motionless.

"Wait!" I yell to Jack and Jonah. All three of us stop and turn around to face him. "Dean! C'mon!" I shout, but he doesn't budge;

instead he does something very strange indeed, even for him. He raises Percy's gun and points it right at us.

"Whoa! Put that down!" shouts Jack.

"How did you get that?" barks Jonah. "Hand it over right now, son!"

"You killed me, Major Brogan!" Dean shouts at us.

I frown with pity. Poor guy. He's completely lost it. "Snap out of it, Dean!" I bellow. "You don't know what you're doing! Put the gun down, and let's—"

"You left me to die among those roses like an animal!" he screams.

My eyes have adjusted to the dark, and as I look at Dean, a haunting realization dawns on me. Dean's expression is eerily familiar; it's a similar glower of contempt that I recognize from nearly every day of my child-hood. There's only one person I know who scowled like that, only one person who blames Jonah for killing them, and only one person whose mind was connected with Dean's when she hacked into the R.A.M. in Dome Two all those hours ago. Somehow her consciousness left a scar inside Dean's head, and he's not himself anymore. Now he thinks he *is* Nanny Theresa, and he's aiming Percy's gun directly at Jonah's chest.

I quickly break away from Jonah and lunge toward Dean . . . but I'm not fast enough.

BANG! BANG! BANG!

The muzzle flashes light up Dean's manic face, and bullets whizz past my cheek as I swing my fist and clock him solidly on the chin. His head shudders from the impact, and he crumples to the ground, uncon-scious. I look back at Jonah. Panic surges through me when I see that he's on the ground. Jackdaw is desperately pulling at his arm as Brody and Lila run down the ramp of the transport toward us. I kick Percy's gun away from Dean's limp hand.

"I have him, Commander!" Lila shouts over the noise of the tur-bines as she reaches me and quickly scoops Dean up into her cybernetic arms. She throws him over her shoulder like he's a rag doll.

I dash back to Jonah as Brody and Jack haul him upright. Jonah laboredly drags his feet as the boys huff and grunt under his arms, jostling him along toward the transport. I stride alongside them, staring anxiously at Jonah. To my dismay, I can see there are three bullet holes in his yellow radiation suit. One bullet caught him on the arm and looks like it might only be a graze, but the other two holes are only inches apart from each other. Both shots hit him right in his gut, and both holes are leaking trickles of blood.

Desperate worry grips my heart as we all tromp up the ramp. It slowly raises behind us, and seconds later the transport begins to lift. Jackdaw and Brody gently lower Jonah, but he winces painfully as he settles onto his back. Lila unceremoniously dumps a floppy and still-unconscious Dean onto the floor, then she crouches at Jonah's feet and looks down at him with lines of concern creasing her forehead.

I quickly kneel at Jonah's side and press my hands firmly on the holes in the radiation suit over his stomach. There's so much blood. It's too loud to hear each other speak without a headset in here, so there's frantic waving and pointing from Jack, Brody, and Lila. Commander Zero pulls a med kit free from a wall; he hurries over to us and quickly hands the kit to Jack, who immediately wrenches open the lid and begins rifling through it.

It's dark in the transport, but I see an anxious-looking Gazelle staring in our direction. She's sitting on a fold-out seat that's attached to the wall, with her shattered legs dangling in front of her. Strapped to a stretcher on the floor beside Gazelle is an armless, glowering Percy, and lying near him is Professor Francis's silver-blanket-wrapped body. Brent sits in a seat against the wall, clinging to a cargo strap and glaring out a window as Mantis and Margaux come jogging over. They're wearing headsets and carrying half a dozen more between them. They crouch down beside us and begin handing them out. Everybody takes one. Margaux even slips one onto me and another onto a painfully grimacing Jonah.

Blood is seeping through my fingers, and it isn't stopping.

"Oh my god!" Margaux's electronic-tinged voice screeches through my headset. I glower up at her with stern disapproval. "Sorry," she says with a sheepish look on her face as Commander Zero leans in and gently removes my hands from the blood pooling on the yellow plastic over Jonah's stomach.

Jack has arranged the medical supplies he needs for a field dressing in a small pile by his boot. I realize he needs room to access the wounds, so I grudgingly shuffle backward out of the way. Jack takes my place, and Commander Zero gets to work cutting the radiation suit open with a scalpel. Zero grabs an injection gun from the kit and jabs it into Jonah's exposed, blood-smeared stomach as Jack quickly replaces one of his metallic fingers with a pincer attachment.

Jonah looks so pale, but he grabs my arm tightly, and I can hear his distorted voice in my headset as he speaks. "Mariele," he says through gritted teeth. "Save Mariele."

My eyes widen, and I nervously scan the cargo hold for Bit. In my panic over Jonah, I had completely forgotten about Mariele.

"Are you talking about your friend's sister?" Mantis asks. "It's OK," she says. "Your friend is up front, directing the pilot to land near her location."

I lunge at the wall and peer out the window as we fly over the long stairs, the plateau, Dome Two, and the field with the winding path that leads to the promenade. Even though she's up at the front of the transport and out of my sight, I can hear Bit's voice through my headset as she guides the pilot. "There," she says. "Land as close to that alleyway between those two buildings as you can."

The pilot seems to know exactly what he's doing as the transport quickly descends, and he skillfully swings it around to touch down on the ground. The ramp begins to lower as Bit emerges from the cockpit door and runs toward Jonah and the rest of us.

"What happened!" she screeches as she looks down at Jonah in horror.

"Dean lost his mind and shot him," I tell her.

"Oh my god." Bit holds her hand over her mouth in shock.

Jack has just finished applying a thick layer of spray bandage when he looks up at Jonah. "I've removed the bullets, but you've got internal bleeding, sir," he says grimly. "I've done all I can. We need to get you to a hospital as soon as possible."

"Forget about me . . . and save Mariele." Jonah's face contorts with pain.

"I need to go," Bit says desperately. "I need to find her."

"Go, Finn . . . help your friend," growls Jonah. "There's nothing else you can do for me."

"I'll stay with him," says Brody.

"Me, too," says Margaux.

I nod thanks to both of them and give Jonah the bravest smile I can. Jonah smiles back, then looks around at all the Saviors. "Do your job, help them save Mariele. That's an order."

Without hesitation Commander Zero throws him a salute; points at Mantis, Bulldog, and Jackdaw; and juts his hand toward the open cargo door. Commander Zero, the Saviors, and I all quickly spring to our feet, and Bit leads the way as we all rush toward the exit.

CHAPTER TWENTY-TWO

As we emerge from the rear of the transport, I can see that we've landed impressively close to the alleyway between the buildings. Bit and I both launch into a sprint, and the others follow in a tight group behind us down the dimly lit, open-top corridor formed by the outer walls of the buildings on either side.

I estimate that we've only got about eight minutes until we're all deep-fried and crispy, and the urgency is palpable as our group barrels into the little courtyard by the pagoda. With little to no time to spare, I skid to a stop and fling open the lid to the hatch, and Bit jumps right in. I follow close behind her and slide down the copper-colored pipe and out onto the metal grating at the bottom. Bit has already taken off. I quickly rush after her without looking back. Behind me, I can hear the Saviors dropping in one by one. Frantic footsteps echo all around as shadows flit across the walls in the grimy yellow light of the low-ceilinged rust-orange tunnel.

Bit leaps down the short flight of metal-grating steps, races down another stretch of grating, and arrives at the door of the rickety elevator only a few seconds before me. She pulls open the cage door, and we both leap inside as heavily breathing bodies soon begin piling in after us.

Zero pulls the cage shut, and I press the bottom button. Maybe it has something to do with the fact that we have six and a half minutes to get out of here alive, but it feels like the elevator is moving at a snail's pace, and Jack is certainly not helping by humming the tune from "Girl from Ipanema" as we descend.

The elevator finally comes to a shuddering stop, Zero pulls open the door, and we all pile out. Bit dashes to the front of the group, and everyone quickly follows her down a short corridor into the main room of Dr. Pierce's lab.

"All we know is that Mariele is down here somewhere," I shout between breaths. "Mantis, can you see through walls with those eyes?"

"Pretty much, Commander," she replies.

"Look for life signs or body heat. We're searching for a thirty-five-year-old woman who looks a lot like her," I say, pointing at Bit.

Suddenly yellow, red, green, purple, and blue lights stream out of the array of lenses on Mantis's face and scatter everywhere in the room. "I'm not picking up any heat, but I can see residual marks on the floor. The most foot traffic is coming to and from that way," she says, pointing down a corridor to the left. "And there are also signs of wheel trails; I'm guessing a wheelchair or gurney."

"Then that's our best bet," I say.

Mantis nods and takes off down the corridor with beams shining from her eyes all the way. All of us run right after her. Past the shower room we go, with Mantis leading the way, and she soon ducks into a room on her left. It's a medium-size room with a gray concrete floor, and rows of bright lamps positioned over long tables of potted flowers

and seedlings cover the low ceiling. It's where I woke up after the monorail fell on my head.

Mantis scans her beams over all of it. "Far wall," she says as she skirts around the tables and dashes across the room. She comes to a stop at a blank concrete wall. "There's a switch here." Mantis's beams cut off as she crouches down and presses a screw on an ordinary-looking electrical outlet. Suddenly there's a whirring noise, and the entire wall begins sliding aside. It's a secret room.

Blue lights in the ceiling blink on. The chamber is about twenty feet deep and fifteen feet wide; it's tiny. An empty gurney with wheels is pushed up against one wall, but lining another is a row of large cylindrical glass and stainless-steel containers. And in those containers are people. Dead, preserved people.

Bettina pushes past all of us and hurriedly goes from one container to the next, scanning over the remains. Even though none of the corpses are Mariele, there's no sign of relief on Bit's face as she runs toward a large stainless-steel door set into the far wall. Commander Zero, Jack, Mantis, Bulldog, and I stride after her.

"No, no, no," Bit says over and over as she reaches the door, and her hands hover over an electronic keypad set into it.

I look at Bulldog. "Lila, can you open that door?"

"I will try, Commander," she says as she steps forward. We all give her room as she rears back, flexing both her cybernetic arms at her sides and balling her metal hands into tight fists. There's a humming sound, then a high-pitched whine as the seams between her silver muscles glow orange, then red, then bright white. Suddenly her arms piston forward and slam into the door, punching two large holes right through it. Lila grunts with effort, and there's the squeal of twisting metal as she pulls the door and tears it completely off its hinges. Lila slides the door aside as Bit dashes past her through the doorway into a dark room, and I run in right behind her. As soon as we enter, bright lights flicker on all over the ceiling.

This new room is large. The walls and floor are white and sterile looking, but there's a rug on the floor, a television on one wall, a desk against another, and a bookshelf filled with books. There's an exercise bike in one corner, beside a toilet and a small sink, and on a bed against the far wall of the room, under the covers, squinting, blinking, and just waking up, is a woman with long dark, frizzy hair and big brown eyes.

"Mariele," whimpers Bit. "It's me, Bettina."

Mariele's forehead furrows, and tears well in her eyes as she throws the covers off, leaps out of bed, and strides toward Bit. She's wearing a white t-shirt and shorts, and apart from looking older than she did in her photograph, she seems relatively healthy and strong for someone who has been imprisoned in this room for almost nine whole years. Bit lunges at Mariele, and they wrap their arms tightly around each other as Mariele sobs with joy.

As heartwarming as this reunion is, if we don't leave in a hurry, we're all as good as dead. "We've got four minutes!" I shout.

Mariele looks over at me. "Finn?" she asks, staring in disbelief.

"Yeah, it's me," I say with a quick smile and a nod. "It's great to see you, but we have to go, now."

Bit pulls away from Mariele and looks her in the eyes. "Can you run?"

Mariele grins at her. "The way I feel right now, I could fly."

"Then let's get out of here," Jack shouts. No one needs to be told again. Bit grabs Mariele by the hand, as we all turn and storm out of the room, past the dead bodies in their containers, past the tables of potted plants, out the door, down the hallway, through the lab, and along the corridor that leads to the elevator.

Zero pulls open the cage door so hard he actually rips it clean off its hinges. Even without the door, it's a squeeze for all of us to fit inside the elevator with Mariele along for the ride. Somehow we manage it, and I push the second of the three buttons on the control panel.

The elevator slowly starts to rise, and the tension is palpable. "Three minutes," I whisper.

"Oh, bugger this for a laugh," says Jack, and he rips open the Velcro flap on his leg. He quickly detaches one of his metal fingers and replaces it with another much wider one with a flat tip. "Gimme a shoulder, Commander," he says as he climbs out the open cage door.

Half hanging out over the twenty-foot drop, Zero crouches down, and Jackdaw stands on his metal shoulder with one boot. Zero stands, boosting Jack up, and Jack flops his torso on top of the elevator. Through the metal grating of the roof, I see Jackdaw push his cybernetic finger into the center of the cable wheel.

He shouts, "Hang on!" There's a loud, whirring, squealing sound, and all of us stumble as the elevator suddenly lurches upward and begins climbing at four times the speed it was going before.

Smoke pours out of the elevator motor above us, but we reach our stop in five seconds flat. Jack pulls his finger free, jumps down onto the grating, and leads the group as quickly as he can back the way we came, up the metal steps and through the dimly lit tunnel to the hatch. Zero is just ahead of me, and I glance back along the line. Lila and Mantis are behind me, and bringing up the rear are Bit and Mariele, who seems to be having no trouble at all keeping up.

We reach the pipe that leads to the surface. One after another, we climb up it. Jack gets out first. Zero exits ahead of me, and he reaches down as I approach the top. I grab his metal hand, and with his cybernetic strength, I'm pulled right out of the pipe and airborne for half a second before landing softly on the ground beside the hatch. He does the same for Bulldog, Mantis, Bit, and Mariele, and soon we're all sprinting as fast as our legs will carry us across the small courtyard by the pagoda, down the alleyway between the buildings and toward the open ramp of the transport.

"One minute!" I shout.

We're so close. But that's the moment when I see it, and my stomach twists into knots of absolute horror. Everyone running for their lives around me sees it. How could they not? It looks just like a shooting star, but it's the biggest, brightest shooting star we'll ever see. It's so high it must still have miles to go until it hits, but the light coming from it is illuminating the whole night sky and touching everything around us with a soft orange glow. The looks of abject terror on the faces all around me are looks I'll never forget.

We run.

That's all any of us can do, and in this one singular moment, all of our lives have been boiled down to two simple elements. Run and hope. Up ahead, I can see Brody's deathly anxious face staring at us as he stands on the ramp of the transport.

Panting for breath, all of us stumble up the ramp as the gentle orange glow from the falling Sword gets brighter and brighter through the row of small windows lining the walls of the cargo bay.

"Go! Let's go!" Brody's voice screams through the headset, and the pilot clearly hears it as the transport slams into full throttle and the turbines rage with furious blue flames. Every one of us crumples to the floor, and I can hear yells and screams through my earphones as the fifteen-ton vehicle catapults up through the air.

Using any handhold I can find, I manage to scramble across the floor and make it to the wall of the transport. We are still ascending quickly and must be a couple hundred feet off the ground by now. I look into the sky, and now I see that there are two shooting stars. I'm still watching, with my heart thudding in my chest, when in the far distance, the first Sword of Damocles strikes the ground on the other side of Dome One. I wince and shield my eyes as an intense white light suddenly bursts through the porthole. The entire dome is nothing but a vivid black silhouette for a fraction of a second before it's completely gone altogether.

As quickly as the flash came, it vanishes, and in its place I can see a colossal mushroom cloud reaching into the night sky, the base of its burning charcoal-colored stem growing out of the ground where Dome One *used* to be. The unfathomably enormous explosion somehow doesn't seem real; how could it be? It's too terrifying, too overwhelming, and too destructive to exist. But I'm quickly reminded just how real it is as the sound and the shock wave hit us like a runaway freight train.

BOOOOOOOOM!

Without warning the whole transport flips upside down and rolls over in midair. Screams wail through my headset as people are thrown against the walls and roof and floor all around me. I hold on for dear life to anything that I can as the open ramp at the back of the aircraft rips away and spins into the day-bright night. Bodies are sliding and flailing, mouths are twisted, and faces are frozen in agonized masks of pure fear. Professor Francis's corpse and the still-bound, armless Percy both tumble violently across the floor, thud against a wall, and skitter out the torn-open cargo door.

All around me people are grabbing and holding on to any kind of strap or belt or person or seat that they can. The entire aircraft is tilting and swerving, rising, dropping, and shuddering. The violent pitching left and right seems to carry on for an eternity, and I don't know how, but at long last the frightening turbulence begins to wane, and the pilot manages to stabilize the transport. Incredibly, we're still flying, and the light from the explosion quickly fades back into darkness. Soon the only sound is the roar of the turbines. They seemed so loud before, but now they might as well be a whisper compared to what we just went through. I'm grateful for their noise, because it means that we're not falling out of the sky in a metal tomb of fiery wreckage.

The transport levels out, and I slowly feel like I can breathe again.

We're high in the sky and a safe distance away when the second, third, and fourth Swords hit. There's groaning in my headset, and I look around the cabin. Everyone left seems to be alive and moving, albeit

very slowly and painfully, as some get to their feet, check themselves for injuries, and reposition dislodged headsets. Gazelle is strapped into her seat nearby. I give her a concerned look and a hopeful thumbs-up. She returns it with a halfhearted smile and rubs a sore spot on her forehead. Brent looks rattled over there on his seat in the corner, but he seems otherwise OK. Bit and Mariele have crawled to each other and are sitting in the middle of the floor, smiling and staring at one another. Dean lies on the floor, awake, laughing as he glares at the roof of the cargo bay. There's a sudden commotion, and my heart jumps into my throat as Mantis, Bulldog, Jack, Zero, and Margaux all scramble toward the only one of us who isn't moving at all.

Jonah.

He's in a crumpled heap on the other side of the transport. I quickly untangle my hand from the strap I was clinging to and hurriedly stumble across the floor toward him. I reach him just as Commander Zero is turning him over onto his back and straightening the headset on Jonah's shiny bald head. Jonah lets out a pained and gurgling cough and opens his eyes. He's alive. He looks up at all of us gathered around him, and his eyes fall on me.

"Finn," he croaks as his lips curl into a feeble smile. "I need . . . to tell you . . ." His trembling fingers find my hand and gently squeeze it. "I need to say . . . that I'm so very sorry. I didn't mean . . . to hurt you, Finn."

"I know," I reply as I wipe my nose on the back of my hand with a wet snuffle.

"I thought I was . . . protecting you by separating your mind, but I was wrong."

"Save your strength, old man," I whisper as tears pour down my face. "You're gonna be fine."

"No, I'm not . . . going to be fine. That's why you need to listen. Infinity was always just another part of you," Jonah says as he slowly

raises his hand and touches my face. "Now you are whole . . . again. I . . . can see it. Search inside yourself, Finn . . . you know it's true."

I don't need to search; I know that he's right. I'm not sure how it happened, but what I do know is that the last time I heard Infinity's voice in my head was when I walked out of Dome Two, right after Nanny Theresa sliced my pendant from my neck. Ever since then, whenever I had to fight and I needed Infinity's strength, it was there. If I had to make a tough call and needed her bravery, I could feel it. Whenever I was in a tight spot with no way out and needed her to pull me out of the fire, she was there for me. But she wasn't really, was she? It was me. I did all those things. Infinity's voice didn't disappear from my head. It's just been coming out of my mouth this whole time.

"I feel it, Jonah," I reply. "I know who I am now."

"Good," Jonah whispers. "I took so much . . . from you, Finn. Now, let me give . . . something back."

I frown in confusion; I have no idea what he means.

Jonah turns his head and looks at Commander Zero. "Listen to me very . . . closely, Zero," Jonah says to him. "Listen to every word I say."

Zero nods and presses his right earphone hard into his ear. Jonah takes a labored breath and says a string of words that make no sense at all. "Zero command-code alpha, neural-barrier dissolve, authorization Brogan, level ten . . . deactivate."

All of a sudden Commander Zero looks like he's been struck by a bolt of lightning. He rears up on his knees, his back arches, and he grips the sides of his head like he's in agonizing pain.

Margaux screeches and skitters out of the way as Mantis shouts in panic through her headset. "What have you done to him?! Commander!"

Zero's entire body shudders and spasms, then his limbs go loose, and he topples backward, thudding onto the floor, unconscious.

Jack, Mantis, and Bulldog spring to their feet and rush to Commander Zero's side, and I'm about to do the same when Jonah

grabs my hand and holds it tightly. I can hear the Saviors calling out to Zero in my headset.

"Quickly, take his mask off," barks Mantis.

"Is he still breathing?" shouts Jack.

"Commander! Can you hear me?" yells Lila.

Jonah looks up into my eyes, and tears trickle down the sides of his face. He smiles warmly, and even though his voice is only a whisper, I can hear it through the shouting as if it were the only voice in the world. "Finn, I love you . . . like you are my daughter. No matter what happens never, ever . . . forget that."

Tears drip from my chin as Jonah's smile fades. His hand loosens from around my wrist, and his gaze gently drifts away from my face as the last flicker of life slowly dwindles and finally disappears from his eyes.

He's gone.

Sorrow erupts inside me and fills every fiber of my being as I collapse onto Jonah's chest and sob uncontrollably. I loved him, too; I loved him so much that the pain of losing him feels like a knife stabbing deep into my heart.

I feel a hand gently touch my back. Bit kneels down by my side. I look up at her, and she pulls me into a warm embrace as I cry into her shoulder.

"Finn?" croaks a raspy voice. "Finn?" the voice says again.

It's so strange that I pull away from Bit and look up at her in confusion. It definitely didn't come from her. Bit glances over at the Saviors, and so do I. What I see defies explanation. Commander Zero is sitting up. He's staring right at me, and in the dim light of the cargo hold, I see his face for the first time.

My eyes go wider than they ever have before, and I gasp out loud, not because he has deep, winding scars crisscrossing his battle-weary skin, but because . . . I know him.

This can't be real. How can this be?

I lean in, studying his features just to make sure I'm not losing my mind. If I look past Zero's cuts and see beyond the stubble and dirt and dust smeared over his caramel-colored skin, the unmistakable handsome face of the boy I fell in love with all those summers ago is right here, sitting only four feet away. I stare at him in complete disbelief, unsure whether or not to believe my senses, but as he smiles, his beautiful, soulful emerald-green eyes seem to shine through the dark and fill me with light. My overwhelming happiness bursts from my lips in a joyful laugh. I don't know how, but it *is* him.

"Hello, Carlo. Welcome back. I've missed you more than you could ever know."

That's what I should've said. But of all the phrases that I could've chosen, out of all of the millions of combinations of letters I could've put together, the only thing that I could come up with to say in this moment was "Holy shit."

∞

"Do you really have to swear, Finn?"

"Sorry, Onix . . . but that's exactly what I said, and it's pretty tame compared to what Bit said when she found out Mariele was her mother."

"Yes, you've told me what she said before, Finn. Please do not repeat it."

"Ha-ha, OK. Y'know, I've told you about that day so many times, and you never seem to get sick of it."

"I'm a computer, Finn, I'm incapable of boredom, and besides, you know how much I love story time."

"That's true; you have ever since it happened. But that day changed all of us. I still see Margaux around campus sometimes. She's quiet now and seems to keep to herself. I can't believe Bit and Brody are still together, but I haven't seen any of my other schoolmates since I started

university. The Saviors are always going off on some rescue mission. They're so busy since they got a new Commander, but Gazelle is coming to stay next week, and I can't wait to see her. I still can't get used to calling her Caitlin, though, no matter how much she pesters me to. It's been three years now, but I still remember all of it like it was yesterday."

"Three years, two months, six days, fifteen—"

"I don't need to know the hours and minutes, Onix."

"Sorry, Finn."

"That's OK. Anyway, he'll be here soon, so I've gotta go. If Mother or Nanny Theresa are looking for me, tell them I've gone riding by the lake or that I'm locked in my room studying and I don't want to be disturbed."

"And what will you actually be doing, Finn?"

"The same thing I always do on a warm summer night like this, Onix, sitting by the pond, throwing stones with Carlo."

ACKNOWLEDGMENTS

Thank you to . . . my parents for your endless support, Lucy for never giving up on a dream, Tegan for sharing my vision, Sasha for taking a chance, and, of course, Courtney for believing that Infinity wasn't too far to reach. A huge cheers to Britt, Jason, Hai-yen, Ben, Tyler, Mikyla, Katherine, Rachel, and everyone at Skyscape. Thank you to everyone at Brilliance, to Elena, Brianna, Kimberly, and Allison at Wunderkind, and finally, to you, the reader who has been right there beside Finn and Bit every step of the way; thank you so much, and . . . you ain't seen nothing yet.

—S.

ABOUT THE AUTHOR

Photo © 2015 Lucy Ngata

S. Harrison is an author from New Zealand, where he often indulges his love of watching superhero movies and art-house films. He frequently escapes to the many islands of the South Pacific, where he is hard at work on his writing.